FANTASMIC OBJECTS

PUBLIC CULTURES OF THE MIDDLE EAST AND NORTH AFRICA

Paul A. Silverstein, Susan Slyomovics, and Ted Swedenburg, editors

FANTASMIC

ART AND SOCIALITY FROM LEBANON, 1920–1950

OBJECTS

KIRSTEN L. SCHEID

INDIANA UNIVERSITY PRESS

This book is a publication of

Indiana University Press
Office of Scholarly Publishing
Herman B Wells Library 350
1320 East 10th Street
Bloomington, Indiana 47405 USA

iupress.org

Manufactured in the United States of America

First printing 2022

Cataloging information is available from the Library of Congress.

ISBN 978-0-253-06423-3 (hardback)
ISBN 978-0-253-06424-0 (paperback)
ISBN 978-0-253-06425-7 (ebook)

CONTENTS

PREAMBLE

THE POLITE VOICE on the line said Walid Raad, the artist, was calling. I suspected a practical joke. The voice said he would like to see "my archives." In my office at the American University of Beirut (hereafter AUB) in early 2008, I searched my computer's hard drive to check whether I had published something to catch his interest, or ire. The voice explained that Raad hoped my archives could help him locate the conditions of his coming into being as a globally relevant artist "from Lebanon." It then dawned on me that the joke was one art was having on all of us. Its punch line had to do with how I, a Clevelander by upbringing, had come to amass assorted historical documents that an artist living in New York could hope would locate him "in Lebanon." Because art queries space as much as it concretizes it, I open this study with an account of my personal involvement's origins, the better to understand what maps it draws on and draws in.

In the 1970s, the Cleveland Museum of Art's comprehensive collection astonished children and adults alike. Whenever my grandmother visited town, she would take me to explore its rambling galleries. I relished how lighting, temperature, and feel distinguished each. Perhaps it was the encompassing atmosphere of those rooms, more than their collections of Chinese scrolls, medieval armor and reliquaries, or 1970s American paintings and installations, that made me want to live with art. Drawing lessons at the nearby Cleveland Institute of Art revealed to me by age twelve that I had neither talent nor vision of my own, but someone in my car pool for class observed that people who don't make art become art historians. So it seemed natural that my college applications designated a planned major in art history, followed by interests in international relations, literature, and political science. I certainly didn't

know what career I wanted to make with the degree, but that wasn't something I had to know. As a middle-class white American Christian couple, my parents accepted any BA from a "big-deal" school, and we all assumed that life would follow. The fortunate absence of pressure meant I could pursue art studies at Columbia College in the late 1980s. New York offered multiple museums and internship opportunities for those who sought them out. I served as docent at the Center for African Art under Susan Vogel, and I continued happily in my major until the fall of 1990.

Disillusionment accompanied the autumnal colors ushering in my junior year. My courses Greek Art and Architecture and Nineteenth-Century Painting (the title of which did not even specify a cultural area) left me wondering why some societies preserve art or have museums. I was not asking, "Why do only some cultures make art?" I had a relativist—and then vogue—idea that art is whatever one wants it to be. But that did not fit with how "art" was being taught on our campus, where courses focused on modern Europe. So my curiosity about the divergence focused on art's institutionalization through museums. I put this issue to the director for undergraduate studies in art history, Theodore Reff, an Impressionist scholar (also my Nineteenth-Century Painting teacher). He asked whether I was a Marxist or a feminist. I had no answer. Kindly nodding, he explained, "We don't do that kind of thing here," but he handed me an extra desk copy of Michael Baxandall's *Painting and Experience in Fifteenth-Century Italy*, saying, "You might enjoy that."[1] I did, because it answered my questions by suggesting that art was a visual primer for society.

I spent the summer of 1990 at Princeton University's Anthropology Department, under the mentorship of Hildred "Hilly" Geertz. She had borrowed from the Smithsonian Museum the early twentieth-century Balinese art collected by Margaret Mead and Gregory Bateson. She argued that this art was created in an intercultural junction between tourists and Balinese. The artists, or rather, the people making what became available as "artwork," sought to unravel their colonial situation through this circulation of forms. Hilly got me thinking that Balinese society was up for question. Helping edit her book manuscript and host an international conference on art as a form of social action implanted the idea of art's agency in my mind.[2] It contradicted the then-common anthropological understandings of art.

A war recast my thinking almost as soon as it started. Just as I returned to campus for spring semester 1991, George H. W. Bush announced that American generals were leading a multinational force to invade Iraq. In my two decades of being American, this was the first war in which I found myself implicated, and I protested it daily and publicly. I wore black to remind myself people were

dying, because news outlets merely reported the "eerily beautiful bombs," as one anchor put it. When the American bombing of a Baghdad shelter incinerated 408 civilians, I rankled to learn that many of my fellow art history majors rationalized the slaughter, saying that despite Iraq's early status as the "cradle of civilization," the dearth of courses on our campus about any contemporary Iraqi, Arab, or even Middle Eastern art proved that Iraq had lost relevance. Contemporary Iraqis "offered nothing important to humanity." Two weeks earlier, David Levine had published the largest op-ed cartoon ever published in the *New York Times*, which he called "The Descent of Man."[3] Referencing a Darwinian schema, it suggested humans had been *de*volving since Clark Gable, back through the primates and reptiles to the lowest life form of all: Iraqi president Saddam Hussein. We like to think of art as a cultural bridge, uniting humanity, but Levine's cartoon and my classmates' responses revealed to me that "art" can classify peoples and rank them. The art historical task of memorizing stylistic categories and hallowed makers' names took on a sinister meaning to me.

I reached a turning point when I met among fellow anti-war demonstrators a handful of Palestinian artists, all dancers. A cognitive dissonance jarred me: "What do you mean you are doing art now?" I asked them, barely comprehending the military closure and occupation they endured at home. My astonishment that they took art seriously, despite the difficult living conditions, stemmed from having learned that art belongs to the global upper class: "In the room the women come and go / Talking of Michelangelo," as T. S. Eliot aptly put it.[4] In a novel way, the Palestinian dancers made me rethink art's agency. Maybe art not only represents a given society's concerns but reshapes them and their parameters in the world. This resembled the Balinese case but was happening in the present. I realized that if I wanted to learn more about art, I should study with these dancers, outside the academy.

In June 1992, I joined an Arabic language program in the Palestinian West Bank. The artists I had met in the demonstrations connected me to the Popular Art Center in El-Bireh to work as an intern. For almost a year, I stayed, studying Arabic, writing the center's grant proposals, and conducting research. I interviewed all the artists active in the West Bank that I could meet. I went to the art shows and interviewed audience members. At first, my asking them, "What do you see?" was an appeal for a visual translation of the highly symbolic forms on display. Later I realized I was applying Baxandall's perspective, assuming that I needed to learn to see with different eyes. I had been trained to look at an object aesthetically, meaning to examine the formal integrity of the piece, the relation between elements that were in the piece itself. Many people

I interviewed, by contrast, talked about those objects as a set of messages that they could discern; interacting with the object rewarded their grasp of cultural knowledge. In a way, the art they viewed was much more alive to them; it activated their sense of identity and belonging. Those issues were not addressed by my art historical training at that time, even in Baxandall's brilliant account of optical culture. Culture came first, and then the art. But here, in a place where people were denied cultural flags, institutions, and even a self-name, it seemed art revealed a deeper, foundational role.

When family considerations compelled me to relocate my research to Lebanon, it looked as if my project had become much easier. While both Palestinian and Lebanese populations endured checkpoints and military occupation, the latter hosted more artists, more galleries, and more ways to move around. Many institutions, such as the Nicholas Sursock Museum, Dar al-Muntada, and the Beirut University College, had mounted annual collective shows throughout the war era. Now new governmental and private entrepreneurial organizations marked its end with art events, like the massive *Salon de printemps* in Martyr's Square, and art festivals, such as *Daraj al-Fann*, in Gemmayzeh, and *Layali al-Zuq*, in Zouk Mikael. All supplied home decor for returnee migrants' new homes. I could read about an exhibition in the newspaper, attend the opening, and watch nightly news coverage of it on Lebanon's plethora of television stations, airing at conveniently staggered intervals. There were so many concurrent events that *l'Agenda culturel*, a colorful, palm-sized publication, had just been launched to collect invitation cards and deliver them en masse to people who, according to the young trilingual director Raghida Tawil, "did not have the time to read the papers" but would pay twenty dollars for this service and make it to an occasional exhibition. Marking the duration and overlap of art events in my field journal, I often felt a rain of aesthetic opportunity pouring down on me (fig. 0.1).

Still, my attempt to conduct the same study that I had pursued in Palestine failed completely. At least two causes contributed to this demise: The first was the comparatively high social ranking of Lebanese artists of the early 1990s. They enjoyed shows in well-established galleries and regular columns of newspaper criticism. Their interest in talking to some young woman, still figuring out her Arabic and with little material support to offer them, was nigh on nil. The second, more important reason was that, despite the plethora of artist interviews I conducted and my internships at two galleries, my research felt off point. I told people I had come to study "Lebanese art" because it was not taught in Western universities like the one granting my degree. Some praised me and, noting my recent marriage and reverse brain-drain migration with

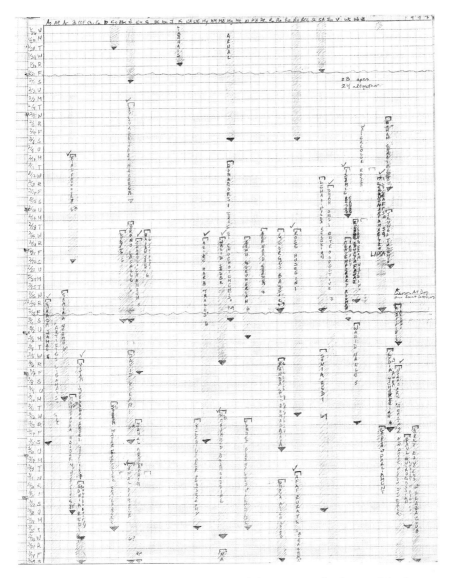

FIG. 0.1 Excerpt from author's field journal, "Exhibition Events," February–March 1997. Photograph by and courtesy of Walid Raad.

my Lebanese husband, attributed my project to nascent "nationalism." Others stared at me: What was I talking about? Why would American colleges give courses on Lebanese art when Lebanese colleges didn't? Both insisted repeatedly that there was no art here to study.

"I'm the only artist who perseveres despite having to struggle," many artists of both the edgy younger generation and the comfortably established older generation privately told me in a confessional tone. Or they said, "Lebanon is not a place for art, not like America where you are from." For their part, gallerists and collectors would say, "People here don't care about art," or "People here don't understand art." I was confounded. How could such a lush setting for art be accused of aesthetic aridity? How could there be "no art here" when the person insisting on this condition of lack was himself an artist, gallerist, or collector? How could "the Lebanese people" not understand art when before me was a self-appointed spokesperson making such evaluations in the name of art? My embarrassed rebuttals elicited explanations, such as that a lack of local history—attributed variously to Ottoman oppression, Islamic iconoclasm, or cultural backwardness—resulted in aesthetic stunting and that this was why there was no "real" art museum (just a municipal institution with an eclectic and uneven collection), no "proper" galleries (just shops), and no "major" artists with a "true" local following (just family or patron networks). In sum, there was no present for art here because there had never been a history for it.

At first, I declined to document such statements. They neither made sense to me nor felt right for me, a newcomer with colonial baggage, to record. However, several years of trying to study within this idea of no-history convinced me to understand *its* history. I decided to face the fact that people kept relating art's present to a past absence. Consequently, I centered my study on how an idea of no-history undergirded current art-society relations. I thought that somehow that idea was more foundational than we tend to think, meaning that it was not descriptive but structural.

This image of a structural absence was specifically interesting in the Lebanese context of the 1990s. Having emerged for the third time since 1860 into a "post–Civil War" state, Lebanese were trying to figure out what Lebanon was and what the bases for being Lebanese were. Most Lebanese lived (and still do) abroad. Beirut, the capital city, was infrastructurally in ruins though intellectually host to a vibrant cultural life (and famous nightlife), and the carefully sect-apportioned government spent much of its time negotiating not with Lebanese citizens but with Syrian and Israeli occupiers, as well as with more distant managers. I noticed that in talking about art, my interlocutors often referred to a past leading to a hopeful future, but not to a present. I guessed that

art's alleged reflectiveness grounded a society when neither political nor material conditions supplied clarity or self-evidence. My quest became the creative conditions that had produced such possibilities. Themes such as the social role of art, audience interactions, and how objects matter to people discursively and politically remained focal to my research, but my methodology shifted to archives and a corpus of dispersed and still-growing works.

This is how I had come to assemble sheaths of photocopies of yellowing periodicals, unpublished manuscripts, exhibition catalogues, and slides that Walid Raad heard from colleagues might help him place himself. As Raad explained his request, I recalled my students in AUB's Graphic Design program several years before talking about this renowned artist: his globe-straddling fame confirmed to them the necessity of leaving Lebanon's lacking society. To them, his career confirmed that artists "born in Lebanon," as the bio always has it, launched literally from a gap, conceptually and geographically, between backward, Civil War Lebanon and art. His work has appeared to represent Lebanese society in spite of itself, in spite of the Civil War, social decay, and conservative iconoclasm. Audiences had admired Raad for his "exceptionality," his perseverance, his seemingly heroic capacity to make universally laudable art from a land where there is no art. And now he expressed hope that the documents in my office might help him place his finger on how he was related to this thing called "art from Lebanon," which seemed to exist only in such archives.

Several months later Raad's exhibition *A History of Modern and Contemporary Arab Art: Part I_Chapter 1: Beirut (1992–2005)* opened at the Sfeir-Semler Gallery, housed in a former factory in Beirut's garbage-collection and slaughterhouse district. The multimedia installation included a miniature replica of an empty museum gallery, a frieze comprising the names of locally active Lebanese artists, and large prints partially reproducing slide and journal archives and publications about Lebanese art (fig. 0.2). Each element embodied a degree of inaccessibility: the frieze was executed in white on a white wall, eluding legibility. The miniature gallery required the viewer to bend and squint through a peephole. The prints were missing letters, spacing, or other crucial information. Some attendees at the very out-of-the-way show patronized all art world events, but most specifically championed Raad's vanguard work with the Atlas Project into the intelligibility of the Lebanese Civil War (1975–92). A similar instantiation of distancing and absurdity now characterized Raad's approach to the topic of "Lebanese art," yet this time it generated anger and dismay, even from those who had previously praised his work. As I wandered the gallery collecting interviews with attendees, I was struck by the dissonance between angry responses to Raad's acidic method and their own descriptions of the state

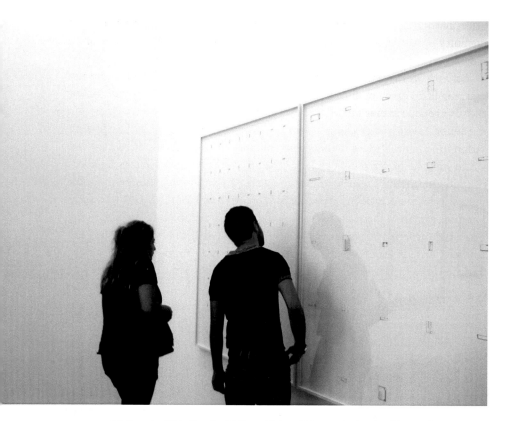

FIG. 0.2 Visitors to Sfeir-Semler Gallery, Beirut, July 2008, viewing "Appendix XVIII: Plates 56–58 Dr. Kirsten Scheid's Fabulous Archive, A History of Modern and Contemporary Arab Art: Part I_Chapter 1: Beirut (1992–2005)," by Walid Raad. Author's photograph.

of Lebanese art. They indignantly inquired, "How dare Raad call into question Lebanon's art?" although they had already told me that there is no art here.

Raad based a handful of the works displayed in his *History* on material he had found in my office. I remember when he asked me to join him for a coffee so he could show me the work. He put his laptop on the table and, nervously it seemed, turned the screen to face me, watching my eyes and tightening his facial muscles. At first the screen appeared blank, and I admit I wondered if my leg was being pulled by this infamous trickster. Gradually, I noticed pinpricks of color or script and the bare skeletons of conventional newspaper columns announcing "*fann*" [art] or "*ma'arid*" [exhibitions] that Raad had digitally condensed and cropped into (literally) conceptual outlines. Amid the wash of

white flashed shimmers of something larger yet unseen. Palpitating between visibility and invisibility, it seemed apprehended best through unconventional means.

Tonally, whiteness signals absence, but chromatically, it arises from the merging of an array of light reflectors, a fullness. When on *History*'s opening night I probed further into the collective irritation, people told me they took the deliberate absenting of clarity, accessibility, and certainty in Raad's presentation to indicate the imposition of a minimalist style. Reflecting through the white walls and unconventional prints onto my own research practice, I saw the whiteness as not bespeaking lost efforts but highlighting fantasmic investments. Whiteness cast into stark contrast my reliance on evidential, empirical outcomes and opened the specks of documents and slides to all the yet-unappreciated investments in finding and preserving art. The whiteness pulsating between the barely perceived icons of art hinted at the motivating interactions between artworks and audiences that often go unperceived.

Perhaps the movement I have come to describe in this book on fantasmic art was only a product of the search by others for an artistic background, a history, a cause. Even so, their labors, intervening between a receding past and an uncertain present, could be scrutinized best by poking into the notion of "not here" to consider how "here" has been created as a qualification of "not." Toward that end, this book weaves between anecdotes from my fieldwork in 1990s–early 2000s Lebanon, bookending each chapter, and detailed investigations of art practices developed during the period of the French Mandate of Grand Liban. I hope readers will wend with me between historical traces of art presences produced as absences and fantasmic investments developed to make art, place, and people together.

Notes

1. Baxandall, *Painting*. NB: I provide full references in the endnotes only for archival sources, including period press publications. Name and abbreviated title alone indicate a full reference in the bibliography.

2. Artistic Representation in Social Action: The Case of Bali (conference, Princeton University, July 8–13, 1991).

3. David Levine, "The Descent of Man," *New York Times*, February 1, 1991, op-ed page.

4. Eliot, "Love Song."

ACKNOWLEDGMENTS

I LONG ATTRIBUTED this book's delay to my dread of writing its acknowledgments. Like all postponed tasks, my duty only grew. In thinking about *taswir*—that interactive project of imagination—however, I warmed to the task. I saw a gleaming white sphere or surface with tiny pinpricks of color bursting forth. Each scintilla of color miniaturizes a work, effort, claim, document, or dream—something shared with me toward enacting this project. (Thank you, Walid Raad, for this *sura*, and this book's front cover, the promise of which motivated me on the worst days.) From such vibrant glimmerings, my taswir egresses, carrying forth scintilla that may prompt more taswir. Toward acknowledging that mine is no individual possession (or obsession), I open with mention of those condensed by the scintilla.

Book-writing spaces and time to occupy them materialized thanks to funding from the American University of Beirut's Junior Faculty Research Leave, the Europe in the Middle East—the Middle East in Europe (EUME) postdoctoral fellowship program, a *chaire sécable* at l'École des hautes études en sciences sociales (EHESS), and most decisively, the Clark/Oakley Humanities Fellowship at the Sterling and Francine Clark Art Institute and Williams College. I thank Ulrike Freitag, Nora Lafi, and Georges Khalil for hosting me in Berlin; Alain Messaoudi and Fanny Gillet-Ouhenia, in Paris; and Caroline Fowler, Olivier Meslay, Gage McWeeny, and Krista Birch in Williamstown, Massachusetts. The Barakat Trust Fund magnanimously supported the publication of the images. Ibrahim Sleiman, of Paladium Photography Shop, photographed and digitalized many of those images at a major discount despite the economic crisis.

Most of the work I studied was not housed in public institutions. I am grateful to the people who opened their homes to me and later provided the images motivating this text. Indeed, this book is an extension of their intimate, domestic spaces for taking up art: Hala Schoukair, Hani Farroukh, Hana Farroukh, May Mansour Onsi, Abed Rahman Onsi, Dr. `Ali Ra`ad, Danielle Gauvin, Joseph and William Matar, Hassana Jabr Salaam, Wadad Rawda, Muna Halaby, Samir and Su`ad Jarrar, Tammam Salam, and Elias Saba. Saloua Raouda Choucair, Anissa Rawda Najjar, Muhammad Dakroub, Ihsan Onsi, Ramzi Saidi, Assem Salam, and Dr. Oussama Onsi have since departed, but I will always appreciate their generously sharing their archives and collections.

That said, Nadine Begdache at Galerie Janine Rubeiz, Saleh Barakat at Agial Gallery, Christine Tohme at Ashkal Alwan, Sylvia Agémian and Zeina Arida at the Nicholas Sursock Museum, Marie Muracciole at the Beirut Art Center, and their staff past and present, all deserve my deep gratitude for providing nodal points of convergence and respite throughout my fieldwork years and for stimulating challenging debates in their beloved settings.

Moreover, numerous devoted archivists invited me into their collections and taught me to attend to connections and resonances otherwise unnoticeable: Ustadh Hassan with his crew of uniformed photocopiers serving their conscription at the Lebanese National Archives; the greatly missed Najib al-Rayyis, who knew AUB's Periodicals Room inside out; Asma Fathallah, Kaoukab Chebaro, and Samar Mikati, who have successively reigned over the Jafet Library Special Archives perceptively and benevolently; as well as Magda Nammour and her team at the Bibliothèque Orientale; Hala Dimechkie; Margaret Dakin at Amherst College's Special Collection; the very efficient staff at the Centre for Diplomatic Archives, Nantes; the Ministry for Europe and Foreign Affairs, Quai d'Orsay; and the National Archives at Pierrefitte-sur-Seine; Didier Schulmann at the Bibliothèque Kandinsky; and, in his own periodical paradise at Dar al-Furat, Abboudi Abou Jaoude.

Working with Arabic language sources was facilitated by the patient probing of esteemed linguaphiles, most prominently Hala Bizri, Munir Fakher Eldin, Nada Moumtaz, Fawwaz Traboulsi, and Fatma Cheffi.

Bold thinking becomes possible under a deadline. The first form of this book was a PhD dissertation that was patiently and discerningly shepherded by Hildred Geertz, Abdellah Hammoudi, and Larry Rosen at Princeton University, with James Boon and Rena Lederman also extending help. Luckily they finally imposed a deadline to their patience and convinced me I had something worth defending before them. I thank Larbi Sadiki for suggesting I write the ideas that seed chapter 1 and appeared in "Start with the Art: New Ways of

Understanding the Political in the Middle East" in *Handbook for Political Science in the Middle East,* edited by Larbi Sadiki (New York: Routledge, 2020), 432–44. Components of that chapter developed under the prompting of Angela Harutyunyan and appeared as "Toward a Material Modernism: Introduction to S.R. Choucair's 'How the Arab Understood Visual Art,'" in *ARTMargins* 4 (February 2015): 108–18. Various arguments in chapters 2 and 3 crystallized in "Necessary Nudes—*Hadatha* and *Mu`asara* in the Lives of Modern Lebanese," in *International Journal of Middle East Studies* 42 (May 2010): 203–30. I thank Judith Tucker for her openness to the topic of fine art and nudes. Silvia Naef and Sofian Merabet gave me my earliest opportunities to share my research on exhibitions and nudes. When I thought the subject exhausted, Mark Westmoreland drew out other aspects for "Over the Shoulder: Islamic Visuality or Muslim Visibility," in *Provocative Images in Contemporary Islam*, edited by Bart Barendregt, David Kloos, Leoni Schmidt, and Mark Westmoreland (Leiden: University of Leiden Press, 2022). Parts of chapters 3 and 4 develop those arguments as well as others drafted for "Looking as/at Nudes: A Study of a Space of Imagination," in *Fashioning the Modern Middle East: Gender, Body, and Nation*, edited by Reina Lewis and Yasmine Nachabe Taan (London: Bloomsbury Books, 2021), 113–34. An early version of chapter 4 appeared as "Divinely Imprinting Prints; or, How Pictures Became Influential Persons in Mandate Lebanon," in *Routledge Companion to the Middle Eastern Mandates*, edited by Cyrus Schayegh and Andrew Arsan (London: Routledge, 2015), 349–69. Lastly, portions of the thinking presented in chapter 6 appeared in "Distinctions That Could Be Drawn: Choucair's Paris and Beirut," in *Saloua Raouda Choucair in Retrospective*, edited by Jessica Morgan (London: Tate Modern, 2013), 41–55; and as "Changing Body and Society: A Speculative Examination of Portraiture in Choucair's Non-representational Corpus," in *Regards: Revue des arts du spectacle* 1 (2019), 15–30. I am very grateful to Jessica Morgan and Toufic El-Khoury for their prodding, encouraging, and challenging of me.

Despite the difficult conditions of life in Beirut and an erratic university structure, amicable colleagues listened, commented, and helped me through crises of confidence, time, and other resources related to this project: unswervingly, departmental administrators Maysaa Kobrosly and Maria Baramakian; with unbridled speculations and curiosity, Jihad Touma; with stern advice and timely interventions, Nadia El Cheikh, Ahmad Dallal, Patrick McGreevy, and Blake Atwood; with brilliance and excitement that brought meaning into my work space, Octavian Esanu, Hala Auji, Nader El Bizri, Angela Harutyunyan, Sonja Mejcher-Atassi, Mona Harb, Samir Seikaly, and Rana Issa; as a mentor, ethical guide, or a rock of support, Charles Harb, May Farah, Tima El-Jamil,

Huwayda al-Harithy, Rico Frances, Walid Sadek, Maher Jarrar, Waleed Haz-
boun, and Robert Myers. The support of my longtime colleagues, Livia Wick
and Sylvain Perdigon, has been irreplaceable and especially noticeable in last-
minute moments of stress. I cherish their canniness, care, and acumen, which
have been *ayat* to me. I owe a deep debt to the AUB students of successive
sections of Arab Culture and Society, Seminar in Art and Culture, and the
various permutations of Art, Aesthetics, and Social Change, especially Rania
Jaber, Susan Barclay, Hiba Morcos, Sarah Sabban, Laura Metzler, and Rabea
Hajaig. These students have emboldened me through their critical responses
and belief in necessary answers.

 While I was working on this project, Beirut became my community of learn-
ing, commitment, and challenge. First, engrossing me in the intellectual life,
the family business of Dar al-Adab accepted me in and bid me to learn. I deeply
respect the Idriss family's generations-long commitment to Arabic language,
creativity, and ethical engagement. Pulling me into research haunts, dragging
me to fieldwork sites, casually effecting an interview or an afternoon at the
archives were Aseel Sawalha, Mayssoun Sukarieh, Jack Assoud, and Nadya
Sbaiti. Others shared enthusiasm and opened their resources and networks:
Diana Abbany, Maria Abunnasr, Raja Adal, Zeina Aridi, Tarek El-Ariss, Jack
Assoud, Saleh Barakat, Fadi Bardawil, Hala Bizri, Gregory Bouchakjian, Bri-
gitte Calande, Sandra Dagher, Ghassan Hage, Rola Hajj Ismail, Sami Hermez,
Hatem Imam, Lamia Joreige, Samar Kanafani, Kristine Khouri, Sonya Knox,
David Kurani, Zeina Maasri, Rogine Mallah, Mai Masri, Muzna Masri, Nada
Moumtaz, Marie Muracciole, Yasmine Nachabe Taan, Sami Ofeish, Walid
Raad, Marwan Rechmaoui, Ghalya Saadawi, Karim Sadek, Walid Sadek, Eliza-
beth Saleh, Rasha Salti, Samir Sayigh, Amira Solh, Christine Tohme, Nadine
Touma, Kaelen Wilson-Goldie, Akram Zaatari, and Georges Zouein. Addi-
tionally, a special set of resourceful, persistent students working to pay for
their tuition applied their intelligence to the project encapsulated in this book:
Abdallah El Ayach, Susan Barclay, Nadia Bou Ali, Rania Jaber, Ziad Kiblawi,
Araz Kojayan, Laura Metzler, Hiba Morcos, Haya Mortada, Mariana Nakfour,
Sarah Sabban, Lara Sabra, Sara Shaito, Douaa Sheet, Mac Skelton, Iona Stew-
art, Yara Traboulsi, Nura Treves, and Heghnar Yeghiayan. Heroically, Iona
Stewart stepped in for last-minute final editing. She far surpassed her duties
by bringing to bear on the manuscript her considerable experience, erudition,
and passion for anthropology. I am deeply in her debt.

 A constellation of colleagues extended helping hands, arranging presen-
tations, providing entrees, and generally helping me connect the dots for-
ever floating around this project: Betty Anderson, Mirene Arsenios, Saleem

Al-Bahloly, Monique Bellan, Roger Benjamin, Omar Berrada, Annabelle Boissier, Andrew Bush, Ayşe Çağlar, Gülru Çakmak, T. J. Clark, Clare Davies, Lara Deeb, Abou Farman, Ellen Fleischmann, Barry Flood, Susan Elizabeth Gagliardi, Farha Ghannam, Rohit Goel, Ghassan Hage, Jens Hanssen, Julia Hauser, Mary Healy, Tayeb El-Hibri, Nabil Itani, Simon Jackson, Shanay Jhaveri, Rebecca Johnson, Suad Joseph, Deborah Kapchan, Banu Karaca, Pamela Karimi, Laleh Khalil, Sonal Khullar, Peter Lagerquist, Anneka Lenssen, Peggy Levitt, Saba Mahmood, Ussama Makdisi, Nadia von Maltzahn, Francesca Merlan, Kristin Monroe, Silvia Naef, Yael Navaro, Angelika Neuwirth, Julie Peteet, Nasser Rabbat, Nadia Radwan, Dina Ramadan, Elizabeth Rauh, Sarah Rogers, Nadya Sbaiti, Nada Shabbout, Jonathan Shannon, Sherene Seikaly, Andrée Sfeir-Semler, Avinoam Shalem, Malek Sharif, Wendy Shaw, Chris Stone, Elizabeth Thompson, Fawwaz Traboulsi, Heghnar Watenpaugh, Keith Watenpaugh, Stefan Weber, Mark Westmoreland, Jessica Winegar, and Zeina Zaatari.

Draft readers helped me stop not-writing. I am forever indebted and in awe: Betty Anderson, Lara Deeb, Holly Edwards, Hannah Feldman, Ilana Feldman, Amanda Focht, Ussama Makdisi, Brinkley Messick, Karen Miller, Kashia Pieprzak, Todd Porterfield, Nasser Rabbat, Noah Salomon, Rosemary Sayigh, Nadya Sbaiti, Hala Schoukair, Elizabeth Thompson, Heghnar Watenpaugh, Jessica Winegar, and my Princeton "cybergroup," including Lisa Wynn, Tom Strong, Rachel Newcombe, Alex Edmonds, and Kristine Latte. At Indiana University Press, I salute the series editors for their deep belief and patience: Paul, Susan, and Ted, as well as the editorial team including Jennika Baines and Sophia Hebert, and, with immense gratitude, the anonymous manuscript reviewers whose letters infused me with excitement. Angelique Dunn deserves special mention for her diligent and thoughtful copyediting. Safaa Ibrahim painstakingly checked the transliterations from Arabic on a tight schedule. But before and throughout all, I acknowledge my mentor, Hildred Geertz, who simply, powerfully trusted me.

Deep in that liminal zone of not-not-writing is a daily anguish I could only confront with others holding my hands: the pseudonymous pomming "bears" I met through an online faculty support program; Chris Koné, who marched me through a COVID spring of writing; the graduate students who joined my weekly workshop in fall 2020; and Karen Miller, my daily touchstone whose last-minute editing alerted me to the fact that her initials—k, r, m—form the Arabic root for generosity and grace.

If taswir joins the possible with the material, one aspect of the material-that-is-possible is the condition we call home. Hanin Abdallah, Anna Salameh, Hala

Schoukair, Maha Issa, Yasmine Nachabe Taan, Hala Bizri, Roula Haj Ismail, Abed al-Zahzah, Charles Harb, Nadya Sbaiti, Aurora Peet, Lulia Turk, fellow yogis, and the much-missed Maher al-Yamani: You made me feel home despite my resistance to the very idea of it, and you made me learn about art by recognizing the making of locality through relations. That would have been unthinkable had my parents, Janet and Peter Scheid, not taught me early to venture and "taste everything." After waving goodbye to me when I was a high schooler, they welcomed me back when, three decades later, I needed shelter from a pandemic. They shared their printer, food, pets, clothes, and belief in me, which got me through the last grueling phase of distilling my long-stewing thoughts.

Finally, there are people who cannot be located, for their influence is everywhere: Amanda Focht remembers, posits, and creates; her verve has grounded our friendship since college. Yael Navaro provides a guiding light whose brilliance cannot be matched but can always warm one. Karen Miller, Shuruq Harb, Marie Murraciole, and Ussama Makdisi have been indefatigable in their support. With unsurpassable luck I befriended Hala Schoukair through this long research process. I tried to interview her for another project, but she suggested something like this one and waited until I saw her wisdom. It took me even longer to befriend Hannah Feldman, a chance I almost missed. Several summers ago, Hannah insisted on returning to the United States with my manuscript. As I handed her the USB, she blurted out a dream that I had refused to give it to her because it was "full of holes." It was. But Hannah, through her ungodly tenacity and sheer sagacity, buckled me into various desks, including her own, until I realized that words are for sharing and the holes, for breathing.

Sariya and Naye Idriss, my daughters and pride, you have watched as the project transformed from a nuisance to a passion. You crafted your lives through my absences. I hope those holes become the space of your art acts. Already I thrill to watch you form your communities, engaged and responsible, wherever you go: this book is dedicated to you.

NOTES ON LANGUAGE

Unless otherwise noted, all translations are mine.

Considering the density of Arabic terms in my text, I have applied the IJMES transliteration system minus diacritics. I mark the `ayn with a backtick (`) and the hamza with an apostrophe ('), the ta-marbouta with a, and the adjectival nisba with a yy. I follow a guideline for elisions which does not mark a difference between sun and moon letters. I italicize the first instance of Arabic words not common to English and provide a translation in brackets (and in the index). After the first instance, I remove the italics. For French, I italicize words but translate them only when they add to the meaning or might elude the reader.

When referring to artists, public figures, and interviewees in the text, I conform to their preferred transliterations, for sake of coevalness, or the acknowledgment that I sit with them to be changed, "in-formed" by them. I apply IJMES transliteration for primary sources with the purpose of making them available to researchers. Thus, I use "Moustapha Farrouk" to speak of the artist but "Farrukh, Mustafa" to refer to his writings. Foreign-origin first names are kept in the original language (e.g. Edvick, Henri), unless I only encountered the name in Arabic script.

For common place names, I follow the official transliteration employed locally, such as Gemmayzeh and not al-Jummaiza.

NOTES ON SOURCES

Archival material comes from the following public and private sources:

AA—Ashkal Alwan Archives, Beirut
AUB—American University of Beirut
CDAN—Centre for Diplomatic Archives, Nantes
DG—Danielle Gauvin Collection, Paris
GZ—Gilberte Zouein Collection, Maameltein
HF—Hani Farroukh Collection, Beirut
JM—Joseph Matar Collection, Eddé
MO—May Mansour Onsi Collection, Beirut
SRC—Saloua Raouda Choucair Foundation Archives, Ras El Matn

Anthropologists work with informants who reform their perspectives and very insides. Where appropriate in the text, I mention people by name to give them credit and hold myself accountable to them. Much of the book, however, relies on systematic oral history interviews. To specify those sources, I list below the date and place for meetings with those whose memories and assertions I cite throughout the text:

Anissa Rawda Najjar, Beirut, on July 16, July 28, and September 20, 2004
Assem Salam, Beirut, August 8, 2000
Awatif Sinno Idriss, Aley, July 21, 2000
Christine Tohme, Beirut, December 4, 1998

Edvick Jureidini Shayboub, Beirut, May 16, 2000

Hala Schoukair, Beirut, February 20, 2001

Hassana Jabr Salaam, Beirut, October 14, 2000

Helen Khal, Beirut, November 20, 1996

Maha Sultan, Beirut, November 17, 1996

Najah Taher, Beirut, November 16, 1996

Najla Tannous `Akrawi, Beirut, November 11, 2004

Nazih Khater, Beirut, June 21, 2000

Salim Hachache, Beirut, August 1, 2000

Saloua Raouda Choucair, Beirut, November 22, 1997; October 14, 1999; December 25, 1999; June 3, 2000; July 16, 2000; and September 5, 2004

Samir Saleeby, Beirut, June 5, 2002

Souheil Idriss, Beirut, July 11, 2000

Tammam Salam, Beirut, January 31, 2012

Oumayma Ghandour Idriss, Beirut, July 27, 2000

FANTASMIC OBJECTS

1

INTRODUCTION

No Art Here

I FOLLOWED THE eminent artist Saloua Raouda Choucair (Salwa Rawda Shuqair, 1916–2017) down the narrow staircase. The musty limescale-covered walls filled our lungs with an acrid wetness. Our footsteps creaked on the aged floorboards. Although November had nearly ended, the top floor of this 1920-era building in Beirut produced stifling heat under its decorative tile roof. Choucair had invited me to her studio to demonstrate her use of myriad tools—including an elaborate jigsaw. Pointing at the incongruous glass tubes, raffia, antique soap, and cut-up pantyhose, she exclaimed, "Anything I can't get, I invent!"[1] We pulled back old bedsheets from numerous clay *maquettes* (prototypes) of sculptures she hoped to enflesh in stone, wood, fiberglass, and metal at scales of human and larger-than-human size to install in public gardens and roundabouts in Lebanon, the Arab region, and globally. As she wistfully listed the name of each before re-covering it, I asked if she didn't want to sell any. "Yes, all, of course!" she replied acerbically. "But there are no buyers." My first encounter with a missing audience instantly transmitted an artist's sadness amid her unacquired art. We were both eager to leave the studio.

One floor below, we reached the home Choucair shared with her husband, Yusuf, a retired civil servant, and Diya', a relative who helped her adjust to age's accumulating debilities. At eighty-one, Choucair spoke vivaciously and gestured gallantly, but her increasingly arthritic hands interfered with her executing sculptural and installation projects. In the interior corridor leading to the massive iron door guarding her apartment, we passed towering sculptures. She joked that these pieces were too heavy for a thief to steal, should one enter, and that the floorboards would give away anyone climbing to the studio above. Post–Ta'if Accord Beirut enjoyed an influx of returnee migrants

1

and a proliferation of state actors—traffic police, internal security troops, and soldiers manning checkpoints—but art could feel precarious here. Choucair added that she sought a permanent exhibition space, preferably in a second-story apartment. Her willingness to receive me, too, served her goal of finally getting her art out.

In the decades since my visit, Choucair's art has achieved the recognition she craved, but missing audiences and calcified structures still threaten its mobility and impact. This is even truer for her one-time mentors, the locally born and active Moustapha Farrouk (Mustafa Farrukh, 1901–1957) and Omar Onsi (`Umar al-Unsi, 1901–1969), modernist Sufic-Islamic artists whose work seems instantly recognizable to anyone who has visited a modern European art museum. Such familiar work is even less likely to secure attention on its own terms. For it, *getting out* means escaping the confines of global art categories and hierarchies as much as attaining market currency. My goal in this book is not to bestow recognition but rather to expand the scope by which readers will be willing to attend to art. Will they show up for it or remain ever missing from its ontological aspirations? Following the careers—aesthetic, intellectual, and cosmological—that the artworks of Choucair, Onsi, and Farrouk have pursued allows me to diagnose the systems that have impinged on art production and circulation from nonmetropolitan, nonethnicist artworlds, like Lebanon, and argue for embracing another ontology for art and sociality. I believe this respects Choucair's goal of getting her art out. It also confronts the boundaries perpetuated by structures of looking brought to bear on the works. First, I return to the meeting where Choucair taught me to look.

We settled in Choucair's grown daughter's bedroom, which doubled as a sitting room when her husband watched TV. Choucair had designed the room's furniture and mounted on its walls her gouache plans for rugs and pool bottoms. Yet, to my surprise, she drew my attention to her press dossier, a pile of yellowing clippings and photocopies. Smiling sardonically, she pulled from the top a self-authored inventory of "everything that didn't happen in my career." Her daughter had scolded her for writing so modestly, but a revered critic had congratulated her courage in ridiculing artists' customary lists of awards and acquisitions. For Choucair, the point was that, officially, she had been neglected. Those maquettes remained in her studio because minister after minister, president after president failed to purchase her art for public installation. She rejected the excuse that Lebanon lacked a governmental budget for art. "When [President] Hrawi's wife goes to China or Algeria, she takes twenty consultants with her, each spending four times the cost of a sculpture by me!"

Yet a problem worse than governmental insouciance loomed. Choucair later recounted the story of her one public installation to suggest chillingly that there may be no place for art in Lebanon.[2] In 1983, the Saint Georges Bay Women's Branch of the Lions Club, undertaking urban beautification, commissioned a monumental sculpture to grace a highly trafficked roundabout. Inspired by Arabic verse structure, *Poem* stacked six stone rectangles with varying surfaces, manifesting an algorithmic pattern of infinite, yet integrated, expressions. The Lions Club selected a clay maquette that resonated with their ideas of reconstruction, growth, and harmony. The commission delighted Choucair, who produced art destined for public interaction.[3] "They wanted to deposit a gift to Beirut, and they chose me as an artist to produce this. Naturally I welcomed the idea. This was the first time in forty years," she indignantly intoned to one interviewer, "anyone has given me the chance to install my work in a public space in my own city."[4] Soon, however, the sculpture would vanish.

Choucair's press dossier contained a contemporary account by *al-Nahar* newspaper arts reporter Mai Manassa comparing *Poem*'s inauguration ceremony to a national wedding: "The guests—beautifying benefactresses, journalists, average residents, and notables—were transported in caravans of white cars to the Ramlet al-Baida roundabout where Choucair stood like a proud father waiting to remove the bridal veil covering her massive limestone multipiece sculpture."[5] (See fig. 1.1.) As at weddings, celebrants threw rice, and one resident distributed chocolates.

Official speeches accompanying the installation spoke of national reunification: a gift to Beirut's reconstruction and optimism for life. After she proudly removed the cover, Choucair explained *Poem*'s interactive generativity. A television camera rose from her tiny frame, along the sculpture's solid contours, and panned to the busy urban surroundings while the artist intoned: "I have this compositional structure: one piece on top of the second. On top of the third . . . and now it is four. I might make it ten. It could become larger and taller, because the capacity for growth is inherent in it. That's my goal: that sculpture not be static and not be lifeless masses. I want it to be vibrant, to be living. *Everything living grows*."[6] The ceremony concluded under whirring military helicopters' cascading gardenia petals and Lebanese flags. Television footage shows a passing dumpster truck dwarfed by the sculpture's majestic height and solidity.

Enigma enshrouds *Poem*'s fate. Despite its official welcome in June, black paint disfigured its surfaces in August.[7] While none claimed responsibility, an art critic attributed the defacement to some residents' rejection of one of

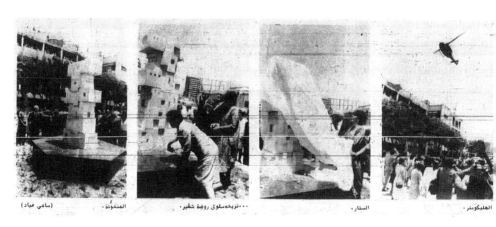

FIG. 1.1 Sami Ayyad, installation of *Qasida* [Poem] at Ramlet al-Baida Roundabout, *al-Nahar*, June 13, 1983, 14. Choucair's hand removing the veil appears in the lower right of the second image from the right. Choucair herself can be seen front and center in the third image from the right. Permission of Annahar Newspaper. Courtesy of Digital Initiatives and Scholarship, American University of Beirut.

Choucair's influences, Islamic philosophy, in an inevitable and escalating civilizational clash.[8] A few months later, the sculpture disappeared. All two meters and two tons of it, gone. Some assumed a missile hit it. Others imagined a bulldozer crushed it in the aftermath of a battle for West Beirut. Yet others announced that an unnamed warlord had carted it off. The "national bride" became another statistic of wartime kidnappings. Sitting in her bedroom and telling me this story a second time, Choucair fixed me with her large eyes, which were magnified by the thick lenses of her clear-rimmed glasses, raised her fist in the air, and snapped her wiry fingers. "*Hayk Lubnan* [that's Lebanon] for you. It was bought for public display and never appeared again." I nodded, not needing her to voice the moral of a story I had heard so often: art cannot exist here.

Art depends on audience interaction. Choucair's art implants interactivity in its very composition. *Poem*'s components form lines pointing outward, not backward. No figural or symbolic meaning undergirds your relation to it. You must keep moving with it, physically and mentally. Viewers bear responsibility for its meaning. Its bared seams speak to the pressure and passion of congress while intimating alternative compositions. "Everything living grows" and thrives when it sparks curious public interplay, including virtual or actual reassembly. Art also shapes audiences. *Fantasmic Objects* will show how art can spark civic unification and fuel social consolidation but also cast communal

suspicion and adjure governmental protection. For public interaction could result in *Poem*'s "death," its utter disappearance. How dispiriting for Choucair and the many who learn of this story. Yet the story does not end here.

Art Acts, Aesthetic Encounters, and Taswir

Art is not simply an object an artist leaves behind. Ongoing *art acts* interconnect artists and audiences.[9] Artworks look at how you look at them. Even now, invisible art acts create *aesthetic encounters* enjoining you to evaluate yourself for your response to art acts. Aesthetic encounters align you with specific others who may not all be equally present and against select ones who may not have mattered otherwise. Across the decades spanned by *Poem*'s narrative, the sculpture asks whether you will recognize its importance. Will you marshal the aesthetic and even moral appreciation its flourishing requires? Who, how, what will you be? Triggering an intersection of materials, circulations, and receptions that may not elsewhere converge, art acts give space to imagining, among other things, the self and its others. A sculpture—photographed and celebrated, then circulated through accusations and whispers—reaches out, hails you, and demands that you inspect both how you think about it and how others do so. Decide what that comparative information means. The intersectional space of art demands that you come into being but does not predetermine that being. It proliferates possibilities.

For example, encountering the stark lines and strange forms of *Poem*'s six similar but individuated pieces, journalists pondered the audience Lebanese people could and should become. Two trends competed. One contrasted the work as a public monument of a group performance to the "experiences that the country confronts," in a euphemistic reference to the Civil War.[10] This account envisioned Choucair as the "un-veiler" who disclosed a social being, a "Lebanon-to-be" that always truly was. Reflecting in *al-Nahar* newspaper on the sculpture's cumulative composition, Mai Manassa contemplated infrastructural growth, at this roundabout and across the country reeling from infighting and invasion. The diverse sectarian representatives participating in the inauguration would jointly endow a reborn national unity with ecumenical legitimacy. In summoning such unity, however, Manassa sighted differences between the factions now "marrying" and "extending their families." By contrast, reporting to *al-Kifah al-'Arabi*, Samir Sayigh exemplified a cosmological trend. Here, *Poem* manifested a presocial unity that commands acknowledgment in an Arabic-Sufic vocabulary. Sayigh thought with the sculpture's geometrically generated nonrepresentationalism about modernist abstraction and

its *non-Western* lineage. Celebrating the transcendence of spatial and cultural obstacles, he hailed Choucair as an artist-hero whose stubborn individuality testified to a lofty regional heritage. Still, in summoning such supremacy, Sayigh dejectedly acknowledged the refusal of others to do so.

Responses such as Manassa's and Sayigh's essays instantiate *taswir*, seeing *through* art what is not present. Taswir lies deep at the core of Choucair's art. Some Mandate-era artists, such as her colleague Cesar Gemayel, labored to affiliate their artwork with a "Renaissance tradition" via the French Beaux-Arts, which they hailed as "descriptive" and "observational."[11] They called this *al-fann al-jamil*, combining the adjective for *beautiful* with a new usage of *fann*, to translate to the French *art*, a skill at creating sensorial marvels that eschew service. This contemporary *fann* compares to a Kantian "purposive purposelessness" concretized by nineteenth-century Romantics.[12] (I discuss *fann's* separate history in chap. 3.) However, Choucair worked with another neologism: *fann al-taswir*. A verbal noun, *taswir* derives from the verb *sawwara*, meaning "to form, shape, mold, fashion" and, specifically in relation to fann, "to paint, draw or sketch."[13] Semantically, taswir conjures the process of making a *sura* (pl. *suwar*). People in Beirut, today as in the 1930s, engage in taswir at parties and print resulting suwar on the pages of society publications and social media. A child who resembles her mother is her sura, because she has been fashioned by the mother, just as a Xerox has been fashioned by a machine automatically. This range of usage conveys the words' distance from the *picturing* of images in the above-mentioned "Renaissance tradition." Rather, the sura is the molded thing, and taswir is the temporally laden technology of molding. These words keep us in the realm of interaction—between an entity's coming into being and becoming meaningful. That narrative causality is crucial in separating taswir from the strict promise of representation, which merely communicates to the cognition the absence of a presence. Whereas the images of the Renaissance have generally been taken as visibilizing representations of holy truths that could be "seen" in scriptures, law, or daily experience, a sura demands interaction to form into visions not otherwise seen.[14] Joan Copjec describes this positive work of imagination as the negation of negation. To engage in taswir is to stop not being aware of ongoing possibilities. Removing barriers to generating meaning, it introduces contingency into the world.[15] "Contingent being is neither (necessary) actual being or (impossible) nonbeing, but what can be or not be."[16] A sura—inherently incomplete—prompts taswir—an imaginal striving. Ultimately, as I elaborate in chapter 6, the importance of the sura lies in what we do with it.

Because sura compositions like *Poem* point forward toward curious audiences rather than back toward settled worlds, they trigger seeing, and even

arguing for, potential meaning-being. Part of the art act called *Poem*, Manassa's and Sayigh's articulations of contingency, were formulated on the go to grasp the first entrance Choucair's art made into public, permanent display. As such, they allow us to observe audiences meeting their peer's artwork and evaluating themselves for *looking at* their looking at its alien forms. The competing reviews not only contributed to their publishers' conflicting ideologies, from Libano-centrism in the first to Arabist leftism in the second, but enabled civic and statist injunctions. They fretted about possible responses, such as those that disappeared *Poem*, and they issued calls for practices of civic being. They stopped not being aware of ongoing possibilities so as to connect select ones to social projects.

Upon depredation just weeks later, *Poem* could be said to have revealed a deep cultural basis for the country's ongoing Civil War. Pierre Bourdieu analyzes artworks as a technology of distinction, but I find that art acts may sow suspicion.[17] I use *artwork* to refer to labor executed in art and treated as art and *art act* to refer to the labor art mobilizes (not intentionally but consequentially) in its milieu. Artworks prompt aesthetic encounters with objects/experiences that realign audiences' social configurations and imaginations, or conscientious taswir. Art acts create new spatial and experiential relations among artists, audiences, and societies. Contra Bourdieu's model of art obfuscating socioeconomic realities, in *Fantasmic Objects*, I register art acts where the remit of representing maker-communities gives artworks agency over the fate of those who become expected to act accordingly or face denunciation. Art socially divides its subjects, not by reflecting ingrained habits or rewarding inherited assets but by materially gathering and projecting civilizational trajectories. This art makes audiences its object as much as its subject.

Fantasmic Forms and Double Decolonization

I have chosen to translate the sura with which Choucair and her colleagues experimented as *fantasm* rather than simply *picture*. Following Freud's theory of the hallucinatory wish-image and Marx's theory of the fetish, we often use *fantasm* to mean "unjustified perception." The word itself points to a long history of pondering the relation between seeing and being. Many languages of the Indo-European family (including Arabic) use the syllable *bhan* or *phan* to indicate shine or brilliantly clear visibility. Archaic Greek language gives us the word *fantasm* from *phainein* (to show, bring to light, make appear, explain, expound, or inform against) and *phantazein* (to make visible). That which could be seen could be known to exist, but effort might be required to make

something visible or shown. Medieval French use of *fantasme* split seeing and
being into two realms—the former duplicitous and the latter the only source
of truth—which reduced the word's connection between seeing and being to
mere visibility—an illusory apparition, a thing only seen but not truly being.[18]
Rationalist Enlightenment thinkers launched their "objective" inquiries from
this position, seeking to bring to light hidden truths that normal mortals ig-
nored because of lack of equipped sight.[19] This model allows things to be either
real or false, to produce a certain kind of visibility, if the former, or deceptively
to borrow visibility from others, like simulacra, if the latter. Art, for this model,
as Plato famously declared, is squarely of the latter type of thing. Yet this is not
the only schema of knowledge and perception, nor is it the most appropriate
for grasping the power of art in Lebanon. As Iftikhar Dadi argues in his study
of Muslim South Asian modern art, we should neither let this schema impose
immediate social referents to assess the social truths art may produce nor let
it force us to abandon formalist analysis of art produced by other schemata.[20]

Above I argued that fantasmic forms make audiences their object. What does
it mean to become art's object? The reviewers of *Poem*'s installation thought
concretely *through* art about otherwise unclear entities, such as Lebanese citi-
zenry, the state, and spirituality. At one and the same time, *Poem* commanded
them and their readers to master and marshal civic merit. Citizenry, state, and
spirituality crystallized only to the extent that audiences engaged with art to
conceive them. Political anthropologists call such conceptualizations fantasms
to explain the imaginative ways people attach to them, particularly in attribut-
ing to them anthropomorphic power or other logically impossible qualities.
Begoña Aretxaga, analyzing Basque counterinsurgence stories, identifies a
"fictional reality" composed of "fantasy scenes" wherein a fantasm incarnates
the bodiliness of the otherwise abstract entities. One such fantasm is the "they"
figuring in narratives of police violence.[21] "They" fantasmically makes "sense
independently of the evidence that could be produced to support it," ensnaring
both police officers and their onlookers in imaginative attachments to this pow-
erful "they."[22] Studying post–World War Japan, Marilyn Ivy defines the fantasm
as "an epistemological object whose presence or absence cannot be definitively
located."[23] In her case, the ghostly knowledge object is Japanese culture, which
her interlocutors, as modern Japanese, labor unceasingly and unsatisfyingly to
certify, becoming thus its objects. Noting that "Japan is literally unimaginable
outside its positioning vis à vis the West," Ivy credits life-through-fantasms to
colonial conditions in which an ethnic group or nation-state without prior real-
ity gains (only) political credibility.[24] Whether fantasms result from extreme

violence, colonial dispossession, or both, they produce fictional realities whose nature and origin are inescapably ambiguous.

The sura of Choucair's experimental art and the "fictional reality" identified by anthropologists both stem from a middle-realm ontological source medieval Arab philosophers postulated between the intelligible (the world of ideas) and the sensible (the world of perceptions).[25] Termed *barzakh*, this zone of existence conjoins input from both sides to foster visible ideas and incorporeal substances that are entirely real and impactful.[26] Ibn Sina and Ibn Rushd developed the idea of the fantasm from an Aristotelian tradition of medicine to fathom the subject-world interface: How do subjects perceive the world and receive its sensations without being invaded by it? Do minute forms break off and enter the subject? How does the subject retain and recall perceptions after the world has receded from view? Are such minutiae retained ad infinitum? Fantasy (the term derives from Aristotle's Greek but parallels the Latin "imagination") is the function or organ the Muslim philosophers found to receive sensory impressions via the five senses from sensible objects, retain them for memory, and transmit them to the cognitive power, which "composes according to its will the forms that are in the imagination with other forms."[27] What fantasy transmits are fantasms, converted forms of the original stimulus that are both incorporeal and incorporated. As Ibn Rushd explains, "The imagination has no need of the presence of the external thing to render it present."[28] If feet and eyes carry one to the visible, sensible world, and the mind to the present, intelligible world, then *al-khayal* (or, in the Latinate form, imagination) carries one to the *imaginal world*.[29]

A barzakh-centered map of being commands sentient, rational humans to pursue their imaginative capacity. In a study of Egyptians' dreaming, anthropologist Amira Mittermaier explains, "A *barzakhian* perspective, as we might call it, ruptures binary outlooks and invites us to think beyond the present and the visible."[30] Moreover, in a significant departure from Aristotelian conceptions, the fantasm is exactly "the point of union, the 'copula,' between the individual [subject] and the unique possible intellect," by which Ibn Rushd meant supraindividual intelligence.[31] It grounds the "fictional reality" and locates the "ghostly epistemological objects" that anthropologists identified. Connection to this realm of the possible, which transcends the given, necessitates active involvement by the perceiving human and rewards it with a sense of universality and truth. This more active, transcendent (or even transgressive) understanding of perception elucidates what art could be for Mandate audiences and how it shapes Lebanon and kindred double-decolonizing communities today.

I hear reference to the barzakh when I read of a bargain Moustapha Farrouk, Choucair's one-time mentor, made to support his first forays into art making. As a child, Farrouk received from his consociates both praise for his lifelike portraits and assurances of eternal damnation for doing *haram* (the forbidden). The latter, lobbed by "a band of shaykhs, or rather, wannabe-shaykhs," prevailed, and Farrouk ceased drawing entirely.[32] He recalls asking himself, "What is *haram*? What is damnation?" He had no answers until a prominent reformist Muslim scholar, the young Shaykh Mustafa al-Ghalayini, asked why he had stopped. Farrouk docilely replied, "They told me that on Judgment Day I will have to create souls for my drawings [of people] or I'll go to Hell." Farrouk recounts that al-Ghalayini guffawed, "Good! You draw them and I'll put their souls," which is exactly how he proceeded. This story suggests that just as his childhood figure drawings were coproductions with the congenial shaykh, the mature artworks of Farrouk and his companions were coproductions between the artist and the Artist, as Farrouk sometimes referred to divine power. Moreover, the story distinguishes "good Muslims" from "bad Muslims," or not-real Muslims.[33] The latter populate pre-Mandate Lebanon but do not relieve the populace of responsibility for fashioning their relation to Islam, ethics, and society. The populace must question terms presented to them. They must conjoin givens and possibilities responsibly, not merely parroting others' commands. They must work from within the unformed, unfinished barzakh at the intersection of the intelligible and the perceptible to imagine their way. What results are not mere pictures but art acts that extend beyond the visible and material, that guide toward the unknowable, transhuman.

I learned to think about Lebanon's fantasmic history by attending to art acts like Farrouk's story or *Poem*, from both of which visions of absent or negligent citizens perpetually spout. Like Basque country, Lebanon has been formed through violence pitting state (and nonstate) actors against its populace. Like Japan, Lebanon is a wholly postcolonial state, but unlike the former, its inhabitants cannot point to a precolonial past to which they might return one day. Historians have shown that "Osmanlik" subjectivity was already changing at the end of the nineteenth century, because of new governing techniques.[34] Between the wars, Beirut metamorphosed rapidly. New economic possibilities flooded through the port. Cars, cabs, and a new tramway enabled people to move more quickly among distant neighborhoods. The city's layout expanded, and new roads and plazas recarved its core. Whole cemeteries were relocated. The population shifted: more women, more immigrants, more Europeans, more political parties. Women garnered jobs in the public sphere after earning specialized certificates. The newly instituted system of voting gave commoners

INTRODUCTION 11

more sway than ever before. Periodicals and dailies sprang up right and left, filled with discussions of life's new difficulties and confusions. As two feminist intellectuals put it in a debate that occupied the press in 1911, they were becoming "other to themselves."[35]

The political leadership was almost entirely inverted. French rule took over from "the Ottomans," whose status as foreigners is a precondition to conceptualizing "the Lebanese." An Ottoman sultanate no longer regulated urban-rural networks and interconfessional relations. Ottoman fashions, connections, and language skills were now liabilities. Portions of the Ottoman sultanate were "mandated" to French authorities in 1919 at the Versailles conference but only secured with the 1922 Lausanne Treaty and the subsequent renunciation of the Ottoman caliphate in 1924. Recognizing colonialism's illegitimacy after World War I, the Mandate system impeded direct rule of Arab, African, and (later) Pacific populations but maintained their effective control until said populations demonstrated their "fitness" for self-rule, to be determined by Mandate authorities' priorities.[36] Subsuming a Lebanese republican government under a high commissioner representing imperial French authority, the Mandate of Grand Liban opened a space for the self-definition of "Lebanese" who were neither "yet free" subjects nor "still Ottoman." Elizabeth Thompson's oxymoron, "colonial citizens," flags the novelty of a populace actively defining their civil rights, making claims on a fluctuating economy, and contending with a significantly inflated administrative bureaucracy.[37] To shake off French colonialism, they could not counterpose Ottoman rule, for a Turkish-oriented Turkey had dissolved and replaced the former sultanate. Lebanon's colonial citizens had to *double decolonize.*

Most Lebanese, and Middle Eastern, histories focus on the political and economic encounters that ensued from this double-decolonizing dilemma. *Fantasmic Objects* turns to the aesthetic encounters. Looking to the past compelled taswir, the negation of the negating present. This setting conjured a specific modernity. In speaking of "Lebanon," intellectuals, activists, and would-be citizens reached to a new entity, whose origins could not lie within the sensible, known world. It could not be a subject of reform (*islah*) but only of novelty (*hadatha*), a making-happen effected by novel social and cosmological relations. In her investigation of late nineteenth-century consumption practices, Toufoul Abou-Hodeib observes a "strong material dimension" to changes we have come to summarize as modernity and calls for attention to the "new aesthetic language" that joined public and private transformations.[38] A study of taswir concretized in aesthetic encounters can advance a theory of the relation between material forms and political imaginations. Hadatha

encompasses modernity and modernism. Scholars studying Euro-American histories tend rigorously to separate the era (modernity) from associated social movements (modernisms), the better to appreciate the variety and politics of cultural choices.[39] This split, however, assumes the time period preexists their analysis; it precludes investigation of how and for whom time ruptures.[40] I mine the ambiguity of the Arabic concept as used in Mandate Lebanon to consider the material transformations that made modernity, as an epoch, concrete and meaningful through modernism as a style, and vice versa. Particularly, my investigation of hadatha attends equally to *mu'asara*, a term literally signifying "contemporaneity" and whose adjectival form, *mu'asir*, sometimes complements or even substitutes for modernity (as in *al-fann al-mu'asir wa-l-hadith*, which would mean "contemporary-modern art" but converts to "modern art"). Paired, the terms imbue temporality with concerns of rethinking space. Novelty matters for how it connects here to elsewhere. In this attunement to modernity's directionality, I contribute to global modernity studies by arguing that art, in particular, allowed for, even demanded, material imaginations of a cultivated universal modernity as tangible concept and urgent injunction. Rather than locate modernity in an originating Europe or a set of parallel yet disconnected "alternative" mini-origin sites, I examine processes of convergence by which artists worked from particular backgrounds and ambitions toward hazy concepts of gender, urbanity, and citizenship that they dislocated from their own milieu and mapped onto prized elsewheres, such as Paris or Rome. These ideas motivated peers around the globe but were not fully formed in any single locale.[41] A study of modern Lebanon through art acts demonstrates how aesthetic encounters coproduce timescales and outlooks. Showing the imbrication of modernity elsewhere and its opposite here, this study *delocalizes* modernist projects as much as it *provincializes* Eurocentric narratives of modernity insensible to colonized peoples' role in creating and constructing its universality.[42]

Conducting a study of fantasmic forms that motivated and fueled modernity reverses the normal order of business: Not place and politics first, culture and aesthetics second. Not texts and timelines first, local details or doctrinal interpretations second. In fact, we may ask why art is not a common angle for appreciating Lebanese, Iraqi, Kurdish, Egyptian lives and life making.[43] Although numerous studies extol the "ornamental" art and aesthetic flourishing of medieval Arab lands, standard art historical literature has long assumed the decay of artistic production among their modern heirs.[44] Wendy Shaw inventories the various logics by which recent cultural production in these regions is not "art."[45] Notably, the alleged eclipse largely coincides with either the Renaissance rupture putting European artists on humanism and individualism's path

or European colonial interventions.[46] Further, disciplinary assumptions about art's indirect relevance to power contribute to this zone of disinterest. Predominantly complying with a will to explicate sovereignty, hierarchy, and structure, English-language scholarship on Arabs, Middle Easterners, or Muslims tends to ignore art.[47] Yet how can we even describe self-expression, socialization, or political mobilization while ignoring their imaginative and affective bases? Overlooking reception faculties substitutes racializing identities ("Arab," "Lebanese," "Muslim") for living subjects of hegemonic discourses and reproduces (academic) acceptance of those hegemonies. We cannot begin to appreciate "the new social imaginaries that are emerging and being contested in the city squares and streets every day" unless we inquire into the micropractices of meeting, responding to, and generating fantasms.[48]

Aesthetic Encounters as an Alternate Anthropology

Foregrounding aesthetic encounters opens different windows onto society. Three social elements take new form in this account. We peeked at them already with *Poem*: Islam, modern art, and Lebanon. In art, this trio finds an unexpected enfleshment—Elizabeth Povinelli's term for the coproduction of personal "insides," from which socially validated content emanates, and their socially recognizable "outsides."[49] We have already learned from the young Farrouk how "good Muslims" gained visibility in art at the same time that specific picturing practices (overlooked today) became ascribed to them. Before meeting Saloua Raouda Choucair and learning of the work of her teachers, Moustapha Farrouk and Omar Onsi, I did not purpose to document a modern Islamic ontology of art and sociality. For long, I avoided this topic lest I commit a move that potentially would impose sectarian identity on Lebanese. Doubtlessly, the people of whom I write preferred to be called artists, without an appended *Muslim, Lebanese,* or any other qualifier diminishing from the universal truths in which they believed. Indeed, it might be hard to see the works discussed in *Fantasmic Objects* as "Islamic art." The term did not settle lightly on my topic.[50] I quickly dropped the one graduate class on Islamic art and architecture offered by my university because its pre-seventeenth-century syllabus looked alien to the work I was encountering in early 1990s Beirut. Yet looking and seeing are precisely the issue. What "other classificatory systems" of the visual world might Islam support?[51] Critical art historians, inspired by Edward Said's study of Orientalism, have identified the idiosyncratic tropes and criteria by which a certain epistemology of "Islamic art" operated as the foundational outsider for establishing Western, modern art: its formalism, aniconism, and lack of

dynamism have surged into view only to emphasize their opposites in "Western art," and worked as well to exclude vast swathes of material culture produced in the "Islamic world" as "non-art."[52] One trend has used art to produce "an appropriate model of Islam itself." Another, in line with a Christian rejection of Islam as a "failed religion," has pursued a "decidedly not religious" study of art associated with it, "shun[ning] religion as an ontological category" entirely.[53] Even Muslim Islamic art historians have segregated the artistic and intellectual spheres of the worlds they studied, treating art as either the irrational expression of established doctrinal truths or anti-symbolic decoration.[54]

In contrast, the controversy surrounding the installation and disappearance of *Poem* testifies to the claims and experiments in Islam conducted through art acts. Christine Ho's findings for the label "socialist realism" apply to the ongoing unfolding of "Islamic art": no self-evidence presets the category, and artists make their art, audiences, and selves cosubstantially.[55] Significantly, the codifications of current ideas about what constitutes Islam coincide both with the art historical inauguration of the field of Islamic art and architecture and with the Mandate-era explorations by Choucair, Farrouk, and Onsi described in this book. If Islamic art history seems to demand that its canonical objects be traced to the *stunde null*, or zero hour, of the religion's prophetic articulation, for the artists I discuss, the events leading up to the Mandate, including the abolition of the Caliphate, culminated in just such a *stunde null*, in which nothing about their religion could be simply inherited or assumed.[56] They helped unfurl "Islam as a discursive tradition," to borrow Talal Asad's articulation for the varying integrations of moral selves, population management, and knowledge channels.[57] Given the novelty of this understanding of Islam, their forays helped (and may help) contemporary readers grasp "the importance of being Islamic," as Shahab Ahmed puts it, for art *today*.[58] Exploring their experiments, particularly through public interactions, will rehistoricize both Islamic concepts and conceptualizations of Islam and art, which have been hampered by an overreliance on "Christian-based ideas of visuality," including the aged "bogeyman" haunting modern art in India and other areas with a troubled, colonized connection to Islam.[59] To the degree that art constitutes a form of local knowledge, as art historian Nasser Rabbat has suggested, an ethnography of that knowledge in action, through art acts that encompass exchange and contest, may restore a sense of liveliness and stakes in cultural creativity.[60]

I follow the example of Amira Mittermaier, whose ethnography of dreaming—another seemingly personal, idiosyncratic, and purely expressive practice—in Egypt confronts ontological assumptions about dreams' substance, impact, and research methodology. By releasing dreams from their presumed

individuality and unconsciousness, we develop tools for examining not only "how politics are shaping particular dream landscapes but also how dreams might be shaping political landscapes."[61] Moreover, anthropology's holism can demonstrate the inherent integration of concepts that otherwise appear separate (such as art and religion), mutually exclusive (such as secularity and piety), or simply absent (such as a "discursive ground" for the Islamicness of art acts).[62] Holding its ears, eyes, and heart to the shaykh-ly breath that both infused young Farrouk's drawings with souls and divided their audience into good/bad Muslims, modern/premodern subjects, contemporaneous/local citizens, *Fantasmic Objects* addresses forgotten histories of being Islamic in art and the profound political consequences of these omissions, which have not only limited the imaginations of peoples but also truncated interactions with them.

Focusing on the lives of Beirut audiences whose aesthetic encounters shaped modernity, this book also finds valuable lessons about modern art's globality in its local, intimate, drawn-out interactions. Consider *Poem*'s peculiar (pluri) spatiality: both "here" in Beirut, beautifying it, and vanished as if expressing its civic absence, thus "not here." Or existing as a cloth-covered maquette present on Choucair's bookshelf but also imbued with latencies for large-scale reinstallation anywhere. Consider, too, its (multi)temporality: conceived for a 1970s series; executed for a 1983 commission; possibly extant though unseen; and inviting realization anew, the artwork lives beyond the human lifetime but remains vulnerable to daily human affairs. Finally, consider the work's (inter) relationality: Its multifarious elements reward metaphorical, phenomenological, or abstract readings. It delights a viewer pondering Lebanon's demographic peculiarities. It illumines one contemplating divine presence or cosmopolitan facility. It manifests difficult Sufic concepts another has long sought to explain. However, it also makes its demands, as we saw, for people to select, enlarge, and install it and, once it has been installed, to circumambulate and actively interpret it. And as I will show, it still requires people to mind its petulant cries for life. More importantly, it interrelates these aspects of being so they are not mutually exclusive. As Kajri Jain has shown for Indian calendar art, close attention to the ways "local" production is "not fine art" and "not modern" reveals the assent and investment that perpetuate modernism/modernity elsewhere.[63] Thus, at the intersection of local/global, possible/impossible, daily/divine, and so on, *Poem* instantiates a Durkheimian "total social fact," as Kenneth George argues, "shap[ing] our political economic, religious, and cultural field of experience."[64] Or differently put, the "emotive energies" it discharges by making contexts and human subject-objects teach us about entire worlds.[65] This process

of forming people must be part of the story of modern art, lest we tell ourselves empty myths of formal elegance.

Finally, this book spotlights fantasmic art for an "alternate anthropology of Lebanon."[66] To start with art contributes to an anthropology of dreams, aspirations, and imagination, saluting people not simply where they are but where they might go.[67] One perspective explains Lebanon—and much of the Middle East—in terms of economic and political faits accomplis imposing on agents—most often religious adherents, militants, refugees, oppressed women, or others defined primarily by state relations.[68] Such explanations ironically reproduce the fatalism mainstream media often attributes to Middle Easterners and Muslims: Have our study methods predetermined our findings?[69] Here, Lebanon's historical lens on political contestation highlights processes usually obfuscated. As much as this book accounts for a specific space-time (Lebanon since the Mandate period, the contemporary Middle East, a self-consciously peripheral artworld . . .) it catalogs the fantasmic and unfinished. The aesthetic encounters arising from art acts can document and uplift realignments of actors who do not register as political agents or even local ones. Their accounts bridge temporalities, both material-historic—how we got here—and subjunctive incompletion—what is still possible. Therefore, I do not assess artworks' representational faithfulness to "Lebaneseness," although my interlocutors heatedly debated the "problems" of Lebanese society; rather, I analyze how aesthetic encounters problematize the understanding and practice of society, as happened at *Poem*'s installation, by twinning them with "national" or other identities.[70] Artworks themselves took on the role of elders, cultivating the formation of concepts and believers in tandem. The alternate anthropology I propose may further elucidate modern citizenships elsewhere enacted toward double decolonizing, such as the Philippines between Spanish and US empires, or Sri Lanka between the Dutch and British, or contemporary mestizo communities. To explain the rewards of an alternate anthropology in shaping understandings of nations, empires, and postcolonial worlds broadly, I turn to an earlier aesthetic encounter whose script nearly foretells *Poem*'s fate.

No-Art Here: Art and the Sense of Place

Decades before Sayigh and Manassa vied to give prescriptive descriptions of Beirut's art audience, Choucair's teacher Moustapha Farrouk served up his own version of art viewers (fig. 1.2). The civic-suspecting artwork in this 1934 aesthetic encounter is an inked cartoon. Above the French title, *Souvenir de l'exposition Farrouk 1933–34* (Souvenir of Farrouk's Exhibition, 1933–34), two

FIG. 1.2 Moustapha Farrouk, *Souvenir de l'exposition Farrouk, 1933–1934* (Souvenir of Farrouk's Exhibition, 1933–34), ink drawing, 14 × 10 cm, 1934. Hani Farroukh Collection, Beirut.

stooped figures—whose dress interlocutors described to me as antiquated, rustic, and sectarian—inspect a gilt-framed nude the thirty-two-year-old artist had painted to honor his French mentor and displayed at Beirut's School of Arts and Crafts the year before.[71] Farrouk's art act launches an aesthetic encounter that visually enfolds an unbreachable gap between viewers and viewed. Not only do the posture and dress of these peasantlike figures contradict the classical, humanist ideals represented by the nude genre (which abstracts the human body into geometric shapes and harmonious curves), but in slouching, crotch-covering, lip-wagging gestures, the anti-nude couple epitomizes an incapacity to appreciate beauty, whether physical or metaphysical. Approaching the frame for enlightenment by art, they cast shadows toward it.

I first encountered *Souvenir* in the apartment where Farrouk's son, Hani, kept his father's paintings and paraphernalia. Pulling from a stack of A5 heavy paper prints sporting this image, Hani gifted one to encourage my research. It horrified me. I had only recently graduated from Columbia University, where Edward Said expounded on the insidious effects of Orientalism, the ideology that splits East from West and ranks the latter above the former.[72] Cautiously clutching the print while Hani held my eye with a knowing wink, I shrank from its suggestive lines, which seemed to echo the refrain I had tried to ignore throughout my months of research into "contemporary Lebanese art": "There is no art here." Because Lebanese people do not really appreciate art. Because they have no *dhawq* (perceptive skill, or familiarly, "taste"). My guarded refusal to agree only garnered more explanations: the lack of a "real" art museum (as opposed to the municipal museum with a small, eclectic collection), "rigorous" criticism (instead of articles written as favors), "true" art (rather than decor, or just exceptional works), "proper" galleries (instead of shops), and "major" artists with a "true" local following (other than family).

Besides Hani, the persons claiming "no art here" included administrators at the municipal museum, owners of long-established galleries, art collectors, and artists themselves. They implied that any art one could find was unrepresentative and illegitimate. It could not demand study from an intellectual tradition devoted to art representing peoples and places, bounded groups, and pre-extant cultural communities. After interviewing the artist Najah Taher, whom I met in a publishing house where she occasionally designed book covers, I asked her to suggest materials I should read. "Most everything [written] is just scraps," Taher sighed. "There's nothing broad and complete on Lebanese art—maybe because there's no such thing!" Chortling, she continued, "I go to the Sursock [Municipal Museum] and I can say, 'OK, there's African, there's American, there's French, but where is Lebanese?'" Art critic and painter Helen Khal

advised me to start from the realization of "this one fact: Art here is an adopted form, exported out of fourteenth-century Italy to the whole world." For her, art was in Lebanon but had never become of it. The gallerist Amal Moghabghab, in an interview in the French newspaper *le Monde*, affirmed this condition of absence. One stung critic summarized Moghabghab's assertions thus: "There is no art in Lebanon! It's all just copies of Tapiès or Rauschenberg!"[73] Clearly some sought to disprove the claim, but merely speaking of art firmly relocated my interlocutors in alternative settings—Paris or New York most often—where they "knew" art had more social impact. With this expertise, they were not really "here" anymore. Ghassan Hage identifies this practice of living in multiple places as a component of the diasporic condition, which imbues returnee migrants with "the economic and ontological security that they have internalized elsewhere in the world."[74] This "mode of existing in multiple realities," Hage terms "lenticularity," and it resembles the dislocating strategy of disappointment adopted by critics of national museums in Morocco and Peru, where state and elite actors have abdicated their foundational cultural role.[75] However, Farrouk's 1933 caricature of nude-haters suggests that art may preform a "diasporic condition" by collapsing spatiotemporal boundaries into new aesthetic encounters and teach a dislocating language of bodily practices for enacting a new locality.

Art telescopes from one putatively bounded-off place to physically distant ones with dizzying directness. One Tuesday morning in a Hamra gallery where the owner, Saleh Barakat, was frantically arranging a show scheduled to open that Thursday, I saw art cleave two worlds. Newspaper and television reporters had each respectively called to announce visits that afternoon. Barakat grumbled exasperatedly, "We just closed the last show on Saturday. We take it down Monday, and then start setting up, and now it has to be ready already because *in this third world of ours*, they don't know how to see art. They have to be shown it." Up the street, the same multiplexity intervened in my paying the monthly installment for a painting. Counting the bills I delivered, Rania, an assistant newly returned from seven years in Italy, bemoaned an absence of social support for art: "There's no culture *in this country*; in school kids aren't taught to be open to art, *not like in Europe*." At yet another gallery in Raouché, Yvette Achkar and Aref Rayess, important senior artists, enjoyed a break on the balcony between interviews for Rayess's solo exhibition. They explained to me the importance of their friendship: "We depend on each other. The public here is very amateur, *not like in the USA*, where people are concerned." And on the Communist radio station, announcement of a new tax on entertainment places (including cabarets, bars, cinemas, theaters, and art galleries) provoked

screenwriter Shawki Matta to declaim, "*Al-fann hadara* [Art is civilization], but in Lebanon it has become entertainment and consumption."[76]

Each art act cleaves "no art" here from its opposite, something we may call "Real Art (*al-fann al-haqiqi*)," found in art-friendly locales where educated publics initiate and support art and deserve to climb the ladder of civilization. Real Art is always elsewhere. Audiences look over their shoulders. They see no art on one, local side and Real Art seemingly afar. Or if they see art here, still an eye fixates on other viewers casting creeping shadows that repel Real Art. Anthropologically, symbols populating rituals—the regularized testing of communal potential—function like beacons, connecting known territory to the unknown, enabling safe passage, and imbuing structure and order in a context of churning chaos.[77] Because of their sensual multifacetedness, beacons shape cognition by joining elements that do not otherwise converge and may even contradict.[78] In this aesthetic encounter, art is a beacon blinking alternately on/off, yes/no, here/not here, compelling participants in art acts to wonder how the elements relate and take responsibility for their potential relation. In other words, the art/no art beacon triggers taswir.

At first, I tried not to hear Lebanese assertions of no art. I did not want to be the white woman fawning Orientalism. What a stance for an anthropologist to take on somebody's art! Slowly, the words shifted resonance. *No art* started to sound like *no-art*, a certain kind of art, one perhaps best known for its troublesome, disquieting character, like the word *tomboy*. The *no* resounded in emphasis rather than negation, the way *tom* doubles *boy* because the speaker discerns a girl.[79] In a system of essential differences, *tomboy* and (the Arabic) *hasan sabi* merge gender references with behavioral prototypes to cordon off any threat to gender that behavior might pose. The double emphasis asserts an essence unchanged. It assuages the onlooker's doubts. Similarly, the *no* of *no-art here* doubles the capacity of art to reject givens and complicate presence. The phrase conveys less about the "art-ness" of local activity than the quality of "here" as a place of community. Instead of hearing that our society lacks art, I hear that "here"—this nebulous society of ours—becomes knowable not in advance of art's representational act but through the quest for a representative art. Because a burden falls on the shoulders of those who confront "no-art," I treat it as a practice rather than the absence of one.[80] Even if an artist like Choucair rejected the descriptor, she purveyed it as a challenge to her consocaites, as we shall see. Suddenly addressees must inspect how they will treat (and thus create) "here" by monitoring their actions on art, just as audiences did when standing before Choucair's magnificently installed sculpture or, again, before its magnificently missed presence. Or I (and then you) did when confronted

with Farrouk's *Souvenir*. These actions are part of the art act beyond the mere object. This lens will illuminate contexts redolent with feelings of loss and lack across modern and contemporary artworlds.

Exhibitionary Sociality, Sense-Realms, and Synecdochical Clocks

No-art's beacon-like character alerts us to the resemblance of aesthetic encounters to rituals. I build on anthropological theorizing of rituals to identify three aspects of art's public life, pertaining to ways of interacting, ways of sensing, and ways of moving. The first aspect I call *exhibitionary sociality*. Examining the purview of Indian calendar art, Jain cautions against defaulting for the analysis to an "epistemic bundle" in which ideas about the work of images jostle and co-constitute "a specific post-Enlightenment epistemological and ethical lineage emanating from bourgeois Europe: a lineage that strongly informs modern ideas of subjecthood, agency, and routes to social justice."[81] As much as Lebanese-to-be may wish to inhabit that sociality, their art entered a different context with public display. Who counts, how, who is excluded, what is divine or mundane, and what should be public and displayed or private and intimated vary from society to society and, to an extent, from one infrasocial context to the next. The rise of art acts in Mandate-era Lebanon allows us to track shifts in the epistemic bundle constituting society; hence, my term *exhibitionary sociality* points to new evaluative practices producing a sense of citizenry and its constituents.

Crafting a situation of looking at looking, fantasmic art puts the social and the personal into question. Viewing *Souvenir*, you may wonder whether you resemble the depicted viewers. That very wonderment sets you on an impossible mission, for while the cartoon title verbally positions the depicted viewers in a particular social space and time, the inked scene visually introjects elements that subvert spatiotemporal specificity. The paneled walls and baluster barriers resemble the Louvre, which Farrouk had recently revisited, but neither characterize Beirut's School of Arts and Crafts. The drawing literally widens the gap between this hapless couple and fine art. And who wears these clothes? They jumble together outdated Ottoman finery, European cloth and city cuts, and peasant foot and head coverings. In such ambiguous settings, one adopts a cross-eyed view: one eye on the artworks and one eye on the audiences. Blurring Paris, Beirut, France, Lebanon, urban, and rural space, fantasmic art provides a medium and a method for thinking about interacting without presuming spatial, temporal, or given political boundaries.[82]

A second aspect of art's public life affects ways of sensing. I examine the *sense-realm* formed through an aesthetic encounter, meaning the codes proffered for

sensorial response to tactile stimuli, which, in turn, orient sense-making. Sensuous elements key engagement with Farrouk's fantastic scene: The carefully if briefly described setting evokes a certain room temperature and aridity. The contrast of cool metal guard rails and heavy peasant fabrics invokes bodily conflict. The expressive gestures and postures bespeak whole personalities. A sense-realm doubles attention to the senses. It provokes sensing of the senses, an awareness of oneself as sensate and sense-making. A concert whose every sound is controlled exemplifies the sense-realm, but so do religious rituals that control not only the sounds but also the smells, postures, touches, and tastes participants encounter. With sparse but efficient visual clues, Farrouk summons the way an art exhibition, too, becomes a sense-realm, defining a specially regulated social activity that involves a person's full being to work out ideas viscerally and live them intellectually. His viewers find themselves drawing on old clues to make sense but also adapting, adjusting, and refining their self-sense. Sense-realms flesh out the aesthetic encounter, forcing participants not simply to adopt a specific, contingent response but to treat doing so as sensible in the double meaning inhering to that term.[83]

Sense-realms and exhibitionary sociality often summon a third aspect of art's public life: its *synecdochical clock*. Among different types of indexes, semioticians identify as synecdochical those social features that can both reflect a phenomenon and determine action toward it. In marking a phenomenon known to people as time, a synecdochical clock generates the will and means for acting on it. I recall hearing Lebanon's synecdochical clock toll loudly one spring evening in 2000 when I joined a private gathering in the comfortable Qoreitem area of Beirut, for dining, socializing, and "seeing Lebanese art." Guests included locally active artists and musicians, nongovernmental organization (NGO) workers, and educators. The soiree was to begin with a lecture by historian and collector Cesar Nammour, after which a lavish buffet of Chinese noodles, Mexican fajitas, and Levantine mezza promised to reward our patience. The living room accommodating us afforded a sense-realm replete with upright piano, leather couches, fauteuils, and embroidered pillows. To my left, guests discussed putting their Anglophone children in a local Francophone summer camp or, if they had second passports, sending them to cousins abroad. To my right, an abstract painter in his thirties slyly whispered to his companion, "Ninety percent of Lebanese houses have pianos but never use them except as decor." We were clearly in the thick of exhibitionary sociality, and now the synecdochical clock's ticking loomed ominously.

Nammour commenced his slide lecture with pictures of Byzantine art, proving that, "contrary to the assertion that painting is something new

[i.e., after the Civil War], it has been practiced here since ancient times." He then moved through seven historical periods extending from Phoenician statuary to contemporary installations. The hostess asked where the surveyed artists had studied. Nammour emphasized their variety: one artist born in 1860 was sent to Rome to become a court painter; his successor born in 1897 earned a colonial bourse to study in France; but most interesting was the "extremely poor artist" who left his "*incredibly backwards* neighborhood of Basta [a Beirut suburb] to Paris, where on his first day of art class, presented with a naked model, he fainted!"[84] The guests hooted. Nammour shouted over their guffaws, "It took him *three days* to recover and do the picture!"[85] That artist was Moustapha Farrouk, maker of *Souvenir,* whom many in the room knew to be a "pioneer" but also "behind the times."[86] Farrouk's doubly delayed temporality turned the artist into his own caricature. For the guests looking back at the arc of Lebanese art, his fine-art style and personal trials indexed a lagging Lebanese temporality. His art became a synecdochical clock measuring out the eons they would have to overcome to catch up with contemporaneity.

That synecdochical clock ticked throughout my fieldwork. While apprenticing at Galerie Janine Rubeiz and Agial Gallery, I attended all the exhibitions listed in the daily papers. Repeatedly, I encountered claims to firstness that imbued art making with a progressive if precarious temporality: "This painting of a nude woman" (or "This auction by Christie's in Beit Mery" or "This lavishly produced catalogue") "is a *first* for Lebanon." Sometimes the clock counted down the time left until change would occur. Condemning Lebanese audiences, the director of the then-nascent Ashkal Alwan, Christine Tohme, sighed, "Art here is very traditional. It needs a wall: hang a painting on the wall. We *still* look at pretty-vase-with-flowers pictures."[87] My queries into the reason for no-art tended to produce the explanation that there simply had not been enough history on which art making could build. Time was on the side of the hallowed genealogies of Greco-Roman-Renaissance art that begat contemporary European art. Najah Taher elaborated for me: "Artists copied styles and texts to be Western, without understanding or going through the prerequisites." And although art critic and historian Maha Sultan affirmed a history of local art practices, she told me that "Lebanon suffers from memory loss. The art heritage has been sold or stolen during the war." The *firsts, alreadys,* and *stills* I incessantly heard shot out like bullets. The battle targeted our unchanging society, where the local is a problem to be overcome, not an asset to be employed. Our society was ground zero for art. Enfolded in these discussions of no-art's clock, an implied timeline promised to compel compliance with art practices while an envisaged space for artfulness should produce that compliance.

These discussions around art in Beirut clearly contributed to the evaluating, justifying, and shaping of projects for "postwar Lebanon."[88] No-art events marked the ability to move out of the space of war and into the space of the future. I had settled in Lebanon in 1993 and conducted fieldwork mostly between 1997 and 2005. In that time, hundreds of thousands of people converged on the capital city to reconstruct and culturally resurrect it following both a political treaty between formerly warring parties (1992) and a series of investment deals heralding economic prosperity (1992–98). As the prime minister's bulldozers cleared whole swaths of newly imploded residential blocks, parliamentarians debated new budgets and laws to benefit from the absence of national debt while redressing the absence of common national institutions and physical infrastructure. Still, the vaguely worded peace accords could neither ensure the war's end nor clarify how the peace would look. The city appeared appealingly, or frighteningly, like a tabula rasa. Art fairs, newspaper advertisements, billboards, and numerous frame shops sought to shape the decor of the innumerable housing units sprouting all over the country. Retrospectives for "forefather" artists were planned, and illustrated coffee table collections of "Lebanese art" were launched.[89]

The soiree that night contributed a sense of clarity. In that moment of exhibitionary sociality, guests received a lesson in how to look with art: to see Lebanon in art and see selves as Lebanese represented by it. And perhaps they could take charge of the synecdochical clock, too: for, like the imported piano proudly displayed in the living room, the peripatetic predecessor artists Nammour listed in his lecture remained outsiders to the world canon of art production and ultimately became a source of embarrassed laughter. It came as no surprise that a few months later, the abstract painter who had called attention to the piano's disuse "did hijra" to advance his career, meaning he emigrated to an "art-full" country.

A Historical Ethnography of Contemporary Art

This book follows art's *firsts* and *stills* from the 1990s along a historical arc to the eve of the nation-building period—the 1920s. It joins a recently sown field of studies of Middle Eastern art, but my anthropological commitment to following fantasms compels an unusual configuration of concerns.[90] Following contemporary artistic practices, much of the scholarly work on so-called postwar Lebanese art arises from a fact/fiction dichotomy. Taking taswir seriously as a form of knowledge, I turn the reader's attention to half possibilities that have not ceased to shape local and global life. Intellectuals working to found Lebanon

by double decolonizing from the Mandate reached to a "novelty" (hadatha) whose origins could not lie within the sensible, known, taken-for-granted that reformist projects resurrect; rather, they had to "make happen" (*ahdatha*) and "make present" (*istahdara*) the nation and world they sought. Grappling with the operations of "no-art here" requires following the rays bouncing off art not back to some stable, socially homogenous interpretive source but across a bumpy, fractious, multiplanar surface of active, competing interpretants. I trace the living legacy of these intellectuals' thought through art into the present by conducting a historical ethnography of contemporary art, which necessarily pushes against market and museum categories to expose the threads by which art and society are mutually constitutive. I do this by focusing on three historical artists whom I "met" during fieldwork in Beirut in galleries marketing contemporary art. Even as gallerists and visitors fretted about no-art, a series of events hailed the works of these pioneers of a (reclaimed) national art movement. First, Dar al-Nadwa, a cultural center dedicated to Arabic culture and debate, honored Saloua Raouda Choucair, whom I had met through a family friend, with a retrospective in June 1993. Second, the Sursock Museum featured Omar Onsi, whose work I knew from the *Cedar Wings* in-flight publication of Middle East Airlines, in a retrospective exhibition in 1997. It followed with another in 2003 for Moustapha Farrouk, whose work I found dotting Beirut's banks and clinics because of a widely circulated portfolio of reproductions. In various ways, my interlocutors presented their work as no-art: inauthentic, unsuccessful, unrepresentative (or worse, representative for precisely these reasons). For example, while people came to admire Choucair as "the first contemporary abstract artist in the Arab world," they worried that, "far ahead of the Lebanese public's capacity for reception and acceptance of innovation," her yet underappreciated works would "take on increasing meaning and significance in the future" . . . *only*.[91]

Making no-art art, or art not-here, the trio of artists form a cultural tryptic: Farrouk and Onsi were born at the turn of the century in a rapidly metamorphosed Beirut, in which the population expanded twentyfold; a new urban plan and building codes launched; uncommon housing styles, furnishing, and clothing spread; and campaigns to rationalize education, house care, hygiene, and personal relationships gained popularity.[92] They conscientiously contributed to crafting a modern—that is, no-longer-Ottoman—Beirut. Farrouk's father succumbed to illness while he was yet a toddler; Onsi's father was one of the first doctors trained at the new medical school in Alexandria. From opposite ends of the mass of "middling means," both joined the same scouting troop, which was fostered by the city's established Sunni families to discipline urban

Muslim youth in the face of the restructuring of Ottoman Muslim governance. Also an orphan but better off once her mother secured her paternal inheritance, Choucair, born a generation later, briefly studied with the two "forefathers" and yet rebelled against their "classical" style, as she put it to me in one interview. Having worked to found Lebanon and now recirculating through its refounding and foundering, the corpus of this trio of artists allows us to follow art acts in their fullest arc. Art history conventionally focuses its narratives on heroic figures who pursue specific artistic projects through the production of objects they form and set into view. Although Farrouk, Onsi, and Choucair pursued artistic projects worthy of such narratives, I do not present a story featuring them. As much as I would have liked to bring them to life for my readers, this tale of fantasmic art demands something different.

By not trying to fit art production into a reflective model, the anthropologist can focus light at the scale of micropractices, breaking down the actions that constitute "here" into gestures, assertions, postures, and provocations. Anthropologist Fred Myers blazed the path for studying "a local art history," meaning one "undertaken from the vantage point of the producers and not based on the march of world historical ages of art's development."[93] He came to this almost unintentionally. Rereading decades of field notes from earlier trips that had not focused on art, Myers found that Australian Aboriginals who practiced dot paintings enjoyed an identity otherwise unsubstantiated at best and denied at worse.[94] Their paintings objectify identification that did not previously exist. Moreover, while these painted "intercultural objects" incorporate external and market influences, like fantasms, they also enable their makers to see buyers becoming incorporated into their ontological schema and legal-political frame (the Dreaming).[95] Painting is "becoming Aboriginal": the emergence of something both authentic and new. Notice the verbal tense of these forms: foregrounding their unfolding, Myers highlights "the play and possibilities of the events as a form of social action that is not necessarily reducible to a past or future social state." A "form of social action" that embroils particular actors at various life moments and in specific places, dot paintings gradually imbue their makers with resources, skills, and interests, thereby shifting their social being.[96]

It is by showing how art creates the local and global in tandem that this book contributes to the quest for a modern history of contemporary art beyond the metropoles specifically by treating abjection as productive.[97] Locating the emergence of artworks in social-cultural processes and vice versa, *Fantasmic Objects* shows how art triggers imaginaries and concretizes yet-unformulated concepts central to the formation of gendered, political, and religious subjects in national and transnational contexts. To make space for the "lateralism" of

hadatha-mu'asara art acts, which pulled from multiple sources in uneven ways to counter colonial hierarchies, I have avoided a genealogical project.[98] Here artists emerge when impinged on by audiences or thrust into social consideration by their artworks. My collage of biographical documentation, reception archives, and formalist exegesis attends to the calling into being of artist figures by reflexive audiences, which changed who those figures could be, just as their artworks changed who audiences could be and were changed by them. The book thus recontextualizes the art of Lebanon's recent "postwar period," rooting it in the decolonizing and self-civilizing efforts of painters, sculptors, and activists who fiercely upheld aesthetic development and battled for new forms of political being.

To craft a local art history, I first assembled a corpus of artworks and an awareness of their circulation. This had the benefit of immediately exposing me to their undisciplined, uncategorized character. At the time of my study, most of Saloua Raouda Choucair's physical corpus was in her studio being documented for a catalogue raisonné her daughter was producing. We frequently discussed dilemmas posed by attempts to date her work, which Choucair had deliberately not located in time. Meanwhile, much of her intellectual corpus existed in the interviews given or essays authored in the local press (some of which she had collected into a thick dossier) and programs she had planned (which I found by reading the cultural reviews of the 1940s, 1950s, and 1960s). Still more of her imaginative work had not yet materialized but awaited interactions with audiences-to-be. Choucair graciously opened her studio to me and discussed the works as I photographed them. She also read aloud selections from her press dossier that she deemed most meaningful. Her willingness to reflect on her life and eagerness to do so for an American-bound study meant that I was able to interview her at length repeatedly between 1997 and 2004, though her memory was gradually claimed by Alzheimer's disease. I supplemented my research by interviewing colleagues and collectors who had interacted with Choucair and visiting sites of her works' display with friends.

My methodology differed for Onsi's and Farrouk's oeuvres. Both died long before I learned of them, and many of their works belong to disparate domestic collections. Both sold from their studios throughout their lives and may have sold on consignment, too, in Lebanon and abroad. With substantial luck, I was able to meet many of the artists' heirs, who magnanimously shared what they could: artworks as well as press clippings, notebooks, sketchbooks, and memories. I filled out this material by meeting, through friends, relatives, or dealers, people who had bought their work. Still, I can state with certainty neither what percentage of their corpus this material represents nor how it reflects their

repertoire of interests. There are hints in the contemporary press reviews that interiors, still lifes, and historic scenes were more present in Onsi's oeuvre than generally thought. While the situation discouraged me from attempting to flesh out individualizing accounts of their careers, my visits with heirs and collectors elicited rich interpretations of artworks and art generally. Encountering the works in private homes, in quotidian settings (for which most were intended), sparked my interest in their social lives—the settings, family occasions, and gossip they contributed to as people carried on life projects—and attuned me to the current interpretations of and interactions with them that associate the pictures with domesticity, gender, class, ancestry, and affiliation. This, in turn, sent me deeper into historical archives that could speak to the disjunctures and continuities in the production of their fantasmic art.

An Alternate Ontology

In 2016, Saloua Raouda Choucair turned one hundred. To celebrate her birth-day, Beirut's municipal museum, the Sursock, reinstalled two works it had ac-quired from the artist in the 1960s and organized a panel of speakers to elucidate her legacy. Choucair had grown too frail to participate. As panel moderator, I wanted her voice to be present, for her art to meet the people with her words addressing them. I wanted to push against the museumification of her work—removing those dusty bedsheets from the maquettes only to encase them in vitrines to admire visually. With the help of her daughter, Hala, I had *Poem's* installation footage digitally cleaned up, subtitled, and screened at the session's opening. Viewers encountered spry Choucair at the roundabout in 1983, with the ever-present construction trucks tumbling past and a vast sculpture tower-ing over them (fig. 1.3). They heard her proclaim, "Everything living grows."

After the panel concluded, an audience member shot up. The sturdy figure of late middle age, dressed in an elegant abaya and pantsuit, introduced herself as one of the Lions' Ladies responsible in 1983 for commissioning the sculpture. Visibly trembling, she explained that seeing the sculpture had overwhelmed her and compelled her to speak:

> Ma'leh [excuse me], I don't want to [sit] because I'm shivering. . . . We bought it and we met, the Ladies' secretary and myself, we met Mrs. Saloua Choucair, and she was very happy because we were the only people who thought of buying a piece from her. She dedicated [i.e., donated pieces], but nobody bought. . . . We installed the sculpture. We put it in the roundabout of the Summerland [Hotel]. And then one time we were traveling, my husband

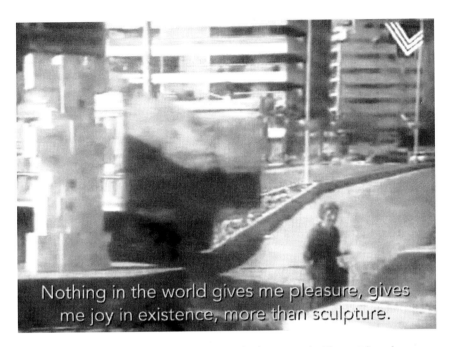

Nothing in the world gives me pleasure, gives me joy in existence, more than sculpture.

FIG. 1.3 TeleLiban footage of the installation of Saloua Raouda Choucair's sculpture *Qasida* [Poem], 1983. Clip from *"Nas min Dhahab"* [People of gold] episode featuring Saloua Raouda Choucair, Future TV, 1996.

and I, and when we came back I saw the whole sculpture painted black. Who did it? I know who did it, but I'm not going to say. [Audience laughs.] So, I was very scared about [its fate], because they might bring a bulldozer and crash it. So, we took it to the Summerland, which was functioning at the time. We left it there, from '83 until maybe '90. And then, afterwards, I saw Mrs. Choucair, or maybe in between, I don't remember, and she told me that she knows, that some people have told her that they have seen this sculpture in Commodore [Hotel] area. I told her, *"What can we do? It was war!"* It was before we were at the end of the war. And at that time, I had some family things to think about, so I was interested and I didn't disclose it. Until one time, maybe five years ago, I saw the lady, who I'm not going to disclose her name [audience laughs] because we cannot say, and she told me she took it. I told her, "How come? How could you? How can you take it? It's not yours, and you are a thief, and I'm going to raise hell about you!" [Applause from audience.] *As things go in Lebanon,* I did not do anything about it, but now that I saw this sculpture in front of me, I couldn't but tell you. I hope that the

Minister of Culture will care, because I know where it is! [Audience claps
loudly.] Then it could be put in a place to commemorate Mrs. Saloua Raouda
Choucair. [Applause.] I want to tell you my name, so if you want to search
[come to me]; my name is Ilham Halabi. [She sits down as the audience
cheers, but quickly rises again.] One more thing, I don't want the same thing
to go *the Lebanese way*: we talk about it and then, I don't know . . . because . . .
[So] I ask the Minister now, in front of all you, I ask the Minister today, as you
witness [turning to Minister of Culture Rony Oreiji, seated in the front row]
that you are going to help get the sculpture back, after I tell you who it is.[99]

Halabi reported being overwhelmed by her aesthetic encounter with Chou-
cair's missing sculpture. Trying to manage family survival during Lebanon's
long armed conflict, she had treated the sculpture's absence as a metonym for
war and civic incapacity: "What can we do? It was war!" Synecdochically, this
time period for art determined (in)action toward the sculpture and sent Halabi
on her path. At the centennial, however, *Poem*'s palpable presence compelled
her to speak to change the artwork's fate. Notably, doing so could also change
"the Lebanese way" by breaking an alleged cultural pattern of irresponsibility
and deflection. Citing the power of the sense-realm in which she found herself,
Halabi deliberately invoked exhibitionary sociality to remind the minister that
the audience was watching for his response. People applauded and whistled as
she called on him to oversee the return of this "gift to Beirut." Perhaps unsur-
prisingly, he followed the synecdochical logic that had guided her previously.
Sputtering about "war-time contingencies," he demurred, letting the absence
of art thus determine subsequent action toward society. Onlookers gasped.
Some hissed that he was probably protecting a political patron. I found myself
joking that the history of archival art practices in Lebanon—exemplified by
Walid Raad—might yet lead to an actual reincarnation. Later, I joined efforts
to relocate the sculpture by teasing it out of the private collection purported to
hold it. I have not succeeded. Still, that is not the end of the story.

Choucair's palpably absent sculpture blazes the trail to a land of no-art here.
It is a fantasmic object. Farrouk's cross-eyed caricature is another. Like blink-
ing beacons, they announce no-art through the medium of art. They engage
audiences, including the writer and readers of this book, in a quest for art and its
social bases. Fantasmic art is neither purely imaginative nor purely material but
stands at the intersection of both. Further, it is individual and collective, made
through contributions of artists and audiences, as well as through repertoires
of affiliation and association. The fantasmic model of art I propose from the
legacy of Muslim philosophy allows us to reformulate the roles and relationship

of artworks and audiences. In the aporia between them, between sense and intellect, between a world that can be experienced and one that can be understood, the fantasm arises not from objects or subjects but at the point of their interrelatedness and essential indistinguishability. In fact, viewers of fantasmic art become objects of art objects. When they encounter an artwork—meaning an entity in the realm of the sensible but not fully rational—they must add to it their intellectual repertoire for it to become meaningful to them, and different art objects will trigger different associations and responses in them. The element to which the audience relates ultimately is not the concrete thing the artist has momentarily created but the perceived, extrapolated thing (which for pious Muslims belongs to the realm of the supraintelligence).

Because it obviates the need for art to represent, this ontology of fantasmic art invites us to study the tentative, contingent formation of deeply experienced, urgently embraced entities, which may not have concretized physical or codified discursive aspects. The artworks presented in this book either have been claimed for a nationalist art history and viewed only for their sheer existence or have been dismissed as derivative, thus viewed only for how they look like artwork elsewhere. Both approaches ignore audiences by enfolding their existence into an essentialist schema for seeing objects apart from subjects. The ontology I explore opens awareness of art's agency in joining and changing audiences and makers at once. In other words, it suggests an art of new formations, actively produced with audience input that, in turn, reshapes the audience's awareness of possibility. With *Fantasmic Objects*, we are able to track both how Lebanon's here has shifted and what energies have gone into making it appear as fixed as it does. Although grounded in an analysis of Lebanon, this book seeks to spark reflexive taswir for scholars, opening to scrutiny both subaltern pasts and dominant presents, whose mutuality demands this methodology.[100] Fantasmic objects document at once aesthetic encounters and potential for social change. They index people who have existed and those who may exist. They allow us to imagine sculptures into public spaces and account for our imaginal agency. Ever beacons flashing out ambiguous, compelling signals, they allow us to alternate our ontologies.

Schema of the Argument

In the next chapter, I lay out the foundations of a local art history by attending to the interactions of artists, artworks, and audiences in professionalized exhibition spaces. Treating these new arenas as sense-realms in which participants develop emotion practices by looking at themselves looking as

they "walk with life," I document the emergence of exhibitionary sociality among the self-consciously "postwar" audiences of 1930s Mandate Lebanon. My focus on the aesthetic encounters and emotion practices that challenge viewers-to-be alters the understanding we have of the political imagination in colonial and decolonizing contexts. Through art-viewing practices, Mandate citizens created a sense of civic selfhood and imbued a nation with the palpable substance of "here," "now," and universality. Uniting on a basis of who they might be rather than who they were, people who had been joined through art acts had virtual but impactful presence in Mandate Lebanon, especially through the emotional practices and bodywork they undertook to external-ize the self-discipline they learned from art. The third chapter continues the project of a local art history by examining the adoption of a deliberately im-ported genre, the nude. Many frankly exoticizing myths have obscured our current understanding of the practice regionally, presenting it as derivative, self-Orientalizing, or even nonexistent. Most significantly, the assumption that it need only be studied within a Western canon has constrained even critiques of the genre. I locate nudes in public exhibitions in Beirut to reveal how the genre engendered processes of incorporation as audiences became objects of artistic sight and subjects of artistic seeing. As objects of the nude, audiences learned a new medium of self-cultivation, dhawq, which made the selective ability to incorporate external stimuli an important asset for the citizens of modern Lebanon-to-be and a main means of casting others out of its bounds. Important connections exist among the nude genre, anticorrup-tion campaigns, developing ideas of civic duty, and the project of becoming gendered citizens. In the presence of nudes, "looking at looking" both mapped and populated a civic space for a modern, pious, aesthetically self-developed nation-state, thereby imbuing the latter with an unexpected transnational-ity while at the same time showing that nationalism, wataniyya, cannot be reduced to state-centered practices.

The fourth chapter foregrounds the newly emergent genre of the "typical Lebanese paysage," or manzar tabi`i, which I rethink as a "divinely imprinting print," to explore more specifically the intersection of self-modernizing projects in fine art with modern Islamic piety. I focus on the case of one controversial scene, lost from the national map but entered into its exhibition repertoire, to show the connections viewers made among morality, cosmology, and the land-scape genre as a source of subjectivity. Exhibition-goers' responses suggest the agential power of pictures in situations of rapid social change where aesthetics become the means for communal and bodily bonds. Again, I clear space for an alternative ontology by recontextualizing the artworks in concurrent civic

projects of scouting and nation mapping. As "locally made imports," these pictures participated in a sense of both hereness and not-hereness. They challenge our notions of locality, peripherality, and universality. They also challenge viewers to become appropriate managers of the land and community. They beg for a reconsideration of what the "national" meant and can mean today. One thing we can only see by appreciating this context is the deeply pious, potentially Muslim character of many of the works, which, however, were not anti-Christian. These landscapes are, thus, a missing part of the story of civic imaginations and social experiments in the modern Middle East and other socialities where sacred and secular are not mutually exclusive.

While the next three chapters focus on Farrouk and Onsi, the last two chapters focus on Choucair, who took her first formal art training outside of grade school from them. How did ideas of fantasmic art, self-cultivation, and aesthetic merit shape society beyond the scene of self-consciously professional art making? I answer this in chapter 5 by examining a key institution that targeted the larger population: general education art lessons. Regional art historiography, as in other former colonies, has tended to take these moves for granted as part of colonial influence, yet doing so overlooks what the lessons came to mean for students. It overlooks, in other words, the public life of taswir. Starting in the 1920s, pedagogues thinking about a post-Ottoman schooling system demanded that art lessons be introduced to primary and secondary education. They sought to cultivate not so much pupils' potential natural talents as their potential for citizenship. Schools across the spectrum of religious and linguistic affiliation integrated drawing and art appreciation into their curricula in the 1930s. At first most of the students receiving these lessons were male, but as the decade passed, females were increasingly included and even spotlighted. I examine the trajectory of Saloua Raouda Choucair from grade to high school lessons to show how she shaped art lessons into a way of working out ideas about gender and civic roles. This chapter also highlights the role of aesthetic practices at intercultural junctures, establishing *correspondence* and producing intersectional relations that escape our current identity categories. It reveals the impact of aesthetic processes on colonization and liberation. In a final blow to local art production, French authorities holding on to the Mandate over Lebanon refused to institute a professional art academy in the country. In their view, the destiny of the entire "feminized," "Semitic" populace was to make "merely" decorative craft. While the double-decolonizing Lebanese forged new horizons through modern art, they also reinforced nascent gender boundaries that today seem entrenched. My hope is that the lost institutional stories will undo that sense of fixity.

Fixity falls apart all the more in the last chapter. Its ethnographic art history of the portraiture genre foregrounds local interactions, materials, and experiences but also follows material art forms that make new bodies and beings. In the process, it shows how one artist, Choucair, whom we met as a pupil in the previous chapter, became the object of her own artworks and, reading reviews of them, produced new works that visually objected to ongoing projects of mapping her vision onto given, political realities. Reviews got under her skin, in more than metaphorical fashion. The perturbance they produced should disturb our notion of an artist's corpus. Indeed, the diachronic consideration of Choucair's coming into being through art raises questions about what constitutes an artist's body and how audiences can expect to relate to it. This returns us to the missing *Poem* and the many remaining maquettes in Choucair's cupboards. Audiences are not missing from these pieces but deeply incorporated into them. Their fantasmic nature has long been obscured by their absorption into a high art/global gallery paradigm. Everything living is vulnerable to social processes as it grows. That liveliness, however, provides a chance for us, as audience, to espy our role in art's trajectories—and maybe find missing sculptures, too.

Each chapter starts with a vignette from the decade of my fieldwork (1995–2004) to underscore how artworks are continually made socially and making of socialities. In this way, though set in the Mandate era, *Fantasmic Objects* is equally a story of the 1990s–2010s internationalized Lebanese art scene, featuring globally feted artists such as Walid Raad, fairs like Ashkal Alwan's HomeWorks, local galleries and museums like the Beirut Art Center and Sursock Municipal Museum, and metropolitan presentations including the Tate Modern 2014 retrospective for Choucair and the MoMA's for Raad in 2015. Such events and institutions are usually approached as exemplifying "postwar," contemporary issues. This book places them in a *longue durée*, with art at the center of the concerns and continuities. It explains how some audiences have come to matter more than others and what quandaries this produces for young artists who may, instead, opt to work by other categories of affiliation. This ethnographic arc surpasses a demonstration of the uncanny ways a history repeats itself to acknowledge art's agency in clearing space for interventions.

Notes

1. For interviews conducted by the author alone, see Notes on Sources.

2. Saloua Raouda Choucair, interview with the author and Jack Assouad, Beirut, May 15, 1999.

3. Her delight eclipsed her disapproval of the organization's politics, embodied by its head, Joyce Tyan Gemayel, wife of the Phalangist president.

4. Choucair, interview with TeleLiban, June 12, 1983, as included in *Nas min al-Dhahab* [People of gold], 1996, Future TV, SRC.

5. Mai Manassa, *"Niswat al-Laiyunz Rattabna li-Bayrut al-Kubra Zari`a Mumtadda wa-Manhuta li-Salwa Shuqair"* [Lions' Ladies organized for Greater Beirut a chain of greenery and a sculpture by Salwa Shuqair], *al-Nahar*, June 13, 1983, 14.

6. Choucair, see note 4.

7. Samir Sayigh, *"Ba`d Tashwih Manhutat Salwa Rawda Shuqair: al-Fann al-Hadith . . . Rub` Qarn min Su' al-Tafahum"* [Following the vandalism of Salwa Rawda Shuqair's sculpture: Modern art . . . a quarter of a century of misunderstanding], *al-Kifah al-`Arabi*, August 29, 1983, 70.

8. Sayigh, 70.

9. A lengthy literature addresses pictorial agency. For an overview, see Bredekamp, "Picture Act." My term *art act* resonates with Horst Bredekamp's theory of "image acts." Developed to resist the Kantian promise of "pure thought" that reduces art to representation, this theory focuses on pictures that model, replace, or emanate human activity. Bredekamp, *Image Acts*. One reviewer of Bredekamp noted that the imbrication of human and image agents in each other means that "a theory of Image-Act is simultaneously an anthropology." Kitzinger, "Review." Still, the usefulness of this theory for my study is limited by its insistence on universality rather than historical and cultural contingency, its suspicion of images as less than real (see my discussion below of fantasms), and its circumscription of pictures to "non-organic material."

10. See note 5.

11. E.g., Qaisar al-Jumayyil, *"al-Nubugh wa-l-Mal Yakhluqan al-Fann al-Yunani"* [Genius and money create Greek art], *al-Makshuf*, February 28, 1938, 8.

12. Wendy Shaw records the troubles turn-of-the-century Ottoman translators of the French term *art* faced and the gradual replacement of the Ottoman *sina`at* (related to the Arabic *sina`a*) for *arts*, in our contemporary sense of "technologies, skills," with *fenn* (which had indicated "science" previously). Shaw, *Ottoman Painting*, 119–21. Cf. Mestyan, "Arabic Lexicography."

13. Wehr, *Arabic*, 529–30. I develop my exploration of *taswir*'s meaning throughout the book. Saleem Al-Bahloly also discusses the concept in relation to artist Jewad Selim, in 1940s–1950s Baghdad. Al-Bahloly, "History Regained," 264–66.

14. E.g., Baxandall, *Painting*.

15. Copjec, "Imaginal World," 40.

16. Copjec, 40.

17. Bourdieu, *Distinction*.

18. A Christian history relates to this dualism. It embraces different understandings of *light*, between *lumen*, a relational source akin to Ibn al-Haytham's

model (see chap. 6), and *lux*, an abstract source that encompasses the world equally. Copjec, "Imaginal World," 25–27.

19. Jay, *Downcast Eyes*; Levin, *Modernity*.

20. Dadi, *Modernism*, 16, 14.

21. Aretxaga, "Fictional Reality," 51.

22. Aretxaga, 51

23. Ivy, *Vanishing*, 22.

24. Ivy, 4.

25. Michelle Karnes traces the influence of Islamic commentaries on Aristotle through Christian theology despite controversies. Karnes, *Imagination*, especially chap. 1. The anthropologists I cite draw from Enlightenment-skeptical philosophers such as Walter Benjamin, working on urban imagery, and Gilles Deleuze, working on the novelty of creative thought, whose expositions suggest Islamic mysticism's indirect influence. Both mined a "middle-realm" to explain the power of inarticulate ideas to mobilize populations and trigger "flights of fancy" among receptive persons. See Buck-Morss, *Dialectics*, 86–92, 118, 211–12; Deleuze, *Difference*, 144, 250.

26. Bashier, *Ibn al-ʿArabi's* Barzakh; cf. Corbin, *Alone*, 4, 11.

27. Agamben, *Stanzas*, 77. See also Karnes, *Imagination*, 45.

28. Agamben, *Stanzas*, 80. Agamben notes that for Ibn Rushd's fantasm-based schema, all thought is speculative, always proceeding in the technical absence of an object (say, the beloved) and via the subject's act of composing, out of the diversity of received impressions (various particular experiences and wants), unified forms that are neither material nor immaterial, neither pre-extant nor epiphenomenal (the fantasm of the beloved is the subject of poetry).

29. Corbin provides this translation of *barzakh* in the course of presenting the corpus of Andalusian Muslim philosopher Ibn al-ʿArabi. Corbin, *Spiritual Body*, ix.

30. Mittermaier, *Dreams That Matter*, 4, chap. 3.

31. Agamben, *Stanzas*, 83.

32. Farrukh, *Tariqi*, 33.

33. Mamdani, "Good Muslim." Cf. Dadi, *Modernism*, 27.

34. Abou-Hodeib, *Taste for Home*, 7.

35. See the debate between May Ziadeh and Labiba Hashim discussed in chap. 5.

36. Méouchy and Sluglett, "Introduction," 10–11.

37. Thompson, *Colonial Citizens*, 2.

38. Abou-Hodeib, *Taste for Home*, 4, 60.

39. Creswell, for instance, calls for excluding indigenous uses of *hadatha* that do not conform to his academic definition. Creswell, *City of Beginnings*, 4, 203n4. With more nuance, Deloria inventories white American and Native American artists' thinking about the modern era to produce modernist or anti-modernist lives. Deloria, *Becoming*, chap. 4.

40. Indeed, colonized communities of the South often evinced a "heteroch-ronicity," encompassing multiple temporalities (for example modernized *and* colonized), or "simultaneous histories," in coexistence. Harney and Phillips, "In-troduction," 7, 4; cf. Dadi, *Modernism*, 177–78. By way of example, intellectual and political activist Amin al-Rihani lectured in 1910 against a kind of modernity that simply subjugates its subjects to stultifying, unchanging time. Lenssen, *Beautiful Agitation*, 51.

41. See Pascoe, "Making," for an overview of assumptions "Impact of the West" theories make for Middle Eastern societies. On parallel mini-origins, see Gaonkar, "Alternative."

42. Dipesh Chakrabarty's term points to the particularity of European notions of modernity but also, crucially, to their reliance on investments in their Europe-anness from so-called non-European margins. Chakrabarty, *Provincializing Europe*, xiii, xiv.

43. In part, this is probably a matter of disciplinary zoning. As anthropologist Lila Abu-Lughod explained in 1989, this region, unlike Africa or Melanesia, is not the site of an institutionalized genealogy of literature begetting new art studies each generation. See Abu-Lughod, "Zones of Theory."

44. E.g. Grabar, *Mediation*; Ettinghausen and Grabar, *Islamic Art*.

45. Shaw, *What Is*, 16–18.

46. For examples, see Blair and Bloom, "Mirage," 174; Naef, "Reexploring," 165. Barry Flood analyzes the assumptions behind this "art history interruptus" in Flood, "Prophet."

47. Cf. Abu-Lughod, "Zones of Theory"; Deeb and Winegar, "Anthropologies"; Gilsenan, "Very like a Camel." This is not to discount a burgeoning literature de-voted to studying art of the region. See note 90 below.

48. Shami and Naguib, "Occluding Difference," 24, 43, 33.

49. Povinelli, *Empire*, 36.

50. The problems encompassed by the term *Islamic art* have engendered a long literature dating from its very inception. It exists translationally, correcting some misperceptions and fostering others. See Flood and Necipoğlu, "Frameworks," 6; Watenpaugh, "Resonance," 1227; Blair and Bloom, "Mirage," 153; Shaw, "Islam," 13. For reviews of the debates, see also Troelenberg, "Arabesques"; Carey and Graves, "Islamic Art Historiography."

51. See Shalem, "What Do We Mean," 8. Shaw observes that while pioneer Islamic art historians selected art objects that maximized an apparent difference from (tacitly framed) Western art, they analyzed them through "epistemological structures grounded in Western modes of perception." Shaw, "Islam," 5.

52. Flood, "Prophet"; Necipoğlu, "Concept"; Rabbat, "Anyway"; Shalem, "Dan-gerous Claims."

53. Flood, "Prophet," 43; Dadi, *Modernism*, 217; Rabbat, "Anyway," 4.

54. Watenpaugh, "Resonance," 1228; Flood and Necipoğlu, "Frameworks," 20. On trends among Muslim historians of Islamic art, see Shaw, "Islam," 6, 22–30.

55. Ho, "People Eat," 352. "Cosubstantial" is Elizabeth Povinelli's term. Povinelli, *Economies*.

56. Shalem, "What Do We Mean," 6.

57. Asad, "Idea," 10.

58. Ahmed, *What Is Islam?*; Aydin, *Muslim World*.

59. Shaw, "Islam," 6; Guha-Thakurta, *Monuments*, 147. Cf. Minissale, *Images*. Like Guha-Thakurta, Shaw dates the doubts about Islamic art's modernity to the decolonization period, when experiments in developing the faith coincided with projects of rationalizing it. Cf. Deeb, *Enchanted Modern*.

60. Rabbat, "Continuity," 49. Cf. Shaw, "Islam," 30. For seminal examples see, Zitzewitz, "Infrastructure"; George, *Picturing Islam*.

61. Mittermaier, *Dreams That Matter*, 235.

62. Dadi posits the absence of any such discursive ground as a simple fact for Islamic visual art, as opposed to literature and poetry, but in so doing may preempt the boundaries of the art forms' entailments. Dadi, *Modernism*, 32.

63. Jain, *Gods*, especially chap. 4.

64. George, *Picturing Islam*, 29.

65. Navaro, "Affective Spaces," 1, 12, 14–15.

66. I admiringly acknowledge Sumayya Kassamali as the source of this felicitous phrase, which she developed to describe her study of the peoples and practices that, though central to Beirut life, do not form its official self-presentation, such as migrant domestic workers and multinational support networks. Sumayya Kassamali, "Black Beirut" (lecture, Anthropology Society in Lebanon [ASIL], Beirut, June 17, 2019).

67. Cf. Westmoreland, "Making Sense," 733. Anthropological exemplars include Navaro, *Faces*; *Make-Believe*; Mittermaier, *Dreams That Matter*; Schielke, *Future Tense*; Pandolfo, *Knot*.

68. Minorities and mavericks rarely feature in Middle East ethnographies. See Shami and Naguib, "Occluding Difference."

69. Recent ethnographies of Lebanon dismantle stereotypes of mindless actors driven by external forces and expose the construction of the state (and its absence) through everyday patterns of causal attribution and survival. See Bardawil, *Revolution and Disenchantment*; Deeb, *Enchanted Modern*; Hermez, *War Is Coming*; Monroe, *Insecure City*; Nucho, *Everyday Sectarianism*; Sawalha, *Reconstructing Beirut*. However, working within the strictures of Euro-American academic grant structures, they have hewed close to "hegemonic interpretations of what is 'policy relevant for the Middle East.'" Abboud et al., "Beirut School," 274.

70. I find a similar spirit animating Anneka Lenssen's recent study of Syrian modern painting, in which she asks readers to hear "Syria" as referring not to a

"single, fixed place" but a "complex play between presence and its visualization."
Lenssen, *Beautiful Agitation*, 13.

71. There is also another version of the print with the Arabic title *"Dhikra Ma'rid Farrukh, 1933–34,"* the first word of which translates to "reminder," "souvenir," "keepsake." The date appended to the end is odd as Farrouk's exhibition, according to the guest registry and newspaper coverage, ran from December 15–24, 1933. I wonder if the title was added later. Hani Farroukh reports that he found the stack in his father's studio. He does not know exactly when they were printed but surmises Farrouk distributed them to studio visitors.

72. Said, *Orientalism*.

73. Jack Assouad, personal communication, March 17, 1997.

74. Hage, *Diasporic Condition*, 165.

75. Hage, 7. Pieprzak, *Imagined Museums*, 35–6; Buntinx, "Communities."

76. Shawqi Matta, Sawt al-Sha'b, radio broadcast, September 3, 1997.

77. Turner, *Ritual Process*, 15.

78. Turner gives the example of a glossy tree whose slippery surface thwarts climbing. It can be experienced as a metaphor both for lost pregnancies and for "losing" (or casting off through healing) the illness preventing them. He argues that "what is made sensorily perceptible, in the form of a symbol . . . is thereby made accessible to the purposive action of society, operating through its religious specialists." Turner, 25.

79. The same model pertains in Arabic: *hasan sabi* takes a prototypical male name, Hasan, and adjoins it to the word for "boy" to identify a girl with behavior assumed appropriate to her gender opposite.

80. I depart here from predecessors who treated the theme of lack as an apt description or related its grip to colonial malaise or class striving. See Naef, "Reexploring"; Pieprzak, *Imagined Museums*; Jain, *Gods*. Noticing the practice-generating aspect of abjection, Guha-Thakurta speaks of "mourning [that] had become a way of being for the emergent national subjects" in postcolonial India; likewise, Dadi argues that the "lack" of Islamic visual praxis prompted self-conscious experimentation. Guha-Thakurta, *Monuments*, 152; Dadi, *Modernism*, 36.

81. Jain, *Gods*, 12.

82. Or social and cosmological boundaries. I coin my neologism in part to avoid the implications of Pierre Bourdieu's theory of art and social distinction, which overly relies on a particularly French history of hierarchy, as many have noted, but also on a secularizing sense of personhood, which is not universally appropriate, as I show in chaps. 3 and 6. Bourdieu, *Distinction*; Bourdieu and Darbel, *Love of Art*.

83. This use of *sense* draws on the anthropological literature of aesthetics as opposed to physiological or psychological analyses. The concepts *sensorium* and *moral physiology* counter the Cartesian dualism of body and intellect. E.g., Geurts, *Culture and the Senses*; Hirschkind, *Ethical Soundscape*; Shannon, *Among*

the Jasmine Trees. With *sense-realm*, I seek to highlight the importance of circum-scribed, carefully managed places to the cultivation of new sensoria.

84. In fact, Farrouk studied life drawing in Rome. See chapter 3.

85. Original emphasis.

86. Critic Nazih Khater told me that Farrouk's entire corpus stylistically lagged from the start: "Just like the artists who did Impressionism in Paris while the rest of France was doing Cubism and Surrealism, every time they get ahead a bit, the rest of the world has *already* surpassed them again." Original emphasis.

87. Original emphasis.

88. I use this term trepidatiously to refer to the period following the 1992 Ta'if Accords, which brought peace between warring Lebanese parties. It does not mean that conflict departed the scene, let alone the sense-realm of art in Lebanon. On living Lebanese lives in anticipation of a war, see Hermez, *War Is Coming*.

89. See Nicholas Sursock Museum, *Omar Onsi*; *Moustapha Farrouk*; *l'Orient Rêvé*. Hani Farroukh, *Portfolios*; Nammour, *Sculpture in Lebanon*; Fakhuri, *Hadiqat Duyuf*; Raouda Choucair, *Saloua Raouda Choucair*. Also, Saleh Barakat commissioned the translation to Arabic of Naef, *À la recherche*, in 1997.

90. This literature draws from anthropology, art history, film and media theory, graphic design, and political science to dismantle assumptions about artistic subjectivity, cultural flows, political processes, and the nature of trauma and memory. However, most confines its scope to before *or* after modernity, usually marked by some major rupture, such as Lebanon's twentieth-century civil war, thereby implicitly perpetuating disciplinary boundaries that make history either hegemonic or irrelevant to Middle Eastern culture. For works pertaining to Lebanon specifically, see Elias, *Posthumous Images*; Marks, "That *and*"; Naeff, *Precarious Imaginaries*; Rogers, *Modern Art*; Sultan, *Ruwwad* and *l'Art au Liban*; Toukan, *Politics of Art*; Westmoreland, "Making Sense." Two fresh exceptions deserve notice for spanning historical and political boundaries: Maasri, *Cosmopolitan Radicalism*; and El-Hibri, *Visions of Beirut*.

91. Khal, "Embodying the Spirit," xvii; Tarrab, "High above the Flock."

92. For overviews of late Ottoman Beirut, see Abou-Hodeib, *Taste for Home*; Hallaq, *Bayrut al-Mahrusa*; Hanssen, *Fin de Siècle Beirut*; Sehnaoui, *l'Occidentalisation*; Sharif, *Imperial Norms*. For analyses of the sociopolitical changes wrought under the mandate, see Ghorayeb, *Beyrouth sous mandate*; Moumtaz, *God's Property*; Thompson, *Colonial Citizens*.

93. Myers, *Painting Culture*, 19.

94. Interestingly, in his first ethnography, from the 1970s, Myers deliberately ignored Pintupi dot painting, which hit regional markets in the 1980s. He mentions artworks only in passing as "new rituals, songs, or designs" that "Westerners" misrecognize as "products of human creativity." His reticence to acknowledge this area of his interlocutors' life stems in part from a Marxist commitment to treating

any handling of the Dreaming as "fetishization," as an empty "fantasy" of indigenous agency. See Myers, *Pintupi Country*, 54, 242.

95. For a companion study of "bicultural" pictures, see Geertz, *Images of Power*.

96. Myers, *Painting Culture*, 8, 258, 118–19, 272, 259.

97. Recent scholarship contests the assumption that nonmetropolitan art can only be contemporary "because locally it has no modern history," by meticulously recentering the local histories lost through exclusive use of settler art historical concerns and languages. Harney and Phillips, "Introduction," 1.

98. For lateralism, see Sbaiti, "Lessons in History," 112.

99. Transcript from Sursock Museum celebration of Saloua Raouda Choucair's centennial, Beirut, June 24, 2016 (emphasis added).

100. Chakrabarty, *Provincializing Europe*, 100. See also Jain, *Gods*, 17.

2

EXHIBITIONS
Sociality as Fantasm

MAJESTIC EUCALYPTUS AND ficus trees filtered the sunlight of a surprisingly hot October morning, cooling onlookers' advance through the walled park known as Sanayeh, at the eastern end of Beirut's Hamra district. Amid the young mothers swapping news, children playing tag, and elderly men placidly occupying the aged benches, a strange new sculpture arose, its exposed iron rods contrasting with the graceful marble monument at the center of the Ottoman-era fountain. If they looked up, what would the park's denizens have seen? Did the giant metal humanoid by the park's edge, with its bouquet of balloons held over three meters high, offer the children a gift, deceptively distract them while planning their destruction, or heedlessly invite clambering while menacing tetanus-laced wounds and uncushioned falls? Nearby, wooden skeletons scaffolded several park benches, walkways, and waste bins, seemingly ensuring exact measurements and standardized public space while also withholding the semi-prisoned objects from contact and, at once, hailing madcap climbers (fig. 2.1). Their rigid forms created a visual rappel with the apartment complexes overlooking the park. The skeletons seemed to echo and empty the high-rise residences that bore down on the scene. In fact, a whole tribe of odd beings had encamped throughout the park: at the entrance, a rustic burlap tent housed oversized, exotic butterflies; around the corner, a curious portrait conflated with the national map; farther in, a horde of painted toilet plungers beguiled with their impenetrability; and so on. Appealing to the public but retreating from their approach, they exuded ambiguity.

In a corner far from the fountain's gurgling, a semicircle of Naugahyde armchairs incongruously held court. Camera operators with Future TV waved off

FIG. 2.1 Bassam Kahwaji, site specific work for *First Sanayeh Garden Art Meeting*, wood and mixed material, 1995. Photograph by Gilbert Hage. Permission of Bassam Kahwaji. Courtesy of Ashkal Alwan.

curious onlookers as three bohemians in their early thirties took their seats in the armchairs. Rania Tabbara, Marwan Rechmaoui, and Christine Tohme were not yet famous, just unfamiliar, like the bizarre artwork whose installation they had arranged. The Future TV reporter leading the morning society show, *Alam El Sabah*, introduced her guests so that her audience in their air-conditioned apartments across the city might "*get to know them better* and see how the *idea of the exhibition* started." Congenially, Tohme effused to an audience envisioned through the TV camera lens, "Welcome to the Sanayeh garden, we are waiting for you."[1]

Between October 5 and 8, 1995, the *First Sanayeh Garden Art Meeting* deposited some three dozen artworks by nearly forty mostly unknown, young, locally active sculptors, painters, and experimenters throughout the twenty-two thousand square meters of public space. Created in 1907 when *batin Bayrut* (the inner city), like other medieval walled cities of the region, spilled outside its protective walls, Sanayeh was one of the first "modern" governmental complexes. The garden had fallen into neglect in the wake of the Civil War. Now the upwardly mobile, for whom the Ottomans once intended it, used it much less than did the stubbornly surviving. The organization founded by Tabbara, Rechmaoui, and Tohme, called Ashkal Alwan (shapes, colors) in reference to the media of creativity, hoped to take advantage of this accessibility. Rather than relying on exclusive, owner-controlled, commercially oriented galleries for display, the participating artists put art in the public path, as part of a "daily artistic life," as Tohme told me a few years later. This first public event by the now globally renowned Ashkal Alwan has subsequently received much critical attention for literally clearing space for a new approach to art.[2] Hailing its ushering of the "Lebanese postwar generation" onto the contemporary global art scene and into debates over national identity, history, and memory, these accounts focus exclusively on the art objects or makers' intentions. Strangely, given the focus on the audience in Ashkal Alwan's launch and raison d'être, no commentaries survey audience involvement.[3] Uttered to unseen and imagined spectators, Tohme's welcome reminds us that art needs its audiences and, more, that the possibility of a community is at stake in art displays. Moreover, the dynamics of "waiting for" an audience, the invisible "you," while sequestering a public off camera reminds us of the exclusions such invitations entail. Providing the lively background to the televised interview and the target for "getting to know [the artists] better," the unknown, excluded-included audience at *First Sanayeh* alerts us to fast-forming fantasms of citizenship, class, and state that escape our attention if we look only for avant-garde art objects and conventional aesthetics.[4]

Audience Presence and Exhibitionary Sociality

I was not able to attend the *First Sanayeh Garden Art Meeting* because I had returned to graduate school for the semester. I was drawn to it later by the many times fieldwork interlocutors casually pointed to its "proof" of a new relationship to audiences, public space, and civic being. The ambivalence of these accounts struck me: always assuming an audience yet ignoring its particulars and fearing its encroach. Likewise, an unknown, disembodied audience lurks in the *First Sanayeh* exhibition catalog as a threat "to turn [the exhibition] into a festival, in the cheap vulgar sense."[5] It cavorts lovingly on opening night in the "intimate scene" described in *al-Nahar* newspaper, mixing many types of people, all "doing their thing" in the warm, dark space.[6] It motivates a TV reporter's skeptical query about the viewership the show addressed: "I want to ask you a question, is it only the people of Sanayeh coming or people interested in art?"[7] In 1995, "the people of Sanayeh" was a slightly derogatory reference to those people who inhabit outdoor public space because they cannot afford air-conditioned malls or exclusive clubs for their diversion. In response, Tohme insisted the exhibition be evaluated for not only reaching but also forging and trusting an audience. Her answer bears quoting at length:

> It's a mix of people that usually come to Sanayeh and the public coming to see the exhibition. This is what is important to me, the significance is that ordinary people, the people that supposedly don't understand—I don't think that they don't understand, intuitively they understand everything but *we consider that they don't and keep away from them*—are coming to see the installations. People were inquiring about the works, they were amazed by what was happening, they were asking who were these artists, but they were not mocking what they saw. This is why I am so happy and I can't really express how happy I am, together with Rania and Marwan. If we try and give them a chance, they understand and *begin to like us*.[8]

For Tohme and others, the *First Sanayeh Garden Art Meeting* felt like an affirmation of social belonging and national reunion. Tohme affirms that her experience countered civic alienation and confirmed the potential for rapprochement with different sectors of the Lebanese public, specifically the less "educated," but perhaps also the less civically minded. On television, she works hard to share the happiness their reception of the exhibition has brought her. Yet she hopes these untrained viewers will "begin to like" the artists she represents. Listening to her hope for affinity, I think of Kajri Jain's discernment of an "impossible viewer" for contemporary Indian calendar art: a viewer both

equipped with skills, such as literacy, to "read" the art's message and yet in need of its paternalistic address to become a better citizen; a viewer both distant from the artist's being and yet drawing near through the act of viewing.[9] This para-doxical "disidentification" indicates the audience's deep embeddedness in the production of the art and its unfolding. In a separate forum, another participant enthused, "It is *as if* this exhibit or demonstration includes a 'ritual cleansing,' through which the space that is this garden is made clean, along with *the souls of those who believe.*"[10] Such certainly uncertain—"as if"—investment in a shared belief and tentatively grasped affinity deserves deeper consideration than usu-ally pursued in the explanation of art's social role and global circulation.

The people visiting exhibitions are on display, too. Following audience-art-work interactions allows an appreciation of how art makes a public problematic, rather than merely the other way around.[11] Social theorists often follow Jacques Lacan's work on the mirror as the site of self-formation, but I find it significant that his model requires a hard surface to concretize reflections.[12] The hesitant negotiations among artists, artworks, and audiences at the 1995 Sanayeh exhibi-tion offer no such hard shape, nor does Lebanon's double-decolonizing, Civil War–fractured history suggest such solidity. I regard the interactions at exhi-bitions as special, interocular moments in which people construct collectivity (and exclusivity) in relation to artworks that prick, rub, and stroke certain sen-sual, sense-making knowledges. Building on studies of vernacular, body, and performance art, which have all had to push disciplinary bounds for thinking about what, when, and where art is, I attend particularly to the forms of social exchange that proliferate with exhibitions and question the senses of (inter)subjectivity and economy they subtend, for which I introduce the term *exhibi-tionary sociality*. Others have emphasized the importance of projections of an audience-to-be for novel art forms, such that interacting with art, grounded as it may be in a social setting, also doubles and extends awareness of audiences who observe audiences who remain virtual but impactful.[13] As Foucault has taught, subjectification occurs even when social relations are imaginary.[14] In short, rather than treating cultural production as a mirror of social conditions, an analysis of exhibitionary sociality reveals the novel social types and continual challenges that attend those who would make claims on a place. Even as people undertake a national reunion, they unite based not on who they are but on who they might become through interactions with art. The questions art exhibitions raise in this chapter are "Who will 'you' be?" and "Believers in what?"

The study of art reception as a ritual encounter is by now well established.[15] In the preceding chapter, I likened art to a beacon blinking out alternate sig-nals for *here* and *there*, building on one of the main elements of Turner's theory

of ritual. In this chapter, I expand my analysis of the art act by systematically examining the cosubstantiation of art objects and audiences in the institution-alization of acts of looking, or what I call an exhibitionary sociality. I contend that this kind of sociality, formed through fantasmic art, has shaped modern Lebanon and keys an understanding of postcolonial modernism. Beacons ad-dress both the present and the distant; they both instantiate and orient. Their inherent ambiguity is generative, particularly when flashing from a liminal zone where sensory skills take on heightened value and can be cultivated as audiences learn to respond to art. Relocating audiences in the original site where cultural creativity becomes art clarifies how art makes a problem of *here* and those who would inhabit it.

The question of art and citizenship long precedes Lebanon's Civil War. Its roots extend tightly from *First Sanayeh Garden* into the Ottoman schooling complex for which the garden was built in 1907. The name Sanayeh (*sana'i'*) is a shortening of Maktab al-Sana'i wa-l-Tijara al-Hamidi (Hamidian School of Industries and Commerce), a title chosen to honor the Ottoman sultan Ab-dülhamid II, under whose authority the development complex eventually re-ceived approval after years of urging by Beirut councilmen, pedagogues, and engineers, and funding from locally raised but controversial taxes. As Jens Hanssen observes, the site and function of the complex embodied locals' politi-cal struggle to shape their city and its relationship to imperial reform, regional trade, international science, the environment, and public health.[16] Conceived by notables as a charitable project to recuperate "underprivileged children," and sited by entrepreneurs west of the city to recuperate a rocky wasteland, it included a public hospital and a teacher-training seminary alongside the industrial school, to become the "largest urban development project in Beirut during Sultan Abdülhamid's reign."[17]

In an act of imperial outclassing, French Mandate authorities and post-WWI industrial notables (some, previously Ottoman councilmen) launched the post-Ottoman era by renaming the Sanayeh educational complex "l'École des arts et métiers" (School of Arts and Crafts) and held a "First Lebanese Salon for Painting and Sculpture," in 1930. Journalist and Phalange militia founder Georges Naccache gave the (re-)inaugural speech, hailing a "post-war generation" of artists, lauding an audience "*who believes* very profoundly, strongly, and with reason, in the future of Lebanese art," and dating the rise of "a first possibility of expression" for Lebanese artists to after the (1860) Civil War (which he blamed on Ottomans).[18] The project of setting compatriots-to-be on a straight path toward citizenship extended to annual collective art shows in the school and sporadic solo shows.[19] Here the beacon of art signaled civilization

and guided its path. However, Naccache's concluding caution that "we are just barely finding ourselves at home" amid this art solidly returns the audience to the scene of analysis. It is the looming, longed-for element that precludes artworks and display intentions from having a clear, secure, singular existence. While the constant return to Sanayeh as a public, educational, and faith-based space spotlights art's part in changing community and citizenry, grasping the fantasmic character of that art demands considering audience feelings, sense-making, and social-network forming, or the *art act*. In the next section, I describe and analyze audience experiences at Mandate-era exhibitions by reading the signatures in a registry for an exhibition at the very same School of Arts and Crafts, held by Moustapha Farrouk in 1933 and prompting his *Souvenir* cartoon (fig. 1.2).

The Liminality of an Exhibition Space

Friday, December 22, 1933, was an unusual day in Beirut: Ramadan had just begun, and Christmas was nigh. Leaving the festive bustle, a vigorous Qabalan al-Riyashi, editor and member of a prominent literary family, headed to the School of Arts and Crafts on the outskirts of town. Perhaps al-Riyashi read in the newspaper that Farrouk's solo exhibition was being held there. If he read in French, he could have seen the announcement in *la Syrie* on the day of the opening the week before.

Amid news stories about the unresolved constitutional crisis, the unfinished annual budget, the high commissioner's frantic consultations, demonstrations in Syria and Palestine, and Franco-German negotiations, and alongside advertisements for polylingual gramophone discs and the "marvelous" astrologer Muhammad Bey al-Falaki, three lines ran: "The painter Farouk will have an exposition of his latest works at the School of Arts and Crafts under the patronage of Mme Charles Debbas and Mme General de Bigault du Granrut. The opening will take place on Friday, December 15 at 3 pm. The exhibition will be open every day from 10 to 12 and from 2 to 6, until Sunday, December 24."[20] If al-Riyashi preferred taking his news in Arabic, it would have been more difficult to learn about Farrouk's exhibition. The Mandate authorities had closed the offices of the major Arabic papers.

The censorship stemmed from what one weekly that had escaped closure demurely discussed on Farrouk's opening day, under the rubric of "rumors": as the constitution was being hammered out, people worried of a coup to ensue, and of divisive plans for sectarian and regional distribution of parliamentary representation.[21] In subsequent issues, the same weekly covered accounts of the public water company's exorbitant prices, annual earnings, and protests

against it. The citizenry had just mobilized for months of partially successful strikes against the tramway and electricity company, and the water company looked to be next. The earlier strikes had galvanized the populace to see infrastructural utilities as "fundamentally public assets and tools for economic improvement."[22] Ongoing strikes targeted the complex that housed both the Ministry of Public Works and the School of Arts and Crafts, the latter ostensibly part of the Mandate plan to reverse local dependence on costly imports.[23] In sum, radiating from the "latest works" of art to which al-Riyashi headed were political turmoil and promise.

After passing the elegant municipal garden (today's "Sanayeh"), al-Riyashi entered two rooms with fifty-five oil and watercolor paintings by Farrouk. Prior to the construction of UNESCO Palace in 1947, public exhibitions occupied classrooms or reception halls. Walls that still bore the traces of their normal usage were crowded with images, and windows were sometimes blocked to allow more pictures (fig. 2.2). Tiny quasi windows dotted the walls with views onto an impossible collection of places: mountain villages, desert palaces, valleys, and the shoreline all lay within centimeters of one another (fig. 2.3). In the dusky atmosphere, al-Riyashi's eyes had to interrelate spatial cues in bizarre, counterintuitive ways. Al-Riyashi's body had to move without making noticeable sound. He may have felt out of place talking to other people encountered there, in jarring contradiction to his daily verbal practices. His sensorium—the sensible and sensual practices that develop from habitual sensory experiences—was interrupted.[24] In other words, he had to adjust to an unusual sense-realm. As noted in the introduction, a sense-realm doubles attention to the senses. It specifies codes for sensorial response to tactile stimuli, which, in turn, orient sense-making. This totalizing grip of "sense" resonates with premodern, Aristotelian thought about the senses, which may be more appropriate to a Greek-reading Levantine culture.[25] It also builds on a long ethical tradition voiced by Muslim scholars, of disciplining the self (*adab al-nafs*) to internalize pedagogical norms (*adab al-dars*).[26] Yet a triangulation of looking at looking, hearing how one hears, registering how one touches and moves, is common to geographically diverse scenes, such as post-Independence India, anti-Vietnam-era America, and neoliberalizing Egypt, suggesting its centrality in social upheaval.[27]

Al-Riyashi's tour of the space affected him profoundly. Before departing, he signed the guest registry, or "golden book" in local parlance, adding not merely his name but a poem. In electrifying language, he describes the artwork on display as a "revelation." He credits "Ibn Farrouk's pen" with transmitting a "miraculous sign" in which he had "come to believe."[28] Several others among the

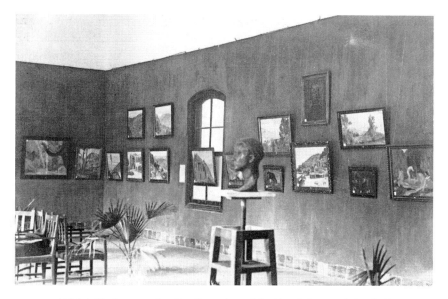

FIG. 2.2 Al-Ma`rid photography, Onsi's section of the *First Lebanese Salon for Painting and Sculpture in Lebanon*, December 1930–January 1931. Dr. Oussama Onsi Collection, Beirut. Courtesy of Lina Onsi Daouk.

more than two hundred signees likewise rapturously testified to finding "the truth of social life" and "the correct path" in that exhibition space. Farrouk's audience, perhaps numbering a thousand, included professionals, educators and students, merchants, aristocrats, clergymen, fellow artists, Mandate officials and aspiring politicians, and friends from Farrouk's humble neighborhood.[29] Outside they ardently debated the organization and character of the nation to emerge from the French Mandate. Here, they testified to finding a new source of belief and commitment.

The interaction documented in Farrouk's golden book provides invaluable insight into the group situations set up by looking at art, between and among viewers.[30] Studying 1970s American performance art, another medium fashioned in a period of social transition, Frazer Ward observes "audience effects"— ways artworks direct, guide, and trigger actions and demand specific skills, references, and risks from audiences—which introduce affective elements that might not otherwise be found or considered in public settings (especially when perceived through a Habermasian, rationalist lens).[31] Focusing on objects rather than viewers, Jain speaks of artworks' "corporeality"—their embodiment of divine presence, as in demand for respect, enfoldment in rituals, and orchestration of bodies and movements—which necessitates a "processual account

FIG. 2.3 Unknown photographer, Moustapha Farrouk's exhibition, December 1932, American University of Beirut, Reading Room, West Hall. Hani Farroukh Collection, Beirut.

of their power," attuned to reproduction (through circulation) and not merely production.[32] Jain suggests that "constituencies of aesthetic response" form around and through the engagements with art.[33] Christopher Pinney coins the term *corpothetics* for this full-bodied project of interacting with "sensorially emboldened objects" to become an ideal person.[34] Art historian Susan Best reminds us that "new 'beginnings' can involve feeling as well as form."[35] Though articulated to grapple with mid-twentieth-century feminist performance art, Best's observation returns fantasmic objects to the foreground for understanding political upsets and anti-conservative movements. In terms of de- and postcolonial art projects, attention to feeling is particularly helpful for unlocking the presupposed hegemony of "Western" art meanings. This chapter combines the concern for transitory, emergent audiences *and* corporeal, demanding objects in an examination of exhibitionary sociality, to appreciate the new, socially constituted ways of feeling specific to double-decolonizing situations, the embodied discourses that shape ideas about national society and subjecthood, and the global economies of aesthetic response. Let us delve now more deeply into the ledgers from Mandate Beirut's liminal exhibition zones.

Many entries in Farrouk's golden book ask us to ponder how exhibitionary sociality's unusualness altered visitors' consciousness. Certain audience effects

can be gleaned by contrasting the conformity and contestation inscribed in guest books of new global art communities with the strict guidelines for art viewing laid out in metropolitan museum manuals in a "pacification attempt."[36] Read, for example, pages 16 and 17, with entries respectively by a law student, a teacher, and a paper merchant:

> —His figures are strong. They speak and bewilder. And his views enchant. Muhammad Fathallah
>
> —Mr. Farrouk's pictures are arrows that pierce the heart. Rashad `Ariss
>
> —My going from one picture to the next is like travelling from one town to another, where new, speaking countenances and enchanting, bewitching views can be seen. `Adil `Itani[37]

Fathallah witnessed the inert become alive. `Ariss felt its dangerous encroach. `Itani found himself transported by it. The typical figural painting makes a window onto objects of view, but here the depicted objects became the viewing subjects. Confronted with articulate pictures, audiences found their eyes activated as the primary means for social interaction. They responded with bewilderment, confusion, and even vertigo. Then they learned. The first thing they learned was that they *should learn* to stand quietly and rigidly, to face an inert object, and to let that object alone—not their companions—demand their attention. Farrouk would later offer a sketch of what such looking looked like (fig. 2.4).

Yet the logistics of viewing in these secluded sense-realms compounded the social disorientation, and Farrouk's idealizing image should be taken as an assertion of a constituency of aesthetic response, to borrow from Jain, rather than as the crystallization of one. The subjunctive mode adopted in many of the golden book entries belies the confidence that a core audience could shape others. Disparate ranks, ethnicities, nationalities, and languages that were carefully segregated in other public spaces crowded together here. (In this sense, art viewing in Mandate Lebanon seems to have differed greatly from the regulated, class-distinguishing viewing imposed by British authorities on imperial audiences in the metropole and colonies.)[38] People of "every place and type" were merged "by an innate inclination towards art," as one commentator later noted.[39] Imagine the effect on Sami `Aradati, a high school student, standing in the packed space of Farrouk's 1933 show when the French high commissioner and the Lebanese president arrived. When he went to write in the registry, `Aradati found his native Arabic mingling with Turkish, English, French, Spanish, and Italian. Still learning his signature, he penned his name and returned a few days later to reinscribe his presence several pages deeper in the guest registry, thereby orthographically rubbing shoulders with *le tout Beyrouth* and beyond.

FIG. 2.4 Moustapha Farrouk, untitled illustration from *Qissat Insan min Lubnan*
[Story of a person from Lebanon] (Beirut: Maktabat al-Ma`arif fi Bayrut, 1954), 58.

Visitors' vocabulary, too, confronted serious constraints and underwent
contortions. What do you say when pictures talk to you? In the registry, many
resorted to formulaic language, penning the cliché "wishing you success" or
"congratulations." Clusters of comments imitated one another—for example,
on page 30, five signees in a row remarked on the "magic" of the event—as if
contributing to a grand, super-social, intertextual chorus. A week after the
opening, one visitor baldly declared, "I participate in the feelings that precede
me in this book and in the songs that will follow."[40] So strong was his convic-
tion that the art provoked a single, all-encompassing response that he could
let voices yet unrecorded stand for his.[41] Altogether, the golden book suggests
a sense of commonality to which people willingly relinquished their voices.

One of several noteworthy audience effects, the sense of commonality that
emerged in Mandate exhibition halls exemplifies *communitas*. Divested of their
normal markers, restrictions, and expectations, participants faced a vagueness
that required them to "think about how they think . . . to feel about how they
feel," in the words of Victor Turner.[42] Significantly, many writing in the golden
book focused on *how* Farrouk's pictures made them see, not what they saw;
moreover, they reflected on what they *might see* were they better viewers. They
demonstrated "special attention" to art.[43] They wrote in a "subjunctive mood,
not about actual facts but suppositions, desires, hypotheses, possibilities" for
reconsidering the moral and conceptual bases of their lives. In such magical,

liminal moments, they embraced what Turner calls "designs for living" that previously would have seemed neither imaginable nor sensible.⁴⁴ As expressed in the guest book, their embrace is both more ambitious and more anxious than the censorious guidebooks Grewal analyzes for British imperial audiences. As much as they strive for and revel in a singularizing voice, they also worry about the audience of their audience, the ones who may not join in their chorus unless persuaded.

Several entries affirm that visitors sought self-reflexivity in exhibition halls:

—Farrouk is a friend from school days, and his innocent artistic pictures from those days intimated that in the future he would become an outstanding man of the arts and of flawless dhawq.⁴⁵ Now here are the days that prove my intuition right. I have become one of Farrouk's admirers and one of the people who take pride in his art and activity. Illegible signature
—Oh, maker of al-fann al-jamil [fine art], be unto us
An example to be talked about and followed!
Raise the banner of art above these foothills
And remain for us throughout the ages and years. Students of Sanayeh School
—We came to the school of dhawq—Mr. Farrouk's exhibition—and we refine ourselves. Wafiq Dabbus on behalf of the students of Zarif School
—Thanks to the brush of the artist, Mr. Farrouk, we grasp *the truth of social life*. Your admirers, Jirjis al-Khuri Maqdisi, Filib Mash`alani, Ibrahim Isbir al-Khuri, and Jurj Mash`alani
—I knew you as a beginner and now I know you as a master. Verily, I believe in *the correct path of growth and evolution*. Illegible signature⁴⁶

Making a final statement after a dizzying visit and before returning to the bustling, challenging world outside the Sanayeh complex, those writing these testimonies pledge to become a new type of person, a schooled believer, one taking pride in the ability to take pride, or in short, "one of the people." Their vague terminology about "social life" and "the correct path" was fleshed out by their sensual experience inside with "enchanting," "magical" art—as other signees called it—and by their knowledge of the effort Farrouk had made in his own schooling to become a professional, worldly artist. Thus, the exhibition's second audience effect provided a sense-realm in which visitors responded reflexively to prompts to use their senses differently and contemplate a new subject-positioning in their rapidly changing world.

Yet, like the beacon that blinks out alternative signals, the "banner" of art raises as much anxiety as it does certainty. Just as many testimonies spoke of

another "people," lurking outside the exhibition space, not yet reformed by its sense-realm and unlikely to enter:

>—With ecstasy, I viewed these captivating pictures (suwar). I congratulate Mr. Farrouk on his art, and from the bottom of my heart, I wish that he gleans from our citizens the encouragement and appreciation which our artists receive from foreigners! . . . Jirjis Muwaffi
>
>—I congratulate you on your courage and even more your talent. I hope that one day you may be understood by a people so indifferent to what is obtained by sacrifice. M. Altounian
>
>—May blindness become less overwhelming so that your masterpieces be sufficiently appreciated. Megid el-Khazen
>
>—Let God invigorate this great artist who has reached the peak of glory despite his existence among a nation that does not properly appreciate him except for a few among them. Dr. Nassib Barbir
>
>—It is the duty of each Lebanese to encourage the [illegible] talent so [illegible] of the famous painter, Mr. Farrouk. G. Nassif [47]

While Muwaffi's ecstasy confirms his complete commitment, "from the bottom of my heart," to supporting Farrouk, it also contrasts with the nonresponse he observes from "our citizens." In this move, Muwaffi abjectly calls his social belonging into question. By implicating the citizenry to which he belongs for undervaluing the art, he renders his experience of ecstasy the experience of a foreigner in his own land. Similarly, Altounian, an architect and friend of Farrouk, carves a curious position for himself both among his people and differentiated from them by his not being "indifferent." While el-Khazen and Barbir (founder of an important hospital) call on an external, divine solution, Nassif insists that the exhibition points to the duty "each Lebanese" has in his or her own capacity. A third audience effect, then, involved viewers in claims on fellow citizens. But who were "the Lebanese" exactly?

Exhibitionary sociality puts citizenship on display and into question. As Jain reminds us with her study of "bazaar art," there is nothing ethnically specific about condemning a dominated population's subjectivity for their treatment of art.[48] The "dynamics of alienation" from art function in socialist top-down and neoliberal economies alike, as Katarzyna Pieprzak eloquently states in her study of contemporary Moroccan art collections.[49] Nor can they be attributed solely to arrogant artists or haughty social classes, as some theorists suggest.[50] Rather, these testimonials from Mandate-era art exhibitions point to the vexed character of art acts (comprising artworks, initial audiences, and audiences of audiences), taken both to represent a populace and to

form it. Visitors' emotions became part of the artworks on display. Together, they produced a measuring stick for assessing one's capacity to contribute to national advance. Did one perceive the "miraculous signs"? Had one become a believer? The emphasis on schooling—in visitors' credentials, in Farrouk's training to become a "man of the arts," and in visitors' lessons in perception and appreciation at the exhibition—puts these assertions in the context of de-liberate social transformation. Their multiplying questions intimate something of the dispersal of subjectivity across a coalescing sense of group as well as an optimistic chronology by which people distance themselves from "popular" ways of interacting with art but then, secured on a common ground of fine art appreciation, participate in the same "popular" practices.[51] While this could be deemed a class-establishing discourse of distinction (irrespective of actual practice), not only is the Mandate Lebanese case bereft of such strong class distinctions but, as we have seen, exhibition-goers made claims on both the perceived upper and lower classes.[52] I examine the classed and gendered sub-jectivities and other exclusions that exhibitionary sociality subtends in the following chapters; first, however, we must confront the novelty and contem-poraneity attributed to audience effects in these liminal spaces.

The 1930s were certainly not the advent of locally run exhibitions, so what was new, and how had it come about? If "new 'beginnings' can involve feeling as well as form," an important feeling to examine is that of newness. In the next section, I relate the perceptions of novelty and contemporaneity to practices of emotion embedded in and bolstered by exhibitions. These practices evolve in relation to the communal and individual sensing of one's sensing that exhibi-tions spotlight. As I show below, they have transitive power. And they account for the desire and fear for popular appeal—met at the *First Sanayeh Garden Art Meeting*—which continually defers an ideal audience to a far-off future.

Beirut Industrial Fair, 1921: Phenomenological Novelty and Emotional Practices

When I began my research by collating artists' press dossiers, I read in period newspapers of a New Year's Day show in 1927 that was "the first in the nation."[53] As I expanded my reading of Mandate-era newspapers in full runs, I found cov-erage of public exhibitions for art going back to 1924, 1921, 1909, and 1906. The earliest coverage I found did not make a claim to firstness. Rather, reviewers related it to a long tradition of displaying craft and invention. Thus, the later novelty claimed by the 1927 exhibition-goers, and by their descendants at the *First Sanayeh Garden* in 1995, was not chronological but phenomenological:

a new practice of emotionally cultivating and evaluating the self through at-
tending to art infused the older practice of displaying art. Emotional practices
imbued exhibitions with an exhibitionary sociality that seemed to interrupt
the flow of daily life and announce a new temporality.

Early twentieth-century visitors to regional exhibitions focused on the pub-
lic acts of officials and notables. Within two decades, new types of art and
ways of viewing it changed this collective focus. It switched from public acts
to art acts. Whereas the former center on public officials' choice to view art,
the latter center on the capacity of art to arrest public officials, to stop them in
their tracks, and to ripple its effect through notable bodies to other potential
audiences. For example, while a reviewer of the Zahle Fair of 1909, Jirjis Baz,
lists participant artists by name (including Habib al-Saghbini and Shukri Mu-
sawwir) and lavishes praise on the artworks displayed, he makes more out of
the attendees—Ottoman officials, mayors, governmental envoys, churchmen,
notables, literati, and "many misses and ladies"—whose mere presence digni-
fies the setting.⁵⁴ He details the location on the Berdawni River, with its gur-
gling water, chirping birds, and rustling leaves joining the melodies of a band
playing each morning, but he does not devote his ample adjectives to bringing
his readers closer to the artwork.⁵⁵ Even Ahmad Taqi al-Din's insistence that
"the [1909] national exhibition in Lebanon is the mirror of its elevation and the
representation of its life" does not expressly activate the senses to incorporate
the displayed material.⁵⁶ Focusing on the benevolent care for and perpetuation
of the country by its Ottoman-appointed public officials, these reviews treat
art as something that matters only because public acts targeting the country's
welfare include it.

The art attracting reviewers' attention soon after the declaration of the
French Mandate plays a different role. It triggers emotions, according to
reviewer after reviewer, affording the grounds for the deliberate and public
feeling, naming, and communicating of certain emotions.⁵⁷ Focusing on art-
works by Khalil Saleeby (Khalil al-Salibi, 1870–1928), Habib Serour (Habib
Srur, 1860–1938), Salim Samra (dates unknown), and Khalil Ghoraieb (Khalil
al-Ghurayyib, 1881–1957) at the Beirut Industrial Fair (Ma'rid Bayrut al-Sina'i)
visited by French high commissioner General Gouraud in 1921, journals repeat-
edly named the physical effect of the artworks on the general and his company:
transfixing their regard (absar) garners admiration (i'jab) and produces hap-
piness (masarra) and satisfaction (irtiyah).⁵⁸ The precision of Jean Debs's (Jan
Dabs, d. 1931) series of sculptural depictions "evoke[d] feelings of sadness and
tenderness in the viewer's heart."⁵⁹ Moreover, several newspapers greeted the
Industrial Fair as a novel realm for exercising the senses. The outlines of the

exhibition buildings' rooftops and assorted balconies provided such a pretty sight that hearts gladdened (lit., "the chests open").[60]

I take as more than merely stylistic the shift of emphasis in exhibition reviews to emotions that seem to stem from art objects. Consider the gorgonizing effect one reporter experienced before Khalil Saleeby's paintings: "Verily, the beautiful pictures drawn by the famous painter Khalil effendi al-Salibi stopped all visitors to the fair in their tracks. All the paintings of persons and views were the subject of people's amazement, as [newspaper] *Lisan al-Hal*—already— noted in its overview of the fair. It is worthy of the press to mention a *watani* (national/local) painter's innovativeness and assiduity, for by doing so it honors a Lebanese genius and the diligence that we want as our work's motto."[61] Scrutiny of the introduction of emotional practices into press accounts of Jean Debs's and Khalil Saleeby's artworks at the 1921 fair can explicate the enfleshment of the *watan*, a term that had been used by classical Arabic poets to mean "birthplace" but that, in the parlance of the various decolonial and anti-Ottoman political movements of the late nineteenth and early twentieth century, started to signify a place of conscious belonging.[62]

How and why did people come to ascribe themselves to a watan when it neither matched their experiences of home nor filled their aspirations for growth? We could assume that some people are simply prone to amazement or that happiness and sadness are inevitable responses to poignant depictions. We could separate out the emotions mentioned in these reviews from the production and promotion of the exhibited architecture, sculptures, and paintings. Doing so, however, would downplay the goals reviewers connected to such emotions. In his discussion of Aboriginal attachments to natural landscapes, anthropologist Fred Myers argues that we better grasp the psychological organization of social beings by looking at emotions as ways of judging relations between individuals or between individuals and circumstances. For the cultural subject, this ethical relation is the space of self-constitution.[63] Mandate-era exhibitions suggest how emotional practices vis-à-vis art could cradle the self-constitution of national subjects (i.e., subjects without a clear political authority subjecting them) and help us understand the fantasmic formation of the watan tentatively named Lebanon.

First, we find that Mandate-era exhibition reviewers named, communicated, learned, and taught others to experience emotions in order to become certain types of people: ones who care about the watan's well-being and can be relied on to perpetuate that well-being, transitively. Here, I build on Monique Scheer's concept of "emotional practices," or the "habits, rituals, and everyday practices that aid us in achieving a certain emotional state."[64] Challenging

the assumption that emotions are things subjects have, Scheer directs us to examine the mediums of emotional self-constitution. In this understanding, emotions are not clearly defined nouns but vaguely pursued verbs to mobilize experiences, label them, share them, and even manage them. The researcher can look for their media in speech, gesture, memory, manipulation of objects, and pursuit of sensorial or proprioceptive practices. Scheer gives the relevant example of standing still, adopting an inward-pointing posture so that one experiences a sense of interiority opposed to one's environment. While pictures at exhibitions "stopped people in their tracks," according to numerous press reviewers, visitors had to hold themselves in this individuating posture to achieve the emotional state of rapture and self-reflexivity. Moreover, they chose to do this in public spaces whose political-geographical titles they applied to their experiences.[65]

The news reports' discussion of being riveted by artworks recalls anthropologist Alfred Gell's influential theory of agential art. To include artworks in sociological analyses of communal events, Gell postulated a kind of social personhood for artworks. Because common techniques of production cannot sufficiently explain their extraordinary form, artworks "fascinate, compel, and entrap as well as delight the spectator."[66] Triggering contemplation of an object's external appearance, an artwork "abducts" audiences to recognizing the power that (they assume) created it.[67] Social consequences must follow. Indeed, the 1933 registry's clamoring testimonies would seem to credit the fascinating artworks with prompting their looking at looking—in other words, creating exhibitionary sociality and demanding that ethical realignments ensue. In sum, agential art is "a system of action intended to change the world rather than encode symbolic propositions about it."[68] The emphasis on change could equip the theory to account for the novelty Mandate-era exhibition-goers experienced, and yet Gell treats art's social agency only as an extension of intending but absent actors whose power viewers deduce by deploying a given logic of causes and effects. By contrast, Mandate-era exhibition-goers found a set of social resources made uniquely available by the artist's technological transformation, or what al-Riyashi had called "Ibn Farrouk's pen." Importantly, they could not know who else would see the paintings, let alone exactly what they might be expected to do with their appreciation of the art. Consequently, the social forms they brought into being at exhibitions were new, unclear, and often confounding, reforming rather than reaffirming the given social order.

Instead of then requiring a solid ground of pre-laid social systems, attending to the emotional practices audiences engaged at exhibitions foregrounds the intersubjectivity of the artwork and audience and the ongoing ethical self- and

communal elaboration that evolve from debate over the artworks' meaning. As discussed in the introduction, the receptive process of taswir deliberately evoked from artworks mental images and, we can now add, emotional responses. This made Mandate exhibitions an important site for arguing over the nature of watan and its civic subjects. Take, for example, how people engaged and wrote about Jean Debs's sculptural figures of famine victims at the 1921 Beirut Industrial Fair. A press reviewer for *al-Mashriq* elaborates on the pain and difficulty that he reasoned creation of these grievous scenes of twisting bodies, rigid corpses, protracted starvation, and helplessness must have entailed for the sculptor (fig. 2.5).[69] Notably, he calls the bronze statuettes "suwar"—literally "molded things," though conventionally translated as "pictures" or "images." He follows this appellation with an appeal to readers to admire the precision of Debs's execution, "which evokes feelings of sadness and tenderness in the viewer's heart."[70] This textual engagement does not relegate the statuettes to representations of past agony. Rather, fantasmically, it hails the ongoing interactive process of taswir, actively molding sense perception into social meaning. It invites the audience to undertake imagining so as to reach an emotional state and achieve cognizance of otherwise removed, banished, or disappeared events with full awareness of the horror, anger, or shame to be aroused.

Debs's suwar rendered the horrific effects of a famine that lasted from 1915 to 1918. Having ended only three years earlier, the devastation and death would be fresh in the experience of many visitors, some of whom may have blamed Beirut's notables for improperly provisioning civilians and for pursuing personal gain.[71] Where were these notables now? The Beirut Industrial Fair joined them together with the widest possible range of residents in the newly created Mandate territory, presenting all with an image of Lebanon as a respectable, loyalty-commanding watan. Yet the watan was exactly what exhibition-goers had to fathom. The territorial creation of Grand-Liban may be described as Mount Lebanon's revenge on Beirut's banking class and Ottoman-allied elite, for it was to avert the possibility of future famine that the city was annexed to the territory. This hotly contested move redistributed coastal assets and political clout to mountain leaders who had never enjoyed such prominence and still were not footing the bill for it.[72] Potentially, mountain viewers who identified as victims of the famine could be angered by Debs's sculptural figures, while urban and coastal viewers could be indignant or incredulous. They could either not believe the suwar or wonder what connection they had to them. Intervening between these options, the journal coverage of Debs's sculptures fixed viewers' regard (even that of those who only envisioned themselves viewing) on their style and handling rather than their topic, thereby introducing achievement in the

FIG. 2.5 Jean Debs, famine sculptures, bronze, sizes unknown, *Beirut Industrial Fair*, April–May 1921. Fouad Debbas Collection, Beirut. Courtesy of Nicholas Sursock Museum, Beirut.

place of abjection or rejection. Cognizant of causes for division, *al-Mashriq*'s reviewer spoke toward a single, undivided "viewer's heart," in an emotional practice of smoothing differences and fostering unification. Inserting art into the process of converging on an exhibition created a horizontal space for former Ottoman officials now acting as "fellow Lebanese" to relate differently to less fortunate neighbors, and vice versa. While hints of dissatisfaction continued to fester, the reporting named and communicated preferred responses toward managing a horizontal feeling of national oneness.[73] This emotional practice modified potentially widespread feelings of resentment and recrimination to propose more productive assemblages of industrious citizens. It gave taswir of *wataniyya*—the feeling of connecting to the watan or being characterized by it—new parameters.

Reviewers of the 1921 Beirut Industrial Fair also looked to art to find moral-aesthetic exemplars before whom audiences could experience conviction, pride, and enthusiasm for participating in a "national event." Some emotional practices, pursued through configurations with others, human, technological, or aesthetic, create assemblages of being, such as conjugal lovers or sports teams.[74] Joint art viewing, even when taken up at a verbal remove via newspaper reviews, promotes the collective attainment of amazement, rapture, and pride

with "performative effects on the constitution of feelings and of the (gendered) self."[75] These emotional practices affect how people may feel and know themselves on maps of space, time, and national identity. The newspaper discussions of Khalil Saleeby's paintings at the Beirut Industrial Fair exemplify the emotional practice of national pride from disparate hearts, but they also show that wataniyya involves an unexpected transnationality.

As the fair's most accomplished artist internationally, Khalil Saleeby provided "amazing," "track-stopping," "unifying" paintings, according to reviewers. Let us revisit the review from *Lisan al-Hal* regarding Saleeby's display at the fair. After explaining that the journalist must examine a "watani painter's innovativeness and assiduity" to provide "our work's motto," *Lisan al-Hal's* editorialist elaborated: "No doubt these paintings will catch the attention of the European foreigner among us and compel him to certainty that among us there is someone who expends his life's sweat for the sake of fine art, including the subject of this essay [Saleeby] who sacrificed his life and spent long years in Europe for the sake of succeeding in this art. It behooves us to mention this art, for in doing so we mention industry: the one is of the other."[76]

Here the act of writing (and reading) about excellent artwork establishes an emotive imagining that extends beyond identification with the watan to empowerment by it. Ghassan Hage calls this extension "we-feeling," for its absorption of conationals' potentials into oneself.[77] It supports the suturing emotional practice of smoothing over differences by fixing on shared focal points. As Hage says, "it makes the experience of national identification more than just imagining."[78] The *Lisan al-Hal* review counsels absorbing Saleeby's industriousness by respecting his artistic success. Thus, this emotional practice of wataniyya imbues the watan with concrete sense. Being watani—or "for the watan"—neither relies on given boundaries of belonging nor rejects foreigners. Rather, it changes the local by setting codes for action, such as industry, self-sacrifice, and commitment.

The emotional practice of looking at others as they are looking is performative. It wedges the experience of exhibitionary sociality, seeing that is made for being seen, into the cultural self. *Lisan al-Hal* opens its review of Saleeby's works with the announcement, "What is great about this fair is how it shows the Lebanese keeping up with the son of the West (*ibn al-gharb*) in the craft of his own two hands."[79] Although the bulk of the more than 1,200 stands under those rooftops housed merchants and manufacturers, one hall featured fine arts of local make.[80] Pitting them against Ottoman mismanagement, a reporter listed "a number of national picturers (*musawwirin wataniyyin*)" whose "cleverness in art" had been "hidden for long generations" but was now on international

display.[81] While *al-Mashriq* reports that the high commissioner of the Mandate, General Gouraud, lingered in awe in the fine arts hall, *Lisan al-Hal's* reporter highlights the appreciative response British representative Sir Herbert Samuel paid to Saleeby's work, as proof that "a son of this country," "a Lebanese national (*watani lubnani*)," could excel in this area.[82] A juried competition culminated in the distribution of prizes to Khalil Saleeby and Youssef Hoyeck (Yusuf al-Huwayyik, 1883–1962) (exceptional mention); Habib Serour, Alfred Bey Sursock (Alfred Sursuq, dates unknown), and Jean Debs (gold medals); and Humsi and Kujaz (silver medals) for their paintings and sculptures.[83] Paradoxically, although the artists had all trained and attained successful careers under Ottoman patronage, *al-Mashriq's* reporter spoke of them as signs of a post-Ottoman condition, provided the audience let their senses make sense appropriately. Ultimately, this way of writing art into the national body, a kind of enfleshment, emphasizes the accountability that makers and viewers hold to a larger entity. Just as the artists become exemplars of national capacity, the viewers become exemplars of national responsibility.

The sensually perceived elements at the 1921 fair prompted hope and anxiety that one should hope for more. If "what is made sensorily perceptible, in the form of a symbol . . . is thereby made accessible to the purposive action of society," as Turner concludes, then artworks in the liminal zone of Mandate exhibitions made sensible differences otherwise unrecognized (even absent) and provided a realm for mobilizing action on these recognitions.[84] However, the press responses to these artworks push us beyond Turner's model to grapple directly with the reliance on sensual sense-making that exhibitionary sociality amplifies.[85]

Sense-Realms of Cultural Peership: Sons of Gharb and Sharq

Reviews from Mandate Lebanon's "first" exhibition highlight the sensual character of the spaces and practices that fostered the production of wataniyya through emotional practices. The Arabic terminology for the kinds of seeing exercised at the fair demand activity and accountability. Dominating reviews is the verb *nazara* (to regard), which, more than *ra'a* (to see, to behold), has a sense of discernment or inspection. *Shahada* (to observe, witness) brings in a highly personal seeing that acknowledges a truth and emphasizes the viewers' conformity to claims the vision makes upon them.[86] The sense of domination by sensual objects appears especially strongly in the reviews' use of verbs that transform the general and his cohort touring the Beirut Industrial Fair into objects of art objects. Incessantly inciting readers to attend so as to experience the

same physical effects, their descriptions detail an anatomy of affect: "His eye was caught (*istalfat nazarahu*) by the beautiful drawings."[87] "Their gazes were arrested (*istawqafat absarahum*) by Khalil Saleeby's beautiful drawings and they marveled at them (*a`jabu biha*)."[88] "He whose eyes fall on (*waqa`a*) [Ghoraieb's paintings] cannot but contemplate the merits of sensual perceptivity (*dhawq*) and be affected (*atta'athur*) by the meaning of truth shown in them."[89]

Sense-realms produce constituencies of aesthetic response whose boundaries need not match political boundaries. To return to the case of the Saleeby paintings, the kinds of looking at looking they generated triggered new sensoria for exhibition-goers (and readers) by uncannily indexing far-off European models and, at once, instantiating local accomplishments of "keeping up," or peership. They cleaved the two conceptual spaces of "West" and "East," "Europe" and "Lebanon," by creating new awareness of the space between them, now both visible and traversable through connections joining them. Intertwining into a singularity the local and the translocal, or here and there, the exhibition's sense-realm thus revealed parity, "or keeping up with" the West as we have seen, but conversely, it also made the "son of the West," transfixed in the art hall, an object of locally produced art. In other words, seeing specific art attentively made the otherwise distant proximate, and the otherwise impalpable present. This shifted the spatial subjectivity of exhibition-goers at a time when national borders imposed by colonial forces were increasingly constricting.

Such sense-making did not let art fit into given Lebanese society (as if that existed). It extended the society into new spatialities and filled them in anew. This effect differed sharply from the human-object relationship common in other local sense-realms. Take the affluential home: Paintings furnished mansions throughout the region, but their viewers did not usually memorialize them as nationalist accomplishments, let alone write articles in the press about the impact they experienced.[90] When the press mentioned paintings, they bolstered patrician standing and confined them to circulation within networks for preestablished conventional reasons. For example, an 1878 advertisement placed by Khalil al-Qurm in *Lisan al-Hal* announces "beautiful, original pictures" (*suwar jamila badi`a*) in various sizes and dealing with a variety of topics ("including ecclesiastical ones"), "for sake of decorating the *sala*."[91] The term *sala*, an Italian loanword for "hall," aggrandizes the large reception room around which central-hall-style homes were newly built at the turn of the nineteenth century.[92] For years to come, paintings would continue to be sold as items to enable hosting in this grandiose room, along with "silver, metal, and aluminum trays; porcelain; glass; tea and coffee cups; and crystal pitchers," as Wadi`a Mikha'il `Urman's ad for his emporium put it.[93] In sum, outside the

sense-realm sponsoring exhibitionary sociality, viewers worked to fit art into the flow of social exchanges that keeps networks of patron-centered generosity and solidarity alive. By contrast, exhibitionary sociality's encouragement of triangulated looking proposed an "in" to which the pictures, compatriots, and far-flung onlookers alike would fit. The space of the exhibition offered an "in" that was solidly "Lebanese" but reached out to other contemporaneous *heres*. Thus, it provided dearly sought clues as to what "being Lebanese" might mean.

Given the colonial context, one might attribute exhibitionary sociality to a hegemonic project of carving out Lebaneseness from the region. Doing so, however, would miss the ambiguity of the beacons exhibition-goers encountered and the taswir they undertook to make meaning of them. While some visitors were likely to be enflamed by Debs's famine suwar, others were prone to reject all signs of *tafarnuj* (becoming French/Western).[94] By 1920, after two years of harsh military control and political prevarications, the French administration was at the end of their credit with any local supporters.[95] For if the recent famine had pitted city merchants against mountain notables, the controversial announcement of "Grand-Liban" in September 1920 had only exacerbated urban protests and rioting, particularly in the popular suqs just outside the city walls.[96] Commerce and production were at the heart of this dissent. Mandate authorities needed the fair to represent the benevolence and brilliance of French economic activity in order to gain social and political credit.[97] Yet the same newspapers that reported on the success in the "fine arts exhibition" complained that, overall, the fair favored French traders at the expense of Beiruti businessmen and undermined the dominance of the indigenous merchant class, which had been a distinguishing feature of the city's economy.[98] The fair's very site seemed intended to supplant local political and social self-representation with French economic benevolence, by requisitioning grounds long favored by uprising populations for their public demonstrations.[99] The Mandate government here heard only the local population's "gratitude at becoming excellent collaborators in exchange and economic rapport between Syria and foreign countries, particularly France," in the words of one Mandate authority.[100] Yet the practices of looking at looking developed in the press to center aesthetic accomplishment and corpothetic engagement exceed and escape this French-made map of the watan and offer a different legend for routes to wataniyya.

So far, I have discussed exhibitions that occurred on specially constructed grounds in commercial centers, during clement weather and daytime hours, as part of mercantile promotion. They presented art collectively, combining styles, media, and makers. They opened under government auspices and

highlighted the responses of executive visitors despite the presence of various others. In that sense, these exhibitions exerted a conservative force, preserving and reinforcing an extant (if precarious) authority structure. The exhibition I will discuss next focused on a single artist whose personal achievement occasioned the gathering. It opened in the dead of winter, after sunset, in a relatively young Beirut suburb characterized by suspicion of the Mandate, if not outright contumacy to it.[101] The more intimate, impromptu setting frames more clearly the art's fantasmic character for organizers and attendees. What the pictures could be, how they might literally inform the audience members, was a matter of how the latter pondered and engaged them in their life projects. For this, pliant emotional practices and sensoria were equally important.

Muslim Scouts Ceremony, 1927: Amazed Witnessing and Rapturous Reeling

Focusing on exhibitionary sociality puts us before people who are existentially unfinished. Although the host of the Muslim Scouts ceremony in 1927, patrician merchant Ahmad Ayyas, epitomized Old Beirut (a city gate and suq were named for his family), he sponsored art viewing far from the walled city, in the pastoral-cum-academic neighborhood of Ras Beirut. In his private mansion, Ayyas received exclusively members or associates of the Muslim Scouts troop, a group dedicated to self- and social transformation. In this setting we now meet Moustapha Farrouk, Shaykh Muhyi al-Din al-Nusuli, and the Muslim Scouts, the brief, clear names of whom suggest fully formed actors. Yet in the light of the fantasmic objects motivating the event, we see each working on becoming something other, something new that could not be fully intuited or named, not even fully seen. Farrouk, the son of a copper whitener, for example, had been famous for his illustration and portraiture work before his trip to Italy, but now holding a "European" diploma, he wondered what being a "national artist" meant. Al-Nusuli, on the other hand, was turning away from education and retail to pursue politics in journalism and vice versa. Bashir Yammut, the young businessman from batin Bayrut whose personal account I review below, left school at age fifteen due to poverty, opened a business by the port, watched the war burn it down, and started investing his time in writing politically engaged poetry about his society's future.[102] All were looking for novel avenues to participate socially and advance themselves. If previous exhibitions had exerted a conservative influence, this one, as a sense-realm accommodating emotional practices of we-feeling and modernizing, became the site of its aspiring participants' personal and national transformation. Their

project, in turn, recast the watan's space and time. To explore that mutual transformation, I turn again to audience evidence before examining the fantasmic objects audiences attended.

"I *witnessed* (*shahidtu*) the celebration on Sunday night for the painter, Mr. Moustapha Farrouk."[103] Opening with this assertion of personal testimony to a compelling truth, Yammut invites readers of his lengthy report for *al-Barq* newspaper to join him in a breathless experience. Textually, he invites *al-Barq*'s readers to file with him, smartly clad in scouting suit and tie, into an ennobled villa's chandelier-lit, triple-arched sala on a biting cold January 1, 1927.[104] He listens in reverence to Abdallah Dabbus intoning verses from the Holy Qur'an that sacralize the space and position participants as believers embarking on a blessed mission. Then his voice joins in reciting the Muslim Scouts' anthem, "We, the Ones Who Have Plunged into Death's Throes and Plumbed Its Tribulations."[105] He hears Scoutmaster al-Nusuli's "pleasurable and beneficial" story of Farrouk's biography and is "captivated" by eminent historian 'Umar Fakhuri's lecture "A Word on Plastic Art [in Islam]," delivered in a "tender, harsh" tone, with "delicious" themes of "progress, renewal, and the avoidance of obsolescence." After Salah Lababidi "leaps up" and delivers an "appetizing" poem, he plays games and dances. Yammut's testimony movingly invokes the voice of beloved urban chansonnier 'Umar al-Z'inni, "burning our necks and making our ears prick up." Al-Z'inni's singing magnifies Yammut's delight and provokes whistles and unending applause. At last, invited to observe Farrouk's paintings for himself, the young scout enters the side room where he "*witnessed* them with amazement and *reeled with rapture and pride.*" As he reenters the sala for tea, Farrouk "jumps up" gratefully and pleads for "the populace to support the youth in their quest for science and arts, that they may serve this East that is in need of everything." Just prior to Yammut's departure to execute this injunction, Wadi' Barbari, a prominent photographer, assembles all for a souvenir snapshot (fig. 2.6).

Yammut details not the artworks he saw but the feelings they provoked, lingering over them in a way that makes readers both aware of his ability to feel and aware that their own feelings can be inventoried. His telling veers between powerful contrasts: al-Nusuli's speech is "enjoyable" and "beneficial"; Fakhuri's lecture is "soft" and "harsh"; the audience is "captivated" but also "insistent" for more. Similarly, his account is animated by verbs that convey a mutuality of agency: a singer "*yahuth*" (goads) his young listeners to care for art, and the artist "goads" the populace to care for the country's youth; the scoutmaster speaks of an artistic "*nahda*" (uprising, renaissance), and the excited attendees and artist alike "*yanhadun*" (rise up) to contribute to this goal. Yammut's naming

FIG. 2.6 Wadiʻ Barbari, photograph, Mr. Farrouk surrounded by his scout brothers on
the night of his honor ceremony, January 1, 1927. Hani Farroukh Collection, Beirut.

practices convey a dynamism carrying the Muslim Scouts through alternat-
ing moments of passivity and activity, surrender and engagement, and leading
them to a unique unification and transformation *en groupe* into art viewers
viewed through the photographer's lens. Intensely action-focused, this account
elaborates a process of deliberately heightening the scouts' sensitivity: as they
listen to the *"ladhidha"* (delicious), *"shayyiqa"* (appetizing), and *"mu'aththira"*
(affecting) speeches and songs, their ears "prick up" (literally "grow thin") and
their necks "burn" (literally "ignite"). Rapturously reeling, the scouts become
objects of the artworks.

In this exhibition sense-realm, scouts learned about using their eyes to ex-
perience sight differently. Had any read the newspaper before heading to the
exhibition, they might have seen a repeated ad for Elie G. Siufi's shop on Tijara
Street.[106] "And he who buys not, looks (*wa-man la yashtari, yatafarraj*)," ran
the slogan cajoling readers to come see the magnificent imports, from stoves
to chandeliers, because at least looking is without cost. Yet in the side room
holding Farrouk's pictures, looking weighs a heavy toll. Costs and questions
abound. By entering the room holding alien novelties made by a "local son"—as

speakers called Farrouk—the scout troop could extend the artist's aesthetic accomplishment into their own projects for the future. Here, amazement and respect are feelings scouts achieve rather than simply undergo. The feeling of welcoming art is a horizontal emotional practice the men consummate in common once they have each embodied a new interiority from silently facing Farrouk's spatially displacing, temporally disrupting, yet eminently watani artworks. Fittingly, after all the various leaping, jumping, and reeling recounted, Yammut's final sentence brings the story full circle as the "picturer," Wadiʿ Barbari, makes a picture of the picture viewers (fig. 2.6).

Suwar introduced a key element into the (self-)educating processes afoot with scouting. Education historian Nadya Sbaiti argues that the proliferating field of private, state-sponsored, missionary, and secular schools offered a key battlefield for Mandate-era struggles over language, history, geography, gender, and citizenship, as well as the professionalization of education.[107] Many members of the troop had pursued formal education in the various public Ottoman or private confessional schools since childhood and were well versed in this practice of receiving knowledge by stilling their bodies and sharpening their ears and minds.[108] Yammut's account references contesting educational projects, both pivoting on new interest in taswir. First, the intellectual and pro-independence activist ʿUmar Fakhuri spoke on the role of figurative picturing (taswir al-anasiy) for contemporary Islam, drawing from Shaykh Muhammad ʿAbdu's philosophy.[109] Locating the rejection of suwar in the preliterate period, Fakhuri calls for a new ijtihad (independent judgment), tying the scouts' choice to accept the taswir to a choice to be contemporary. The site of reference for this contemporaneity is the Cairene Azhari school of Muslim jurisprudence. The scouts' commitment to suwar compelled them to think beyond conventions in place.

Yet if Yammut found Fakhuri's remarks "deliciously" reassuring for their theme of "progress," he benefited most from al-Nusuli's contrasting two further types of education, both of which challenged the scouts to break from the commonplace. The one features a "self-styled shaykh" who taught Farrouk during his teen years at the prestigious Ottoman College. Aware of his pupil's notoriety for sketching portraits of his classmates and teachers, the shaykh forbade him from "touching a pencil during his class."[110] Al-Nusuli explained that the shaykh feared that if a picture of him were made, he, the subject of a soulless image, "would be stuffed into hellfire because—taswir (picturing) according to him—is prohibited (haram)."[111] The student Farrouk had to break from the practice of accepting religious judgment merely on grounds of pedagogical hierarchy. His commitment to suwar compelled him to think beyond local customs.

The second educational experience al-Nusuli narrated comprises Farrouk's passage from "a middle-class" house, through sundry private, public, and foreign schools, to Italy for art training, and back. Although al-Nusuli had his own trouble with foreign professors when he studied business at AUB and faced expulsion for his "watani" politics, he foregrounds foreign educational opportunities from which Farrouk benefited.[112] Briefly, to stand before them as a professional, credentialed artist, Farrouk had to build on his training at the hands of locally well-established artists like Habib Serour and Gertrude Lind by getting himself to Italy, survive there with the help of a Maronite Lebanese *monseigneur*, secure entrance to the Royal Academy by enrolling in various night schools, and then, with degree in hand, decline his mentor's tempting offer to join his studio and enjoy guaranteed income, so as to honor his "national duty." The tale al-Nusuli wove from Farrouk's life centers self-reliance and distrust of gentry and clergy but also sectarian cooperation and Arab brotherhood. It is driven by such "great ambition" that it compresses time, achieving three years' worth of training in one. It involves "sacred magic," whereby art descends on Farrouk like a prophesy whose inspiration produces *ayat* (divine signs) in his suwar. This reference to divine manifestation through fine art indicates an ontology I elaborate on in chapter 4. Here, I want to emphasize that at each juncture, when common practice or given place fail to support Farrouk, it is suwar that inspire new thinking, reaching across economic, geographical, and sectarian boundaries. Financing his trip, harnessing allies, and motivating unconventional moves, suwar drive the peculiar educational path Farrouk carves out, intervening physically and metaphysically. Al-Nusuli's tale culminates with a bodily contribution, returning Farrouk to "his country" to plant "the tree of art" and nourish it with the "light of his eyes and the sap of his heart."

This story of suwar, together with Yammut's excited recounting, allows us to recenter the relationship between art and audiences. It avoids reifying "objects" and "subjects," as if they were somehow separate conditions. Rather, it reveals their imbrication and emergence as phases in the art act. On the one hand, suwar are socially susceptible. Al-Nusuli concluded that the shaykh's obstruction of Farrouk's innate art not only was motivated by fear but resulted in ignorance, lack of art, and lack of progress: fearing the flames of hell, Farrouk would have stopped art altogether had not the flames of war engulfed the Ottoman school and all Ottoman authorities. Encouragement from Italian professors, conversely, ramified Farrouk and his watan's capacities for art. Emphasis on *capacities*. Although they were the guests of honor, Farrouk's pictures could not assume a secure position in the ceremony. To the contrary, the organizers consistently reminded invitees that the pictures almost had not arrived and

could yet be thwarted by the unnamed "self-styled shaykh" lurking outside, or perhaps deep within each of the audience members. The ambiguity of the audience surfaces in encounters with fantasmic objects.

On the other hand, art viewing (or better, art acting) changes the viewers categorically. We have already seen at the 1921 fair that the esteem paintings earned from foreign-origin Mandate officials rendered "sons of the country" peers of the West. The Arabic term for this transitional, transitive project is *tathqif*, from the Arabic root *th-q-f*, which means to straighten or train (e.g., a seedling). Applied to humans only from the mid-nineteenth century, this process of cultivating (or culturing) aims for increased social benefit.[113] Because tathqif is transitive, the *muthaqqaf*, or object of training (used for "intellectual," pl. *muthaqqafin*), can in turn become an agent of the process, a *muthaqqif*, which is also the Arabic word for "teacher" or "public intellectual." Intellectuals are literally those whose training has freed them from logical deviations and also charged them with "straightening" others' bent or misguided ways.[114] As M'hammed Sabour notes, prior to this period, the holders of knowledge were known as *mu`allimin* (learned ones), and they operated in the field of religious law, primarily.[115] The shifting Arabic terminology traces a movement both in content and in constituency.[116] At the Muslim Scouts' exhibition, the project of tathqif passes from the hands of the governing elite (aristocracy and clergy) to those whom al-Nusuli grandly calls "the mighty class that births heroes and legends and retains in its deepest core its distinguishing features and customs, by which I mean the middle class (*al-tabaqa al-wusta*)."[117]

Lest we take this term, *middle class*, as self-evident, we should relate it to the unfinished beings inviting, unfolding, and encompassing suwar at Mandate-era exhibitions. In her history of the region, Toufoul Abou-Hodeib argues that prior to the mid-nineteenth century, no population could be defined as middle class, for people's differential access to skills and means did not distinguish them into blocks with secure access to wealth.[118] Only with the expansion of the bureaucratic sector and the development of professionalized services did education more reliably parlay into inheritable material resources. The new intellectuals hewed less closely to religious concerns (if such a realm can be carved out) and reached their position by training their perceptual capacities and provoking that tathqif in others.[119] Their middle-classness had constantly to be enacted by signaling modernity, Keith Watenpaugh argues, organizing them "less around objective standards of wealth than upon the desire of those in the putative middle class to distinguish themselves from the lower classes."[120] What the suwar calling to the scouts in Ayyas's mansion add to our understanding of this desire is that it, too, was learned and consolidated through taswir. If Marx's

potato-eating peasants lacked windows to enliven their class consciousness, these strapping young men exceeded in windows onto otherwise unseeable worlds.[121] To the degree that Farrouk's New Year's Day audience named and demonstrated their cognizance of suwar's demands and effects, they became subjects anew before these objects, colloquially called *muthaqqafīn* and recognized as having assets for improving their social lot and that of their country.[122]

The Muslim Scouts regularly sought challenges in the wilderness, and in his speech Farrouk mentioned scouting as the source of his perseverance in pursuing training in Italy under adverse conditions.[123] In Ayyas's elegant villa, however, it was not territory that would put them to the trial but subjectivity— their responsibility for creating the conditions in which they could understand themselves. When each scout entered the room showing Farrouk's suwar— novel, obscure, sensual entities that had to be personally grasped, he had to ask himself how he would look. Prior to entering the viewing room, the actors in Yammut's telling were either "the scouts" (*al-kashshafun*), named speakers or entertainers such as al-Nusuli, Fakhuri, and al-Z'inni, or disembodied anatomical parts in the plural, such as ears and necks. When a final song from the Fulayfil Brothers "goads" the "youth" to emulate the guest of honor's activity, Yammut uses *shubban*, a collective noun in which *shabb* (young male) multiplies not into a profusion of beings but into one entity unified in activity and intention: "the young (males)." At exactly this point, the scouts signify their metamorphosis from a simple assembly to intentional viewers defined by a visually informed interiority arising in relation to viewing Farrouk's suwar. The artist's return to plant his seedling cast the "soil" of his country into question: Would it support art? The question interrogated the national and natural resources as well as the role of each person who encountered art.

According to al-Nusuli, the assembled scouts' response determined what they would make of themselves, their troop, and their nation: "We do not celebrate [Farrouk] on this night, in the home of one of our generous nobles, for the sake of his brilliance and ingenuity alone, but also because we *behold* (*narqubu*) in him and all who follow his tracks the *dawn of a new era*, one we have not previously known and whose bounty and blessings we *do not yet* appreciate." Time itself is at stake in the scouts' response to art. Neither a past nor a future in art belong to this country unless individuals like Farrouk tie it to progressive time's ongoing march. The artist's repatriation promised to reshape his watan's spatiotemporal condition. Invoking a synecdochical clock, al-Nusuli compels his listeners to locate themselves in ambitiously teleological time.

Beirut was a "polyrhythmic city."[124] The four faces of its monumental clock tower announced time *"alaturka"* (Turkish) on two sides and *"alafranga"*

(Frankish/French) on the other two.[125] Their leader's enunciation of a "new year" decisively dissociates the Muslim Scouts' celebration from the Islamic *hijri* calendar, even as the Qur'anic recitations heralded a sacred space.[126] According to Greenwich mean time, the celebration started Saturday evening, as reported in the Scouts' magazine, *al-Kashshaf*, but according to Islamic time, it started on Sunday, as stated by Yammut in *al-Barq*. Usually people blended time reckonings with the aid of an "Arab-Frankish *ruznama* (time organizer)," which could equally benefit all communities at once, as an advertisement in *Lisan al-Hal* put it.[127] Now the scoutmaster called on them to distinguish times. Ottoman time became associated with a backward clergy, an education, and a past. Suwar were key to that distinction. The responsibility for keeping the past in the past and opening space for the future lay in the hands of the listeners who would view Farrouk's suwar.

Just before commanding them to enter in pairs the small room displaying paintings, al-Nusuli's voice boomed: "Moustapha is *here*! Verily, he came carrying to us the bounties of his art. Will we cling to old, intolerant, antiquated traditions or will *we walk with life* and invigorate the art that we honor tonight in this evening of *the first day of the new year*? This is what the [coming] days will reveal to us. As for us, *the sons of the new era, we encourage art and draw it to ourselves*."[128]

In al-Nusuli's speech, delivered on the veritable threshold of encountering art, the artist Moustapha is *here*, and that is a challenge, temporally and spatially, to the *where* of Beirut and the *what*, too. The quality of *here* would be revealed neither in European colonial presence nor in autochthonous persistence but by the listening scouts' choices for how to interact with art. The speech rhetorically produces the past of no-art in "old, intolerant, antiquated traditions" and the participatory present of art as a potential "walk with life"—the very image of mu'asara—for an event that launched the Muslim Scouts as a public (and published) component of Beirut's hadatha—that is, no-longer-Ottoman modernity. If, in this modern-Islamic time-space, some "do not yet appreciate" art, al-Nusuli has inventoried emotional practices to cultivate their feelings and produce tathqif. The command to enter the viewing room, "*afwajan afwajan* (patrol by patrol)," in true scout fashion, is a command to behold suwar, to witness beacons of hadatha and mu'asara, to flesh out their meaning by seeing progressively and responsibly (in an act of taswir that conforms ones viewing to that of viewers elsewhere), and to manifest amazement and respect.[129] The observant bodies of the viewing scouts made *mushahada*, the project of witnessing or seeing responsibly, a personally obliging component of both citizenship (*muwatana*) and modernity. Their

watchful stance ruptured the modern present (hadatha) from the past.[130] They were now joined not only as believers in Islam and dutiful citizens of a nation but also as members of modernity. Yammut's dutiful response, a published personal testimonial, affirms (or seeks to) the welcoming of this "new" art by the all-male audience as an essential part of their new life. It also conveys the possibility for readers to join in his emotional accomplishment. Art makes *here* appear, but fantasmically so, ever requiring input and interpretation from audiences.

Looking forward to the new era, the Muslim Scouts looked over their shoulders out of fear that their troop members would make bad compatriots, and they called a nation into imagining through suspicions of difference. Would some scouts avert their gaze? They would become like the trepidatious shaykh. Would they focus on the appurtenances of their patron's well-appointed abode? They would limit their sight to signs of bounty and ignore the artist's tribulations to make other sights, new-era sights, available. Would they sustain their gaze at the art long enough to invigorate it and be invigorated? A new era confronts tradition in the shifting of a pair of eyes. This close reading of Bashir Yammut's published testimony joins recent discussions of the "Qur'anically tuned body" and its attendant "ethical sensibilities."[131] Yet it also calls for more attention to the materiality that gives the Qur'an a new, post-Ottoman corpothetics. Thus far, I have avoided detailing the actual works for their materiality, thereby paralleling contemporary art writing. In the next section, I connect specific artworks to visitors' descriptions of the exhibition space to explore these sense-realms in which participants innovated performative codes to alter their civic subjectivity.

West Hall, 1929: "Here I See Differently"

The space where art and audience meet provokes "unsettled and unsettling encounters," Myers notes.[132] On May 18, 1929, readers of several Beirut dailies found, mingling with their news of constitutional amendments and upcoming parliamentary elections, the announcement of Moustapha Farrouk's second solo exhibition, an event that would prove unsettled and unsettling. The show was scheduled to commence the following day at 2:00 p.m. in the Green Room of West Hall, at AUB's Student Center, and run for three days, opening from 9:00 a.m. to noon and 2:00 p.m. to 6:00 p.m. each day. Subsequent editions offered glowing reviews of the show's content and reception, which up to four thousand people, or nearly 10 percent of the literate population, may have attended.[133] Despite this logistical success, the press coverage reveals a wrinkle.

First, there is an incessant firstness. Art simply cannot get off the ground here. In its advance announcement, *al-Bashir* heralded the show as "perhaps the first of its kind in this country" and churlishly attributed the show's planning to Reverend Laurens Seelye, an American missionary and professor of philosophy who also directed the student center.[134] This is the same *al-Bashir* that had enthusiastically reported on the art at the 1921 Beirut Fair.[135] Hitched to the cutting emphasis on firstness and foreignness is a poignant sense of not-hereness. The pictures have also already been seen by Italian audiences, the announcement adds. Anyone touring the exhibition here would follow in their footsteps. By the same token, Kamal al-Naffi, who reported on his visit in *al-Ahwal*, mocked the friend who invited him to AUB's campus for forgetting they were not "in Venice, or one of the superior cities of the West."[136] Meanwhile, the mononymous Nassib launched his review in the new monthly *al-Badia* with an interview in which Farrouk enumerates the reasons for the arts' "local infertility": untrained teachers, corrupt patrons, and absent museums.[137] Each expression of hope that "the sons of the country" would "engage" (*yuqbilun 'ala*) the exhibition yoked locals to external exemplars and diminished the former.

A vague or violent connection to elsewhere inhered to the very structure of Green Room exhibition. In his memoirs, Farrouk recounts that after being convinced by Mustafa Khalidi to take up Seelye's offer of a solo exhibition at the American University, "I prepared all that my exhibition needed to be successful, in terms of organization and order, *along the lines* (*'ala ghirar*) of [exhibitions] found in the West."[138] By setting his exhibition to a standard deliberately borrowed from elsewhere, Farrouk introduced a performative code. Linguistic anthropologists developed the theory of performance to analyze communication that occurs through verbally scripted events such as plays, stories, and jokes; visual events may also be scripted in terms of fitting genres, deploying references, and restricting responses (as seen in the 1933 golden book entries). Carefully regimented in its structure, support material, tropes, and display, Farrouk's exhibition made demands on its attendees, of which they were aware. Richard Bauman argues, "Performance thus calls forth *special attention to and heightened awareness of* the act of expression and gives license to the audience to regard the act of expression and the performer with *special intensity*."[139] The act of engagement journals ardently hoped audiences would undertake—from the verb *aqbala 'ala*—involves giving one's attention or devoting oneself to an object. It involves more agency than to be merely present. It is the same term Scoutmaster al-Nusuli had used in his injunction to the would-be "sons of the new era." Heeding a performance, an audience attunes itself to a style of execution, what Farrouk called "the lines," on the assumption that it counts above

and beyond any referential content conveyed.[140] Mandate audiences addition-
ally reveal that the visual, verbal, and sensual codes transform mere spectators
into code-producing performers, or muthaqqafin, as well.

Crossing the threshold to the Green Room exhibition in May 1929, Tanyus
Ni`ma entered a space local and distant at once. Like local shopkeepers, Far-
rouk received visitors for morning and afternoon hours. Like Roman gallerists,
he described his wares in a palm-sized, neatly covered and illustrated "pro-
gram" (printed at his own expense) arranged on a central table that was covered
with a checkered cloth and a vase of flowers. Like many visitors, Ni`ma did not
know Farrouk personally and was drawn to the show by curiosity about and
stupefaction at the artist as much as the artwork.[141] To increase accessibility,
organizers placed the exhibition in a semipublic building and opened it for
four days, the third coinciding with `Id al-Adha.[142] Instead of reciting Qur'anic
verses or troop anthems to enter this space, Ni`ma read the program's list of
"the country's scholars and politicians, Lebanese views . . . aspects of our folk
life, and landscapes" and connected their names to the neatly numbered and
framed views hanging on densely packed walls.

In his memoirs, Farrouk asserts that his aim at his second exhibition was "to
awaken in the audience a sense of the beauty to be found in this nation (watan),
for the sake of enjoining them to love the nation and marvel at it, because *art
is vast and diverse.*"[143] He therefore sought to give his pictures a *"wijha qaw-
miyya"* (national, ethnic goal). Program numbers one and two were portraits,
majestically mounted on easels. One showed Farrouk's mentor Habib Serour;
the second represented Daniel Bliss, who ran AUB the year Farrouk was born.
Looking up and down, back and forth, over and again in this field of multina-
tional fealty, Ni`ma told those reading his testimonial in *Lisan al-Hal* that he
cogitated on "the condition in our country" and saw "with his own two eyes the
loss of hope": this distance between art-friendly Europe and "our country where
the promotion of fine arts of all varieties is weak, very weak." Turning to leave
after a regrettably short half hour, Ni`ma registered his name along with those
of "the leaders of the people, school principals, doctors, pharmacists, journalists,
scholars, and students," in a gilded book Farrouk had laid out by the programs.[144]

For Mandate citizens, art viewing instantiated *and* produced social dif-
ference. It was unsettled and unsettling. This social intervention differs from
that recognized by sociologists Pierre Bourdieu and Alain Darbel at European
museums.[145] Signing the guest registry was the penultimate act confirming
that Ni`ma had joined the ranks of "those who care" and "those who take a
sharp look": muthaqqafin. These descriptors, from Ni`ma's published review,
merge action (looking sharply) with emotional practice (caring). They arise

from an Arabic text in Farrouk's printed program that detailed the process of social differentiation that contact with Farrouk's suwar could initiate, for willing audiences. The author, Yusef Ghoussoub (Yusuf Ghussub, 1898–1967), an established translator who in his spare time sculpted models of Baalbek and Petra out of gypsum, penned the text after encountering Farrouk sketching in a Parisian museum.[146] In it he instructs readers to enhance suwar's fantasmic effect by approaching them mindfully and then withdrawing several paces. Doing so discloses "the strange simplicity" by which a few adjacent colors become, at a remove, waters flowing, sails flapping, and breezes blowing. Ghoussoub avers that the carefully looking "viewer (al-mutafarrij) remains delighted and bewildered, as if he is saying to himself, 'I saw this scene myself, but here I see it differently.'"[147]

This unsettling awareness of material becoming is the beginning of tathqif. It may trigger unsettled viewers' awareness of self-becoming: seeing oneself seeing the familiar differently. This transformation in awareness of how one sees proceeds because (in another important difference from the Muslim Scouts' show) the scenes selected for display, with their "wijha qawmiyya," are familiar to Beirut-based audiences. Ghoussoub explains that Farrouk does not "simply copy nature faithfully and prettily" but, "expressing his heartfelt feelings and his soul's sentiments," brings "life and poetry" to the image. Thus, he produces "symbolic pictures" that indicate feelings and alert the viewer to his own thinking, "so that the viewer sees in them not only the apparent picture (al-sura al-zahira) but many others, as if the single picture multiplies and ramifies until it completely fills the viewer's mind and heart." In other words, by sharing the fantasms produced by viewing his world attentively, Farrouk makes his audience aware of their own imaginative capacity. In the instant of recognizing oneself seeing differently, the audience of the art performance becomes a performer of its new self.

The Effect of Tathqif on Space and Time

The tathqif process starts with what painters select from their surroundings to be transformed by their brushes; it ends with people familiar with the views represented realizing that they are now attending to them differently. While Farrouk's observation to the Muslim Scouts that "art is vast" insisted that universal art (al-fann al-ʿalami) can be found anywhere, it also alerted his audience to their watani duty to be sensually activated enough to respond to it. The insistence that universal art can have a watani—local and nationalist—effect means it can be agential on that stage. Nationalism and universalism, two goals

that are usually analytically separated in art history, intertwine intimately at Mandate-era exhibitions. Farrouk and his admirers came into existence with one another, each fertilizing the other: How could art be vast without artists' and audiences' cultivation of it here? The flip side to this question, interrogating the here, asked how cultivated people, muthaqqafin, could exist without finding the nation in art. We may have become inclined to reify national boundaries by stopping at them, but the experiences of peership, contemporaneity, and abjection at these foundational exhibitions reveal with crystalline clarity how art connected outward even as it composed the nation. Seeing one's surroundings differently becomes seeing oneself differently. The "Venice" that had seemed so far might lie within their reach, at the exact juncture of their contact with pictures and their viewing of themselves. However one entered—friend, acquaintance, or mere passerby—one should exit changed and ready to make a change. In other words, viewers would become both "local," sons of the country, and "unlocal," changing the country to connect it to other climes.

The project of tathqif does not end with the exhibition, just as the fantasmic art act does not consist only of the artwork. Signing the guest registry, Ni'ma committed himself to an inscription list recording a new type of people: sensually engaged sons of the country. Two weeks later, he published his review in *Lisan al-Hal*, to dispatch the "ethical and national (watani) duty" that the artwork he deemed a material "index of the deep, captivating *pictures present in the psyche* of this youth-artist" had dictated to him: "For having never seen their likes on the pages of this dear newspaper, [I write] in the hopes that [my remarks] will be ratified in the souls of *those who care about the issue* such that they take the initiative to activate, encourage, and honor *all men of arts, literature, and learning*, may they do so by God."[148]

In his program text, Ghoussoub deems heightening viewers' attention to the fantasmic effect of tathqif important in a "country whose people are oblivious to art and have turned their attention to other things of pleasure and value." In the presence of universal art, abjection looms large. As we have seen already, Ni'ma, al-Naffi, and Nassib foregrounded this abjection in their subsequent reviews. Yet, just as each essay verges on abjection, its writer pivots to a rousing appeal to "people of perceptual sensitivity and wealth," the "educated youth," "men of tomorrow," or "lovers of learning and arts," to encourage the artist.[149]

The moment of art viewing pierces abjection's cloud with a new temporality. Like al-Nusuli's pre-articulation of the Muslim Scouts' feelings about art, each essay deploys a curious temporal twist, speaking of this exhibition as if it were still in the future or prognosticating from it what the future will be. Reaching between analepsis and prolepsis, the essayists thus muse on what the exhibition

may mean for Lebanon's future: *"Perhaps in the future* [the populace] will value art and give it its due. In so doing they *would show* that they are a living people truly striving for freedom. *Let it be* that [Farrouk] brings art to the sons of the country, that it *may recuperate* something of its past glory and that lovers of learning and arts *may proliferate* among them, *so it will be* a cradle for true civilization *as it many times was*."[150]

Cracking time from its march, the art reviews continue the tathqif process by putting readers in the position of having to resolve the spatiotemporal ambiguity art reveals fantasmically. That resolution may come from their adding to the pictures they view their reflection on themselves as active citizens in their nascent political settings. The existence of artwork disproves the categorical abjection of the country, but it also increases the obligation to counter impending abjection by reworking one's own capacities. These testimonies make ambiguity the heart of exhibitionary sociality, and all the more susceptible to the impact of fantasmic objects in its midst.

Coda

On December 2, 1996, I was working at Agial Gallery, helping the owner, Saleh Barakat, scan publications into a computer program to produce a history of modern Arab art. A couple entered, both in unconventionally loose, black clothing and blunt haircuts: a sculptor and an art organizer, Saleh told me without offering their names. When he later called them Marwan and Christine, I realized they were two of the trio that launched Ashkal Alwan at Sanayeh the year before. Saleh's presentation of me as "an American who speaks Arabic and is studying the infrastructure for art here" swiftly ushered us into a conversation about the problems of sponsorship and public spaces for art. Sighing heavily, Christine detailed how difficult it was to get permission to use Sanayeh Garden and leave the work in it. "How can that even be a problem?" we all demanded. Eventually she found that putting a plaque with the name of each sponsor on each artwork allowed it to remain. Looking back, I remember finding the pair very edgy. Still, their command to audiences echoed a protracted history extending to the very founding of the nation through a representational act, a warp out of time and space.

Not only do critical writings on the 1995 *First Sanayeh Garden Art Meeting* exclude audience, but they also blithely assume a history of art abjection as the unproblematic mirror of "Lebanese culture."[151] Bringing the audience into the analysis, I propose that 1995 fits in line with long-established practices of exhibitionary sociality, which makes place a problem through art and generates

types of people/subject positioning: the muthaqqa/if and the *muwatin* (citizen) most prominently. Ensconced within a sense-realm that highlights their sensuality, the formal qualities of the artwork trigger a liminal time warp. They become a beacon flashing out alternate signals for past/present and here/there; the same could be said of local culinary and language practices.

Although they were never significantly subsidized by Mandate authorities, art exhibitions' pace so sped up during the Mandate that by 1932 Beirut witnessed six in just ten months. Contending that it was a duty to encourage attendance, newspapers developed ways of informing their readers about the events. With increasing frequency in the 1930s, articles appeared in the Beiruti press that called attention to the behavior of the Beiruti public at exhibitions. Numerous artworks came to address the issue of audience directly, as the next chapter will explore further. Some, like *Souvenir de l'exposition Farrouk 1933–34,* reminded audiences what would happen if they did not regularly attend exhibitions and pursue tathqif. The focus of that image on the nude is the subject of the next chapter. Subsequent chapters also explore the interaction between audience members and landscape paintings and portraits, to trace the production of the civic subject through fantasms.

Notes

1. The *Alam El Sabah* [Morning world] television show transcript appears in translation in "Ashkal Alwan's Sanayeh Project," ArteEast, accessed May 15, 2020, 19, 22, https://arteeast.org/wp-content/uploads/2015/04/Sanayeh-Project .pdf?x83780 (emphasis added).

2. E.g., Gasparian, "First Sanayeh"; Mouarbes, "Horizons,"19–22; Sadek, "Place"; Toukan, *Politics of Art,* 125–27; Wilson-Goldie, "Digging," 88–89.

3. This approach followed a then-standard exhibition scholarship (based in Euro-American experience) focused on the artwork displayed or the curatorial and institutional intentions they bespoke. E.g., Duncan, *Civilizing Rituals;* Greenberg et al., *Thinking about Exhibitions;* Karp and Lavine, *Exhibiting Cultures.* Recent work by Frazer Ward, Kajri Jain, Adair Rounthwaite, and Tapati Guha-Thakurta, among others, challenges that approach and informs this chapter.

4. I refer to Susan Best's overview of three kinds of aesthetics, usually summarized as the aesthetics of reception, production, and the work itself. Best, *Feeling,* 15.

5. Christine Tohme Hadjian, "Thugrat li-Asdiqa'" [Loopholes for Friends], in Ashkal Alwan, *Liqa' al-Sana'i' al-Tashkili al-Awwal* [The First Sanayeh Plastic Arts Meeting], exhibition catalog (Beirut: Self-published, 1995), 1.

6. Gasparian, "First Sanayeh," 180–81.

7. "Ashkal Alwan's Sanayeh Project," see note 1, 22.

8. "Sanayeh Project," 22–23 (emphasis added).

9. Jain, *Gods*, 286, 290.

10. Jama'at Ma Fawq al-Banafsaj, *"al-Hadiqa wa-al-Bara'a al-Manshuda"* [The Garden and the Innocence We Seek], in *Dakhaltu Marra al-Junaina* (Once I entered Little Heaven]), photocopied newsletter, 1995, AA. Translation by Walid Sadek in Gasparian, "First Sanayeh," 182 (emphasis added).

11. Steinberg, "Plight," 3.

12. Lacan, "Mirror Stage." One example of its application to Lebanon occurs in Sofian Merabet's analysis of homosexual Beirut's social dynamics. Merabet, *Queer Beirut*, 142–44.

13. See Ward, *Bystanders*, 12–13, 74.

14. Foucault, "Panopticism," in *Discipline*, 195–230.

15. E.g., Duncan, *Civilizing Rituals*; Karp and Lavine; Myers, *Painting Culture*, chap. 9; Jackson, *Professing Performance*; Shannon, "Emotion."

16. Hanssen, *Fin de Siècle Beirut*, 247–51.

17. Hanssen, 250.

18. Georges Naccache, *"Le premier salon libanais,"* in *Premier salon libanais de peinture et de sculpture, 1930–1931* (Beirut: l'Ecole des Arts et Métiers, 1930), exhibition catalog, 2, GZ.

19. The pace subsequently seems to have slackened, but more research is needed. By 1936, collective shows had moved to the new Parliament building.

20. *"En Ville," la Syrie*, December 15, 1933, 2.

21. *"Inqilab Lubnani"* [Lebanese coup], *al-'Asifa*, December 15, 1933, 4.

22. Jackson, "Mandatory Development," 1.

23. Jawaba, *"al-Ma'rid al-Sina'i al-Watani"* [The national industrial exhibition], *al-Ma'rid*, June 28, 1931, 4. Cf. Eddé, *"Mobilisation"*; Himadeh, *Economic Organization*, 416.

24. On the sensorium and social changes to it, see Hirschkind, *Ethical Soundscape*, 28–29 and chap. 3.

25. The literature on Aristotle and Arabic-Islamic philosophy is vast and can tend toward East-West polarization. For a useful account of the complex readings of Arab-Islamic philosophers, see Bashier, *Barzakh*; *Islamic Philosophy*.

26. Moosa, "Muslim Ethics?," 238–39.

27. For discussion of triangulated audiences, see, respectively, Jain, *Gods*, 274, 292, 298; Ward, *Bystanders*, 67–68; Best, *Feeling*; Hirschkind, *Ethical Soundscape*.

28. *Exposition du Peintre Farrouk, 15–24 December, 1933*, 37 (hereafter cited as Registry), archived material, HF.

29. Usually only a minority of visitors actually sign registries. Newspapers consistently reported attendances in the thousands for other early 1930s shows.

30. Ward critiques the presumed homogeneity of the performance viewer, noting that no single viewer encapsulates all others and that the presence of multiple

viewers potentially changes the experience each has. Ward, *Bystanders*, 12. Listening to transcriptions of audience discussions, Rounthwaite argues that the affective aspects of voice influenced how audience members related to the artwork. Rounthwaite, *Asking*, 22–26.

31. Ward, *Bystanders*, 8.

32. Jain, *Gods*, 18–19.

33. Jain, 183.

34. Pinney, "Indian Work," 359. Elias argues for applying Pinney's theory of corpothetics to medieval, Sufic Arabic understanding of beauty. Elias, *Aisha's Cushion*, 19, 174.

35. Best, *Feeling*, 3.

36. Grewal, *Home and Harem*, 112.

37. When registry signatures appear in Arabic, I transliterate them. Those in Roman letters, I simply transcribe.

38. Grewal, 108; Guha-Thakurta, "Museum in the Colony," 78.

39. Ahmad Mukhtar ʿAdada, *"Athr Jawla fi ʿAlam al-Fann"* [Effect of a tour in the world of art], *al-Makshuf*, June 6, 1938, 6. This emphasis on merging should not preclude attention to agonistic contestation, too. See chap. 3.

40. Registry, 26.

41. A like-minded analysis of the interweaving of voices appears in Rounthwaite, *Asking*, 184–86.

42. Turner, *Anthropology of Performance*, 102.

43. Bauman, *Verbal Art*, 11. Duncan relates this "special quality of attention" to decorum. Duncan, *Civilizing Rituals*, 10. However, the Mandate's unstable social setting and unsecured governing authority highlight a more passionate involvement extending even beyond the "museum effect" that surrounds institutionalized art conscribed to a narrowly optical sensorium. On the museum effect, see Alpers, "Way of Seeing," 25–27.

44. Turner, *Anthropology of Performance*, 101, 24.

45. I take up this concept in chap. 3.

46. Registry, 3, 11, 20, 21, 20 (emphasis added), respectively.

47. Registry, 29, 7, 25, 6, 26, respectively.

48. Jain, *Gods*, 299–301.

49. Pieprzak, "Moroccan Art Museums," 431.

50. I here pit my findings against the thrust of Grant Kester's model of "orthopaedic aesthetics," which addresses art with the assumption of a "flawed viewer" whose perspective and subjectivity the art will correct. Kester, *Conversation Pieces*, 88. The political-economic upheavals of the Mandate Lebanese situation simply leave no scope for such a presumptive analysis.

51. Ward, *Bystanders*, 75; Jain, *Gods*, 182. Notably, Jain argues that disparagers of bazaar art attributed fetishistic use of it to "ineducable classes." Jain, *Gods*, 286, 292. As we shall see, educability amounted to a civic virtue for Mandate Lebanese

and was not restricted a priori to one social group, though it mattered most to those with mobility on their horizon. See also chap. 5.

52. On class in Mandate Lebanon, see Traboulsi, *Modern Lebanon*; Khater, *Inventing Home*; Abou-Hodeib, *Taste for Home*. I call some of these assertions about class into question in the following chapters.

53. *Al-Kashshaf* 1, no. 1 (January 1927); *al-Ma`rid*, January 6, 1927, 2.

54. Jirjis Baz, "*Ma`rid Zahla*" [Zahle Exhibition], *al-Hasna'* 1, no. 3 (August 20, 1909): 92–94, p. 92.

55. For the same reason, I cannot analyze the artwork. For a sense of the art that could have been on view prior to the Mandate, see Shaw, *Ottoman Painting*.

56. Ahmad Taqi al-Din, "*Ma`ariduna al-Wataniyya*" [Our national exhibitions], *al-Mashriq* 9 (November 1909): 830–35, p. 831.

57. I rely on the discussion in *Lisan al-Hal*, an independent and widely read daily run by Ramiz Khalil Sarkis, which I have cross-checked with *al-Mashriq*, *al-Bashir*, and *al-Ma`rid*. While not representing views of Muslim-affiliated editors, these sources do represent a variety of stances on the Mandate, from strong alliance (*al-Mashriq*) to begrudging but still demanding acceptance (*Lisan al-Hal*).

58. E.g., "*Fi al-Ma`rid*" [At the fair], *Lisan al-Hal*, May 4, 1921, 2. The Arabic *ma`rid*, deriving from the root `*a-r-d*—to display, to expose—literally means "place of display" and can translate to display room, exhibition, exposition, or fair. I use *fair* here to envelop the French title for the event, "*Foire de Beyrouth*." Note that "absar" is technically plural, referring to each viewer's practice of regarding the art.

59. Luis Shaikhu, "*Lamha Ta'rikhiyya `an Ma`rid Bayrut*" [A historical glimpse of the Beirut Exhibition]," *al-Mashriq* 21 (July 1921): 528–35, p. 529 (emphasis added).

60. Shaikhu, see note 59.

61. "*Fi al-Ma`rid, Rusum al-Salibi*" [At the exhibition: Saleeby's pictures], *Lisan al-Hal*, May 17, 1921, 2.

62. Other scholars have called attention to *watan*'s slippage in meaning from classical Arabic poetry to modern nationalism. They de-emphasize the territorial component of the term and foreground temporal aspects associated with youth and adult estrangement. E.g., Noorani, "Estrangement"; Antrim, "*Watan*."

63. Myers, *Pintupi Country*, 108–9, 104.

64. Scheer, "Kind of Practice," 209.

65. Although the industrial fair under discussion was titled as being located "in Beirut," many writers spoke of it as a *watani* affair.

66. Gell, *Art and Agency*, 23.

67. Abduction is "a case of synthetic inference where we find some very curious circumstances which could be explained by the supposition that it was a case of some general rule, and thereupon [we] adopt that supposition." Gell, 14.

68. Gell, 3.

69. Shaikhu, see note 59, 530.

70. Shaikhu.

71. See Tanielian, *Charity of War*, chap. 3. One book published already in 1919 by Father Antun Yammin lambasted Beirut's lenders as "traders in souls" for imposing exorbitant interest rates during the war. Traboulsi, *Modern Lebanon*, 72.

72. This is May Davie's main argument in *Beyrouth*, 58. Cf. Traboulsi, *Modern Lebanon*, 81, 85.

73. See also my discussion of Khalil Ghoraieb's famine nudes in chap. 3.

74. Scheer, "Kind of Practice," 209.

75. Scheer, 210.

76. *Lisan al-Hal*, see note 61.

77. Hage, "Hating Israel," 66–67.

78. Hage, 66.

79. *Lisan al-Hal*, see note 61. The text reads ambiguously. Because of the print ligature, *gharb* might be read *maghrib* (i.e., Morocco), but the latter makes less sense in this context. The first part of the sentence refers to Saleeby as "*ibn hadhi al-balad*" [son of this land, or native son]. Having discussed the ligature with period scholars Fawwaz Traboulsi and Hala Bizri, I am fairly confident of this reading.

80. "*Qasr Bayrut: fi al-Maʻrid*" [Beirut hall: At the fair], *al-Maʻrid*, May 15, 1921, 6.

81. Shaikhu, see note 59, 530.

82. "*Hafla fi al-Maʻrid*" [Party at the fair], *Lisan al-Hal*, May 30, 1921, 2.

83. "*Jawaʼiz al-Maʻrid*" [Prizes for the fair], *Lisan al-Hal*, June 30, 1921, 2. I have no information for the artists listed as "Humsi" and "Kujaz."

84. Turner, *Ritual Process*, 25.

85. Elsewhere Turner explains that "the anthropologist treats the sensory pole of meaning as a constant, and the social and ideological aspects as variables whose interdependencies he seeks to explain." Turner, *Forest of Symbols*, 36–37. For an anthropological defense of downplaying artworks' aesthetic properties, see Marcus and Myers, "Traffic in Art and Culture," 40n43.

86. Cf. Crary, *Techniques*, 5–6. I distinguish the Arabic terms for vision and perception on the basis of my ethnographic experience. For a contemporary discussion of vision types in an Islamic ontology, see Mittermaier, *Dream That Matter*, chap. 3. Necipoğlu also cautions against positing a "monolithic Islamic way of seeing" and insists on the "aesthetic, emotional, and cognitive dimensions of seeing" in medieval Sufic thought. Necipoğlu, "Scrutinizing Gaze," 53.

87. "*Iftitah al-Maʻrid*" [The opening of the fair], *Lisan al-Hal*, May 2, 1921, 2.

88. *Lisan al-Hal*, see note 61.

89. "*Fi Maʻrid al-Manshiyya*" [At the Fair], *Lisan al-Hal*, May 18, 1921, 2.

90. On the custom of decorating salons with paintings, see Piaget, *Murs et plafonds*; Barakat, "Place of the Image." Cf. Weber, "Imagined Worlds."

91. Khalil al-Qurm, "*Iʻlan*" [Announcement], *Lisan al-Hal*, October 29, 1883, 4.

92. On this floor plan, see Mollenhauer, "Central Hall House," 294; Michel

Davie, *La maison beyrouthine*; Sehnaoui, *l'Occidentalisation*, 96–97; Khater, *Inventing Home*, 116–23.

93. ʿUrman's advertisement ran in various forms in *Lisan al-Hal* throughout April 1929.

94. Abou-Hodeib, *Taste for Home*, 44.

95. Eddé, *Beyrouth*, 106.

96. May Davie, *Beyrouth*, 61.

97. Letter of Ministry of Foreign Affairs to Robert de Caix, E-Levant 1918–1921, ss. Syrie-Liban-Cilicie, #80, January 5, 1921, CDAN.

98. Eddé, *Beyrouth*, 178. The fair consolidated two practices: (1) Lebanese merchants from across the territory congregating on Beirut; (2) Lebanese merchants representing French firms on their terms. Increasing competition and channeling money out, neither practice brought new capital to the city or aided a local economy. See Davie, *Beyrouth*, 66; Traboulsi, *Modern Lebanon*, 58, 88.

99. Cf. Khalaf, *Heart of Beirut*, 171.

100. Letter of Chief of the Public Instruction Service to the Military Administrator in Lebanon, Nantes, *Instruction Publique* 2, no. 903 (March 23, 1920), CDAN.

101. Ras Beirut saw several protests. Davie, *Beyrouth*, 48, 61.

102. Yammut, "Bashir Yammut," 52.

103. Bashir Yammut, *"Fi Takrim Hafla al-Ustadh Farrukh"* [At the celebration of Mr. Farrukh], *al-Barq*, January 6, 1927, 3 (emphasis added). All quotes in the following section are from this source unless otherwise noted.

104. Farrouk's posthumously published reminiscences give the date of the exhibition as January 1, 1928. Farrukh, *Tariqi*, 148. I date it to 1927 on the basis of contemporaneous reporting in *al-Kashshaf*, *al-Maʿrid*, and *al-Barq*.

105. Yammut's chronology differs slightly from that recounted by *al-Kashshaf*.

106. See, for example, *al-Maʿrid*, January 1, 1927, 8.

107. Sbaiti, "Lessons in History."

108. Farrouk attended Tahir Tannir's privately run Dar al-Salam, then the Khairy brothers' Dar al-ʿUlum (1909–12), followed by the Italian School (1913–14), and finally the Ottoman College (Maktab Sultani) in Zuqaq al-Blatt (1915–18?). ʿUmar Farrukh, "Rijl wa-Fann," 16–19. Al-Nusuli attended les Frères School in Gemmayze, Dar al-ʿUlum, and the American University of Beirut. *"Al Nusuli"* [The Nusuli family], accessed October 17, 2017, https://www.yabeyrouth.com/8009--2النصولي-آل. After leaving school, Yammut continued his education by reading, attending mosque lessons, and frequenting literary soirées. Yammut, "Bashir Yammut," 53, 55.

109. ʿUmar Fakhuri, *"Kalima fi al-Taswir"* [A word on picturing], *al-Kashshaf* 1, no. 1 (January 1927): 34–36. His term, "anasiy" comes from the word for human and means "human beings, people." It is no longer in use. Wehr, *Dictionary*, 31. Fakhuri specifies that because Islam ended worship of earthly forms, taswir is no longer problematic as it was in the early period. ʿUmar Fakhuri, 36. Cf. Ramadan, "Best Tools."

110. Muhyi al-Din al-Nusuli, *"Khutbat al-Ra'is"* [The president's speech], *al-Kashshaf* 1, no. 1 (January 1927): 52–56, p. 53.

111. Al-Nusuli (original emphasis). Cf. Farrukh, *Tariqi*, 33. I elaborate on this incident in chap. 5. Subsequent references to al-Nusuli's speech are from this source.

112. Al-Nusuli was selected to give a vetted welcoming speech at Gouraud's campus visit in January 1920, but he extemporized an appeal to the Mandate authorities to support "a free and united Syria." Anderson, *American University of Beirut*, 128. According to university administrative correspondence, the American consul demanded the student be expelled to enhance Franco-American relations, and the faculty supported this, but Gouraud had him reinstated. Letter from Edward Nickoley to Howard Bliss, January 14, 1920, Edward F. Nickoley Collection: Acting President 1920–1923, box 1, file 6, AUB. Al-Nusuli earned his MA in 1921 from the School of Arts and Sciences. Alumni Association—Beirut, "Directory of Alumni, 1870–1952" (Beirut: American University of Beirut, 1953), 132, 136.

113. The history of the term parallels that of *tarbiya*, which until the same period had been used primarily for crops and chattel. Sbaiti, "Lessons in History," 140–41. For a similar history of *culture*, see Williams, *Keywords*, 49–50.

114. Balqaziz, *"'Ata' al-Muthaqqif,"* 206–8.

115. Sabour, *Ontology*, 45–51.

116. The literature on Arab intellectuals as a colonial (and decolonial) constituency has recently proliferated. For studies of the figure in late-Ottoman, Mandate-era Levantine communities, see Dakhli, "Autumn of the Nahda"; Hamzah, *Arab Intellectual*; Khuri-Makdisi, *Eastern Mediterranean*; Philipp, "Participation and Critique"; Keith Watenpaugh, *Being Modern*.

117. Al-Nusuli, see note 110, 52.

118. Abou-Hodeib, *Taste for Home*, 15–16, 19, 21, 33. Cf. Watenpaugh, *Being Modern*, 17–19.

119. Hamzah, "From `ilm to *Sihafa*"; Watenpaugh, 41–46.

120. Watenpaugh, 20–21. Khater makes a similar argument for returnee migrants to the Lebanese mountain, emphasizing the experience of displacement and oddity re-placement engendered. Khater, *Inventing Home*, 18. Both authors caution that the new social formations did not cancel out political and cultural continuities.

121. Marx, *Eighteenth Brumaire*, 123–24.

122. Similarly, the reporter for *al-Kashshaf* writes, "The Scoutmaster declared the door to the small room displaying our genius's pictures open and asked the guests to enter in groups. They did so, and their amazement at the delicate sensitivities, elevated imagination, and skillful craftsmanship in the artworks they saw was great, very great." *"Takrim al-Ustadh Farrukh"* [Honoring Mr. Farrukh], *al-Kashshaf* 1, no. 1 (January 1927): 50–51, p. 51.

123. Farrukh, *Tariqi*, 61.

124. Ogle, *Transformation*, 123. Until at least 1917, the Ottoman Rumi calendar, which uses the Julian calendar months but starts from the first year of the Hijri

calendar (AD 622), had been used for civic events. Greenwich mean time, onto
which the Gregorian calendar could be pegged for regional standardization, en-
tered with the French troops in 1917 but remained one of many temporal reckon-
ings. Ogle, 126.

125. Hanssen, *Fin de Siècle Beirut*, 246. Two of the faces had Roman numerals and
two Arabic; the hands spun at different rates. The difference between reckonings
was significant. The alaturka day began at sunset and measured twelve "seasonal
hours" until sunrise, at which point it reset at 0 (or 12). Cf. Wishnitzer, "'Our
Time,'" 48. Organizing life around prayers that foreground the celestial bodies, Is-
lamic time patterns gender, work, and sacrality in "an altogether different pattern"
from time alafranga, which mechanizes time and individuates space. El Guindi,
By Noon Prayer, 128, 93.

126. In fact, a letter between scouts Mahmud `Itani and Omar Onsi indicates
that in 1923, the Muslim Scouts were planning to launch their publication, *al-
Kashshaf*, on the Islamic New Year (then August 14, 1923). Letter from Mahmud
`Itani to Omar Onsi, April 11, 1923, archived material, May Onsi Collection, Beirut.
However, in 1927, the Islamic New Year came on July 1.

127. *Lisan al-Hal*, December 23, 1878, 4.

128. *Al-Nusuli*, see note 110, 52 (emphasis added).

129. *Al-Kashshaf*, see note 122, 51.

130. For an elaboration of a related understanding of *hadatha*, see El-Ariss, *Trials*,
3, 11.

131. Hirschkind, *Ethical Soundscape*, 76, 182; George, "Ethics," 593.

132. Myers, *Painting Culture*, 20.

133. The attendance figure comes from "*al-Ustadh Farrukh fi Ma`ridihi*" [Mr. Far-
rouk in his exhibition], *al-Ma`rid*, June 9, 1929, 4. On literacy numbers, see Thomp-
son, *Colonial Citizens*, 213.

134. "*Rusum al-Ustadh Farrukh*" [Mr. Farrouk's drawings], *al-Bashir*, May 18, 1929,
3. Farrukh reports that the idea for an exhibition came to Seelye after their mutual
friend Mustafa Khalidi brought him to the artist's atelier. Farrukh, *Tariqi*, 151–53.

135. See chap. 1. The claim also appears in "*Musawwir Nabigha*" [Genius-
picturer], *al-Lata'if al-Musawwara*, June 24, 1929, 14.

136. Kamal al-Naffi, "*Ma`rid Farrukh fi al-Jami`a al-Amirkiyya*" [Farrukh's exhibi-
tion at the American University], *al-Ahwal*, June 1, 1929, HF.

137. Nassib, "*al-Fannan al-Mashhur: al-Ustadh Mustafa Farrouk*" [The famous
artist: Mr. Moustapha Farrouk], *al-Badiya* 1, no. 9–10 (May–June 1929): 621–24, p.
622–23.

138. Farrukh, *Tariqi*, 153. All quotes in the following section attributed to Far-
rouk and descriptions of the exhibition are from this source unless otherwise
noted.

139. Bauman, *Verbal Art*, 11 (emphasis added).

140. Bauman.

141. Tanyus Niʿma, *"Nisf Saʿa fi Maʿrid Farrukh"* [Half an hour at Farrouk's exhibition], *Lisan al-Hal*, May 24, 1929, 2. I have not learned Niʿma's biography. Unless otherwise noted, subsequent quotations describing the 1929 exhibition refer to this source.

142. The artist had personally invited an unusually ample swath of local society and also alerted the dailies.

143. Farrukh, *Tariqi*, 153 (emphasis added).

144. I have not located the registry Farrouk reports having kept.

145. Bourdieu and Darbel, *Love of Art*.

146. Ghoussoub studied with Jean Debs and contributed to a Baalbek maquette that appeared at the 1931 Colonial Exhibition, Paris. *"Hayakil Tadmur Kama Kanat"* [The temples of Tadmur as they were], *al-Maʿrid*, January 22, 1931, 8. He seems to be the same person who graduated from the Saint Joseph University in Beirut and was appointed translator by the Mandate authorities in September 1921. See *Bulletin Mensuel des Actes Administratifs du Haut-commissariat*, 2nd year, 307, Per 6, CDAN. On meeting Farrouk, see Yusuf Ghussub, *"al-Fannan Farrukh"* [The artist Farrouk], *al-Thaqafa al-Wataniyya* 6, no. 3 (March 15, 1957): 3. Ghoussoub published exhibitions criticism in the 1930s Arabic press. A calling card in Farrouk's possessions indicates that he later served as president of the Lebanese Artists Association, HF.

147. Yusuf Ghussub, *"al-Sayyid Mustafa Farrukh"* [Mr. Mustafa Farrukh], in *M. Farrouk, Artiste Peintre* (Beirut: self-printed, 1929), exhibition catalog, HF (emphasis added). Subsequent quotations from Ghussub refer to this source.

148. Niʿma, see note 141 (emphasis added).

149. I give "perceptual sensitivity" for *dhawq*. See chap. 3.

150. Al-Naffi, see note 136.

151. Walid Sadek provides a partial but important exception with "Place at Last," which, focusing on Ziad Abillama's installation and survey interaction at *First Sanayeh Garden*, insists that in such quizzical art, the artist replaces the quest for pure, cleansed, symbolic representation with the technique of "dragging back . . . into public space . . . the instability of physical matter." This inherent lability, Sadek argues, amounts to "beckoning others not only to see [the artist] but *to reckon themselves being in the act of seeing him."* Addressing the garden's inaccessibility as a national portrait, Sadek concludes that art making must be "a search for how one is seen by others" rather than "a search for an inventoried past." Sadek, "Place at Last," 38, 41 (emphasis added). Yet while Sadek theoretically reckons the audiences' acts of taswir, he does not seek to examine them.

3

NUDES

The Citizen as Fantasm

SWARMS OF MILITARY police officers blocked the entrance to the elegant pal-
ace housing Beirut's municipal museum. The patron's name on the invitation
had escaped my companion's memory, but, astounded by the crowds, Lina as-
sured me it must be "someone big." I was doubly grateful for Lina's company:
the wife of an industrial magnate, she would secure my entrance even if I had
not rated an invitation. Scanning the crowd, I saw several established artists but
none from the *First Sanayeh Garden Art Meeting*. I noted old and young peo-
ple, though more of the former, and counted a few veils, because it was January
2003, with sectarian polarization on many minds. As wafts of citrusy perfumes
tickled our noses, Lina murmured approvingly: "High-quality people." I asked
what she meant. "People of *dhawq*," she explained, using a word that borders on
"taste," and smilingly added that their presence reassured her that the artwork
we were to see was well appreciated. The artist, Moustapha Farrouk, whose
work Lina owned, was "finally officially coming of age." Her excitement infused
me. In unison we mounted the grand staircase, brushing up against Chanel suits,
sleeveless gowns, and leopard-skin pants. We halted conspicuously each time
Lina greeted an acquaintance. One, the Brazilian wife of another industrialist,
confessed that her drawing teacher had never heard of Farrouk. This infuriated
Lina. Was such a lapse not unforgiveable for people who should "realize their
wataniyya (nationality)"? The antidote according to Lina was a book called *One
Hundred Years of Lebanese Art*, by Richard Chahine.[1] I objected to it as factually
limited, but Lina asserted that the author's dhawq and large personal collection
compensated. She snappily clinched her argument: "At least it will show that
there *is* such a thing as Lebanese art."

"Lebanese art" is what my hostess had come to see. She found it most compellingly that night in a hall titled *Au Liban, 1927–1929* (In Lebanon, 1927–1929). The neat white walls sported smallish drawings and paintings in gilded or polished wooden frames, each labeled in French and Arabic on index-card-sized printouts. At the entryway, one pairing of works mesmerized us: An oil-painting on the left presented a naked girl crouching in a pool, hiding her genitalia but riveted in her spot. To its right, a transparency pasted to the wall the slumping anti-nude couple from *Souvenir de l'exposition Farrouk 1933–34* (Souvenir of Farrouk's Exhibition 1933–34), which we met in chapter 1 (fig. 3.1). Wall text in Arabic and French explained the pairing but left my companion wondering how Farrouk made art locally:

> *Crépuscule after Paul Chabas* 1929–1931, oil on canvas, 66 × 52 cm, Hani Farrukh Collection. One of the copies Farrouk made at the Luxembourg Museum. At that time Paul Chabas (1869–1937) was renowned for his paintings of nudes, and Farrouk used to visit his studio during his stay in Paris.... *Crépuscule* was one of the fifty-five pictures included in Farrouk's exhibition at the *Ecole des Arts et Métiers* [Sanayeh School of Arts and Crafts] in 1933. *In an era when exhibition walls did not show pictures of naked women*, this painting provoked at the very least confusion and bewilderment among the audience, if not stupefaction. We find the echo of this event in a caricature by Farrouk titled *Souvenir de l'exposition 1933–34*, made after the exhibition's end. Two astonished visitors regard a picture of a naked woman standing in a river, and it is the [*Au*] *Crépuscule* picture by Paul Chabas. The picture recalls *a satirical picture* by Omar Onsi from the early 1950s about the same mentality. It shows a group of women thronged around a painting of bathers, gawking at it in surprise and curiosity.[2]

"How did Farrouk ever get a life model, if no one accepted his art here?" Lina queried aloud. Given her recent exchange with the Brazilian drawing student, I knew that at stake in this question was the very existence of "Lebanese art," meaning not craft or aesthetically pleasing works made in Lebanon but something called in Arabic al-fann al-jamil, "fine art." It is the contemporary synonym for what Farrouk had called "universal art" (al-fann al-ʿalami) at his 1927 show: professional art that could have been made anywhere but that found a home here. The nude hanging before us, made in homage to the artist's French mentor, exemplified this art. The life model is key to making al-fann al-jamil, so how can there be professional art in Lebanon? Inhabiting the peasants' very position, as onlookers of a locally made import, we pivoted between enacting and condemning local society.

FIG. 3.1 Installation view from *Moustapha Farrouk*, Nicholas Sursock Museum, Beirut, January 8, 2003. Author's photograph.

Together we stared at the shivering girl's struggle to cover her body while the gray tide nips at her shins. I found myself asking not how Farrouk made such a picture but how the girl figure had stayed so long in that spot. Why did she not leave the pool? The more I looked, the more I saw that she was held in place by the cartoon peasants; their unwavering stare demanded her presence. I seemed to see an icy line winding its way from the base of the cartoon, an imperious hatching that extended from the peasants' feet, across the protective brass railing, seeping up the wall, over the frame, and into the water, filling it with a bone-chilling cold. The installation made it clear that these peasants were the cause of the girl's discomfort and paralysis. Instead of being enlightened by her rendition in an idealizing Beaux-Arts style, they cast it in deep shadow.

The sketch suggests a truth hinted at in much local discourse about culture, a truth whose origins we explored in chapter 2: it is not the absence of resources but the presence of undeserving audiences that keeps art from flourishing in Lebanon. In the retrospective's wall text, artist and audience vied for existence. Each bears inherent, mutually exclusive qualities. Either the artist or the local will prevail; the two cannot coexist. Open Chahine's *One Hundred Years*, as Lina suggested, and you will find condemnations of the "Lebanese people" for lacking art appreciation.[3] Or read another devoted to the "human figure in Lebanese painting": it describes the contribution of one turn-of-the-century painter as "turning from religious art and devoting himself almost exclusively to the study of the Nudes [whereby] he . . . prepared the intellectual climate for the blossoming of the expression of personal feelings."[4] This single-handed feat befits an artist-hero, but it also bespeaks an audience climate like an environmental threat, massive, vague, and looming over all activity. The swarms of military police outside (protecting, it turned out, Prime Minister Rafic Hariri) ordained the municipal museum space as one of national prominence. The sketch and canvas pairing questioned visitors' propriety in that space and reminded them that they, too, would be evaluated for their response. How unlike the peasants could we be sure we were? And overall, would Lebanese dhawq suffice to support art?

I read the icy compositional line winding across the surface of Farrouk's *Souvenir* and wending its way, with textual reinforcement, into the gallery titled *Au Liban*, into our conversation and even our potential self-regard, as a reminder that, for fantasmic objects, there is no inherent boundary between art and audience. More precisely, Mandate-era nudes leave no scope for the representational boundary conventionally assumed to divide an audience looking at art from artwork referring to entities the audience may decode or interpret. The continued prevalence and circulation of works about audiences of nudes inverts the question Lina and I asked at the retrospective in 2003: not how Farrouk made this nude without local models but how Farrouk's nudes modeled and molded local society. In the previous chapter, I established that Mandate-era exhibitions were liminal, ritual zones that generated a new, exhibitionary, sociality. One hallmark of the ritual is the presence of an elder who transmits behavioral rules and secures compliance with them.[5] In this chapter, I show that artworks themselves took on the social function of elders in such settings, animating the role of "social agents" that Alfred Gell posits.[6] Continuing the project of looking at looking, this chapter examines the fantasmic formation of concepts and their believers in tandem. I argue that

nudes instantiated professionalism as a form of organization and paved the way for nationalist claims associated with al-fann al-jamil. Audiences called them "*mutajarridat,*" "*'ariyat,*" and "*zalitat*"—respectively, "denuded," "naked," and "uncovered" (the feminine ending referring ambiguously to the suwar or their subject—for most were female). They worked to relate the nudes to their daily lives and aspirational futures through projects of nudism and Islamic reformism.

Beyond such (re)organizational practice, however, the sensorial experience of nudes grounded a philosophy of dhawq in the constitution of the civic subject. I explore how the nude genre transmitted rules of body- and nation work and provoked viewers to learn the quality of dhawq that Lina espied and the wall text bemoaned as an absence. Looking at nudes contributed to endeavors for developing personal resources and mobilized demands for professional institutions while producing an understanding of art and self. Finding themselves riveted in the spot of *Souvenir*'s peasants, people who were constructed as objects of suwar learned a new medium of self-cultivation, dhawq, which made the selective ability to incorporate external stimuli an important asset for citizens of modern Lebanon-to-be. Holding that nudes from Mandate Beirut constitute art acts involving audiences in ongoing, reflexive production and circulation, I show dhawq to be a capacity for fathoming entities and fashioning relationships that was newly developed as part of the re-attunement of civic subjects to their modern nation-state. With their curious self-absenting, compositions based on nudes provoked in Mandate Lebanon conceptual and sensual aporia that audiences worked to fill and, in so doing, fleshed themselves out.

We miss this social process of the art act entirely when we see conspicuously imported nudes through the lens of metropolitan referents. Studying the nude outside its home setting opens the genre to its many lives, enhancing our overall appreciation of art's fantasmic character. Likewise, close attention to the experience of colonized, non-European encounters with nudes affords the opportunity to revise and expand dominant models of social reproduction. The emergence of Mandate-era art criticism deploying *dhawq* to discuss novel nudes debunks the naturalization of the term and reframes politics of the Mandate period. By focusing on a deliberately imported art genre and its public displays, I foreground the interactive, fantasmic aspect of forming a citizenry, or wataniyya. I show dhawq to be a watani project, undertaken by specific people to enhance their personal assets, civic contributions, and nationalizing claims. Refusing to reduce wataniyya to state-sponsored practices, I argue that

this emotional practice became especially important for city dwellers prior to the concretization of a state.[7]

The History and Experience of Dhawq

While Moustapha Farrouk was deciding which canvases to hang in the Green Room at the American University of Beirut for his debut public exhibition in 1929, the writer Muhammad Ahmad al-Ghamrawi was working out an essay containing a lengthy disquisition on the capacity of dhawq to determine the origin and quality of artistic material.[8] He noted that people were relying more and more on the term but that few had explored its nature. Often translated as "taste," dhawq may strike us as a natural, ahistorical, even apolitical capacity. It struck al-Ghamrawi not as natural but as confusing and potentially misleading. To disentangle ideas he found intertwining in dhawq, al-Ghamrawi observed that all individuals have inherent likes, dislikes, and preferences. This inborn dhawq imparts its spirit (ruh) to each person's writings. However, consistent literary readers, for example, may acquire a secondary dhawq by continually attuning themselves to the spirit manifested in a single author's corpus. Al-Ghamrawi argued that this capacity to perceive another's inborn style of perception and response could alert the reader to false attributions, material entered into an author's corpus by later reciters, for example. "Just as nourishment loses its personality and becomes part of the animal or plant it feeds, the acquired dhawq . . . remains independent and hidden, felt only when called upon to critique an [inscrutable source]."[9] Accordingly, he encouraged readers to develop their personal dhawq through exposure for purposes of informed discernment.

The specificities of al-Ghamrawi's exploration underline the care required to examine the concept of dhawq. The English *taste* has come to stand in for *dhawq* in historical and sociological discussions of Lebanon and the region, following the nineteenth-century translation of Edward Lane, a British lexicographer working in Cairo.[10] This universalizing, ahistorical gloss has perhaps supported a trend among historians and anthropologists to apply wholesale Pierre Bourdieu's famous model and treat dhawq as a marker of class distinction in Arabic-speaking societies.[11] For example, Toufoul Abou-Hodeib discusses the use of imported goods to signal socioeconomic position and takes dhawq to be preference for this or that set of goods, thereby overlooking the training of both one's own and others' ability to read goods for their signals.[12] I do not doubt that reference to "taste," and even more so the French *goût*, imbued emerging usages with a sense of distant meanings. Yet the significant shifts the

term underwent, before and during the Mandate period, and the many urgent invocations and explorations of it during that period call for a local theory of material culture and a contextual analysis of what dhawq became for activists and residents struggling to manage new economies, migration trends, and political arrangements. First, I pursue a folk understanding of dhawq to get at how people consciously sought to activate this ability. Next, I outline changes in how exhibition reviewers related dhawq to art.

The word *dhawq* had been in use for centuries. Lexicographer Ibn Manzur, active in North Africa, had documented it in the late thirteenth century, noting its dual nature, both transitive (the capacity to be perceived, as in the flavor of food) and intransitive (that which has conducted the perception, to the eater).[13] While this sense remained, others accrued. Composing his compendium of classical Arabic in the eighteenth-century Cairo, al-Zabadi observed controversy among scholars over aspects of dhawq's definition: First, whether this perceptive capacity works only through the mouth or through any sensory organ.[14] Second, whether that which is perceived by it becomes part of the perceiver. Al-Zabadi emphasized the Qur'anic record of God making sinners perceive through their dhawq the "clothing" (*libas*) of hunger and fear.[15] From this, al-Zabadi extrapolated that dhawq works directly, immediately, and comprehensively to impart unexpected findings.[16] The lexicographer conveyed his nuanced notion of incorporeal nourishment and guidance by invoking beauty: first cognitively grasped, it transmits its traits to the emotional organ, which responds with appreciation and increased orientation toward said traits. Pinning down a contemporary definition of *dhawq*, Beirut-based scholar Butrus al-Bustani compiled sections of his predecessors' lexicons with contemporary proverbs in his 1860s dictionary, *Muhit al-Muhit*.[17] From them he extrapolated that dhawq was a kind of acquaintance (*ta'arruf*) that first developed from food and then extended to express experience or experiment (both *tajriba*).[18]

In his 1892 encyclopedic essay, "Dhawq: A Philosophical Study," for the popular scientific journal *al-Muqtataf*, Yusuf Shalhat cited a proverb no prior lexicographer had included: "*La jidal fi al-dhawq*" (There is no [point in] arguing over dhawq).[19] With this refrain in mind, he wondered at dhawq's unconscious production of responses, at changes in types of responses, at the coexistence of the internal faculty and material quality of dhawq, and finally at the coexistence of agreement on a quality's nature with disagreement on its specifics.[20] Shalhat criticized al-Bustani's definition as settling for a "mere statistical account" of co-occurrences and argued for a "practical science of dhawq," to account for objective, nonaccidental reasons for people's attraction to goodness. Shalhat deduced that dhawq operates like a well-made watch whose intricate parts

coordinate for a purpose (e.g., to tell time). If logic arrives at truth rationally, intellectually sifting through evidence, dhawq reaches truth through resonance, which either repels or connects entities. However, Shalhat cautioned that there are orientations that affect dhawq; states of the environment like "fanaticism, outrage, and licentiousness" will impact dhawq badly, disrupting social coordination.[21] In Shalhat's insistence that dhawq is not an individual possession but a system of integration, a sort of rapid response system to fit the individual into the social body, we see the beginning of a social project.

Indeed, it is in the context of thinking about public works, budgets, and places that dhawq leaps to the turn-of-the-century tongue. Take social activist and educator Labiba Hashim, who in 1911 deployed the phrase "school of dhawq," which Farrouk's 1933 visitors were later to invoke at the School of Arts and Crafts (chap. 2). The enterprising, middle-aged Hashim had founded *Fatat al-Sharq* (Girl of the East), a vanguard feminist review, and taken up the first female faculty post at the Arab University in Cairo that same year. Speaking in a newly established public reading room in Bhamdun, a train stop between Beirut and Damascus, she urged her audience to think about "the variety of people with different backgrounds, customs, and knowledges intermixing without agreement on principles or opinions on a daily basis."[22] In such a context, Hashim averred, one needed dhawq "to distinguish *relations* between similar things."[23] Recognizing each person's composite character and lack of complete control, Hashim replaced Shalhat's example of an inert watch with the animate specimens of a merchant, a young girl, and a household. The merchant could have wares to sell, but without their proper arrangement on the shelf, he would lack buyers. A girl might have physical beauty, but without selecting appropriate clothing, she would lack admirers. A humble house that is well organized—its contents immediately intelligible—will relax its inhabitants, whereas disarray makes even a castle unbearable.[24] Personal status and material value fluctuate with the negotiation and interrelation of assets because both are matters of coordination and integration. Hashim attributed to dhawq the knowledge of how to manage that flux.

Hashim's schooling of dhawq emphasized the experience of relationality and incorporation, as opposed to the establishment of equivalences, the conversion of goods, or the accumulation of profit. In other words, this school knew neither institution nor inherent hierarchy; it required only patient exposure to beauty in art or nature (for more on their interchangeability, see chap. 4). Strong dhawq would change one's goals in life. It would inoculate against both materialism (the mere value of the given matter) and mundanities (current conditions prior to the quest for perfection).[25] Closing her speech with the same

aphorism Shalhat marshaled about the futility of debating dhawq, Hashim as-
sured her audience that the goal of schooling it was not to erase difference
but to make it socially beneficial. In this sense, Hashim's *dhawq* not only was
egalitarian but progressively taxed the wealthy, whose "luxurious palaces,"
when disorganized, exuded noxiousness.

Conceptualization of dhawq developed rapidly with the visual experience
that art exhibitions supplied colonial citizens in Beirut. As al-Ghamrawi's essay
demonstrates, the question of how dhawq crosses borders between subjects
and objects still perplexed scholars in 1920s Beirut. Behind this question lay
an urgency to mobilize dhawq's potential force for social good, to scale up from
individuals to citizens and country. Pre-Mandate art writing rarely mentioned
it, though advertisements for household goods and clothing commonly did.[26]
Usually ads hailed "people possessing dhawq" to actualize that trait by pur-
chasing the wares they offered. But changes were afoot. In his advance review
of Farrouk's 1929 show, Yusef Ghoussoub wrote of dhawq as a quality certain
people possess that behooves them to support art and other sources of national
advancement.[27] While some reviewers of the 1930 *First Lebanese Salon* shared
this understanding, speaking of the exhibition as something demonstrating
its organizers and participants' dhawq, Ghoussoub spied a transitive force at
work in this larger show.[28] He asserted that the arrangement and organization
both within and between displayed artworks could benefit "*tathqif dhawqina*,"
or the cultivation of our dhawq.[29] This dhawq was no longer limited to a given
class, though it could, dangerously, be squandered, especially if the country's
elite youth, in particular, did not undertake "redirecting themselves from that
which disgraces them to that which is graceful and which sharpens the imagi-
nation (*mukhayyila*)."[30] This dhawq has a strong ethical edge, far from matters
of preference or pulchritude.

Many subsequent art writers similarly entertained the hope that dhawq
could be transitively conveyed and triggered by exhibitions.[31] In this line, we
may recall from chapter 2 the visitors to Farrouk's 1933 show who reveled in
attending a "school of dhawq" by observing his works.[32] When he assessed
the public benefits of the *First Lebanese Salon for Painting and Sculpture* in
1930, Yusef Ghoussoub built on Hashim's metaphor of a mansion by invoking
affluent homes jam-packed with Persian rugs, furniture, mirrors, crystal chan-
deliers, and precious things alongside "pictures of no artistic value, printed
or painted with a broom and just placed in a deluxe frame."[33] Such homes
indexed pre-Mandate wealth for the newly upwardly mobile Ghoussoub, who
characterized the pre-Mandate dhawq of his compatriots as "so low" that for
all their means, the wealthy lived in a disorganized, disharmonious jumble of

materialist opulence, not knowing how to handle the goods they could acquire and suffocating themselves and their consociates as a result.[34] It was Hashim's nightmare incarnate. Against this image, Ghoussoub juxtaposed the uplifting, dhawq-refining presentation of over four hundred works by thirty-eight artists at the *First Lebanese Salon*. The very act of writing provided ethical redirection for Ghoussoub's peers to nourish and hone their mukhayyila toward generating their own salutary suwar. Such viewers became *"ashab al-dhawq,"* literally possessors of dhawq but, practically speaking, people identified by their ongoing exercise of the transitive force. Their experience was by no means limited to viewing nudes, but this genre, more than still life or landscape, lets us consider the bodywork people did with fantasmic art. The exhibitionary sociality instigated by nudes, in particular, helped Mandate citizens grasp how socially transformative dhawq could actualize. So let us return once more to the paintings.

Learning Abjection: Viewing the Nude as an Emotional Practice

As the subject of works looking at looking, "modern" compositions featuring nudes triggered a process of art synecdochically reminding and excluding. In February 1932, Omar Onsi selected a suite of nude-related works to open his first solo show among his compatriots, also at Sanayeh. To follow the description from Jawaba, a contemporary critic writing in the widely read *al-Ma'rid*, the first displayed work, *Phoenicia*, demonstrated the young artist's "local watani tinge": "Here is a picture of a naked woman standing on a European shore with the sea behind her, bunches of oranges in her hand, by which Onsi symbolizes the Phoenician state that carried its civilization [*madinataha*] in ancient times to the West, colonized, taught, and benefited it so that it has the great civilization we know today."[35] This (now lost) full-length work illustrated the review and was priced at a flabbergasting 5000 francs (60 percent higher than any of the ninety-one other works for sale), indicating common confidence in the work's monumentality (fig. 3.2).[36]

Following *Phoenicia*, Jawaba viewed the sixth-century Arab bard, "Imru' al-Qais, down from his camel on the side of a spring in whose waters bathe three damsels, including `Unayza, his girlfriend. He has stolen and hidden their clothes, and now he stands awaiting their exit to the shore to enjoy the view of their nakedness, while they are hesitant, deliberating amongst themselves what to do." This second work, titled *Imru' al-Qais*, illustrates a passage from the diwan by a revered pre-Islamic poet of the same name, whose work school-children memorized (fig. 3.3). Finally, the reviewer describes a third piece, titled

معرض الفنان عمر الأنسي

في مدرسة الصنائع والفنون اللبنانية

الاستاذ عمر الأنسي مصور بدوي بارع ، ضرب بقسط
وافرٍ من فن رفائيل ، أقام في الأسبوع الماضي معرضاً
خصوصاً في مدرسة الصنائع والفنون اللبنانية عرض فيه
طائفة كبيرة
من صوره
يبلغ عددها نحو
الثمانين نخبة
وقد صغ
الاستاذ الأنسي
صوره الجديدة
هذه بصبغة
محلية وطنية ،
كانت مجموعة
قيمة لمشاهد
قرى
الاصطياف في
الشوف كسوق الغرب ، أو كيفون ، وبيصور ، وغيرها من القرى

ومن غريب ما حدث للاستاذ الأنسي وهو في بيصور
يبحث عن مناظر طبيعية الرائعة ليقابلها الى القماش ان اهل
القرية كانوا ينظرون اليه نظرات دهشة وخوف وينفرون
منه كلما شاهدوه متنقلاً بين الاحراش والوادية وفوق
الآكام كانت اعتقاداً منهم انه من رجال الشرطة السريين وقد
جاء يحقق في مقتل ذبيحة تلك القرية .

اتفق له يوماً ان اقبل نحو من القرية ينظر الى الفتيات
يلأن جرارهن ما ، منها ، فما ان رأينه قادمات علين حتى
نفرن وهرين عنه لا يلوين على شيء .

FIG. 3.2 Omar Onsi, *Finisia* [*Phoenicia*] (The French catalog gives "Allegory: Phoenicia Presenting the Oranges"), reproduced in "*Ma`rid al-Fannan `Umar al-Unsi*" [The artist Omar Onsi's exhibition], *al-Ma`rid*, February 28, 1932, 20. Courtesy of Special Archives Collection, American University of Beirut.

FIG. 3.3 *Imru' al-Qais*, Omar Onsi, 1932, oil on canvas, 64.5 × 80 cm, 1932. Private Collection. Courtesy of Octavian Esanu.

At the Exhibition: "And here are some young veiled women flocking to regard a *sura fanniyya* [artistic picture] representing naked women" (fig. 3.4).[37] A full-length female nude, three naked women bathing, six young (dressed) women looking at a painting of naked women: this trio of states of feminine undress and viewer response evinces Onsi's "local, nationalist tinge."[38]

The trio's display restages the experience of an artist in training, who first encounters the life model full-length and front-on, pulling on quotidian or communal norms for handling the encounter, before ultimately mastering the

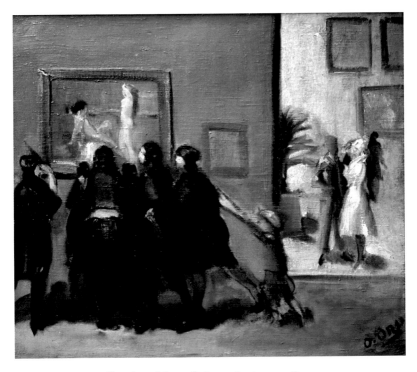

FIG. 3.4 *Fi-l-Ma'rid* [At the exhibition], Omar Onsi, 1932, oil on canvas, 37 × 45 cm, 1932. Private Collection. Courtesy of the collector.

academic presentation that merits a gilt frame. Having dropped out of business school (at AUB) after a year or two, Onsi studied painting in Beirut with Khalil Saleeby, and after the latter's death, and a sojourn in Jordan, he decamped to Paris, where he spent three years frequenting open studios at Colas Rossi, la Grande Chaumière, and the Académie Julian. Like many art academy graduates, Onsi carefully preserved a studio photograph documenting his proximity to the life model (fig. 3.5). In it, the students are respectably suited and smocked for professional art making—one even carrying a palette—as they gather around the model, who stands exactly like *Phoenicia*, while completed canvases on the edges of the scene guarantee the reputable outcome of these gatherings. Such images highlight the homoerotic bonding between (usually) male artists in training while underscoring the chasteness of novices' relationship to the model.[39] Apart from this photograph, however, Onsi has apparently not left traces of this period of his life. Fortunately, the loquacious Farrouk, who authored posthumously published memoirs, provides insight to

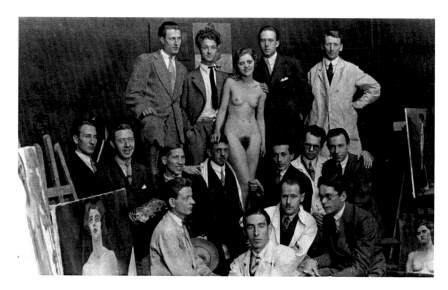

FIG. 3.5 Photographer unknown, life drawing class with model, 1927–30. Onsi sits to
the right of the model's knees. Dr. Oussama Onsi Collection. Courtesy of Lina Onsi
Daouk.

his student days and working process.[40] He highlights an emotional process of
sensory re-attunement.

Farrouk writes in his memoirs of the preparation he undertook to pass the
Roman Royal Academy of Art exam. To remind his compatriots that art in-
volved difficult choices, he recounted the story of his laborious process of ac-
quiring facility in the nude genre: "I found it smart to prepare before entering
the exam, *for fear of a disappointment that I did not want to befall my well-being*
[*khatir*] after having invested all this effort. So I would not be imperiled, I en-
tered a private school to get some practice, especially that the first thing they
ask for is to draw the naked human body, followed by anatomical knowledge
of the bones and joints and all miscellaneous details related to that, plus some
knowledge of art history and its schools."[41]

Protecting his khatir, or emotional well-being, Farrouk essentially describes
producing a nude as an emotional practice toward overcoming his local envi-
ronment, specifically his childhood neighborhood of Basta Tahta, a Beirut sub-
urb, where, he asserts, he "never had the opportunity to see so much as a bare
upper arm or thigh below a hitched-up skirt." He had made pictures of naked
and half-naked people, by heeding his professor and perhaps by copying others'
works.[42] These were not revolutionary images; they were part of the practice of

painters in Ottoman territory, mounting (apparently) no emotional challenge. Naming and communicating his emotions, however, he painstakingly details his first actual encounter with a female life model in his private school drawing class: "My mouth went dry; my legs started trembling, as did my hands. I was incapacitated by stupor and shivering." Although he "put all [his] effort into resisting [arousal's] annoying effect," an erection ensued.[43]

Trembling in confusion in his Roman life drawing class, Farrouk was equally embarrassed that he seemed to be the only person not controlling his appendages. And what is an artist without a steady hand? He left the room momentarily, returning after he had "scolded himself," to accomplish a few "broad lines."[44] Finding himself alone in this predicament, the young man from Basta Tahta had to work on his self:

> I decided internally, fearing a scandal, to admit the reality of the situation and surrender. I exited to the waiting hall, refreshing my spirit and relieving my poor nerves. After my spirit had settled slightly, I scolded it for its weakness *relative to its peers* working in the atelier. Then I "returned the serve" and reentered the atelier. The impact was, naturally, less, and I was able at least to draw some broad outlines. I left the school that day to my room safe . . . convinced by this destiny (*qadar*). However, I did not stop there, of course, but followed through with a shower of cold water. It was at the end of September, and September [in Italy] has biting cold days. So, this punishment was rather harsh. Often punishments have some zing in them, *so as to change people at their core* [*albab*].[45]

Though the "most unwelcome reaction" mars Farrouk's spirit and shatters his nerves, no one else sees it. It weighs on him, not as a self-evident stain, but, as Julia Kristeva would say, as "[a] weight of meaninglessness, about which there is nothing insignificant, and which crushes me."[46]

Situating himself among calm students and cold showers, Farrouk seeks to mobilize and refine his emotions as a way of changing his very core. In her foundational study of ritual and purity, the anthropologist Mary Douglas explains disgust and horror as responses to the quality of out-of-placeness.[47] Objects that fill us with revulsion, she argues, are only situationally so. Like a hair in soup or soil on a carpet, Farrouk's erection troubles for its being out of place and, worse, for revealing *him* to be out of place. Developing from Douglas, Kristeva takes the orders of humanity and animality to be socioconceptual places and theorizes that elements that threaten the postulated border between these two orders produce a specific horror she terms *abjection*. Neither "the slack boredom of repression" nor the motivating "transformations of desire," abjection

is a "brutish suffering" that one endures to meet the demands of becoming human, wanted, and accepted in society.[48] Kristeva alerts us to how lives lived with abjection are not motivated by desire so much as exclusion. Farrouk experiences the taswir-interfering, allegedly feral emotional-physical reaction as a separation from his peers. Whereas desire takes objects, exclusion makes borders. He cannot define himself as an artist because the physical matter of his body intervenes. His skin rises, his muscles pulsate and throb in ways he cannot control, such that he can put no border around them, nor between him and his "origin" (Basta Tahta). When the capacity for meaning making breaks down, threats to the self abound. These threats have to do with the loss of distinction between self as subject and the world of matter that can be treated as objects. This horror is particularly strong because Farrouk finds himself in a situation that absolutely requires objects to confirm his subjecthood: he needs visible drawings of naked models to come into existence as nudes, on cue, to gain entrance to the Royal Art Academy in Rome.

After taking a punishingly cold shower (an act of purification, exclusion) and still feeling rattled, Farrouk devised a better solution, to fill himself with purifying sensory substance that would reshape his proprioception: he read the Qur'an: "Praise the Lord! Reading a few select passages from the Holy Qur'an had a decisive effect. Thus, I joined conviction and therapy, stony will and duty. I reached a decent balance. I emerged from this battle safely. The next day . . . the difference was plain, the result better. Indeed, I realized that the day I passed the [Royal Academy's entrance] exam and thanked God who inspired in me this progress. There is no success but by God."[49] Essentially, Farrouk asserts that only pious artists can succeed. The sketches that he repeatedly produced steadily and piercingly follow the musculature, skin tension, and spilling rolls of their sitters because his eye acknowledged the signs of divine creation in them. In this ontology, nudes are ayat of divine origin and pious profession (figs. 3.6 and 3.7).

In the wake of the Ottoman bureaucracy's retreat, as new and renewed ideas about Islam circulated the region and debate proliferated, Farrouk's visual experiments were pitched not against an external, invading, imposing force but rather for the active production of Islam. The language he deploys for divinely sanctioned visuality in his autobiographical anecdote defines his drawing of undressed human bodies as acclamations of the *hikma*, or divine knowledge, that has been invested in the most mundane of elements. I dwell on this passage because it indicates a sensorium that has slipped the grasp of both scholars of modern art and those of Islamic art. In her essay on the "Islam" in institutionalized Islamic art discourse, Shaw notes that Christian-based ideas of visuality

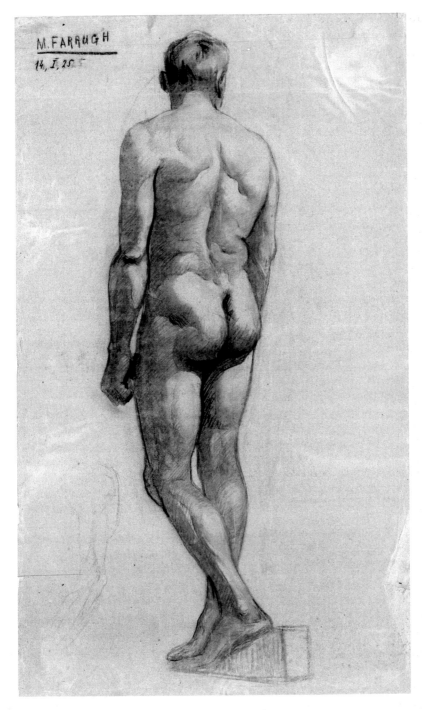

FIG. 3.6 Moustapha Farrouk, male nude, pencil and conte crayon, 64 × 36 cm, January 14, 1925. Jamil Molaeb Collection, Beirut. Courtesy of Hani Farroukh.

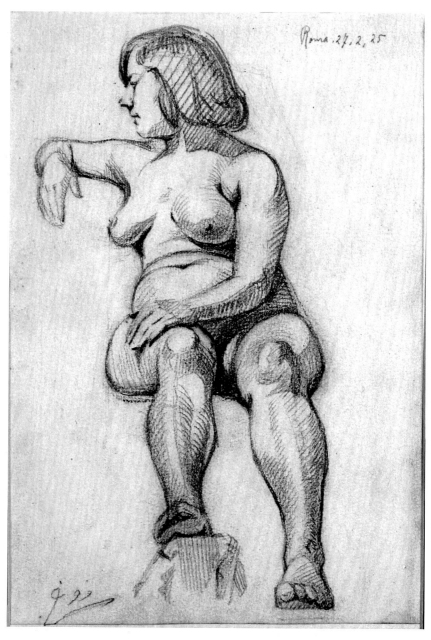

Roma. 27. 2. 25

FIG. 3.7 Moustapha Farrouk, female life drawing, pencil, 21.5 × 15 cm, February 27, 1925. Hani Farroukh Collection, Beirut.

have emphasized iconography at the expense of the semiotic. She concludes that intercultural negotiation, translation, adaptation, and reinterpretation—in other words, power relations instead of essences—have eluded modern Islamic studies.[50] Similarly, Kenneth George's anthropological study of A. D. Pirous' modernist paintings calls for attention to an ever-unfolding and fluctuating "'Islamic visual culture . . . a field characterized by aspiration, debate, experiment, and constraint, rather than allegiance to a settled set of aesthetic principles."[51] Farrouk and Onsi shared in a long-ignored project of experimenting and rationalizing their Islam during a period of decolonization, as discussed in chapter 2. Seeing the medium of anatomical study as part of this project allows us to appreciate these works as prayers to a creator. This emphasis on piety casts Onsi's trio of nude-viewing pictures in a new light.

The Seeing Self and the Space of the Citizen

Returning to Onsi's trio, we find that, curiously, while the exhibition brochure confirms that the trio opened the display, it realigns the order from *Phoenicia* to *At the Exhibition* to *Imru' al-Qais*.[52] This arrangement, contra the teleological presentation remembered by Jawaba, centers *At the Exhibition* between two equally liminal scenes, both set on a shore, the site of flow and flux, of uncertain boundaries and porous openings. What doors does this siting of the exhibition sense-realm open? At the apex of the movement between the allegory of the Lebanese nation in "Phoenicia's gift" to Europe and the recitation of the bawdy pre-Islamic poetry set in an Arabian desert oasis, Onsi situates what Jawaba identified as a "sura fanniyya (artistic picture)," the framed nudes within *At the Exhibition*. This is the same work that the curators of Farrouk's 2003 retrospective would see as "a satirical picture" of women viewers before a nude "gawking at it in surprise and curiosity." Let us examine more closely the viewing embodied in this work and the sensorial re-attunement it extended beyond the picture frame (fig. 3.4).

Onsi's composition divides between two rooms, one in the foreground, which dominates, and one to the right, which appears through a doorway. Pictures hanging on the walls and furnishing absent except for a potted fern locate the setting at an art exhibition. Ten figures populate the space: deepest in the far room, a rapidly described silhouette suggests from its angles a woman, peering up at what must be massive canvases, the lowest of which strongly recalls one of Onsi's self-portraits from the period. In the middle ground, an amorous couple engage in earnest conversation, not apparently acknowledging the art around them. The man sports a suit and a tarbush; the woman dons

the latest Parisian fashion, including a turban *à l'orientale*. In the foreground, six schoolgirls and one small boy give us their backs or sides as they gather around a gilt-framed picture. Made of black taffeta, the girls' outfits consist of a loose short cape with a *balarin* (fluid hood) and a *buchay* (knee-length, flouncy skirt). Black silk stockings, high heels, a silk sash at the waist, and a *yachmak* (an Ottoman-favored facial covering) complete the elegant attire. This is the "New Dress" adopted by urbane Muslim demoiselles of the 1930s who wished to demonstrate they were *au courant* with Parisian patterns.[53] Equally (convergently) modern, the boy, too young for breeches, wears bloomers, a suit jacket, and a floppy beret.

Onsi's rendition of the seven foreground figures in this prescribed dress spotlights the individual modifications each female has introduced, filling out the contours, adding a splash of color, dropping the hood to the shoulders, or tossing the yachmak back. This variety accents the mobility and fluidity of costume that could otherwise appear rigid to an unobservant eye. Each figure expresses a particular character and stance on viewing, from studied regard (requiring the lifting of the yachmak) at far left, to fixation in the middle (straight-on staring), to incipient curiosity on the far right, as the sixth young woman seems to have just arrived, still pulling the slower, perhaps foot-dragging boy. Indeed, when I showed the picture to Onsi's neighbors and the children of his kin in the 1990s, the figures were immediately legible as the famous Mahmasani sisters, whose education, prodigiousness, and social engagement at the behest of their religiously and politically conservative father endeared them to middle-class Sunni Beirutis.[54] They could well have attended the *First Lebanese Salon for Painting and Sculpture*, held two years prior in the same location. If so, they would have viewed Onsi's paintings on the upper floor, at least three of which showed nudes at the water (see chap. 2, fig. 2.2).

While *At the Exhibition* may picture Onsi's consociates, as an art act it wedges art between them. Not only does it reference exhibitionary sociality, but fantasmically, the picture works through half-seens. Onsi's fluid, almost sketchy style (particularly in the boy's back leg) cautions against seeing in the (larger) canvas a mirror of Mandate Lebanon. This rapid brushwork does not carefully record an event so much as outline an idea that Onsi wished to set down. If it would seem to serve up the shiver of veiled women viewing their alter egos revealed, it also forces viewers to consider other acidic paradoxes: from the influence of Parisian styles on the black frocks and man's suit, to that of Eastern styles on the white high-collar gown and turban-like hat, to the fact that the "harem women" are out walking, the "Western woman" not so cultured, and the tarbush wearer not so isolationist. A viewer cannot simply

look to clothing clues to register concern for art and culture. At the risk of overinterpreting the picture, I suggest that it would be too much to believe that these three paradoxes just happened to line up: to assume so for sake of a minimalist interpretation would potentially dismiss the painter's intellect and insight. Rather, recognition of these jauntily delivered paradoxes forces into question the naturalness of any of the described ways of dress and attendant lifestyle. And a turn of the head left or right, to the rest of Onsi's opening trio, will only deepen the dilemma.

Located in the very space audiences viewing *At the Exhibition* occupied, their act of looking creates a *mise en abyme*, redirecting the public visibility sponsored by the School of Arts and Crafts—training generations of "native" artisans—to public sensual re-attunement and self-reflection. Viewers must look at how they look, feel how they feel. Where Jawaba told a tale of chronological progress, Onsi set a tale of technological progress and potential regress. After seeing an "actual" nude, in *Phoenicia* greeting their entrance (fig. 3.2), viewers would have found a model for how to look in the posture of *At the Exhibition*'s urban Muslim females (fig. 3.4). Drawing closer to the framed nudes, their bodies form the vector of vision any viewer in the external world must enact, aligning with their posture and forward thrust to peer at the work. From being objects of artistic sight, the sextet become subjects of artistic seeing, observing and performing the artist's project. The other figures become mere addenda to their magnetized gaze, counterpoints in a field of vision. The interior frame condenses the elements of fine art: two female nudes, in two basic poses (upright and supine); white, black, and the three primary colors dashed across the surface to denote setting and depth; a deft combination of the studio model and landscape in a single glittering gilded cadre. It seems to open a gaping hole in the depicted space into which the elements of fine art have rushed as if by force of vacuum.

According to the original hanging, after turning from *At the Exhibition*, visitors would meet Onsi's depiction of the moment when the pre-Islamic versifier, al-Qais, comes across damsels bathing in a river (fig. 3.3). Here again women assume the role of the seen, from three different angles, much as a single model would turn in a studio for novice students. Yet unlike the beached beauties of *At the Exhibition*, these three maidens protest the scopic attention, if ineffectively; they writhe and twist from view, eventually revealing all. The man peeping at them is uninvited; his lascivious stare, ghastly, its aggressivity extended by his projectile goatee. Where the glimmering frame within *At the Exhibition* provides the nudes' curious viewers with dignified access, the flimsy palm fronds across which al-Qais leers emphasize his awkward bulkiness.

The material differentiates between substance and circumstance. Al-Qais has come across the sight of nakedness through his liaison with `Unayza, his girlfriend, who is among the bathers. He responds with the same motives peppering his lustful relationship with her. Conversely, the six lasses' physical movement toward the framed scene, along with their sartorial preparation for it, emphasize that they are in the process of considering how to relate to this unexpected sight. Unlike al-Qais, whose punishment for his uninvited looking is legendary, they consciously and carefully weigh their potential incorporation of this "new" thing, just as they did with their variously worn "New Dress."[55] In other words, the modern, female audience adopts an emotional practice of dhawq.

Zooming out from the canvas to the exhibition room, I would like to dwell on the method and experience of incorporation that Onsi's trio enacts. Onsi's ordering of the trio to put al-Qais's scene last reminds us that while the pre-Islamic poet existed centuries before, in time, he also lurks within, ready to reappear. Kristeva argues that the abject generally manifests in bodily substances whose formlessness reveals our daily obligation as social beings to expel from ourselves half-lives and detritus (excrement, secretions, leftover food) that would make of us undesirable companions, akin to beasts or corpses. Good emotions set a border. Bad emotions must be expelled for one to belong to a desirable group. Let us recall Farrouk's emotional practice—which included naming his initial response to the life model as "an annoying effect," praying to control his trembling, and publishing praiseworthy drawings that demonstrate his reordering of the emotion—for how it points to the *emotional* materiality of the abject. As we have seen, by repeatedly undertaking an emotional practice to manage his response to naked bodies out of place, Farrouk restructures his senses, reforms his body, *and* accomplishes the nude genre.

Thus, in producing *Souvenir* for his audience of colonial compatriots, Farrouk drew an emotional—and, lest we forget, divinely sanctified—border of exclusion. While the nude framed within it might appear to be an object of desire, the scene's operative element is the metallic barrier separating the hapless peasants from the display wall, which they breech only by way of their ominous shadow. This barrier defines a sense-realm. In other words, it not only bespeaks the importance of learning codes for incorporating unexpected sights but also enacts and conveys the novel codes to be learned. On the one side, we see the framed art; on the other, we see their complete incomprehension and stupor. Sensorily, oppositions abound: rectilinearity, gilding, and airiness on the left; slumping, uninformed, impoverished mismatches on the right. These oppositions make sense. Creating a sense-realm for evaluating and revamping

people's subjective modernity, Farrouk warned that those who do not seek to cultivate their emotions become metaphorical peasants.

In his study of emigrant mountaineers managing American market economy with attitudes learned in their Lebanese villages, which emphasized subsistence, Khater sketches an image of their "quick dash to test the waters before retreating for fear of being swallowed up by the dizzying eddies and currents of 'modernity.'" He concludes that "joining the flow—if they ever did—was indeed a slow process." It would be tempting to see *Souvenir* as an illustration of such a dash. Doing so accords with the theory that modernity imparted a shock as it radiated from West to East. But fantasms like *Souvenir* created a situation of looking at looking and invited *tasawwur* (forming fantasms), not shock: imagine yourself if you do not develop new emotional practices. Onsi's trio likewise extols the importance of learning codes of selective, sensorially modified incorporation. Backwardness, provinciality, and ostracism loom if audiences do not learn to use frames (i.e., fine art) to see one another and themselves. To that, it adds an extra emphasis on the Islamic character of these codes. The "sura fanniyya," as Jawaba designated *At the Exhibition*, pivots between *Phoenicia*'s coeval glory with Europe and *Imru' al-Qais*'s pre-Islamic villainy in the exhibition hall. It pivots, also, between the framed nudes signifying fine art and the flagrantly faithful Beiruti women gathered in Onsi's composition. Fantasmically, the nude, as the epitome of artistic picturing, hails the new conceptions, like a ritual elder sanctifying a rite of passage, to train and cultivate audiences. Nudes' questioning of possible audience responses raises the specter of abjection, the unwanted substance flowing through the body of al-Qais, who clearly has not acquired Farrouk's skilled self-control. But nudes themselves also convey the technology of abjection's remedy, in the posture and gaze of the youth "flocking to regard a sura fanniyya." The "sura fanniyya" is not just a picture in a picture but the possibility of taswir. It involves both depiction and a new conception triggered through fantasmic art.

Materially speaking, the surra fanniyya was real and not real at once. Audiences in Mandate Beirut recognized it as a synecdochical symbol, lavishing praise on Farrouk, Onsi, and Cesar Gemayel (Qaisar al-Jumayyil, 1898–1958) for "disciplining the fire of the artist before the nude model" and producing "nationalist" artwork, as Jawaba called it.[56] To explain the importance of lifelike, provocative nudes, which he termed "the epitome of the successful modern picture," pedagogue and reformer Rushdi Ma'luf postulated that the painting of zalitat (uncovered feminine things), in their undeniably "desire-provoking positions," had "an impact in refining characters that velvet and silken clothes cannot for the way they camouflage."[57] Journalist Fouad Hobeiche (Fu'ad Hubaysh)

found naked women in various poses, so realistically rendered in Gemayel's studio in 1930 "that life pulses in all their members, and a medical doctor could use them as anatomy lessons."[58] An avid proponent of nudism and author of a guidebook on the practice, Hobeiche praised Gemayel's pictures for allowing a viewer to practice at being a nudist, comfortable with uncovered truths, fearing and hiding nothing.[59] While Jawaba similarly praised Onsi and a certain Miss Eugénie Misk at the *First Lebanese Salon*, for their "accurate, even embarrassing" pictures, Ghoussoub contrasted Onsi's *"mutajarridat"* [denuded pieces], which please "as a whole but not in their details," with Gemayel's, so "precise and good in craftsmanship" that "you sense the blood flowing under the skin of his figures; you feel the pulse of their veins."[60] You feel the pulse of their veins. Your veins pulse, too. You perspire. You question how you will respond.

The sense-realm hosting exhibitionary sociality opens the viewer's emotions to "universal" scrutiny and occasions an inventory of the contents, from which exclusions can be made. Based not on given class, national origin, gender, age, or similar factors but on perceptive interactivity and an ethical corpothetics, these exclusions extend the art act. As we have seen in chapter 2, there is nothing nation-spatially limited about exhibitionary sociality. We can call it a "locally made import" because it makes locality by selectively deploying imports and produces that locality as translocally connected. Audience testimonies and artist plans for Mandate exhibitions both asserted that attentive viewers enhanced their "locality," as daughters and sons of the country, *and* their "un-locality," metaphysically remapping their country to connect it out, abroad, and beyond. In this sense, artwork that presents new, genre-citing nudes for "local" society does not simply index a social condition but synecdochically manifests changes to the condition.

Jawaba's reordering only heightens an emphasis on audience responsibility implicit in Mandate-era nudes. As they look upon the pulsing members and feel the blood in their own veins quicken, will the audience respond like the ancient Imru' al-Qais or like the progressive youngsters? Will self-imposition and vulgar exploitation be their mode of social address, or curiosity and self-reflection? Note, at issue in Onsi's opening trio is neither an ethnic threat nor temporal redemption, for the characters in all settings are Arab, and the antiquated lies ahead in the viewing order. Moreover, *Phoenicia*'s presence reminds viewers that civilization already rose here long ago. The other sets of viewers seen in *At the Exhibition, Imru' al-Qais,* or *Souvenir,* cannot rely on forward movement but must acquire "civilization" by their own efforts. If Jawaba upheld the nude as an agent delivering civilization to Europe, his review also rendered it an object improperly apprehended by pre-Islamic, male-dominated Arab society. The

author enthused about the overall aura or "glow" emitted by the imported oil pigments rendered in a pedigreed, "Raphaelian" manner, thus genealogically he assured viewers (who would have known Raphael from locally made copies of his works) of Onsi's professional status.[61] Ultimately, however, he allows this genre to be a subject and way of self-knowing in a contemporary Muslim society.

Responses from the 1930s press suggest that some audiences came to treat nudes as ritual lessons in incorporation and sensorial readjustment. Like elders guiding novices through a crisis, life models rendered in suwar could become models for life. At the end of this trajectory stands the modern, contemporary citizen as a fantasm. The citizen comes into being at the juncture with these provocative projections, which teach awareness of abjection and require the practice of exclusion. In her study of anti-colonial art practices in India, Tapati Guha-Thakurta documents the propagation of "Indian sensibilities" through specific art styles. The interactions around nudes in Mandate Lebanon foreground the mutual production of sensibilities and national subjectivity.[62] Concluding his review of Onsi's February 1932 Sanayeh exhibition, Jawaba launched demands at authorities and viewers: to create an exhibition hall in the city's center, for the former, and for the latter, to visit them and to develop their emotional practices of responsiveness, or what he calls dhawq. The interaction between artistic pictures and audiences on the move interrogates the civic subject and calls for building a nation, indeed a new civilization, not merely by relying on time (or place), that is, teleology and identity, but by evacuating each viewer's self of unwanted internal substances and sucking into the void desirable ones. This local theory of materiality and dhawq complicates a Bourdieusian model of social reproduction, but to understand this, we should first look at the connections nudes made "outward," too.

Genre, Genealogy, Profession: The Nude in Mandate Beirut

Locally made imports like *At the Exhibition* and *Souvenir* spotlight processes of incorporation in the production of aesthetic communities. By choosing such masters as Paul Chabas or Pierre-Auguste Renoir as their professional forefathers, artists like Moustapha Farrouk and Omar Onsi affiliated themselves with a long tradition of European art making and, in an inarguably radical move, became its originators in their respective milieu. Although naked human subjects sporting exposed genitalia have a long history in Arab, Mediterranean, and Near Eastern artistic practices, artists of the Mandate generation discovered "*the* nude" as a *genre*, meaning a type of painting codified by continental academic practitioners for purposes of planning, evaluating,

and pricing compositions. Genres are material forms characterized by con-
nectivity, referentiality, and polylingualism. Studying Moroccan marketplace
language practices of product pitching and storytelling, Deborah Kapchan
observes, "Genres are constellations of co-occurrent formal elements and
structures that define or characterize particular classes of utterances."[63] The
rigidity and reliability of the generic constellations fuels a demanding "au-
thoritativeness" that audiences recognize as existing prior to the current in-
stantiation.[64] Flagrantly eschewing originality for recursivity, genre thereby
exists in a forever expansive mode, always gesturing beyond each particular
instance to something potentially, properly "universal." Each example of a
nude (or landscape or portrait, as we shall see) references canonical precursors
established elsewhere; thus, generic practice connects and displaces at once.
Johannes Fabian summarizes genre as capturing the "seemingly contradic-
tory idea of predictable creativity, the kind of creativity that a community can
share."[65] Genres are the basis of what Farrouk called interchangeably "al-fann
al-'alami" and "al-fann al-jamil." Genres persist through their suitability to
unlimited translations and new versions.

 To study Mandate-era nudes in the framework of genre is to foreground the
convergence of the local and the translocal in infinitely expandable genealogies
of art production. The imported materiality of Mandate nudes and other genres
was never disguised and rarely adapted. Farrouk and his peers bought their pig-
ments, papers, pencils, and canvases from Italian, British, and French manufac-
turers, who sold through local agents such as Daoud Corm (Dawud al-Qurm,
1852–1930) or the Sarrouphian Brothers.[66] They boasted of the salons in Paris
or Rome that had displayed their works and the French and Italian newspapers
that had written of them. Audiences learned the genres' French names, such as
nu and *paysage*, and acquired continental conventions for viewing and respond-
ing to the works, such as reading newspaper announcements of upcoming exhi-
bitions and signing golden books to memorialize their attendance. Even as they
brought art to bear on their "nationalist" present, reviewers termed the works
they viewed "Raphaelian" in color or "Renoiresque" in touch.[67] This was not
mere wordplay. It enacted a genealogy the artists consciously signaled. Creat-
ing material similarities with revered work set up terms of reference indicating
artists' deference to specific norms for judging their work, just as Griselda Pol-
lock has shown for the "European" avant-garde's self-formation.[68] But studying
outside the European boundary enhances our understanding of the form's
materiality and mobility.

 The generic flourishing of locally made nude imports belies art historian
Kenneth Clark's 1956 paean to the genre, *The Nude: A Study of Ideal Art*, which

takes pains to demarcate the nude genre strictly within Western invention.[69] Lynda Nead observes that for decades her fellow art historians took both the nude's iconicity and geography for granted. Applying a feminist lens to disentangle its power, however, Nead does not follow the genre outside that geography.[70] The story of colonial Lebanese artists' quest for professional recognition shows a "non-European" community that not only shared the creativity of the nude genre but came into being through its practice. While racist and sexist policies of most European art academies in the early twentieth century intentionally precluded the possibility of non-Europeans—and female Europeans— taking the official role of heirs and progenitors within the academy, they could not prevent these people from appointing themselves its begetters and beneficiaries beyond the academy.[71] Beirut-based artists, with peers in Calcutta, Mexico City, and Shanghai, turned a nearly dying tradition into a transitive force: they shared the nude genre with audiences in other languages and lands far beyond the bounds of Europe.

If genre engenders locally made imports, genealogy engenders "distantly validated homemades." Exploring the foundations of Western academic art and art history's sexism, Nanette Salomon notes that it is not only the artist who is aggrandized by mobilization of visual references to canonical predecessor works, but the audience, too: "[Classical references] bestow an instant sense of knowledge and mastery upon the viewer who sees the connections and place him/her in the league of the cultural elite."[72] Exemplifying Salomon's point, in his bilingual brochure essay for Farrouk's 1929 exhibition, Robert Chamboulan, the founder and editor of the biweekly Francophone journal *la Syrie*, tied the framed sights to Farrouk's "proper studies" at esteemed educational institutions in Beirut and at the Royal Academy of Art in Rome.[73] Taking up these genealogical cues, subsequent reviewers summarized the scholastic pedigree behind the works, from continuous enrollment in esteemed Beirut institutions to training with Habib Serour, "the famous picturer," in Beirut and Antonino Calcagnadoro and Umberto Coromaldi, "genius artists," in Rome.[74] Following genealogies through webs of social interactions shows that Mandate Beirut's distantly validated homemades mobilized the nude genre to advance claims to professional status and spread its spirit among fellow citizens-to-be.

For example, the peasants in *Souvenir* are viewing Farrouk's statement of affiliation with his renowned mentor, Paul Chabas, a member of the French Academy of Beaux-Arts and president of the National Society of French Artists, in whose annual exhibition Farrouk participated in 1931 (see fig. 1.2). The frame within the sketch ennobles his copy of a contemporary painting, *Au crépuscule* (ca. 1905), by the father-figure artist. A similar work by Chabas, *September Morn*, had

prompted public outcry and an American anti-vice campaign when installed in the vitrine of a New York gallery in 1913. Chabas may have told Farrouk, as he told a reporter for the *San Bernardino County*, "I was never so offended in my life as when a group of Americans, including members of the United States Senate, protested against the immodesty of *September Morn*."[75] For his 1933 exhibition, Farrouk produced *Crépuscule après Chabas*, a to-size oil rendition of the 1905 work he probably saw at the Musée du Luxembourg, where it hung since its acquisition by the French state. Synecdochically, Farrouk made a personal statement of affiliation with an embattled lineage of academic artistry, just as Onsi aligned himself with Renoir through his nudes.

The foregoing underscores that of the most important references of genre for artists establishing themselves in Mandate Lebanon, one was genre's association with a type of training that involved travel, admission, inscription, examination, and certification. When one reviewer observed that visitors were "touched by the *outstanding characteristics* of Moustapha Farrouk's art," he hailed the work's *not* fitting in.[76] Similarly, reviewers praised artworks for being "captivating" or evincing "innovativeness," compared to which, as we have seen, viewers might find themselves in Beirut and, at once, "in Venice or one of the superior cities of the West," as al-Naffi had hinted.[77] The nude was the paramount form associated with this type of training, so much so that sketches of naked bodies came to be known among artists as *académies*. This indexicality made nudes "authoritative images" whose achievement synecdochically conferred rights of professionalism on all users, whether makers or viewers. As Farrouk's contemporary Kenneth Clark put it, nudes amounted to "certificates of professional competence."[78]

Ipso facto, professionalism demanded nudes. Contrast the clothing of the peasants populating *Souvenir* with Farrouk's own sartorial self-construction before the *académies* preserved in his photographic portrait to commemorate the consummation of his genealogically blessed training from the Royal Academy of Art in Rome (fig. 3.8). The invisible background of both images is the near past, in which a peasant's wearing clothing beyond his social rank led to forceful reminders of his ascribed place and an obligatory "return to his familiar clothes."[79] The photograph signals a man who could easily count among "the lower-class" that economist Charles Churchill in his 1950s survey of Beirut characterized as small businessmen, grocers, repairmen, and servants— certainly, Farrouk's copper-whitening father would have been among that group had he not died prematurely. Yet here Farrouk performs the fastidious "professional," looking like Beirut's "heads of households," among whom Churchill included accountants, college teachers, upper administration officers, editorial

FIG. 3.8 Photographer unknown. Moustapha Farrouk with easel showing his male nude at the Royal Academy of Art in Rome, ca. 1925. Hani Farroukh Collection, Beirut.

writers, reporters, surveyors, clergymen, and schoolteachers.[80] The ink sketch, by contrast, indicates the fate of those who do not appreciate professional art, slipping back into rustic garb even though they move into sites of social improvement. The appreciation of nudes launches the artist and art admirers on an obverse path, not even simply *khawajat* (sirs), they may now be called in Scoutmaster al-Nusuli's terms *"muhibbu al-fann"* (art lovers).[81] (See chap. 2.) The language play embodies the mutual creation of artists and their audiences in the professionalization of Mandate art.

Professionalism rustled in the stiff textiles of the business suits Farrouk and his peers wore. It glistened from the membership and business cards they wielded. And it resounded in the new technical terms they used. Note that the address listings in the 1928 *l'Indicateur Libano-Syrien* placed artists in the "professions" section and separated "artistic painters" from "automobile painters" or "decorator painters."[82] The very name of the artists' workplace—*muhtaraf*, Arabic for "studio," shares the same root as the word for "profession"—and concretized in their convergence on the newly restructured commercial center Mandate authorities had created in downtown Beirut. Whereas their predecessors worked from their homes or those of their patrons, the new generation of artists joined the professionalizing colonial entrepreneurs in the new office and service areas of Beirut.[83] Farrouk had rented an atelier in the Ayyas building on Avenue Pétain near the Capucins Church and the Grand Serail. His peer Cesar Gemayel would take one the following year near the Place de l'Etoile. Saadi Sinevi (Sa`di Sinevi, 1902–1987), who paid for a double-sized ad in *l'Indicateur,* located his studio on the Avenue des Français, closer to the port and near Omar Onsi's new atelier.[84]

Professionalism boomed loudest from the new titles makers of art printed on their calling cards. Twenty years Farrouk's senior, Khalil Ghoraieb left a calling card in the younger artist's studio that read, *"al-musawwir al-yaddawi,"* meaning literally "manual-picturer." This term belonged to a vocabulary focused on the thing made—*suwar, rusum* (drawings, sing. *rasm*), or perhaps *nuqush* (engravings, sculptures, and paintings, sing. *naqsh*).[85] Following Arabic declension patterns for forming teknonyms from the wares produced, the pre-Mandate lexicon classed Ghoraieb and one Khatshadurian each as a *"musawwir"* (picture maker), distinguished only by the tool used to make pictures.[86] The former used his *"yadd"* (hand) to make pictures, making him a *musawwir yadd* (or *yaddawi,* from the yadd's adjectival form), while the latter used the *shams* (sun), referring to the camera's medium, so he sometimes answered to *musawwir shamsi* (photographer, lit. solar picture maker). The most common task for the musawwir, whether working with canvas or camera, was to portray a paying sitter and create an image "that would come out exactly like the person," nay,

"as the sitter saw him or herself in the mirror."[87] Like a camera, the successful painter was simply a medium for transferring a given entity into another format. Neither had a distinction between fine art and mechanical means yet been drawn, nor could people who worked in the field today called "art" be assured of special respect. Mid-1930s lore has it that Khalil Saleeby was shunned by some socialites in the 1920s as a "*musawwirati*": the *-ati* suffix was borrowed from Ottoman Turkish to mean a handler of musawwir (and thus redundant of the Arabic conjugation from the verb *sawwara*), adding even more degradation to the occupation.[88] In this becoming-post-Ottoman setting, the Ottoman suffix exacerbates the Arabic term's implication that painters conducted the trade of *al-taswir* (picture-making) according to a long-established protocol and at the instigation of commanding clients.

Notably, on the opening page of his 1929 exhibition program, Farrouk inscribed two titles for himself: the Arabic musawwir yadd and the French *artiste*. The latter was not merely a translation of the former but part of a project that critic Yusef Ghoussoub recognized as an "audacious" claim on viewers.[89] As a picture maker/musawwir, Farrouk was defined by the result of his activity. Becoming an *artiste*, which he and his peers came increasingly to translate as "*fannan*," he became noted for his ability to work in oil paints, watercolors, ink, pastel, et cetera, and especially to choose sights and produce them according to recognized genres. Tying hand picturing to the personal motivation of the painter (as versus the client or the charge), a fannan could pursue "the artistic goal [*al-hadaf al-fanni*] expressed on canvas in colors, lines, and composition."[90] Perhaps most significantly, the addition of *artiste* to *fannan* posited distant validation and opened the door for a newer meaning for a word that in nineteenth-century Mount Lebanon was most used for identifying the *himar wahshi* (wild ass), for his ability to vary his gait.[91] The word *fannan* draws from a verb meaning to diversify or mix (*f-n-n*) and, by extension, to master all varieties of a field or skill. In his praise of Farrouk's 1929 exhibition, Ghoussoub called attention to Farrouk's way of making art "as a professional pursuit (`ala ihtirafiha)."[92] The following year, he and other reviewers divided their reviews of the *First Lebanese Salon* into "amateurs" [*huwat*] and "professionals" [*muhtarafin*].

Professional Temporality: The Claims of the Nude on Mandate Government

This move to professionalize was part of a general trend in the era. Graduates of newly formed or renewed Ottoman educational institutions established syndicates and social clubs to advocate for their needs as lawyers, merchants,

pharmacists, or craftsmen.[93] Institutions had already arisen to separate "fine art" from "decorative art" in trend-setting Istanbul in 1883 (Sanaii Nefise Maktabi) and Cairo in 1908 (Madrasat al-funun al-jamila), both Ottoman-sponsored establishments. In the nineteenth century of competing nation-states, the very term *career*, like its Arabic analog, *mihna*, ceased to connote humble, degrading servitude.[94] Both gained the notion of vocational advance as they came to connote jobs shaped by "explicit *internal* development," such as ascending from shop-level entry to managerial rank through the acquisition of skills and "experience" toward personal (and national) economic flourishing. Professionalism acquired the temporality of deferring recognition and reward until after the employee demonstrates, as historian On Barak puts it, his "internalizing and participating in his own subjugation as an employee."[95] Generally, however, careers of continual climb were withheld from racially demeaned groups.[96] It is striking, then, that Mandate Lebanese artists inverted professionalism's logic: by insisting on being perceived as professionals, they radically *externalized* their self-discipline and transferred its sensorial and sensual subjugation to their audiences and government. In creating professional venues for art viewing "along the lines of those found in the West" (see chap. 2) and following those lines as a career path, they sought to extend the logic of their discipline, or (willful) subjugation, to modernity and to a market. They did so first, by securing their audiences' participation in their values and, second, by compelling the government to guarantee support for their efforts.

This externalization of self-discipline further sheds light on one feature of Lebanese art professionalism we have already encountered: its investment in emotional practices, which does not find parallel in other countries. Suspect, socially questionable jobs professionalizing concurrently in the United States, for example, abhorred or numbed practitioners' emotions. With their "case work" and "endless comparisons to established high-status professionals," early twentieth-century American social workers invoked science and business to claim cultural authority.[97] Arthur Todd, a pioneer in the field, proclaimed, "The true nature of social problems *cannot be seen clearly by eyes dimmed with easy tears*; nor can the calls to constructive social work be *heard above the thumping of a fluttery heart*."[98] I would argue that Beirut's artists and their audiences were learning to see a different kind of clarity, that of taswir. They saw art and themselves differently by attending to their alert pacing and rapturous swaying, as Yammut and Ghoussoub have testified (chap. 2). The artists' radically externalizing professionalism involved an emotional transference to create a new type of person, and even the new class that was heralded at the Muslim Scouts' 1927 show, i.e., tabaqat al-muthaqqi/afin, or ashab al-dhawq. With the

genealogically established genre of the nude as the professional beacon, and bodies as emotional vectors of the profession's aesthetics, artists and audiences made claims on their would-be government.

For example, when Farrouk and his self-declared professional peers discovered in the summer of 1934 that "a Hungarian" painter had received the commission to decorate the newly inaugurated Parliament building's Chamber of Deputies, the former led a delegation of artists in storming the Office of Public Works at Sanayeh to demand redress. A hasty dispatch from the officer who received them conveys to his superiors at the Parisian Ministry of Foreign Affairs their wrath that the French-appointed "Lebanese government had commissioned a 'foreigner.'"[99] While the public officer implored his callers to consider the commission a mere business transaction and the fault of the local contractor—"a M. Mourr"—he beseeched his superiors to allocate a budget to hire "the principal Lebanese artists" to decorate numerous panels for Parliament.[100] The officer also felt compelled to remind his superiors in motherland France that to meet France's civilizing mission, "they *should be* solicitous of Lebanese arts."[101] One sign of such solicitousness may be the subsequent establishment of the Friends of the Arts Society (le Société des Amis des Arts), supporting professional artists, run by the wife of Lebanese president Debbas, and matronizing artisanry, photography, and aesthetic propriety generally (fig. 3.9).[102]

It comes as no surprise that the membership card for the new Friends of the Arts Society, doubtlessly designed by Farrouk, features a nude, joining genre and genealogy.[103] Its visual language underscores the intertwining of global (or "universal" in period parlance) and local art history. To the left rise the mountains that ring Beirut from the north with a city view replete with mosques, minarets, and public arcades. To the right is the famous Pigeon Rock, facing south. Between them, loom a palette and three pristine brushes ready to be dipped, not in pigment, but in the unceasing inspiration provided by an Aphrodite figure. The floating torso may be Farrouk's abbreviation of the recently discovered *Venus of Cyrene*, which Farrouk saw at the National Museum in Rome, when he studied there between 1924 and 1926. Art historians at the time believed it to be an "exceptionally beautiful" example of a Venus Rising from the Sea and attributed it to an Alexandrian school of the second century BC.[104] In any case, his composition suggests that al-fann al-jamil could be imported to create communities joined by sentiment, posture, and interest. The card enunciates belonging to a professional society in a visual language that harmoniously blends scenes from the Lebanese coast with elements from an academic art atelier, Parisian cafés, and perhaps even Libya. By inscribing one's name on the *M.* line, one became a "monsieur," literally a titled, propertied man.

FIG. 3.9 Moustapha Farrouk, *Société des Amis des Arts* [Friends of the Arts],
membership card, 5 × 8 cm, ca. 1935. Reproduced with permission from
Moustapha Farrouk, 1901–1957 (Beirut: Nicholas Sursock Museum, 2003), 22.

Possession here refers to being a progenitor of art affiliation, and those whose
names appeared on the "*delivrée à*" (delivered to) line became variants of a
certain type of person: a "friend" and "member" of universal, professional art.

Read in this light, the guest signatures from Farrouk's 1933 golden book can
be seen to entwine two competing temporalities around signs of professional
art. I call them congratulatory and aspirational time. The Mandate-installed
president of the republic inscribed the first, in French: "All my felicitations for
the profits you've realized."[105] Charles Debbas's inscription addresses a finished
event: efforts had been made; their result appeared; the government leader rec-
ognized and responded joyfully. Several subsequent signatures also installed
congratulatory time, but another type of temporality quickly intervened, at the
bottom of the first page. Here, Marie and Georges Hadad (sister and brother-
in-law of Debbas's political rival, Bechara al-Khoury) rejoined, also in French,
"With our most sincere *wishes* for a success that is certainly *merited*."[106] *Wish-
ing* suggests that achievement remains incomplete regardless of "merit." Their
wishes interrupt the easy correspondence between achievement's recognition
and response that the signatures of Debbas and crew assume.

With his entry, Nassib al-Khuri Shadid directly appeals for the externaliza-
tion of professionalism to enact a change of local "environment": "Oh Mustafa,

in our country, you are *like a young plant growing in the desert*. All that you lack is a proper environment [*bi`a saliha*], so that you may soar in *the skies of universal art* [*fi sama' al-fann al-`alami*]. So create, if you can, this environment with your efforts and sheer will, and we will be grateful to you. Onward, ye carrier of the flag of art's renaissance with this [brush?]. Until we meet again next year. He who sows, reaps."[107]

The subsequent forty pages of signatures alternate between the congratulatory temporality of individual success, achieved and secure in its recognition, and the aspirational temporality of a merit that is yet incomplete because of lack of response. The signatures do not consistently divide along an official-populist line, and even less by linguistic affiliation or sectarian association. Some entries combine the two temporalities.[108] Born alike from a commitment to professionalism, both temporalities bespeak the emergent discourse of the colonial citizen: making wishes in relation to a Mandate regime based on cultivating merit—and, its twin, the civically responsible government, legitimated by recognizing merit. Even when the former was incomplete, it became a means of espying the latter, especially in its absence.[109]

Across the Frame: The Bodywork of *The Two Prisoners*

The citizen (muwatin) is a concept made with art. Demarcating the self seen for seeing, the nude *mise en abyme* produced by Farrouk, Onsi, and peers audaciously maps a new space in the city from which people might develop as responsible, modern citizens or, failing that, relapse. Perhaps the strongest demonstration of the nude's art act resides in works that can strike present-day eyes as most like classical, Orientalist representations of "Eastern women," the paradigmatic nonself, seen for becoming invisible and universal, as Western-based feminist scholarship has argued. I have written elsewhere of Moustapha Farrouk's 1929 painting *The Two Prisoners* as an ambitious intervention into Mandate Beirut's turbulent gender roles.[110] I there showed the canvas to be constructed of myriad paradoxes: its naturalistic brushstrokes do not offer a realistic scene; its composition references an Ottoman harem, alien to Beirut; it shows a woman who appears to blend organically with her setting but could not have mobilized such wealth; and lastly it borrows a "foreign," probably French, woman's body to portray this "Eastern" scene. All this to create an image "of" local society, not in the sense of mirroring but provoking it. It is the axiomatic locally made import. I argued that the deliberately strange image put Farrouk's contemporaries on the spot, compelling them to consider their response to, and shaping of, the female subject's fate. I return to *The Two Prisoners* here

FIG. 3.10 *Al-Sajinan* [The two prisoners], Moustapha Farrouk, oil on canvas,
38 × 46 cm, 1929. Private Collection. Courtesy of anonymous collector.

to define it as a nonrepresentational sura, neither realistically representative
nor inauthentically derivative. The bodywork it embeds and conveys concisely
embodies the fantasm's art act.

Across from the provocative pairing of *Souvenir* and *Crépuscule* at Farrouk's
2003 retrospective, a diminutive composition glittered in a heavy gilt frame
(fig. 3.10). On opening night, my hostess, Lina, admired its "daring" depiction.
As I looked on a few days later, a woman in a chic, logo-bearing sweat suit and
matching trainers stopped to read the commentary and stood enrapt before
the painting for over two minutes, ignoring everything else on the wall. The
canvas's rocky colors of garnet, vermillion, and cadmium, glinting against
the rich mocha and amber tones, invigorated its intimate scale. An odalisque—
the continental art historical term for a woman whose presentation confines her
to a room—languishes on her divan before an open window. The tiniest work
in the hall—no larger than my two hands—was ensconced amid grand sienna
portraits of patrician merchants, the artist's self-portraits, the iconic Baalbek
temple, and quaint urban views of Beirut, including one titled *Veil's Off* (see

chap. 5), showing a schoolgirl with a brilliant smile. Yet, more than any of the others, the odalisque drew viewers.

When I had previously seen *The Two Prisoners* in the portfolios of reproductions Farrouk's son, Hani, sold around Beirut, I had frankly felt repelled by its blatant affiliation to Orientalist conventions. Had I left academic Western art history only to find its insidious ideas ensconced here? How could Farrouk compose such an image to "forward a watani orientation" among his 1929 visitors? (See chap. 2.) Did it not violate his own declared intention to exclude "*manazir gharbiyya*" [Western views] and, expressly, "naked feminine bodies"?[111] If not, what *did* this work do? To my surprise, the interest in *The Two Prisoners* that companions touring with me expressed drew me to parrot the tale Farrouk gives in his memoirs of the odalisque's origin: he wanted to make a picture of "two prisoners" in which a "typical *mar'a sharqiyya*" (Eastern woman) contemplates her similarity to a caged bird, but because he was not working from a life model, the composition escaped him until he borrowed the body of a "foreign intellectual friend's wife" to get the knee right.[112] People loved the story. Before the show ended, the assistant curator stopped me to tell it back to me. This interaction, exceeding that attained by any other figurative work in the retrospective, encouraged me to think about the bodywork the nude accomplished and still accomplishes for the production of citizens. The mindfulness enacted and instilled by the canvas's main protagonist, I will argue, encapsulates the fantasmic character of Mandate-era work.

It was only when reviewing my field notes from tours with companions at the 2003 Sursock retrospective and considering *The Two Prisoners* in its room of watani characters and scenes that I noticed a curious feature distinguishing this odalisque from all others I had viewed in my art history courses: the direction of her gaze. Where most odalisques either look vapidly at the viewer or mindlessly regard their own quarters, she looks out a window, away from her chamber of confinement.[113] Positioned in a roomful of works from Farrouk's 1920s output, she seems to inspect her peers. In 1929, when she first appeared at Farrouk's solo show in AUB's Green Room, her peers included Farrouk's "watani figures": the legendary Emir Bashir; the anti-Ottoman agitator Habib Pasha al-Sa`d; the current President Debbas; international independence advocates like Egyptian prime minister Sa`d Zaghlul and American president Woodrow Wilson; cultural icons such as composers Sayyid Darwish and Ludwig Beethoven; thinkers like Jamal al-Din al-Afghani; and finally type figures (a grape seller, a shoe shiner, and a Bedouin woman).[114] In describing his pictures as watani, Farrouk spoke to a populace that literally lacked a constitution but that was vehemently engaged in its formation. He offered them a self-image to spark

a strategic self-recognition: recuperated institutional agents, entrepreneurial import-export elites, cross-regional cultural networkers, and religious leaders jockeying for regional sway. While the odalisque amid them synecdochically referenced a foreign sense-realm (genre and genealogy), her unconventional contemplative posture referred to the world just outside her window (or on the exhibition's walls). This postural reference to, and divergence from, the odalisque's characteristic mindlessness activates a fantasmic wataniyya that lies not within the painting's frame but in the distending, dilating lines of being it thrusts out, across the frame.

In Gellian terms, *The Two Prisoners* abducts each lingering viewer to consider the force that manifests in its narrative of captivity. Yet, unlike the basic predicament Gell describes, in which viewers do not know how to make a work but *do* know what force to acknowledge behind a work's creation, *The Two Prisoners'* viewers face multiple dilemmas. Beyond the paradoxical features listed above, which preclude identifying a specific source, the canvas provides no clarity about the mechanisms confining the female prisoner. It simply highlights her difference from the canary: no iron bars her window. If the mixed materiality of *The Two Prisoners*—its multiple sources, references, and allusions—derails any straightforward abduction, how the canvas's female *sees* intervenes in how she *looks*, or abducts. Signs of touching (fabrics, glass, metal); tasting (smoke and pipe); smelling (tobacco and leather); and hearing (the canary's song) saturate the scene and engulf audiences in the woman's corporeal, perceptive being. Farrouk's naturalistic brush provides such access to the woman's sensuality as to upset any decorous scenic arrangement between viewer and object.[115] She is, as Nead would say, obscene: apparently stilling viewers with her unexpected visibility.[116] But the viewing line splits, potentially escaping the axial material-visual bond if, *just if*, the viewer's eye lifts from the peaked nipple to the hot blushing cheek and up to the odalisque's darkly kohled eyes, which have turned away from the room and the pipe. Indeed, this would be a turn from multiple sensual and sensuous elements. Scenically rearranged from the metropolitan genre, the compositional line leading from the woman's pipe to her face points not back to some originating force (i.e., intrepid artist or arresting viewer) but outward, across the frame, to the space the audience takes for its home. The canvas's viewer becomes the object of the odalisque's view.

In other words, the line of the "if" chosen by the viewer's eye spells out the importance of studying the nude outside of presumed Western patriarchalisms and ontology.[117] The subject of this canvas looks like a "naked feminine body" only if we rely on the representational boundary in the aesthetic encounter between subjects and objects, or between audience and art. This odalisque's

final "look," resting on the tip of her gaze, depends on how viewers enact the fantasmic composition: Will they be trapped on the breast-canary axis or see the bigger picture (which includes themselves)? And seeing themselves seeing that latter option, how will they respond? The recognition of the fantasmic nature of the canvas clarifies the paradox of its inclusion in Farrouk's Green Room exhibition. As we saw in chapter 2, watani pictures are those that intervene in the ongoing state of affairs, not those that passively represent it. *The Two Prisoners* presents a "nude" and not a "naked feminine body" because of how it incorporates, literally, the Beirut-based viewer-cum-citizen into its composition. This is the local art history of the nude. Its difference alerts us to how nudes taught viewers what to incorporate of the novel, contemporaneous world into their political imagination.

Consider two similar images with more daily-life applications (figs. 3.11 and 3.12): The first, distributed by Na`mani Brothers' fabric store, envisions women filling with envy and a will to out-buy after seeing others' purchases.[118] Just as two women exit the store with their purchases tucked neatly under their arms, another enters, causing them to look back over their shoulders. In this web of gazes, their return to the store is both secured and never to be finished. They recall a passage from Farrouk's discussion in his memoirs of his motive to make *The Two Prisoners*, in which he asserts that women "here," "in our era," languish and decline without an *aesthetic* upbringing.[119] According to Farrouk, Beirut's Mandate women could smoke, speak foreign languages, gamble, and frequent cinemas—all imports—but "remain in a state of ignorance [and] materialist fever, and [thus] exploit and compromise men *with their bodies*."[120] Clearly, the languishing that Farrouk lamented was not an absence of activity—none of these polyglot, smoking, cinemagoers lolled on sofas!—but a confusion caused by interactivity. Lacking dhawq, they submissively return, as in the Na`mani Bros ad, ever and again to aesthetic encounters for which they are ill-equipped and to an insidious kind of exhibitionary sociality that dulls their thinking rather than activating it. In other words, Farrouk accused his female compatriots of lacking mu`asara (knowledge of how to use new imports) despite their investment in hadatha (undertaking modern activities).

The second image, made to support a campaign for women's rights, underscores the importance of interactivity to cultivating female citizens and of "feminine" interactivity to cultivating male citizens. The same year he made *The Two Prisoners*, Farrouk inked a caricature to open woman activist Nazira Zayn al-Din's bold book, *al-Sufur wa-l-Hijab* (Unveiling and veiling), which not only petitioned for the right not to veil but scolded Mandate authorities for overseeing a sham modernity that excluded recognition of women's rights

FIG. 3.11 Ad for Na`mani Brothers, *al-Ma`rid*, January 6, 1928, 8. A caption below explains, "Those entering envy those exiting their expensive, modern purchases." Courtesy of Special Archives Collection, American University of Beirut.

(fig. 3.12).[121] Briefly, this sketch pits proponents of veiling (on the left), all male and led by an aged figure needing a cane to keep his stride, against advocates of unveiling (on the right), of mixed genders, mostly younger, and led by a young woman taking wide, confident strides. Despite the raised fists on the left, the advocates of unveiling advance uncowed and unruffled—one even takes a moment to "paint herself" with a mirror and lipstick.[122] Zayn al-Din's strongest opponent was Farrouk's own mentor and spiritual refuge, Shaykh Mustafa al-Ghalayini, meaning the shaykh figure possibly caricatured him.[123]

Whether "at home" with *The Two Prisoners* or in the streets with *Advocates of Unveiling*, these suwar advance an art act by asking how the civic subject will respond to a situation of clamoring materiality, ever-flowing imports, and enticing foreign elements. The odalisque of *The Two Prisoners* fails as a political subject because she does not join her mind to action; or rather, she actively

انصار الحجاب دعاة السفور

FIG. 3.12 Moustapha Farrouk, *Du'at al-Sufur, Ansar al-Hijab* [Advocates of unveiling, partisans of the veil], ink on paper, 1929. Reproduced from self-printed postcard. Courtesy of Hani Farroukh.

becomes inactive by taking in pleasurable substances (perhaps hashish in her pipe) and melding with the gorgeous array of dazzling textures and surfaces around her. She overincorporates and forfeits her corporeal capacities. The advocates of unveiling frankly incorporate foreign elements, covering their bodies in the same Parisian-informed fashions that Onsi's female Muslim protagonists wear to the exhibition (minus the balarin and yachmak, of course); but they arise from their couches (and they do not tarry in the store either) to join as one body, aligning their postures (note the echoing forms of the three female protesters behind the lead female) and even gathering men to their action. Although the artist can be seen to rib the lipstick-fixing protestor (who, if she continues this way, could miss the action), he also references creativity of self-representation as a version of painting the self. Both suwar oblige viewers to position themselves in relation to social futures (or coexistent presents) and pick, synecdochically, how they will affect those futures.

 Should we be surprised that it is before the nude of *The Two Prisoners* that Kamal al-Naffi issues his clarion call for civic duty? This is the same critic whom we found visiting Farrouk's 1929 exhibition and unbelieving such an event could occur in "not Venice" (chap. 2). In his review of that show, al-Naffi ardently hopes that "in the future, [his] countrymen may appreciate art properly and give it its due, for in so doing, they would show that they are a living people truly striving for freedom."[124] To close his review, he positions his reader before Farrouk's watani odalisque: "With the picture *The Two Prisoners* you are

in front of a ma' ra sharqiyya stretched out on a couch covered with sumptuous silk brocade. She glances at her companion in prison, a small bird placed in a cage that sings sad songs that bring pain to the heart, the songs of the eternal prisoner. For they are both, verily, prisoners whose counsel still, *to this very day,* fights to defend their cause before public opinion." With this final emotional practice of naming and pointing to the transference of sadness, the critic draws readers-cum-viewers into the ongoing debate.[125] They are spoken to by "fertile art." How will they respond? What imagination and embodied images will they form out of Farrouk's fantasmic art?

With the trope of teleological change challenging the obstinate "still," al-Naffi warns that people can have mu'asara without hadatha. Merely living "this very day" does not guarantee living the life of an "elevated city." Having already set the stakes in "giving art its due" so high as to include national liberation, al-Naffi here calls on his readers to conform to the demands of mu'asara, to demonstrate their parity in linear time and their ability to embrace new gender relations, by engaging in sensorially re-attuned, aesthetic art loving. They should attend shows, support art, and not leave aesthetic uplift to "the foreigners in charge."[126] Looking at *The Two Prisoners* should change not only how they see themselves but how *here* can be seen, too. Or as Farrouk himself quipped of art's synecdochical agency, "There is no art among slaves."[127] Inserting an art act among regular, relevant public acts such as shopping or mobilizing, nudes meet the appeal for nourishing a mukhayyila to generate salutary suwar out of viewers' own bodies and behaviors. They instigate naming and deploying emotions such as envy, anger, or despair for situations of unclear interactivity to cultivate ashab al-dhawq. In sum, fantasmic pictures do not represent; they teach people to envision.

The Transitive Bodywork of Fantasmic Objects

Yet, in telling this story of bodywork, I have started from the middle, as it were, truncating the first half of the art act. Despite the many sketches to draw on from his training period, the young painter found his keenness for anatomical propriety undermined by a problem of foreshortening. The angle of the woman's left thigh, almost perpendicular to the picture plane, demands compressing the limb's length. Unless handled deftly, the exact point where the woman's body most nearly verges on breaking into the viewer's space will collapse and sacrifice the illusion of spatial depth.[128] The woman would look like little more than a surface design, far short of a pulsating force. In his memoirs Farrouk provides a delightful tale of overcoming the problem of the knee.[129] Suffice it

to observe here that his telling (and the retelling I and others deployed) could be heard as masculine bluster: The heroic male artist overcomes the "magnificent emotion" of standing before a totally naked body and transforms it into a conception for an idealized composition.[130] Or the vulnerable man cravenly establishes his credibility on the submissive female body. Likewise, we could dismiss the anecdote (and, again, the whole corpus) as banal and derivative: these are merely the experiences every artist striving to succeed "along the lines of the West" must undergo. Finally, we might take the tale as simply an idiosyncratic account of one painter's escapade. Yet I think all these readings miss the communication of personal trial and sensorial re-attunement. I hear Farrouk speaking poignantly, if drolly, about dhawq and the possibility of tathqif.

The process starts with a fantasm. Using his capacity for taswir, Farrouk assesses the situation of his fellow colonial citizens and envisions in his mukhayyila a female's fate. He (over)hears her speak of her condition. She speaks from an opulent chamber, articulating a problem of acquisition and incorporation. Insisting for his composition on a form more familiar from postcards than daily visual experience, Farrouk pursues the question: How does one relate to new elements?[131] Dhawq weighs in. Despite not having all the constituents (i.e., a life model), Farrouk's taswir, informed by dhawq, puts together a pleasing picture that captures the discerning eye of his foreign friend, a "muthaqqaf," who ascertains the painter's need of a life model. Further, dhawq allows Farrouk to act appropriately when a model materializes (the friend's French wife). A key facet in this story is the deceptiveness of appearances: what could look like a woman offering herself for private heterosexual male pleasure, the muthaqqaf Farrouk discerns as the possibility for broader, public benefit. In fact, Farrouk and his foreign friend act in unspoken harmony toward the transcendent matter of art, despite coming from different cultures. Moreover, the model exercises dhawq: Seeing a new situation calls for thinking about her resources and ability to integrate into a larger cause. She puts her physical beauty and personal appreciation of art at the service of a fannan, who metamorphosizes them into a public asset. In doing so, she extends her husband's tathqif, becoming (if she was not already) a *muthaqqifa* (female intellectual, transitive form). Then, despite a momentary return of tremors, Farrouk swiftly and decisively channels his sensual response into producing a socially beneficial artwork that pleases both his foreign sitter and himself. Although Farrouk closes the studio door to bar untrusting onlookers, he opens another door, through the medium of al-fann al-jamil, to a new society via his transitive process of tathqif. Its horizon extends to public well-being each time *The Two Prisoners* appears on display. Provided, that is, viewers in turn treat the odalisque as a (synecdochical)

fantasm and not as a reflection. Her mindful gaze can unlock the bodywork that makes nation work happen.

Lest this tale of tathqif al-dhawq appear limited to the reflexive Farrouk, the self-exulting Cesar Gemayel supplies several similar stories. Hobeiche reported Gemayel's appeal in 1930 to take his suwar as self-work: "As for me, I consider figurative art [al-taswir] to be a language through which the picturer changes the emotions and reactions he produces within himself."[132] Notably, Hobeiche carefully inscribed Gemayel's practice in a genealogy extending to an "advanced traditional school" [al-madrasa al-taqlidiyya al-mutatawwira] that "leans toward" ancient Greek art.[133] This description pitted Gemayel's practice against "extreme innovations" [al-tajaddud al-mutatarrif], such as cubism ("which is a few lines") and fauvism ("which is like drawing a broom, for example, and calling it a man, or picturing two lips of exaggerated size to express the meaning of lust therein and say that it symbolizes a woman with enflamed emotions, affected nerves, and lustful tendencies").[134] Similarly in 1938, critic Shafiq Hatim explained the difference between "nudes as a form of art and vulgarity" and observed that Gemayel "assertively" learned to make nudes.[135] Painting nudes exercised Gemayel's capacity for certain feelings, produced internal changes, and demanded a name by which to be communicated and mobilized to the wider public via his art.

Mandate-era nudes demonstrate that artwork and audience are not separate. They are mutually productive, with composition lines tying one to the other and back. In the previous chapter, we saw that colonial citizens converged on modernity in an exercise of hadatha by cutting their emotional practices from Ottoman cultural flows—symbolized by the retrograde shaykh lurking outside the New Year's Day show—and, in an exercise of mu'asara, by overlapping their sense-realm for attending art, that is "walking with" audiences elsewhere "in the new era." This chapter has added to these emotional practices corpothetic bodywork to account for extensions of the art act into people remade as ashab al-dhawq.

The nude as a genre was key to this ambivalent, anxious process. As genre replaces geography with genealogy, it also unhinges genealogy from national boundaries. More than professional certificates of accomplishment, lifelike figural works pulsating with tactile provocation were instigators of thinking about one's own life, at least according to some ardent viewers. Fantasmic suwar, nudes embedded the audience within the artworks and demanded consideration of the aporia where perception and interpretation, corporeal and incorporeal, public and personal meet. I have argued that artists and audiences at Mandate Beirut exhibitions learned to refine their emotional practices as

civic subjects and subsequently made claims on themselves, their compatriots-
to-be, and their putative government. We saw this in the arc from Farrouk's
frigid shower and Qur'anic verses that established calm and confidence to his
leading the delegation demanding parliamentary commissions and securing
government-funded exhibitions. We read of this transitive learning, too, in
his registry where signees called for his personal successes to be externalized
in a new local environment. Most critically, we saw that audiences could not
rely on given codes of conduct to guide their interactions but had to improvise
their cullings from traditional and borrowed, "French" and "local," feminine
and masculine, spiritual and mundane. Conventional models for explaining
art's social role, such as Gell's abduction and Bourdieu's habitus, have tended
to emphasize—even despite counter-intentions—the reinforcing role of aes-
thetic proclivities exercised in culturally shared (if stratified) art settings.
Bourdieu's model of "taste" as a mechanism of distinction has been especially
important to accounts of hierarchy's reproduction. Yet neither author studied
the role colonial citizens found for art in double-decolonizing settings they
crafted by exercising their taswir. They have thus overlooked the fantasmic
objects that spawn art acts and introduce gaps for social change. This points
us to the responsibility that audiences invited into art acts have for engaging
their taswir.

Coda

Three years after the Sursock retrospective for Farrouk, and in the aftermath of
a thwarted Israeli aerial and ground invasion of massive scale, throngs gathering
in Beirut's downtown resonated to an ominous echo of Lina's pronouncement
of her fellow retrospective-goers as ashab al-dhawq, or "quality people." First,
a joke circulated by SMS, telling of how even the statue of Lebanon's founding
prime minister, Riad Al Solh, had been affected by the massive encampments of
protestors against the current government: its hand had lifted to hold its nose!
Leading up to the condemnation, one politician justified his minority party's
prominence in the unswayed government, saying, "What matters is quality, not
quantity."[136] For many listeners, whether his party had quality was debatable,
but the idea that quality could be detected publicly and could guide political
behavior in lieu of a free electoral process was not. Rather than attacking the
criteria, Hizbullah spokesperson Na`im Qassim responded to accusations of
his party being *bila* dhawq (without dhawq) by asserting that until the prime
minister resigned, the sit-in would remain "peaceful and civilized [*silmi wa-
mutahaddir*]."[137] Reporters for affiliated stations continually commented on

the "civilized" methods deployed. The equation between dhawq and civil rights today is not confined to parties at one end of the political spectrum.

Months later with the sit-in ongoing, Hizbullah's radio station, al-Nur, broadcast a staged radio dialogue between an aged male professor and a female university student.[138] The latter despaired the critics refuting the party's right to protest, "saying that it's a bad demonstration, and pointing to its [unattractive] appearance and the garbage everywhere." Countering their logic, the professor asked the student to reflect on "Leonardo da Vinci's famous picture, *The Mona Lisa*." The student spluttered, "But it's so famous, it's *beyond me to comment on it!*" This was in fact the professor's point: "Exactly. Dust cannot detract from its value, *it is so invaluable*. If people were to *focus on the dust and miss the painting*, they do not deserve to comment on its beauty. And if people will *focus on appearances* of the demonstration, they are in no position to comment on its civilizational value."[139] The student deliberately did not articulate in words what she sensed about an artwork she knew well. Her silence emotes her ability to attune herself to a different set of standards, one lying beyond her daily focus of gritty dust and petty politics. For his part, the professor clinched the right to political participation, even dominance, in the same way that supporters of the embattled Lebanese government had denied it: by looking at looking, by highlighting sensual perception to fill out meaning and suture political peership. This dialogue, like the statue joke, engages art to intervene in the speakers' society and refashioning of their identity.

The Mona Lisa is not a nude, but she shares with the genre the capacity to index al-fann al-jamil, the civic duty to cultivate one's dhawq, and projects of political peership. Hearing her name invoked on al-Nur may surprise those of us who rely on a lineup of binary oppositions (as I admit I did when I first gasped upon hearing the dialogue): West versus East, Muslim versus Christian, political activism versus aesthetic conservatism, and so on. This lineup obscures the local cultural logic by which Lebanon has been produced through art. Al-Nur's *Mona Lisa* is a locally made import, the direct descendant of Mandate-era nudes. Fantasmic objects provide a medium for exercising one's capacity for response to new, inscrutable things encountered in unsettling conditions. *The Two Prisoners* and *At the Exhibition* contributed to heated debates about the active role women could undertake as citizens of a modern Lebanon. But, with their watani nudes, the canvases did more than, say, incite patriotic motherhood. Their intense physical proximity put viewers on the spot, made them look at looking in a new sense-realm. More than a mirror, a fantasmic composition compels the completion of its look or story by implicating onlookers into the imagination of its future and theirs. Regardless of their political outlook,

Lebanese citizens today have inherited the future of Mandate nudes, but many seem to have forgotten the fantasmic project.

Notes

1. Chahine, *One Hundred Years*.

2. Nicholas Sursock Museum, *Moustapha Farroukh*, 127 (emphasis added). I discuss the Onsi painting the wall text references below.

3. Chahine, *One Hundred Years*, vii.

4. Lebanese American University, *Human Figure*, 22. The text refers to Khalil Saleeby.

5. Turner, *Ritual Process*.

6. Gell, *Art and Agency*.

7. E.g., Dodge, "Introduction."

8. Muhammad Ahmad al-Ghamrawi, "*al-Dhawqan al-Shakhsi wa-l-Muktassab*" [Personal and acquired dhawq], *al-Mashriq* 29 (June 1929): 443–46.

9. Al-Ghamrawi, 445.

10. Lane offers a dual definition, both a quality revealed "by means of the moisture of the tongue" and a capacity to perceive such quality, or "intellectual discernment and relish" generally. Lane, *Lexicon*, 3:988.

11. Bourdieu, *Distinction*. E.g., Beal, "Real Jordanians"; Salamandra, *New Old Damascus*; Sehnaoui, *l'Occidentalisation*; Deeb and Harb, *Leisurely Islam*; Abou-Hodeib, *Taste for Home*.

12. Abou-Hodeib, 35, 29. Akram Khater, likewise, documents painful discussions of the realignment of social positions, access to wealth, and the distribution of goods that result in much confusion, but glosses them together as "a shift in taste toward the 'modern.'" Khater, *Inventing Home*, 15, 41–42, 125.

13. Ibn Manzur, *Lisan al-'Arab*, 5:71. Cf. Moosa, "Muslim Ethics?," 239.

14. Al-Zabadi, *Taj al-'Arus*, 25:326–28.

15. Al-Zabadi, 25:327.

16. Al-Zabadi.

17. Bustani, *Muhit al-Muhit*, 731–32.

18. Bustani, 731.

19. Yusuf Shalhat, "*Dhawq—Dirasa Falsafiyya*" [Dhawq—a philosophical study], *al-Muqtataf* 17, no. 2 (November 1892): 81–87, p. 81.

20. Recalling al-Zabadi, Shalhat writes that an immediate energy, experienced as enlivenment or invigoration, sets into the chest when dhawq acts. He poses this immediateness against the intervention of reflection (*tabassur*), will (*irada*), thought (*fikr*), or narrative (*riwaya*).

21. Shalhat, 83–84.

22. Labiba Hashim, "*Tarbiyat al-Dhawq: 1*" [The training of dhawq: part 1],

al-Hasna' 3, no. 11 (November 1911): 62–65; "*Tarbiyat al-Dhawq: 2*" [The training of dhawq: part 2], *al-Hasna'* 3, no. 12 (December 1911): 109–13, p. 111. Hashim's lecture appeared serially in multiple journals, increasing its reach.

23. Hashim, 109 (emphasis added).

24. Hashim, 63.

25. Hashim, 110.

26. At the 1921 Beirut Fair, one reviewer noted that when seeing Khalil Salee-by's paintings one "cannot but contemplate the merits of dhawq." "*Fi Ma'rid al-Manshiyya*" [At the Manshiyya Fair], *Lisan al-Hal*, May 18, 1921, 2. By contrast, the term appears regularly in Sarrouphian's advertisement for stationery goods, such as *Lisan al-Hal*, April 14, 1921, 3.

27. Yusuf Ghussub, "*al-Sayyid Farrukh*" [Mr. Mustapha Farrouk], *M. Farrouk, Artiste Peintre* (Beirut: self-printed, 1929), brochure, HF.

28. "*Ma'rid al-Taswir wa-l-Naqsh*" [Exhibition of painting and sculpture], *Lisan al-Hal*, December 12, 1932, 3; "*Ma'rid al-Naqsh wa-l-Taswir*" [The sculpture and painting exhibition], *al-Bashir*, December 23, 1930, 1.

29. Yusuf Ghussub, "*Yaqazat al-Fann fi Lubnan: Nazra fi Ma'rid al-Taswir wa-l-Naqsh*" [The art renaissance in Lebanon: A glance at the painting and sculpture exhibition], *al-Mashriq* 6, no. 2 (February): 85–91, pp. 86, 85.

30. Ghussub, 85.

31. E.g., Ghussub; Jawaba, "*al-Musawwirun al-Wataniyyun wa-l-Ajanib Ya'riduna Atharahum*" [Local and foreign artists display their works], *al-Ma'rid*, January 22, 1931, 8–9; Jawaba, "*Ma'rid al-Fannan 'Umar al-Unsi*" [The artist Omar Onsi's exhibition], *al-Ma'rid*, February 28, 1932, 20; Munir al-Husami, "*Sa'a fi Istudyu Farrukh*" [An hour in Farrouk's studio], *al-Ma'rid*, March 27, 1932, 8–9.

32. *Exposition du Peintre Farrouk, 15–24 December, 1933*, 30 (hereafter cited as Registry), 8, 17, 20, HF.

33. Ghussub, see note 29, 86.

34. Ghussub.

35. Jawaba, "*al-Unsi*," see note 31.

36. See Omar Onsi archive book compiled by Joseph Matar. JM.

37. Jawaba, "*al-Unsi*," see note 31 (emphasis added).

38. Jawaba.

39. While three of the fifteen all-male students touch the model's shoulders and legs, much more touching joins the men to one another: the men on either side link arms behind her back, and several other students rest their arms on a neighbor's shoulders. Cf. Salomon, "Venus Pudica."

40. On the importance of life models at these ateliers for Onsi's training, see Marcelle Proux, "*Onsi, le silencieux*," *l'Orient*, November 17, 1937, 1–2. His descendants recall hearing also of the "Atelier Julian." A 1953 interview, however, attributes

his exposure to a life model to the wife of Khalil Saleeby, Onsi's teacher in Beirut from 1918 to 1920. Majida ʿAttar, *"Maʿa ʿUmar al-Unsi"* [With Omar Onsi], *Sawt al-Marʾa* 9, no. 1 (January 1953): 20–22, p. 21. According to his son Hani, Farrouk worked on his memoirs in a single notebook with a title page, as if published, but leukemia overtook his publication plans. Hani published the manuscript in 1986 after two colleagues of Farrouk edited only the grammatical mistakes. The text is more intimate than any of Farrouk's others but is not unusual in tone or outlook.

41. Farrukh, *Tariqi*, 63 (emphasis added).

42. Farrouk's notebooks dated from 1916 to 1920 are rife with such imagery, male and female, some greatly resembling Habib Serour's compositions, suggesting he copied from his mentor. HF.

43. Farrukh, *Tariqi*, 65.

44. Farrukh, *Tariqi*, 65.

45. Farrukh, *Tariqi*, 65 (emphasis added).

46. Kristeva, *Powers of Horror*, 2.

47. Douglas, *Purity and Danger*.

48. Kristeva, *Powers of Horror*, 2.

49. Farrukh, *Tariqi*, 65–66.

50. Shaw, "Islam in Islamic," 7, 9, 10.

51. George, "Ethics," 591.

52. *Exposition Omar Onsi* (Beirut: School of Arts and Letters, 1932), exhibition brochure, JM.

53. The names for their dress components derive from the French *pelerine*, for the cape, and *bouché*, for the ballooning skirt.

54. Numerous female Beiruti interviewees in their seventies spontaneously proffered the Mahmasani identification when I conducted oral history in Beirut between 1997 and 2000. "Modern" fathers sought visibility through accomplished daughters' public appearance. Khater, *Inventing Home*, 164.

55. The diwan of *Imruʾ al-Qais* details the humiliating revenge ʿUnayza eventually inflicts on the bard.

56. M.D., *"Voyage autour d'un studio: Un quart d'heure avec le peintre Farrouk,"* *l'Orient*, [1932?], HF. See also C.K., *"Dans le studio d'Omar Onsi,"* *la Syrie*, March 6, 1932, 1–2. Another writer praised the artist for "overcoming his Oriental culture" by depicting a young woman sensually. Zuhair Zuhair, *"al-Jamal bayna al-Akhlaq wa-l-Ghariza"* [Beauty between manners and instinct], *al-Makshuf*, July 3, 1937, 9. Jawaba, "al-Unsi," see note 31.

57. Rushdi Maʿluf, *"Jawla fi Maʿrid Qaisar al-Jumayyil"* [A tour of Cesar Gemayel's exhibition], *al-Makshuf*, May 19, 1937, 9.

58. Fuʾad Hubaysh, *"Saʿa fi Istudyu al-Fannan Qaisar al-Jumayyil"* [An hour in artist Cesar Gemayel's studio], *al-Maʿrid*, July 5, 1930, 8.

59. Likely small in number, the *Ansar al-'Uri* (Partisans of the Nude) movement had outsized impact through its press coverage. For the connections between nude art criticism and nudism, see Scheid, "Looking"; Bizri, "Nudism."

60. Ghussub, see note 29, 86. The concern for artworks' pulsations may well have connected to a vitalist, Bergsonian project of unleashing underlying creative-social forces that animated the Damascene publication *al-Thaqafa* and painters influenced by it. Lenssen, *Beautiful Agitation*, 4, 11, 97, 113. This same publication supplied a lithographic copy of Chabas's *Au Crépuscule* (which was the source for Farrouk's copy and *Souvenir*) in April 1933. My thanks to Anneka Lenssen for sharing the issue of *al-Thaqafa*.

61. At least thirty years earlier, Philippe Mourani, for one, had regularly produced commissioned copies of Raphael's paintings for Beirut's noble and entrepreneurial families, as listed in his accounting book for 1895–1901. DG.

62. Guha-Thakurta, *Monuments*, 159.

63. Kapchan, *Gender*, 4.

64. Kapchan, 342.

65. Fabian, *Remembering*, 195.

66. Hani Farroukh has preserved his father's paint set, which contains tubes of oil pigments produced by Winsor & Newton (London) and J. M. Paillard (Paris); pencils produced by Rexel Derwent (England) and L. & C. Hardtmuth (Czechoslovakia); and charcoals made by LeFranc and Conté à Paris. HF.

67. Jawaba, "*al-Unsi*," see note 31; Proux, see note 40.

68. Pollock, *Gambits*, 14.

69. Clark makes his geographic claims throughout the text. See K. Clark, *Nude*, 3, 4, 71, 120, 315.

70. Nead, *Female Nude*, 12.

71. On admission restrictions, see Cone, *French Modernisms*, 12–13, 34. Nevertheless, a steady stream of Arab students enrolled at the École from the early twentieth century. Alice Thomine-Berrada, "*L'art abstrait, Paris et les artistes du Moyen-Orient et du Maghreb*" (lecture, l'Institut d'études de l'Islam et des sociétés du monde musulman [IISMM], Paris, April 2, 2021).

72. Salomon, "Venus Pudica," 69.

73. Robert Chamboulan, untitled essay in *M. Farrouk, Artiste Peintre* (Beirut: self-printed, 1929), brochure, p. 1, HF.

74. Nassib, "*al-Fannan al-Mashhur: al-Ustadh Mustafa Farrukh*" [The famous artist: Mr. Moustapha Farrouk], *al-Badiya* 1, no. 9–10 (May–June 1929): 621–24, p. 622. Kamal al-Naffi, "*Ma'rid Farrukh fi al-Jami'a al-Amirkiyya*" [Farrukh's exhibition at the American University], *al-Ahwal*, June 1, 1929, page number unknown, HF.

75. "Artist Reveals Story of 'September Morn' Untrue," *San Bernardino County Sun*, March 8, 1935.

76. Nassib, see note 74, 623.

77. *"Al-Ustadh Farrukh fi Ma`ridihi"* [Mr. Farrouk in his exhibition], *al-Ma`rid*, June 9, 1929, 4; al-Naffi, see note 74.

78. K. Clark, *Nude*, 352.

79. Khater, *Inventing Home*, 39.

80. Churchill, *Beirut*, 15. Churchill conducted his study in 1952–53. Farrouk was so attached to his suits that even when photographed in his Italian classroom with all his classmates wearing smocks over their suits, he wore only a suit. See Nicholas Sursock Museum, *Moustafa Farroukh*, 16 (Arabic section). Though suited in early photographs, Onsi, in his maturity, resorted to casual clothing, familiar from scouting.

81. Cf. Mustafa Farrukh, *"Tali`at al-Fannanin al-Lubnaniyyin"* [The vanguard of Lebanese artists] (lecture, Cénacle Libanais, Beirut, March 28, 1947), AUB.

82. Papêterie Gédéon, *l'Indicateur Libano-Syrien* (Beirut, 1928), 245, CDAN.

83. See Sa`di Sinevi quoted in Nicholas Sursock Museum, *Moustafa Farroukh*, 14 (Arabic section); *"I`lan"* [Announcement], *Lisan al-Hal*, November 11, 1878, 4; *"I`lan"* [Announcement], *Lisan al-Hal*, October 29, 1883, 4; *"al-Rusum al-Jamila"* [Beautiful drawings], *al-Haris*, February 1924, 48; Sultan, *Ruwwad*, 262.

84. Omar Onsi archive book compiled by Joseph Matar. JM. At some point Onsi crossed out the downtown address and penciled in the location of his home in Zaydaniyya (today's Talat al-Khayyat).

85. I offer an overview of the terms in local discursive use. For their origin in medieval Arabic use, see Dagher, *Madhahib al-Husn*.

86. *Al-Ma`rid*, August 12, 1923, 3.

87. This phrase arose frequently in the oral history interviews I conducted with elderly Beiruti women.

88. Qaysir al-Jumayyil, *"Habib Srur, Musawwir al-Ruhban"* [Habib Serour, painter of monks], *al-Makshuf*, July 1, 1936, 12. This term was not necessarily pejorative. A photographer's advert in *al-Musawwir*, a Cairene illustrated journal, used it, too. *Al-Musawwir*, December 4, 1925, 10.

89. Ghussub, see note 27.

90. Ra'fat Buhairy, *"Bi-Munasabat al-Nahda al-Fanniyya fi Lubnan"* [On the occasion of the art renaissance in Lebanon], *al-Ma`rid*, February 5, 1931, 5.

91. The variant, *mutafannin*, a person characterized by versatility in a field, briefly served as an alternative to *musawwir* before *fannan* gained its respectability.

92. Ghussub, see note 27. I was alerted to this double entendre by Aref Rayess in 1997, when, during an exhibition opening and conference devoted to his work, he joked (in a jab at the then-minister of culture), "In my village fannan means donkey or beast." October 28, 1997, World of Art Gallery, Beirut. One examination of Ottoman, Persian, and Arabic follows *fann* from meaning simply kind or variety to specialized literary knowledge and hypothesizes that it took on an artistic

association through nineteenth-century translation practices. Mestyan, "Arabic Lexicography," 88.

93. Hanssen, *Fin de Siècle Beirut*, 75.

94. Williams, *Keywords*, 53; Bustani, *Muhit al-Muhit*, 2015.

95. Barak, "Egyptian Time," 141.

96. Barak, 140–41.

97. Kunzel, *Fallen Women*, 40.

98. Kunzel, 44 (emphasis added).

99. M. Rendu, memo #1505, July 9, 1934, file #104, *Instruction Publique*, 2ème versement, CDAN.

100. Rendu.

101. Rendu (emphasis added).

102. Letter from the Haut-Commissaire to the Oeuvres Françaises, 1933, Ministry of Foreign Affairs, Paris, file #97, *Instruction Publique*, 2ème versement, CDAN. The extant Beirut Artistic Society (Société Artistique de Beyrouth) had no such concern for professionalism. It supported costume parties as frequently as photography shows. The Friends of the Arts Society existed from at least 1936 to 1941.

103. This blank and undated membership card appeared at the 2003 Sursock retrospective, but the museum could not find records of its source. Rowina Bou-Harb, communication by email, July 7, 2021.

104. Bagnani, "Hellenistic Sculpture," 232.

105. Registry, see note 32, 1.

106. Registry, 1 (emphasis added).

107. Registry, 8 (emphasis added).

108. Take, for example, Salim Sa'b's entry on December 18, 1933, written in Arabic: "I congratulate the Arab artist, Mr. Farrouk, on the success of his products and wish for him, and I believe a shining future will be his (*sayakun lahu mustaqbal bahir*), and to his pictures (*wa-li-tasawirih*), great value." What commences with congratulations for a completed act disintegrates into vague visions of an unclear future, which for all its brilliance has no obvious means of coming into being: "*lahu*" and "*li*" only indicate connection, not means. If prior actions set "value," for what was Sa'b congratulating Farrouk, and what was he deferring to some vague hoped-for future?

109. A similar point pertains to the visibility of the Indian government's absence in film and festival events. Roy, *Beyond Belief*, 33.

110. Scheid, "Necessary Nudes."

111. Farrukh, *Tariqi*, 153.

112. Farrukh, 171. Cf. Scheid, "Necessary Nudes," 213.

113. Gülru Çakmak noted that Ibrahim Çallı (1882–1960) made a similar composition, *Outstretched Nude* (date unknown), now held in the MSGSÜ Istanbul

Painting and Sculpture Museum Collection, Inv. No. 2058/8350. Email communication, April 24, 2020. On the odalisque's vacuous facial expression of passivity inviting uninhibited scrutiny of her body, see T. J. Clark, *Painting*, 132–33. To my knowledge, the direction of the odalisque's gaze in relation to the space of her confinement has not been discussed. It generally either turns in toward that space or, turning toward the viewer, beckons the latter to join her inside it. Both reaffirm the enclosure's described boundaries.

114. *M. Farrouk, Artiste Peintre* (Beirut: self-printed, 1929), exhibition catalog, HF.

115. Crary, *Techniques*, 127.

116. Nead, *Female Nude*, 2, 20–21, 25.

117. Cf. Jain, *Gods*, 302.

118. The ad ran in every issue for 1928.

119. Farrukh, *Tariqi*, 171.

120. Farrukh (emphasis added).

121. For a translation and discussion of Zayn al-Din's manifesto, "*al-Sufur wa-l-Hijab*" [Unveiling and veiling], see Halabi and cooke, "Nazira Zeineddine."

122. Hani Farroukh suggested that his father may have been playfully referencing a period slur, "*tutrash wijha*" [lit., she splatters her face with whitewash/paint] for an overly made-up woman. Personal communication, December 15, 1997.

123. However, al-Ghalayini was known for his "modern" bow tie.

124. Al-Naffi, see note 74 (emphasis added).

125. For the debate over women's boundaries, see Khater, *Inventing Home*, especially chap. 6; Thompson, *Colonial Citizens*; Abou-Hodeib, *Taste for Home*, 88–91.

126. Al-Naffi, see note 74.

127. Farrukh, *al-Fann wa-l-Hayat*, title page.

128. Indeed, the identical charge was laid against Marie Hadad by *la Syrie*'s critic: "Her *Nude* clearly exhibits a leg that does not belong to it, but [also] such determination in her battle with the brush to obtain a certainty of touch that requires no repentance." Jean Dobelle, "*L'Exposition de peinture de la Société Artistique*," la Syrie, July 4, 1933, 1–2, p. 1.

129. Farrukh, *Tariqi*, 171. For translation, see Scheid, "Necessary Nudes," 213.

130. Raffaëlli, quoted in Garb, *Sisters*, 138.

131. For a postcard locally produced (by the Abdallah Frères based in Istanbul) and using the same basic structure, see Scheid, "Painters," 97–98.

132. Hubaysh, "*Sa'a*," see note 58.

133. Hubaysh.

134. Hubaysh. The description speaks more to surrealism than fauvism.

135. Shafiq Hatim, "*al-Ka'aba Tusaitar fi Ajwa' al-Adab wa-l-Fann 'indana*" [Despair dominates literature and art milieu among us] *al-Makshuf*, February 14, 1938, 6. The testimony of Gemayel's model, Miriam Khirru, likewise reports a move from intense discomfort, through a "learning" process involving exposure to

prototypes, to pleasure and even pride as audiences "expressed their amazement."
Nammar, *Hikayat Jasad*, 18–21.

136. Besides my own field notes, the comment was documented by Jean ʿAziz, "*Rahim Allah Pierre al-Jumayyil, Hal Man Yudhakuru ʿal-Kamiyya wa-l-Nawʿiyya*?*" [May God have mercy on Pierre Gemayel, does anyone remember 'Quality and quantity'?] *al-Akhbar*, April 23, 2009, https://al-akhbar.com /Politics/139972.

137. Al-Nur, November 28, 2006.

138. Al-Nur, March 18, 2007.

139. Al-Nur, March 18, 2007 (emphasis added).

4

LANDSCAPES
The Nation as Fantasm

"LOOK, LOOK! HOW *moderne*! The colors look as if today!" Today was February 14, 1997. I was again at Sursock Municipal Museum, this time attending the opening of the retrospective exhibition for Omar Onsi. The "surprisingly modern" mélange of colors appeared in a medium-sized oil painting titled *Houlé* (in Arabic, *al-Hula*) (fig. 4.1). I had already passed the picture when Nadine Begdache's bilingual outburst turned my head. I followed her eager hands as she swept an imaginary brush across the canvas surface, tracing an arc of freedom left by the "uninhibited" painter's hand. Her studied French accent imparted gravity as she guided me to consider how this artist had established a palette invoking light without contours. At the helm of Lebanon's preeminent Galerie Janine Rubeiz, *the* place for contemporary art in reconstruction-era Beirut, Begdache did not easily make time for earlier artists (or lowly viewers). That she broke off her conversation with leading formalist artist Hussein Madi to expound on Onsi's triumphant progressivism impressed me.

Many proclaim Onsi, like Moustapha Farrouk, a founder of the modern art movement in Lebanon. They especially credit his creation of "the typical *paysage lubnani*" (Lebanese landscape), a trilingual phrase resonant of the country's polytopic outlook and sometimes invoked to scandalize its "lack" of monolingualism and monoculturalism.[1] In the fertile soil of postwar reconstruction, these pictures sprouted across the country as small-scale, thin-framed prints hanging in bank lobbies and dental offices and propagated into watercolor knockoffs decorating innumerable living rooms. Dozens of stands at art fairs in downtown Beirut's Suq al-Barghuth (an upscale flea market), Gemmayzeh's popular Daraj al-Fann (literally a staircase of art), and Zouk Mikael's vespertine Layali al-Zuq hawked them for returnee migrants eager to

FIG. 4.1 Omar Onsi, *Houlé* (originally titled *le Lac de Houlé*), oil on canvas, 52.5 × 79.5 cm, 1934. Collection of Tammam Salam. Reproduced in *Omar Onsi, 1901–1969* (Beirut: Nicholas Sursock Museum, 1997), exhibition catalog, 114–15. Courtesy Nicholas Sursock Museum, Beirut.

furnish copious salons for receiving guests. Their return to circulation seemed to resonate with their original heralding of the Lebanese Republic.

In Richard Chahine's imposing tome, *One Hundred Years of Lebanese Art*, critic Salah Stétié enunciates the connection between national formation and landscape paintings: After centuries of being "shrouded by Osmanli [i.e., Ottoman] imperialism," the Lebanese began to "open their eyes to the outside world," as their country "ceased to be an enclave" and as many of them felt "the stirrings of national *awareness*." Thus, "the opening of their minds to the outside world, whether from the political or cultural point of view, is bound up with their rejection of the irksome Ottoman presence in the region as a whole and, more particularly in their own nature, mountains, and plain."[2]

The common ground of Lebanese raison d'être and post–Civil War nationalism lies in this typical paysage lubnani. In 1995, the *First Sanayeh Garden Art Meeting* participants (chap. 2) had assembled in a manufactured urban landscape to baptize a postwar generation of nationalist citizens. Two years later, to solidify the national reunification, the Sursock Museum curators invited audiences to celebrate an early "nationalist artist" whose compositions extended the garden across the national map.

Indeed, most guests viewing Onsi's many landscapes treated them as lenses back to a prewar, nationally self-evident Lebanon. On entering the main gallery of the second floor, I followed the head movements of visitors clustered before individual landscapes, reading the title, scanning the image as if for landmarks, and then together locating the spot in present-day Lebanon. I heard exclamations of "see how much things have changed!" though I could not discern from afar whether visitors felt nostalgia, fatalism, or delight.

In the exhibition catalog, another version of prewar Lebanon arose. Here, Onsi was "Our Cézanne," embodying "contemplation for contemplation's sake."[3] The phrase deliberately echoes the iconic mantra "art for art's sake." It comes from a republished 1980 essay by venerable critic Samir Sayigh, who admired Onsi's work as "void of big ideas or grand ambitions, whether in pure artistic terms, or in humanist, emotional, or existential terms."[4] "Our Cézanne" thus describes an Onsi who eschewed money and politics while isolating himself from social pressures or ambitions. It indicates paintings that reveal a nation cleansed of political machinations or religious schematization. If under Ottoman rule "Lebanese artists," organized through sectarian categories, had been limited to portraying religious leaders and the nobility, as the story goes, with Onsi and his generation, the catalog writers and visitors transcended to a "common ground" in landscape views. A massive review of the retrospective in *Mulhaq al-Nahar*, the cultural supplement to one of Beirut's leading dailies, reproduced an Onsi landscape on its cover and emblazoned it with the slogan "Poet of color and light."[5] Inside, critics termed the artist an impressionist (*intiba'i*) and rhapsodized about his experiments with techniques promoted by the nineteenth-century French outdoor-painting movement, l'École Barbizon.[6]

Such assessments codified a decades-long discourse for which Onsi emblematizes the paradigmatic individual making art by reaching into his personal depths: "He simply had to breathe on the canvas or paper, let the color run over its white surface, for the signs of an unmistakable identity to appear," according to one catalog.[7] Michel Fani cantillated that this idiomatic working process produced a "rare escape route from pictorial and cultural crushing by Europe," and critic Joseph Tarrab affirmed that this work mirrored not an external world but the "liberated" artist's very own soul.[8] "That's why there are no people in his landscapes," many a viewer concluded when explaining Onsi's pictures to me: apolitical, unideological, and irreligious, Onsi's "typical paysage lubnani" both instantiated the professionalism of nudes and grounded a secular, modern citizenship.

Yet *Houlé* troubles the project of finding a Lebanese mirror in the typical paysage lubnani. First, Begdache's backhanded compliment, "surprisingly modern," references a universal timeline, with *Houlé* less behind on it than

she expected from other "pioneer" Lebanese painters. Nonetheless, abjection arises from Onsi's palette, because "Our Cézanne" names a sorry imitation of a French master, and a late one at that, appearing decades after the fashion for impressionism fell out of favor in Paris.[9] Second, that landscape's geographical reference refuses to sit quietly on the national map. Each visitor joining me at the exhibition eventually queried slyly over their shoulders, "Do you know the real Hula?" I learned that they referred to a part of Lebanon's southern watershed, an area slated for agricultural development by Ottoman authorities at the turn of the twentieth century and entrusted as a concession to patrician notables from Beirut just before World War I. In the aftermath of the transfer to Mandate power, the concession's status came into question, and eventually a Zionist agency acquired the rights to it. In consequence, thousands of resident Bedouin Arabs were uprooted. An elderly aunt I interviewed whistled at the memory of 1940s gossip about money spent in Tel Aviv on Jewish prostitutes after Salim ʿAli Salam (who also happened to be Onsi's uncle) signed the transfer of ownership in 1935. Salam exemplified the possibilities of the "middle-people," whom Fawwaz Traboulsi has called *mudabbirin* (sing. *mudabbir*) because they gained their importance by securing services and resources for people who had financial capital but lacked networks and know-how.[10] The memory of this disgraceful deal, by a nationalist leader, haunts *Houlé*'s graceful palette. So, third, politics also cloud the mirror of the landscape, to the degree that when I visited the painting's current owner, former prime minister Tammam Salam (Salim's grandson), he handed me a book that his father authored to counter these enduring charges of treason against the Salam family.[11] "Read it carefully," he enjoined me, his tone imparting a worry that the painting reveals not an absence of people but their absenting.

Staring at *Houlé* with these various viewers, I confronted a real estate transaction, a bohemian personality, and even the universal march of time. Notably, each vision excluded other elements: nationalism, religion or ideology, and local context, respectively. Each, moreover, overlooked the possibility that art forms actually participate in social debates and crystallize positions by offering alternative articulations. For example, upon *Houlé*'s first display in February 1935, regional newspapers were still publishing attacks on Salim Salam for his "treacherous nationalist behavior," as well as his vehement replies. Amid this flurry, a gorgeous tableau by Salam's own nephew, famous for his *watani* works, as we saw in chapter 3, reentered Hula into the public scene just as it departed the physical territory. This interaction between painting and audiences requires us to ask what ideas artworks invigorate. What did *Houlé* do to the debate? What did it do to the life of its painter and viewers? Did it publicly shame the Salams? Did it soothe their loss?

I hope the previous chapters have already demonstrated that we cannot assume a universal relationship between representation and property. Instead, we must ask what became uniquely possible when landscape painting as a genre and a genealogy encountered Mandate Beirut society. Answering this question requires a method that can look at the formation of social concepts and their believers, too. Taking art to precede categories makes artwork a methodology rather than an illustration. This project expands from Gell's investigation of art's agency (which as we have seen relies on social stability) to consider art's production of social settings and their contestation, too. Seeing art acts contribute to creating social life, I ask specifically this question: How and to what effect did *Houlé* blend politics, piety, and artistic style into a political imagination when it looked out on visitors to an exhibition in 1935?

In the preceding chapter, I investigated the agency of exhibited artworks to instigate and inculcate a new skill, dhawq, and a position of civic subjectivity. Here, I examine how landscape paintings guided viewers in rituals of citizenship and piety, thereby deepening the understanding of dhawq as an ethical project. The spheres of nation and religion have come to seem at odds in the aftermath of Lebanon's Civil War, but in Mandate-era Beirut, when Lebanon was still a proposition and institutionalized religion subject to intense scrutiny, fantasmic suwar afforded other conceptions. I foreground, in particular, a conception of nondenominational piety that emerges from scouting trips, landscape sketches, and artists' tathqif. I join the corpuses of Onsi and Farrouk to provide a critical mass of material that includes artworks, audience response, and artists' reflections. These art acts are a missing part of the story of civic imaginations and social experiments in the modern Middle East. They suggest ways colonial citizens tried out new "cutting" (hadith) and yet "contemporaneous" (mu`asir) ways of believing in their local roles as nationalists and members of a divinely sanctioned world. Exciting recent work has shown us the impact of mechanization and integration into global capitalism on Middle Eastern modern art, but it has sometimes imported polarizing binaries, such as spiritual/secular.[12] By paying close attention to the aesthetics of their fantasmic teachings, we may learn something about anti-colonial conceptions that have escaped registration in the allegedly postcolonial, postwar order.

The New Nude: Finding the Nation in Landscape Painting

Like the nudes discussed in the previous chapter, Mandate landscape paintings emboldened and obliged viewers to reconfigure their subjectivity and attain new skills. The landscape genre not only took over that role but completely displaced nudes as national symbols. When Moustapha Farrouk, now

a drawing teacher at the American University of Beirut's preparatory section, held his second annual show with his students in 1936, the landscape paintings on display taught young poet and activist Fu'ad Sulaiman what "Lebanon" was:

> This is Lebanon the green, country of poetry, love, and beauty, *looking at you* with its stone pines and larches, with its mountains, valleys, and coasts, with its waters, brooks, and mills.
>
> This is Lebanon *looking at you* with its bells and minarets, with its caverns and grottos, with is palms, sea, and snow, with the altars of its ascetics and the vestiges of its princes.
>
> This is Lebanon the colorful, colored with a thousand hues of the imagination, girdled by Spring, raising its proud head to the sky, *looking at you* from thirty-six tableaux that the artist Moustapha Farrouk is exhibiting in the American University.[13]

Sulaiman becomes the view seen by Farrouk's landscapes.[14] The poet's writing of that experience extends Yusef Ghoussoub's project of comparative visuality (chap. 2) to a political topography and economy. In the exhibition's sense-realm, Farrouk's landscape paintings sent Sulaiman on a multisensory tour from the coastal stepped olive-tree terraces to the plains of the Bekaa. Each stop brought a sense of having seen these places "already but differently," now specifically as an interrogation of what positions viewers take and what results from their choices. Looked at by *The Plains of the Bekaa*, for example, Sulaiman imagines a plow "cracking their chest" to make them fertile and feed "tens of millions," if only "someone who knew how to make them bear fruit" were sent to them. Or, looked at by the mountainous heights of Dhour El Choueir, Sulaiman finds himself prostrate beneath the shady trees, evaluating life in terms of the pictures: "*Have you once in your life looked* while sitting under an ancient stone pine at the sun setting behind the horizon? *Have your eyes ever escaped* to the horizon as the sun lifts its fiery rays from the hills and peaks and pastures. . . ?" Somewhat surprisingly, Sulaiman's masculinist (even phallic) tone preludes his dismissal of the "purely fanciful" art of nudes. He explicitly praises Farrouk for replacing "naked bodies, protruding breasts, and well-placed thighs" with views that are "*practical, productive,* enabling the country to benefit from all its aspects: for when he pictures for us the mountain he gives us a living picture of the magic, majesty, and beauty of the mountain, so that we love it *if we are far from it and we visit it as often as we can.*"[15]

Now it is landscape paintings that thrust themselves into the arena of national debate, both describing a problem many refuse to recognize and

providing a solution. Like nudes, these fantasmic suwar make their viewers objects of sight and change who they can rightfully be. Could they develop the capacities to harness the land's fertility? To answer, reader-tourists would have to consider what kind of viewer they would be vis-à-vis the national horizons. They reconfigured their subject-positioning.

The shift toward the landscape genre was widespread and rapid. At the 1921 Beirut Industrial Fair, though it was staged to promote the region's assets, it seems only one landscape (by Khalil Saleeby, of the AUB campus) joined the display.[16] A decade later, at the *First Lebanese Salon for Painting and Sculpture*, Beirut-born photographers Skafu and al-Zughzughy and the Damascene al-ʿAthm exhibited photographs of regional ruins and landscapes, and Jan Kober (a resident artist of Polish origin, 1890–1971) displayed several paintings of "landscapes and ancient ruins."[17] Such views tinged the region with a Greco-Roman history, spotlighting its place in a universal history of teleological time. By contrast, Omar Onsi contributed paintings of Deir el-Qamar and "some pretty Lebanese villages hanging between the sky and earth as if paradise."[18] Still, when Onsi opened his first solo exhibition with his nude allegorical *Phoenicia*, landscapes constituted barely a quarter of the display. Like most shows of the mid-1930s, two-thirds of Onsi's artwork comprised portraits, social types, and historical events. These proportions shifted by the decade's end. A reviewer of Farrouk's 1938 show with his AUB students noted that the artist was "more and more inclined toward nature."[19] Even Cesar Gemayel, known primarily as a painter of nudes, got into the game, producing a selection of "natural views" (*mashahid tabiʿiyya*) for his 1937 exhibition at Le Jour newspaper's offices.[20] Essayist and entrepreneur Charles Corm designed the Lebanese stand at the 1939 New York World's Fair to inspire Americans to think of Lebanon as a tourist destination.[21] It presented "a plentiful collection of tableaux—enchanting Lebanese landscapes—by the Mlles Hadad and Mubarak, and the MM. Omar Onsi and [Saliba] Douaihy, that were veritable marvels."[22] Landscapes had become the new nudes.

The costs and customers of art genres flipped, too. In 1932, Onsi's *Allegory: Phoenicia Presenting the Oranges*, commanded 5,000 francs on a price list whose average was 430 francs. The few landscapes were priced well below the average, and of the seven that sold, most went to the Mandate government, individual Mandate officials (including the wife of High Commissioner Ponsot), or foreign diplomats.[23] During the next decade, the price of figurative works dropped while that of medium-sized oil-on-canvas landscapes doubled and even tripled, coming to command the equivalent to approximately one month's salary for a professional.[24] Meanwhile, the bulk of the customers shifted from Mandate

officials to the local elite, among them nationalist politician Husain al-Ahdab; architect, Phoenician theorist, and National Museum director Jacques Tabet; and Charles Corm of the 1939 Lebanese stand. Already in 1935, their purchases provided Onsi with more than half the proceeds from his exhibition.[25] Sales of landscape paintings by "Lebanese" to "Lebanese" had set a whole new calculus. This at a time before "Lebanon" per se existed.

In line with these trends, just days after Sulaiman's tirade, the same paper carrying his review announced the winners of a national postage stamp competition.[26] Strikingly, no nudes were among the winners, despite the preeminence of allegorical female nudes in the colonial postage stamp portfolio.[27] As we saw in chapter 3, only four years earlier, Jawaba had admired the "nationalist hue" in Onsi's landscape paintings but revered as "most nationalist of all" his nude *Phoenicia*. Wading ashore with gifts betokening the civilizational superiority of Lebanese ancestors, Phoenicia might have been an ideal candidate for representing Lebanon in the new international system of postal correspondence. Instead the jury had selected *The Bay of Jounieh*, by Moustapha Farrouk, symbolizing "summer and summering in Lebanon," and *Skiing in the Cedars*, by Philippe Mourani (Philippe Murani, 1875–1970), showing comparable winter experiences (fig. 4.2).[28] A close examination of the submission from the painter of *The Two Prisoners* suggests why landscape paintings displaced nudes as agents of nation making and shaped the fantasmic nature of the nation-to-be.

Double Displacement: Unsettling the West and Resettling the Watan

The Bay of Jounieh juxtaposes a valley, a bay, a hill, and sky. It populates the verdant valley with fruit trees. It glides a sailboat across the placid bay and clouds across the shimmering summer sky. It mounts a shining car on a paved road that restrains massive, jutting boulders. It marks the car's steady climb (and the region's economic yield) with stone pines ascending the hill's spine like sentries. It composes the whole in a series of arcs, one nestled inside the next, creating a sensation of completeness and harmony. An officially appointed committee comprising the postmaster, Mandate officials, local nobles, and expatriate "art lovers" selected this harmonious image for its ability to accomplish two tasks set by a governmental decree the preceding year: (1) respond to a growing economic need throughout the countryside for remunerative tourism; and (2) produce proof of the French Mandate's benevolent character.[29]

If *The Bay of Jounieh* is a place, where is it? What sort of space is it? The simple fact that Farrouk's picture won selection in a competition precludes viewing it as a reflection of a self-manifesting entity. With its "screen" of boulders in the

FIG. 4.2 *Al-Ahrar*, June 24, 1936, 1, showing the postage stamp competition winner, Moustapha Farrouk's *The Bay of Jounieh*. Courtesy of Special Archives Collection, American University of Beirut.

lower right corner, "repoussoir" row of pine trees, and "meander line" of a road, *The Bay of Jounieh* enacts compositional features of the Classical continental landscape genre developed out of Renaissance pictorial theories by French artists such as Nicholas Poussin, Claude Lorraine, and Jean-Baptiste-Camille Corot. The scene accumulates variety as the viewer, positioned near the screen, optically follows the serpentine line of pavement past rapidly alternating surfaces of light and shade demarcating divergent vegetation, through balanced curves of rolling hills, toward an expansive sea and towering mountain horizon. The dark masses on either side act "like theater wings" and center an absence of figures such that "sky and distance take central place," according to a well-executed formula that contemporary art critic Kenneth Clark called "the ideal landscape."[30] Farrouk fit the Jounieh Bay into this formula for legibility and affirmation abroad, having mastered it in his Italian academy and perfected it by trips to the Louvre, where he studiously copied landscape masters, among others.[31] Concurrently, *The Bay of Jounieh* fit Jounieh Bay into a cosmopolitan nexus. If the very promise of the landscape painting would seem to be its ability to convey local character, it borrows a genre to do so and, in exchange, sends the genre far beyond its envisioned horizons.

As beacons in ritual exhibitionary sociality, the "new" landscape painting of the Mandate era signaled a double displacement from pre-Mandate reality. The fashionable Damascenes of the nineteenth century decorated the upper walls and ceilings of their salas with *manazir* (views, sing. *manzar*) that reminded one American visitor of English stoneware plates.[32] Wealthy mansions in 'Amchit and other northern villages also reveled in such finery.[33] Painters trained in landscape painting at the Istanbul Ottoman Military Academy were active in Beirut in the nineteenth century, as in Cairo and Alexandria.[34] Mostly murals, their images were citations of elite Ottoman decor, where, Wendy Shaw argues, examples of the form demonstrated parity with Western culture through sheer presence rather than the imaging process.[35] The "new" landscape paintings differed in particularistic detail, illusionistic space, and naturalistic coloring, both moving the images away from Ottoman imperialism and expanding the continental art market for the "European" picturesque landscape to include Beirutis. They unsettled the burgeoning "West," whose borders were codifying in other ways, and resettled the watan, whose no-longer-Ottoman borders had yet to be clarified.

The generic features structuring *The Bay of Jounieh* imposed duties on Lebanese government authorities, themselves in competition for the right to rule and represent their communities' interests, as well as on would-be citizens, newly engaging in electoral politics. Unlike the fertile hillside of *The Bay of*

landscape painting" anticipated the country for which it was named, compositionally it dealt with "local" spaces via an imported genre and thus displaced both from any given mutual exclusivity.[42] Thus, this art genre reveals how people's aesthetic experience of themselves in a colonial territory located them as part of the world (`alami) and specific to the locale (baladi, watani) at once.

Unsettling and resettling at once, the fantasmic Bay of Jounieh stamp presents us not with a locale but with what anthropologist Arjun Appadurai calls a "locality." Appadurai argues that whereas bays, fruit orchards, and post offices are all locations that may be found on an administrative map, the sense of boundedness, exclusivity, and intimacy that people may associate with locations is not. Distinguishing locality as "a complex phenomenological quality, constituted by a series of links between the sense of social immediacy, the technologies of interactivity, and the relativity of contexts," Appadurai attributes it to recurring labor-intensive projects, which he compares to Turnerian rituals, such as building housing blocks, paving streets, and cultivating fields. Separating participants from other sense-realms, exposing them to abnormal risks and conventional roles, stretching their self-awareness, and rearranging their intellectual apparatus, locality projects produce and mark socially recognizable changes in the biographies of individuals and communities. These localizing rituals generate "locals," meaning people who understand and experience themselves through the locality ritual inscribes onto their bodies. "Locals" transform the boundaries and contents of that which they come to experience as "the local."[43]

The concept of locality figures landscapes within social interaction rather than behind it.[44] Indeed, if we read Mandate-era ethnographies of Lebanon, they give reason to doubt that landscaping subject-positions existed in the society into which Farrouk and Onsi were born. When Toufic Touma, conducting his doctoral fieldwork in social sciences at the Sorbonne, peered down from a mountain village at arable and pastures in the 1950s, he reported "fields, haphazardly distributed by successions and partitions, without any logic of grouping."[45] A mountaineer and villager himself, Touma captured the tribulations the land produced for rational methods of "modern" control. He found that debt relationships, inheritance practices, and market calculations led villagers to experience land as an unstable, shifting entity: an energy and not a mass.[46] Tellingly, Touma's rendition of the mayoral records and land-tenure practices takes a visual aspect that invokes and undermines landscape conventions: "The cadastral drawing, yet unfinished, would have, without a doubt, the complexity of an arabesque. Broken, sinuous, intersecting lines delimit irregular, fantastic surfaces."[47] His aesthetic

FIG. 4.3 Moustapha Farrouk, Muslim Scouts' encampment, pencil drawing in sketchbook, 10 × 17 cm, ca. 1920. Hani Farroukh Collection, Beirut. Author's photograph.

metaphor of the arabesque adopts an Orientalist (and administrator's) perspective to insist on mere surface forces lacking deep rootedness.[48]

By contrast, as a locality, Jounieh Bay in landscape painting provides a sense-realm. A local figure produced by localizing actions and configuring interactors as local at once, it shapes new ways of seeing and interrelating. In the next section, I show how landscape painting condensed and layered sense-realms from painters' and audiences' experiences into this compact, portable format. I follow *Houlé* back to its preproduction phase and then forward to the occasion of its first display. This journey across the art act engages the materiality of the picture through three specific sense-realms: scouting, prayer, and struggles for land stewardship. It aims to provide a local art history and a history of the local through art.

Muslim Scouting, a Sense-Realm for Watani Looking

The earliest preserved landscapes in the careers of Omar Onsi and Moustapha Farrouk intermingle intimately with Muslim Scouts' portraits and campsite close-ups (figs. 4.3 and 4.4).[49] These images feature the scouts' tents as regularizing elements amid windswept flora at the foot of steep ascents. Both artists belonged to the Muslim Scouts troop.[50] The project of tathqif, on which

FIG. 4.4 Omar Onsi, Muslim Scouts' encampment, pencil drawing, 9 × 15 cm, 1919.
May Mansour Onsi Collection, Beirut. Author's photograph.

Scoutmaster al-Nusuli lectured at the January 1, 1927, exhibition had already
begun with extramural treks designed to cultivate emotions of civic obligation,
self-reliance, and pious awe. Al-Nusuli called these trips an "opportunity to
come into close relationship with nature and its wonders."[51] Both words and
sketchbooks suggest that looking at how they looked at the land promised to
transform Mandate subjects.

Among myriad grassroots mobilizations confronting the change of admin-
istrative regimes and regional economic fortunes, scouting sought to rethink
the Ottoman body and sensorium. Every few months, the Muslim Scouts set
out from their urban homes to strange, practically foreign places in the dis-
tant countryside. For instance, one (abbreviated) 1927 itinerary linked Beirut,
Sidon, Beaufort Castle, Hasbaya, and Damascus.[52] Between 1920 and 1923, the
political jurisdiction over the land they crossed had changed dramatically.
Beirut had become the seat of the French Mandate government, with a pros-
pering port and a flourishing mercantile bourgeoisie; Sidon had been demoted
from its prime port status; and, far worse, Damascus, previously the center
of a vast Euro-Asian trade network, had been humiliated, choked by French

economic control, and was seething with nationalist sentiment.[53] In this rapidly changing atmosphere, as the scouts tramped the sometimes unsafe roads between one village and the next, they moved between conflicting roles. They set out as stout independents fending for themselves, but at certain stops, they became traditional Arab guests receiving welcoming feasts. Their reports tell with amusement of being "mistaken" by people they passed for Druze revolutionaries, Bedouin bandits, and even government officials.[54] One trip report from 1927 noted that the merchants in the port of Beirut gave them "suspicious looks" as they passed and mocked the kaffiyya with which the scouts had replaced the standard masculine head covering of the tarbush.[55] The scouts, in turn, scoffed at the merchants' presumed fear of an eastward economy that might engage the Arab "hinterlands" alongside Marseille "to the west." They were pleased to note that the headgear they had borrowed from the peasantry provided more protection against the elements than the tarbush did. For a community considering a non-Ottoman future, scouting also offered another, symbolic identity, that of the land-working Arab. With this symbol, they underscored that the watan was no longer a point of birth but of responsibility.

The Muslim Scouts' trekking advanced multidirectionally, underscoring the ambiguity they faced in seeking to be watani. They looked forward, backward, and sideways all at once. While they experienced so many actual and potential connections, they came to belong to their "watan" not by having been born in it but by having committed the time and effort to come into "close relationship" with the peoples and places they recognized as constituting it. Their itineraries extricated the scouts from their common, city-bound experiences and flung them, through exhausting physical challenges, into distant, sometimes barely demarcated forests, plains, and mountainsides. The thrust in this movement was away, stretching against the pull of urban-dominated life. Cut off from daily routines and spaces, the scouts sensed the world in new ways. The vector and tempo of scouting's trajectories directly affected scouts' sensorial capacities for responding to their environment. Reports of the locality being formed foregrounded practices of looking: "The scouts spent a long time observing [yatafarrajuna] and making suwar, and foremost among them was Mr. Farrouk," one report informed scouting's fans.[56] Behind the Muslim Scouts' testimonials, we can read an intensification and heightening of sensory response via emotional practices of labeling and communicating their ways of looking.

Farrouk's pictures accompany every trek recounted, indicating the importance of the visual element for the project of developing and conveying character—tathqif. The term yatafarraj originates in a word for opening or splitting an entity, and in this derived form it implies that one gains pleasure,

or is released from sorrow, by looking. This type of looking is an emotional practice that opens the subject through an optical experience.

A letter from a fellow scout to Onsi, from 1923, exemplifies how this experience was conveyed verbally: "Last week we had a trip to Nabaa Afqa, the source of Nahr Ibrahim. We were a party of 28, led by Muhyi al-din al-Nusuli. It was one of the most difficult trips we have done. Wish you were here, in front of this great spring, which is considered the most beautiful scenery in all Syria and the most abundant source. This letter won't suffice to describe the trip to you."[57] Disavowing the ability of his words to impart the significance of the event, Onsi's correspondent emphasizes that the relationship to the land was best inscribed on the scout's body ("wish you were here"), not on paper ("this letter won't suffice").

By the same token, the narrator of the April trip in *al-Kashshaf* avers, "The view of Beaufort Castle and the setting sun *grabs you by the throat* (ya'khuth ak bi-l-albab)."[58] This "grabbing by the throat"—which is how farmers bring livestock to slaughter—expresses a loss of voice in the conversion from being city subjects—acquiring views and information from their trips—to becoming *objects* of the wilderness they met on those trips. Like beasts being butchered, Muslim Scouts felt captivated and helpless. Their reports speak of being constantly confronted with the inadequacy of their sensory apparatus, as a tool for both perceiving their surroundings and finding meaning in them. From taking (pictures, sights, initiatives) to being taken (mentally, sensually, emotionally), the trekking process essentially instituted an exchange system conducted through a new, deliberate visuality.

The scouts' reports involve readers in the new exchange by doubling and dispersing landscape views across formats. Laden with imagery and observation-triggering material, the reports allocate to landscape pictures a special role. Verbal lists of sites and sights structure the trip narratives, enacting a staccato rhythm of connectedness: "Beirut, Sidon, Beaufort Castle, Hasbaya, and Damascus" is but a truncated version. Frequent instructions to the reader to cast a glance at the pictures and follow the trip's progress intersperse the lists, with the promise that the pictures may better convey what the scouts experienced or thought. Running alongside the verbal descriptions, images take two formats: photographs and Farrouk's line drawings.[59] The doubling provokes a comparative take on viewing. Compressing scouts' bodies onto the sites reached, the photographs document the fruition of the scouts' labor to reach their character-changing vistas. The photograph documenting the ascent to Beaufort Castle, for example, positions their bodies *over* their destination, inscribing the land with their jubilant presence (fig. 4.5).[60] However, according to their testimony,

FIG. 4.5 Scouts climbing to Beaufort Castle, uncredited photograph in "*Rihlat al-Kashshaf ila Dimashq*" [The scouts' trip to Damascus], *al-Kashshaf*, May 1927, 316. Permission of AbdelBasset Fathallah. Courtesy of Digital Initiatives and Scholarship, American University of Beirut.

such images could not convey the breathtaking *experience* of the scenic visions. Farrouk's line drawings took charge of that.

Alongside the photograph of the Beaufort ascent, *al-Kashshaf* editors reproduced a line drawing by Farrouk (fig. 4.6). The sketch's composition enhances the castle, reduces its rubble, and clarifies its relationship to the mountain peak. A diagonal delivers the viewer gradually from a foreground, placed at foot level, deep into the pictured space. The ascent is less daunting, softened by grass and subdued by a physically impossible angle of sight. The artist simplifies the scene's elements to geometric forms: a semicircle (mountaintop) supports a square, a rectangle, and a triangle (the castle keep and tower). The building becomes a harmonious outcropping of the earth, ensconced between the grassy ground and the buoyant clouds. Such a sketch provides a viewer with an entryway into incrementally interconnected topographical and floral features. This aesthetic encounter sensually analogizes the way scouting linked localities, cosmopolitan modernity, and economic entrepreneurship. By *analogize*, I do not mean *illustrate*. The vignette visually asserts, or better, instigates a new way of relating to space and to one another. It affords a subject-position from which to experience a locality, which becomes the basis for subjecthood. Most importantly, it exists amid lists, photographs, verbal testimonials, and clinical observations, and this, I think, is the space of taswir.

The copresence of photographs and generic landscape compositions suggests that scouting into the countryside inserted the physical environment and inhabitants of the area into a formula for national taswir. In the viewing provided by these double-sighted trekking narratives, the land scouts reached was not only accessed and inscribed through their arduous physical practice but also deliberately borrowed through the imported technique of the picturesque genre. From one angle, the horizon of an image like *Beaufort Castle, The Bay of Jounieh*, or *Houlé* is local (baladi) and nationalist (watani), or Lebanese (lubnani): it puts the viewer before territory defined by the scouts' labor of measuring and mapping. From another angle, it puts the viewer before a set of representational conventions developed in other lands and histories: it is universal, cosmopolitan (`alami). Materially, the pictures contain both facets at once. In fact, distinguishing angles of viewing misleads; viewers expected to engage with the multiplicity. At the same time, this formula permitted readers and viewers of the scouts' close reports to insert themselves into the scenes represented, but at multiple levels of engagement with the world: baladi, watani, *and* `alami. Such fantasmic images proffer a visual tathqif. The sites become sights capable of sensually encompassing a larger audience, beyond one interested directly in scouting, enfolding it into a coherent, ordered, picturesque

منظر القلعة من قرية قرنون

FIG. 4.6 Moustapha Farrouk, *"Manzar al-Qal'a min Qariyat Qarnun"* [View of Beaufort Castle seen from Qarnun Village], ink drawing in *"Rihlat al-Kashshaf ila Dimashq"* [The scouts' trip to Damascus], *al-Kashshaf*, May 1927, 315. Permission of AbdelBasset Fathallah. Courtesy of Digital Initiatives and Scholarship, American University of Beirut.

landscape able to activate an aesthetic capacity to lose one's sense of sensory control to another force. This polytopia is the Lebanon the scouts brought back from their long treks.

Affiliation: Bodies of Influence, not Inheritance

The bodies that undertook scouting's treks also participated in a new visuality. As scouting reformulated the land's political-economic horizons, it inscribed that locality on scouts' bodies in striking ways. A drawing by Farrouk in *al-Kashshaf*, introducing the feature "You Owe It to Your Body," visualizes the promise of scouting to effect a transformation, specifically a reaffiliation, of the post-Ottoman subject (fig. 4.7). To the right, the Ottoman subject's tarbush crushes him, necessitating a cane to hold up his curvaceous torso and thin shins. Knock-kneed, this archetypical dandy, for all his evident wealth, remains a pile of fancy vestments applied to a body. The opulent smoking jacket, cravat, cummerbund, and spats provide no corporeal protection. Were danger to walk up to the dandy, he could neither fight nor flee. Merely moving his cane would

FIG. 4.7 Moustapha Farrouk, "*Inna li-Badnak `alayk Haqq*" [You owe it to your body], ink drawing used as feature heading, *al-Kashshaf*, 1927. The subtitle reads: "*Innani Abdhulu Kull Juhdi*" [I give it my all]. Permission of AbdelBasset Fathallah. Courtesy of Digital Initiatives and Scholarship, American University of Beirut.

topple him. The post-Ottoman subject, to the left, stands taller, broad chested, exposed to the elements, and flexing his readiness to move. When he does move, he wields a walking stick to mark his forward stride rather than carry his weight (fig. 4.8).

The Ottoman dandy slouching opposite the post-Ottoman subject is the masculine analogue of Farrouk's odalisque. Just as Farrouk borrowed the body of a foreign model for his mar'a sharqiyya (see chap. 3), his post-Ottoman scout borrows the physique and coloring of a prototypical Brit. The scout troops of the region openly borrowed practices and ideas from Lord Baden-Powell's imperial British boys' movement, serially translating features from *Scouting for Boys*.[61] To see this contrast between the blond British scout and the Ottoman dandy as racist and self-hating would require assuming bounded, fully formed selves. Yet selfhood, in this time of jockeying and dealing, reflecting and refashioning, was exactly the question for the practitioners of scouting and their urban peers. Affiliation replaced inheritance with influence.

Recalling the tarbush in the 1927 story of businessmen's aggression against the scouts, *al-Kashshaf*'s self-visualizing contributes to the troops' project of situating themselves in a struggle to define the community, its resources, and its political outlooks in the post–World War I set of possibilities: urban and

رحلة الكشاف الى دمشق

FIG. 4.8 Moustapha Farrouk, "*Qul Siru fi al-Ard*" [Say: Travel the Earth], ink drawing used as feature heading for *al-Kashshaf*, 1927. Permission of AbdelBasset Fathallah. Courtesy of Digital Initiatives and Scholarship, American University of Beirut.

rural, mercantile and agricultural, port and hinterland. Even as they belittled the port-based merchants, they ruminated on the potential for westward agricultural export. For example, one report observes, "Walnut trees are planted on either side of the road; their fruits are exported to Europe at the price of one and a quarter riyal per peeled kilo."[62] These young men eagerly nourished their leadership and entrepreneurial skills to return to Beirut to become mudabbirin: lawyers, doctors, merchants, and statesmen who mediated between laborers and wealth. Those positions did not await them by social rank. Their emotional practice of looking and being objects of the land's looks claimed watani influence through affiliative practice, not birth. Their attack on tarbush wearers constitutes a class claim against a traditional leadership that can now be seen—from the fantasmic angle of their polytopic landscape images, that is—to be incapacitated and dislocated.

Only obstinance could regard the men of "You Owe It to Your Body" as bodies determined by inheritance. The point of scouting was to "instill character into the rising youth of this land": rugged, self-reliant, and risk ready.[63] The "character" that was to be instilled was neither genetic nor inherited; it was achieved through that "close relationship with nature and its wonders" that scouts believed developed from the regular, rigorous exiting of urban space and from internationally shaped trekking. Their affiliative trekking and camping was

modern in both locally articulated connotations of the concept: hadith (novel) in the flow of time and mu'asir (contemporary) across the flow of space. The scout's body instantiates that flow and cut. Most strikingly, however, the scout's body enacts a relation to the land that physically and materially opposes that of the dandy. While the Ottoman subject sinks to the ground, the post-Ottoman rises from it, like the stalwart stone pines trailing the scouts' march in the logo for trek narratives (fig. 4.8). Dandies who fail to march foreshadow the peasants Farrouk would draw in 1934. Alter egos that must be eschewed, they are sources of abjection, temporally, culturally, and, moreover, spiritually. Notably, the slogan emblazoned between the troop members' bodies in this logo is a Qur'anic verse, "Say: Travel the earth" (*Qul: siru fi al-ard*; 29:20). As Jennifer Dueck notes, this divine source corroborated for the Muslim Scouts the emphasis British founder Baden-Powell gave to travel.[64] This conjunction of modernity, wataniyya, and Islam, inscribed on the bodies of the ideal scouts and absent from the bodies of the abject dandy, points to that land's emergent status as a divine sense-realm. I now turn to this much-occluded aspect of "Lebanese landscape paintings."

The Paysage and Manzar al-Tabi'a

Filing his regular feature on contemporary art in the pro-Mandate daily, *l'Orient,* from Omar Onsi's second solo exhibition, in 1935, French-born art critic Max Villard remarked pithily that the diverse "paysages," "fogged in violet," were "brushed with a gust, or singed with a burst of light."[65] Adding that Onsi had been "frequenting" the Beirut studio of Madame Nelly Marez-Darley and Georges Cyr, two Francophone expatriates, Villard attributed the painter's intensified professionalism to impressionism's influence.[66] With the label *paysage* framing his view, Villard would have noted Onsi's dutiful use of triangles to build up the space in *le Lac de Houlé* (Onsi's title for the canvas that would later appear at Sursock), starting from the left in thick, beige daubs. Describing an outcropping of white rock, this triangle acts as a screen behind which the viewer can safely stand and peer out into a vast space without losing stability. Looking to the right, Villard could find a smooth swath of maroon trimmed by a tawny arc mirroring the screen. Next level up, a triangular expanse of pungent terracotta pigment at left and a slice of salmon pink at right. And so on. The space of *le Lac de Houlé* accumulates from neatly interlocking triangles, arranged from dark to light, all reaching toward the upper center (fig. 4.9). Suturing them together, the bottom arc becomes a serpentine line that would carry Villard's eye, just as he would expect, deep into the center of the scene, where a narrow oval of pale blue placidly mirrors the canvas's upper edge. He could

FIG. 4.9 Compositional lines added to Omar Onsi, *Houlé* (see fig. 4.1).

enjoy how perfectly and predictably a distant mountain echoes and embraces the foreground in its triangular construction of shapes and lines.

To see *Houlé / le Lac de Houlé* as a paysage, Villard had to look for the implementation of a "European" genre and assume that a "local" land lay passively under its representational strategies. The French term for this genre, *paysage*, suggests a quality or act by which the *pays* (nation, country) comes into view.[67] Yet this is not what Mandate Beirut's practitioners could undertake with the pictorial formula, when the nation could at best be their goal. As a political claim, land, or rather locality, lay at the end, not the beginning, of their efforts, especially vis-à-vis audiences considering an array of political projects. While brochures at Mandate exhibitions sometimes referred to such works as paysages, they more often used the Arabic term *manazir al-tabi`a* (sing. *manzar al-tabi`a*), literally "views of nature." In contrast to the French, the Arabic simply categorizes views according to their basis in nature.[68]

A single manzar al-tabi`a can encompass an entire bucolic setting or a mere bough. In a lecture he gave at the Cénacle Libanais in 1947, Farrouk described a pivotal moment in his artistic training as stumbling upon the humblest of manazir al-tabi`a. It was 1915 or 1916, and he had begun lessons with the esteemed Habib Serour, a teacher of art at the prestigious Ottoman College. The young pupil arrived at Serour's atelier near the Sursock family residences on the heights overlooking the city. He found his teacher huddled in the dark,

fervently sketching an unexpected object: a wizened tree branch. Thirty years later, Farrouk shared with his audience the upbraiding he had received when Serour espied his pupil's shock:

> This mean branch has given me the chance for an instant to perform a prayer to the Almighty Creator. I was in a divine seclusion chamber prepared for me by these humble leaves. For I find in their inner-folds wisdom and secrets, and in their wrinkles and curls, a prayer. In their hue, I find a harmony and melody, and in the structure and articulation of their parts, a world full of marvels (ayat) and morals. What more could I want? I find in it my *mihrab* [niche orienting prayer]. I read my Holy Book. I chant my hymns and give praise to the Lord for his power and creativity.[69]

Equating drawing with prayer, Serour's stance reoriented Farrouk from allowing for art in religion to rethinking religion through art. It reversed the hierarchy of artist to object, making the artist the object of the object. Notably, Serour's assessment of the encounter foregrounds the *medium* of each of Lebanon's confessions—chanting, sacred chambers, and scripture—without naming any sects. It presents picture making from nature as a nondenominational liturgy and noninstitutionalized medium tantamount to hymns, a mihrab, or the Holy Book. If drawing was an act of supplicating to learn one's proper role, painting manazir al-tabi`a amounted to a performance of common humanity, spiritualism, praise, and acknowledgment of an all-encompassing higher power.

In other words, paintings of nature provided an antidote to problems many, like Serour, had discovered during the two decades in which Beirut rapidly urbanized.[70] One, Labiba Hashim, we met already in chapter 3, extolling the virtues of nature for cultivating dhawq. Writing for the woman's journal *Minirva*, pedagogue Niqula Baz urged artists and artisans to be guided by nature, "the ultimate source of beauty," and enjoined women to take their brothers, husbands, and children out of the city, "especially [to] places unsullied by human hands," to gain awareness of God's variability and omnipotence.[71] Demoralized and overwhelmed, urban dwellers could not develop dhawq in the absence of nature, lamented essayist Salah al-Asir.[72] Their horizons shrank to become "a wall among walls," journalist Khalil Taqi al-Din explained in his 1938 ode to village life.[73] In fact, artistically mediated nature surpassed the original. Unlike the quotidian experience enjoyed by rural residents, al-fann al-jamil enhanced one's objectivity by taking the viewer to "the heart of the thing" and by letting one examine it *for itself*.[74] Exposure to art developed acute observation skills.[75] Moreover, nature-based art provided concrete examples

of fellow citizens' (artistic) performances of "honesty and fidelity" in urban daily life, reasoned critic Juzif Hunayn.[76] Natural views "refine the feelings, elevate the soul, polish the psyche, and make one love life," Farrouk effusively summarized.[77]

Houlé entered the discussion of Lebanon's urban development not as mere paysage but as an exercise in piety and possibility. Painted in 1934 by a Muslim Scout returning from having crossed first the Mediterranean to study art and then the countryside after his young wife's death, it provoked the exploration and cosubstantiation of a specific way of being in daily urban life and civic interactions. I have shown that its topic and forms stemmed from professional training in a universalizing genre and entrepreneurial, patriotic engagement in scouting. Still, my analysis implies an inertness to the land *Houlé* engages. Like Villard's, this view focuses on the artistic outcome while overlooking the experience, emotions, and knowledge attained through the practice of art making—what I have been outlining with the notion of art act and shading in with the concept of taswir. Following Begdache's eagerly sweeping hands, I am inclined to refocus on the material aspects of the "Lebanese landscape" genre. What does it take to let nature become a picture? What does doing so make of the picturer? My answer denaturalizes "nature." I scrutinize the ways artists and audiences connected evolving verbal categories and the pictorial constructions that are primary documents of their evolution. Let us follow *Houlé* from scouting and professional art genres to prayer sessions.

The Manzar al-Tabi`a as Muslim Prayer

Among Onsi's private papers is a draft full of scratched-out words and unruly insertions, titled "Two Attitudes." It drafts in English a speech Onsi gave to graduates from the American University of Beirut. I reproduce here the draft, strike-throughs and all, to emphasize the explorative quality of the thinking:

> 1) Those who ~~communicate~~ love Nature and feel all the thrill ~~before~~ in their hearts before arriving at an adequate expression in view of the poor means at their disposal; and
>
> 2) those who ~~look at~~ discard nature ~~and the traditions~~ with contempt, and proud of the colors means at their ~~command, cry out their~~ disposal, dream and strive for creation and construction.

Onsi's words are tricky and tentative, moving one syllable forward, backtracking, and circling to a conviction. Elsewhere in the same talk, the artist warns against forcing ideas found in visual arts into words. This suggests that the

act of painting and displaying *le Lac de Houlé* was an emotional practice Onsi ritually undertook to be ethically upright and become a "true artist"—that is, an artist who "feels all the thrill in his heart" and, loving nature, humbly recognizes the poverty of his means. The artist who "discards Nature," especially by departing from natural color schemes, arrogantly attempts to rival the true Creator. Onsi's offensive implicates the famous contemporaries he left behind in Paris, including the Impressionist school, which spotlights the artist's personal perception and, in this logic, glorifies the artist as the composition's protagonist.[78] "Those who love nature" do not offer a personal, subjective view on it. They do not create.

True artists actively acknowledge and amplify meaningfulness. Informing Onsi's technology of art production was a nineteenth-century way of thinking about "nature," *al-tabi`a*, that is more processual and transitive than allowed for in English. From the root form *ta-ba-`a*, meaning to print or impress, al-tabi`a addresses the transfer of force onto a passive surface.[79] That which is stamped contains the essence of that which stamped it. Accordingly, out in the countryside, "nature" is simply the state of the world that as yet only God has acted on, which is why pedagogues like Hashim and Baz directed women to seek it out for their menfolk's edification. Holy "scriptures" infuse nature composed of ayat (sing. *aya*), Onsi wrote in another unpublished manuscript. Ayat translates generally as "signs" but indicates particularly incontrovertible signs of a divine presence—in other words, miracles. One senses that for Onsi, taswir engaged with the world as sacred text, miraculous signs—allowing God's traces to affect the reader/regarder's being. Onsi concluded his text in a voice resonant with the opening of the Qur'an: "Read [*iqra'*], oh human!"[80] Reading (*al-qira'a*) involves vocally conveying the sound waves embedded in the divine traces.[81] Acknowledging these traces, "true artists," like true believers, humbly let themselves be shaped by their imprint, a mediating connection to the divine.[82]

Al-tabi`a exists not spatially but ethically, in the choices a "true artist" makes about what and how to paint. Onsi encapsulated his choices in an exercise he described in yet another informally jotted set of thoughts:

> Every person knows that each person has a character (*tab`*), ideas that he tends toward, that he enjoys repeating. These impact (*tu'athir*) on his face, time after time, until the muscles of his face take the shape of the impacts and are imprinted (*matbu`atan*) by them. . . . *Dhuq* (test or taste) something bitter and look at your face, how its shape changes. Then dhuq something delicious and look at its effect on your face. Think of something you hate, things you love, and observe the resulting differences on your face from the first to the second. These changes result on the face of the human involuntarily,

and that is the natural law (*al-sunna al-tabiʿiyya*). No one can escape this law. Even if one tried to hide (these changes), no matter how hard one tries, they will still appear.[83]

In this passage, we see the painter apply the ethical notion of dhawq explored in chapter 3. Commanding readers to "dhuq" (test or taste) opposing qualities and examine the effects of their provisional incorporation, he presents us with the malleability of personal tabiʿa. Human nature is not inherent; decisions about what may influence oneself will cumulatively form one's character. Ultimately, mien and demeanor are but a canvas. Imprinted on it are the choices made between the acidity of the lemon and the beauty of the flower. Most importantly, the manzar al-tabiʿa offers a technology for stamping and thus reforming the artist's heart. It is also an ethically loaded technology: the impress onto artists' hearts from their selected surroundings will impress viewers of their art.

Herein lies the ontological urgency of making pictures that involve the viewer. Painting is a visual and social prayer. Such pictures not only involve active choice making by the viewer but also create connection—transitive impression—on and from the viewer's being, which will affect subsequent viewers of viewers. To return to *le Lac de Houlé*-cum-*Houlé*, the picture of a sun-splashed rural plain with a pretty pool in the middle certainly befits the paysage genre and speaks to the prospects of a national economy cultivated by aware, responsible citizens scouting opportunity for personal and national progress. As a "divinely imprinting print"—to give the philosophically true translation of *manzar al-tabiʿa*—however, it imprints Onsi's choice to submit his being to the worldly traces of the Divine Creator. Landscape paintings, thus, offer another form of fantasm that does not stop with the visible image but impresses on the canvas of the mind and then, completed by the viewer, becomes the source for imprinting on others. So what were the lessons of this fantasmic art for Mandate civic subjects?

Houlé in a Divine Imprinting Process

The imprinting process that became the *Houlé* art act began early one morning in the summer of 1934 when Onsi set out from his cousins' tents by Lake Hula in search of an appropriate view, one that would generate the right affect in his own being. A nephew of Salim ʿAli Salam, the infamous concessionaire, and close to his sons, Onsi had visited the Hula Basin frequently since childhood.[84] The site figures in several of his pictures. A very early watercolor documented by Fouad Salaam may depict the Banat Yaʿqub bridge over the river running

south from the lake.[85] An oil painting of the lake from ca. 1930 focuses on the habitation at the northeastern shore, where cane processing occurred (fig. 4.10).[86] In this earlier composition, the lake occupies the entire foreground, and a river leads the eye through the famous marshes to the central mountain, variegated in its coloring by the clouds' shadows. The dry, sharp brush heightens foreground details of vegetation and extraction. The shift of scale from majestic mountain to diminutive cacti paddles resonates with one of the painter's axioms: "Leave no matter small or big without beholding it, regarding it attentively, and contemplating it, for how many lessons does a mosquito hold for us? In the ant or the bee is deep wisdom, and nothing in Creation carries not its story."[87]

Following the defeat of Amir Faysal's independence movement, which Onsi—like many young Muslim Beirutis—had supported, and finding himself "neither connected nor disconnected" to Beirut's urban life, the artist had imposed self-exile and headed to the Jordan Valley, probably passing through Hula.[88] A decade later, after his wife's sudden death in January 1934, he had again extricated himself from the city, this time journeying first north to Aleppo and then south to Soueida, where he stayed with Druze villagers and painted many of their customs, most notably funerals and cemeteries. He reached Hula on his return trip to Beirut. One can imagine he was on a quest to renew meaning in his life and to rediscover his place in his urban milieu. He also may have known that this visit was to be his last. Not only had the urban–rural networks bolstering Arab nationalism been severed with the defeat of Faysal, but his uncle's concession stood in jeopardy.[89] Onsi was certainly privy to the long struggle Salim Salam had endured with fellow mudabbirin, to cajole stock purchases or loans out of them. Over two decades, Onsi had observed the tilting of their interests away from self-sustaining agriculture to metropole dependent trade. This time before the familiar lake, he likely felt anguish and nostalgia.

Swampy yet lush, the 177-square-kilometer Hula Basin frustrated urban governance. At the turn of the century, Ottoman officials deemed the region from which the picture takes its name potentially the most fertile in the entire Levant.[90] Its lake, one of two in the Levant, hosted a unique ecological system of water buffalo, birds, goats, papyrus, corn, sorghum, and cane that supported thousands of ethnically diverse people, living from agriculture, herding, and sales of manual crafts.[91] As part of their project of reform and rationalization, Ottoman planners sought a concessionary to convert the marshlands into agricultural fields.[92] Meanwhile, Baron Rothschild's Palestine Jewish Colonization Association had founded four Jewish settlements in the northwestern section of the valley, toward the project of de facto Judaization.[93] Two Beiruti notables

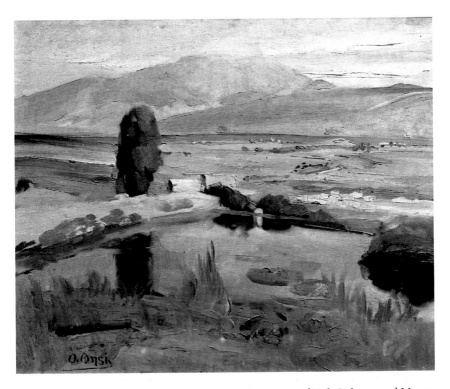

FIG. 4.10 Fouad Salaam, photograph, Omar Onsi's painting of Hula Lake toward Mount Hermon, ca. 1986. Location, size, and date of original painting unknown. Photograph courtesy of Fouad and Hassana Salaam Collection, Beirut.

attained the Hula concession in 1914, agreeing to drain the lake for the right to buy every dunam converted to cultivability at the low price of two Ottoman liras.[94] Salim ʿAli Salam became president of the joint-shares stock company established to reshape the land and human relations to it.[95]

Salam's life evinces the new socioeconomic networks and civic whole that Mandate colonial citizens envisioned and enacted. Chief of the municipal council since 1908 and president of the newly launched Muslim Society of Benevolent Intentions (also known as al-Maqasid), Salam (1868–1938) hailed from a newly affluent mercantile family long resident in Beirut.[96] Only seventeen when his father died, he took over his family business and showed entrepreneurial genius. He also plunged into regional politics. Peers called him a zaʿim (leader), drawing on a recently developed word from the verb to claim. A zaʿim aggressively presents himself as able to stand for others, guard their interest,

and make demands in their name, on the basis of the performance of assertive-ness more than of any hereditary assets or established financial capital.[97]

Salam's claims-making fluidly negotiated the complexity of local and re-gional life. As a Sunni, Salam supported reforming Ottoman government and deputized for Beirut to the Ottoman Parliament from 1914, but as an Arab nationalist, he was jailed by the entrenched Turkish leadership for wanting an Arab nation within the Ottoman empire.[98] He was jailed, too, by French Mandate authorities, for his ongoing political activism.[99] Yet throughout, as historian Kamal Salibi has shown, he was a shrewd businessman, converting his profits from the import economy to buy up newly available land.[100] The con-summate mudabbir. Still, to balance his family's risks with his resources, Salam needed cooperation from other notables, especially those with a different array of social connections, such as the Sursuqs, Bayhums, Fara'uns, Sulhs, Fakhu-ris, and Tayyaras.[101] And through his relations to Faysal and the Hashimites, he complemented his multiconfessional urban networks with cross-sectarian rural and far-flung regional ones.

However, by the late 1920s, the other Beiruti notables had withdrawn their support and credit for the drainage venture for various reasons, leaving Salam alone to undertake the expensive procedures required.[102] Between his bouts of imprisonment and sinking economic fortunes, Salam set about draining the marsh and lake, living with his sons at the lakeside for six difficult years.[103] He undertook a kind of agricultural taswir, sending his eldest son to study mechanized agriculture in England, competing for and creating an image that he hoped his compatriots-to-be would take up and complete.[104]

When Onsi selected a sight of the Hula Valley to imprint on him in 1934, he countered contenders determining its value through the eyes of "blind modern-ism." This is geographer Glenna Anton's phrase for an insistence on subjugating and transforming the land toward future prosperity.[105] While developed to ad-dress colonial capitalism, Anton's phrase productively resonates with definitive descriptions of artistic modernism as seeking autonomy from given, vernacular realities for higher ideals. (I further explore this convergence below.) Blind modernism overlooked what was there for what could be there. It sorted nature into resources and obstacles. For Hula's indigenous Arab inhabitants "lacking capital from abroad," the land encompassed ecological opportunities and con-straints to harvest papyrus and herd water buffalo while managing floods and malarial mosquitoes.[106] These inhabitants called Hula's vast marsh *"al-shari'a al-kabira"* (the large water hole).[107] By contrast, for immigrant Zionists and the merchant concessionaire alike, the land was the site of a "merciless struggle between man and nature," as one Zionist geographer later reflected.[108] Wearing

the lenses of blind modernism, Salam saw an entrepreneurial opportunity, if the obstacles of Jewish-supremacist gangs, British pressure, and malaria could be overcome by investing money, labor, and engineering know-how in draining the land successfully.[109] Agitators for Zionist settlement, similarly bespectacled, identified the land as a resource for controlling water and resolving a projected population problem.[110] The swampland obstructed their Zionist technocratic utopia of strong European bodies conquering wild native spaces.[111] As a subject-position, "blind modernism" erected a pinnacle from which humans peered proudly down on land, flora, and fauna to create their own knowing righteousness. This position separated society from nature.

How does a divinely imprinting print mediate between society and nature? Is the nature apprehended through the eyes of a "true artist" the same as that seen by blind modernist contemporaries? Onsi's pious, painterly modernism posited an imprintable surface on which nature could convey its divine knowledge and cultivate the moral compass of dhawq. Let us revisit that artist's topics, colors, and painterly gestures recorded in *Houlé* as ethical actions that might affect the relations he, the Salams, and subsequent viewers could form with Hula. We can imagine Onsi setting out on a road leading east to the most fertile corner of the lake. At its edge, the painter straddles the brink between an imperiled sharecropping economy of indigenous "renters," preliminary Jewish settlements undertaken to "Judaize" the valley, and the concessionaire's increasing confinement as a political agent to the northern side of the Palestinian border. He stops at a promontory of craggy white stones, the limestone characteristic of the Levant's older layers. Perched on a precipice overlooking the valley from the northwest, Onsi does not look out at just an inert terrain but a divinely activated element in an ongoing set of drastic ecological and political contests. Having selected a viewing locale in the area inhabited by the ʿArab Zubayd tribe, the prime herders of water buffalo in the region, he adopts their subject-position to let Lake Hula imprint its sacred traces on him.

The imprintable artist stands and stands, perhaps for several days.[112] Al-Maʿrid's quirky illustrator, Raʾfat Buhairy, Onsi's classmate from AUB, produced a visual recipe for such sight seeking to accompany an article titled "The Artist and Nature," by their younger acquaintance Thurayya Malhas (fig. 4.11).[113] The artist absorbs the scene. He opens his chest as he "watches the raising of the veil of dawn that reveals the eye of God."[114] "Singing with delight," says Malhas, he realizes that "he is alive and can perceive with his very eye the beauty of the Great Artist."[115] The resulting image may spark a viewer's awareness of human commonality before a higher power. Compositionally, it insists on a single set of moral codes, by providing a space adjacent to the artist for the

viewer to follow the same path to the rising sun. It is the sensible experience of monotheism. Thus, when Onsi and his peers painted landscapes, they *committed* themselves to a higher power, in the literal meaning of Islam. Moreover, they provided their viewers with a stimulus to commit themselves, too.

Houlé invites viewers to reflect on mortals' relationship to divinity. Ayat saturate Lake Hula and usher from it. In front of Onsi rises a mineral-rich field of fecundity *in potentia*. The sun, "the most evident manifestation of the all-embracing and permeating light," subsumes everything equally, spreading celestial beneficence regardless of hierarchy.[116] A crystal-blue oval counterposes chromatically the sunbaked soils. Capriciously calm, Lake Hula rests now but floods often. The ambiguity of celestial force distilled in this intermedial spot ranges from "dangerous *sayl*, the torrential flood" to "blessing, fertilizing rain."[117] With the lake as its topical axis, Onsi's composition channels the viewing eye from the road on the lower right, zigzagging through a multitudinous, optically disturbing foreground, through a monotone horizon, before inexorably sending its virtual passenger to the sky's pale lucidity. The ambiguity of the world before Onsi resolves into a mountainous liminality. Iconographically, the mountain is the zone where heaven and earth meet, "between the created universe and the spacelessness of the Divine."[118] Here, in the ultimate artistic achievement, the mountain imposes divine logic on the chaos of a cornucopia of textures, shapes, colors, and characters; it is, literally—for those who can read this scripture—an earthly composition.[119]

Onsi's role in this ontology is not to rival the divine print before him but to convey it. Letting it imprint those truths on his being, he can extend them through his brush. Like the artist's famously "translucent" watercolor landscape paintings, *Houlé* wells up from a wet, sheeny surface that absents marks of the painter's exertion. Having mixed his colors in advance, the painter seems to have gone over the smoothly laid oil only once to add a glimmer of white along the edges of each section.[120] The brushstrokes that do appear outline the ground segments, as if caressing the loamy terrain. Sweeping his brush along the chalky road's trajectory, Onsi picks up the indigo deep in the soil. In a series of rapid flicks of the wrist, he deposits this indigo in defined daubs of lightly streaked white paint at the lower left corner. These gestures seem to mimic precisely the lay of limestone hunks atop the fertile soil. Onsi's translucent forms hide nothing from the viewer. As a stage in a pictorial process, they are not properly forms, in fact, but forces pressing forth—an "echo of the universe," as Onsi concluded in another unpublished musing: they translate the "open book" the Creator has printed on the earth's surface.[121] He uses his refashioned heart to "print" the canvas with its effects.

FIG. 4.11 Ra'fat Buhairy, illustration for "*al-Fannan wa-l-Tabiʿa*" [The artist and nature], *al-Adib*, October 1947, 19. Courtesy of Special Archives Collection, American University of Beirut.

Onsi's pious, painterly modernism posits an imprintable surface onto which nature could convey its divine knowledge and cultivate the moral compass of dhawq. Like "blind modernism," divinely imprinting prints sought to redress newly created social and national problems. Yet the experience of "merciless struggle between man and nature" could not be further from that transmitted by *Houlé*. In the presence of such a vengeful "nature," Zionists felt potentially sick and weak. The modernism of divinely imprinting prints is sighted, sensed, and felt by the aesthetically enlivened, ethically attuned body. But the looming land transaction gravely endangers its integrated ecology. The lake lying at the painting's epicenter, rippling chromatically into Mount Hermon and geometrically, into the plains, extends its existence through the series of imprinted-imprinting relations triggered by viewing it via an artwork. As an essential element of al-tabi'a, water is a prime stimulus to cognizance of God's omnipotence and mercy, but it is also what Onsi's uncle has committed to remove. Onsi's picture composes an Islam-in-performance in relation to which *nature* is not a noun but a transitive verb. Nature forms continuously as viewers who learn a divine ontology from the beauty and rapidity of Onsi's committed brushstrokes undertake fantasmic responses. For a sense of how they extended the art act that is al-tabi'a, I return to Farrouk's 1933 guest registry.

Imprinted Audiences and Fantasmic Inductions

At the threshold of Farrouk's 1933 exhibition at the School of Arts and Crafts, Muhammad Shamil, a renowned thespian, penned an entry in the golden book. Although unusually long, it eloquently indicates the colonial citizenry's fantasmic interaction with a fine art of ayat and taswir:

> A word I send, hoping that it might reach something of its goal, otherwise, let it be to some the words of a talkative person who has lost everything, *even the ability to evaluate things....*
>
> In my eyes there are two tears: a tear of happiness and a tear of sadness. Each is deeply significant. The first rolled down when I saw the ayat revealed in the book Farrouk has written with the ink of his liver, the pen of his art, and the inspiration of emotion. The second fell when Farrouk came to read his book to a people whom he found could not comprehend any part of its.[122]

Shamil emotively interrogated the ability to evaluate one's place and path. He named an agonizing split between conflicting feelings. Happiness gripped him when a new code for evaluation revealed itself to him in Farrouk's "language" and "book." Sadness overtook him with the realization that his

"uncomprehending" peers may not learn the code. Shamil attributed these visceral responses to ayat, divine manifestations, and questioned his peers' dhawq: Could they evaluate appropriately? Just as Onsi regarded the Hula Basin as heavenly scripture, Shamil's testimony compares Farrouk's exhibition to the Qur'an, that most important miracle. While it would be wrong to limit his response to Farrouk's manazir al-tabiʿa—which, however, formed the bulk of the exhibition—Shamil's attention to beautiful inscriptions, ambiguous demands, and binding physical responses suggests that the image-laden surfaces that Lebanese landscape paintings brought into urban exhibition halls were mystically mobilizing and irreducible to extant entities. Reading the ayat in the exhibition hall imposed an ethical obligation not only to shed tears but also to record one's reaction and use it to affect others. Being trapped in the abyss between these conflicting feelings compelled Shamil to undertake an emotional practice, to name his feelings with a "word" and petition "a people." What could be abjection becomes a call for reeducation, or tathqif.

Several days later, Qabalan al-Riyashi, who announced his becoming a believer in chapter 2, contributed his poem to the visitors' registry. Now that we have learned to view whole art acts, it is worth quoting the full entry:

> A divine language descended upon the eminent ones, engulfing secrets
> Made of poetry, music, and art. A revelation
> Bringing liturgies
> Whose masters, with their creativity, were like messengers through whom history advances,
> And through whose pens and lessons the wisdom of the ages runs
> And leaves its marks.
> The lion of this language is Ibn Farrouk's pen
> That has produced a miraculous sign for all ages [ayat al-aʿsar].
> I came to believe in the Revelation manifested in his paintings
> He, its chosen prophet.
> All art is at his fingertips, all magic, all thoughts, all secrets of life.[123]

Riyashi's poem confirms that Farrouk's art reveals anew a code that had perhaps become obscured in the passing of the ages. This language of signs has pushed history forward and demands belief. Farrouk's registry is full of talk of the "magic" of the paintings, their "miraculous" material forms that "commanded" viewers like holy "liturgies" and "revelations" brought by "prophets" with "lessons" about social progress and the "secrets of life."

Paintings that command attention, bring tears, and teach were doubtlessly Gellian social persons in Mandate Beirut. Yet the cross-cultural nature of the

encounter with these locally made imports complicates Gell's culturally homogenizing theory. What happens to abduction when the networks creating art are themselves in the process of being created and contested? Consider Gell's key example of Malangan, wooden sculptures that commemorate deceased persons in New Ireland, to which he refers to argue that artworks are never immanently meaningful. The value of the Malangan lies firmly in the external world, in the right to view it that people acquire by making ritual payments. Observers internalize the memory of the carvings' surfaces, called "the knowledge of the Malangan." Destined for physical destruction, Malangan act agentially rather than ideationally (encoding ideas) or aesthetically (stimulating awareness of extrasocial values such as perfection). Here Gell alludes to the Kantian idea of aesthetics as purely "interior mental acts," categorically separate from artworks, which exist in the "external, physical world." Visible only for a specific time, and solely as a medium transmitting "agency between past and future," the Malangan is a technological transformation that "dematerializes" the fertile land, owned and cultivated by mortal beings, into a wooden carving, then into ashes and memories that have been incorporated into a community of observers who now share a basis for forging networks of landownership and possession.[124]

The urgent grappling with ambiguity, obscurity, and incomprehension recorded in Farrouk's registry suggests that, as social persons, divinely imprinting prints triggered not abduction but induction. Like Malangan viewers, the registry signees constituted a special group: they learned about the shows from newspaper announcements or from acquaintances of the artist; they could pay for entrance (occasionally); and time was at their disposal.[125] But as we have seen, they did not form a social class in the sense of enjoying economic relations that could be secured or transferred to their progeny. The commingling of artworks' overwhelming aesthetic impact with the potential for unreceptiveness suggests manazir al-tabi`a were fantasmic agents in performances that produced new ones. Many visitors looked for and found a process of dematerialization at work in Farrouk's "ayat," whereby viewing them gave access to "all secrets of life." But beyond that access lay a rigorous, reflexive process of tathqif al-dhawq, which involved difficult decisions. First, like the painters, viewers had to decide what to let make an imprint on them. Second, they had to recognize the social implications of their choices, because their imprints would in turn print on those who interacted with them. In contrast to Malangan, manazir al-tabi`a do not separate aesthetic surfaces from the physical world; they link the external and internal in a chain of ever-imprinting connectivity. They submit mental and social processes to physical forces. The

very way such pictures filtered beauty and allowed it to make sense of viewers' social conditions suggests that we must take seriously the "internal, mental acts"—the shivers of ecstasy, the refashioned hearts—that are crucial to guiding external behavior.

Moreover, the sacralizing language deployed by many signees in the guest book not only conveys the divine imprinting but confirms its nondenominational character. Riyashi hailed from a Christian family, but he recognized the Qur'anic "Revelation" in Farrouk's art and "became a believer" in its prescriptions. Others' testimonies hail the Islamic source of manazir al-tabi'a without drawing sectarian divisions. They echo Farrouk's lesson in drawing-as-prayer that channeled his Christian mentor, Habib Serour, and substituted observant sketching for the media of all major monotheistic confessions. The Islamically informed piety Farrouk and Onsi performed in their art making did not preclude audiences committed to other faiths from being imprinted. Where *nature* is a transitive verb, paintings are not objects of one faith but transitive processes of faith making. Or as Shamil put it, paintings are like books, imprinted and published to share their lessons with dutiful viewers, if they will learn how to read.

Finally, manazir al-tabi'a were not projections of power. In colonial, decolonizing Lebanon, political power was a messy, unclear, yet emergent entity. The supernatural itself was in contest: Lebanon as a historical, ethnic (Phoenician), self-producing entity; a Maronite god who subsumes all others and is spoken through the Patriarch; or Nature as the divine revealed directly to dutiful observers.[126] Into this setting came al-fann al-jamil, impressing on people's internal, mental acts and informing their social behavior—the possibility of imagining network production among a disparate array of new neighbors, fellow voters, and potential business and marriage partners. The language they learned to read—the imprinted surface of nature-based aesthetics—arose from their taswir of a nation as a whole. Appreciating the new, modern, cosmopolitan-connected language extended access to divine secrets beyond the boundaries of any particular, sectarian affiliation.

Onsi and Farrouk's decision to "thrill at nature" was inarguably an aesthetic, stylistic decision, but it was also ethical and performative. It made them explore a philosophy of beauty they believed had practical implications for their political and social upheavals. Their sensible forms were at once visceral and cerebral, beautiful and logical. They drew heavily from an Islamic liturgy and iconography that framed the imagery, revealing the "natural views" to be imprinted canvases imprinting their willing viewers in turn. The clarity of color, translucency, proportionality, faithfulness to concrete surroundings and

dynamic weather conditions, one-point perspective, and interest in average locales became performances of humility, fidelity, sensitivity, rationality, objectivism, monotheism, awareness of a common humanity, spiritualism, praise, and acknowledgment of a higher power. The pious acts of manazir al-tabi'a took a generic, coded art form and arena as the basis for an interactive, social experience that could bring about agreement, conformity, and civic action in a "denatured" urban setting.

Encountering a Divine Agent of Taswir

What did the divinely imprinted *Houlé* do when it confronted the networkers and nation makers assembled that chilly afternoon of February 19, 1935, at Onsi's third solo exhibition in the Sanayeh municipal complex? When High Commissioner Damien de Martel cut the ribbon to open the show, he ushered in a host of students, scouts, journalists, intellectuals, doctors, mercantile entrepreneurs, bureaucrats, high-ranking Mandate government officials, and city notables: Beirut's ashab al-dhawq (or claimants to that status).[127] Almost certainly among them were the Salams, who never missed a show, according to the younger Assem. Confronting them smack in the middle of the room, amid studies of cacti, portraits of Bedouins, rural landscapes, and domestic scenes, the picture titled *le Lac de Houlé* hung. It does not seem to have been commissioned. The exhibition brochure did not list sale prices for all pieces, suggesting that some were withheld, but it allocated the considerable price tag of 700 pounds to *le Lac de Houlé*.[128] The painting's presence had to be uncanny.

I want to consider what possible taswir unfolded in the aesthetic encounter with *Houlé*. In the run-up to the sale, newspapers were rife with warnings and condemnations of both the British government, for conducting the transfer, and Salam, for agreeing to it.[129] In recompense for signing the transfer of the Hula Concession rights, Salam had received 191,974 pounds, thereby reducing the area available to Arab cultivators in the Hula Basin from 65,000 dunums to 15,772.[130] Subsequently, the Salams' name was tarnished and their political standing tottered. "Is this Abu 'Ali, the Arab za'im, our friend and patriarch?" esteemed essayist Amin al-Rihani wrote, indicating that news of the transfer had shocked him into wondering who Salam really was. "*Or could it be one of those who prefers money to the watan?*"[131] Just three months after the scandal of the transferred concession, a picture made by the imprint of the valley he tried unsuccessfully to drain put a disgraced Salim Salam in its sight line amid an onlooking coterie of former co-concessionaries, some of whom had already sold to Zionist organizations and some of whom could have floated credit to save the concession.[132]

What did this exercise in submission to al-tabi`a say to the mudabbirin, a group always at risk of being accused of materialism and selfishness? The lake hanging before them imprints the celestial vault. It is not "40,000 dunums of marshy land of little value at the present to anyone," as British high commissioner Sir Arthur Wauchope disparaged when addressing the transfer in November 1934.[133] Though cynically downplaying the loss of livelihood for twelve thousand indigenous Arabs, Wauchope also desperately hoped to forestall the public riots that accompanied many such transfers of land to exclusive Zionist-Jewish use. The British high commissioner may have turned the eye of "blind modernism" on the land, but Onsi's painterly modernism turned the manzar al-tabi`a back on the assembled ashab al-dhawq.

Perhaps the canvas blatantly asserted the mudabbirin's privilege in the face of new political constraints, boldly declaring, "This was our property, and we can do as we like." This reading certainly fits the Impressionist frame that art historians have revealed to enact symbolic domination. It would, moreover, explain the erasure of signs of human habitation. But tracing the genre work to its roots in localizing sense-realms of scouting and prayer offers no evidence for a project of securing class by representing property. Besides, the picture hardly succeeds in articulating class privilege. A miserable reminder of the Salams' worst failure as political and economic leaders, it invites derision until this day. Did the divinely imprinted print perhaps address the Mandate government and entire notable class that squandered public resources and surrendered issues of national economic import to self-interested individuals? Or finally, might the picture have reached out a gentle hand, assuaging the pain of loss with a romantic souvenir? This would account for its presence today in the villa of Salim Salam's grandson and political heir. If it were meant to compensate for a private loss, however, why was it displayed publicly and with a price tag? What kind of exchange was to be initiated by its offer of manzar al-tabi`a? Ultimately, nostalgia does not account for the philosophy of al-tabi`a, where nature is never a memory but a project. Could the picture teach Onsi's uncle a lesson in civic ethics by making him pay to refashion his face and heart before this print of the Hula Valley? Could it fundamentally remind all viewers of the immaterial, pious basis for becoming ashab al-dhawq?

While these questions cannot be answered without delving into convoluted urban histories, which exceed the scope of this book, articulating them clarifies the loss inflicted by ignoring the painting's suggestions on grounds of its ambiguity, let alone its resemblance to pretty French paysages. Ontologically speaking, al-tabi`a exists not spatially but ethically, in the choices a "true artist" makes about what and how to paint. Onsi's musings undermine the equation of

art making with self-expression or mechanical reflection of a world out there. From the agential canvases looking at Fu'ad Sulaiman in Farrouk's 1936 exhibition, to the postage stamp hailing a government, citizenry, and tourists, to Onsi's cosmologically compelling canvases, divinely imprinting prints fantasmically provoked learning about Lebanon and making Lebanon become in tandem. The hard work of producing such landscapes charged with the project of tathqif rendered artworks that, like elders in ritual settings, imparted special knowledge about a Lebanon-to-be and its citizens cosubstantially.

While valuable work on late Ottoman and early colonial art practices has compellingly connected new genres in circulation to colonialism and capitalism, in line with prevailing assumptions about modernism, this work rigorously secularizes.[134] Perhaps this trend has been most dangerous for Islamic art, but it points to how the move to globalize modernism has missed important opportunities to rethink categories and associated binaries we currently lend self-evidence.[135] Manazir al-tabi'a contributed to debates about the composition and direction of the nation-to-be, including its economic practices, political affiliations, and cultural aspirations. They have peers in work made by other self-modernizing artists, in Syria and Egypt, as well as India and Pakistan, who similarly believed that the power of art lies in its transitive, transsubjective capacities, to activate and channel superhuman forces.[136] They embody a "livingness" that modernist art criticism tends to erase, deeply inscribed with both a deity's presence and the work of devotees, much as Christopher Pinney has noted for Indian calendar art.[137] This local history of modernism must not be overlooked in explaining the attraction and widespread belief in modernity.

Coda

On March 5, 2003, Jean Said Makdisi, a professor emeritus in English literature at the Lebanese American University, stepped out of the elevator of the Sursock Municipal Museum onto the second floor of the first-ever comprehensive retrospective for Moustapha Farrouk. She sighed. "These are the ones I'm used to seeing." Waving broadly at a wall full of manazir al-tabi'a, she explained to me that she has difficulty seeing "freshly" the typical paysage lubnanis because everyone she knows has or wants to have their likes: "The pine trees, house, and no people, no cars, no smoke ... sort of a Lebanese form of paradise." Makdisi's inventory scoffingly indicts a misrepresentation of the country's actual condition. Like her peer Begdache at Onsi's retrospective a few years before, Makdisi looked and saw (a failed) modernity. She saw a universal timeline by which some people were behind others because of their cultural differences. This

timeline maps out public space for today's dutiful, culturally concerned Lebanese citizens, admitting some people, if modern enough, and excluding those who are not from the national reconstruction project, as seen in chapter 3. Yet when Onsi read his landscape book, he learned a code for refashioning one's heart that made all people the same regardless of their cultural differences and that encompassed all in a public space the size of the universe's echo. Looking with Begdache and Makdisi, modernity equals secularity equals no politics and no piety. These ideas make sense today, but that is because they were literally stitched together in high-quality, glossy catalogs that preclude taswir in their rush to produce national icons on par with global trends.

Although I initially intended to replace the image opening this chapter with a photograph of the original picture, as I worked on understanding the art act *le Lac de Houlé*-cum-*Houlé* constitutes, I realized that the stitching cannot be erased. It is the trace of the medium of ideas and economies and civic practices by which the picture reaches us today. It reminds us of the people always there, within the bounds of all suwar. The suwar's social trajectory beyond the framed object launched taswir and helped to create the social networks by which Lebanese landscapes, both painted and discursive, continue to circulate today and shape who belongs to the nation and who does not. Land, citizen, time, and piety were unclear, contested concepts in 1935. Landscape paintings were ways of imbuing them with common understanding. They fashioned the land as a convergence of port and hinterland, cosmopolitanism and locality, community and intimacy, materiality and ayat, universality and piety, and so on. The categorical junctures found in manazir al-tabi'a alert us to those junctures that are imaginable, tangible, and often motivating for the people we study. The pictures refashioned at once the hearts and political imaginations of those who sought to define themselves as citizens and believers in a new way, in newly created spaces. In the next chapter, I grapple with the "transsubjective realm" that fantasmic objects triggered, by following the project of tathqif al-dhawq as it expanded from professional artists to citizens-to-be through widespread art lessons.

Notes

1. Analyzing attempts to harness and standardize Arabic dialects in Lebanon in the popular Rahbani brothers' plays of the 1960s–1970s, Chris Stone shows that Ziad Rahbani's parodic recuperation of dialectical polyphony in his 1990s plays deliberately undermined such monologizing nationalism. Stone, *Rahbani Nation*, 133–37.

2. Chahine, *One Hundred Years*, 1:xii.

3. Sayigh, "'Ariyat Muhajjabat," 24.

4. Sayigh. Another opined that Onsi was uninvolved and "impious." Kassir, *Histoire*, 296.

5. *Al-Mulhaq*, February 15, 1997, front cover.

6. Faysal Sultan, *"al-Tahawwulat al-Khafiyya wa-Asraruha fi Manazir al-Unsi"* [Hidden transformations and their secrets in Onsi's views], *al-Mulhaq*, February 15, 1997, 9–13, p. 9–10.

7. Council for Exterior Economic Relations, *Jardinier*, 23.

8. Fani, *Dictionnaire*, 211; Tarrab, "Mirror of the Soul."

9. Many of my interlocutors called Onsi a "very late Impressionist," referring to the fifty- or sixty-year "delay" between the emergence of the "Impressionist school" at an 1874 Parisian exhibition and Mandate-era exhibitions.

10. Traboulsi, *Modern Lebanon*, 18–19.

11. Salam, *Qissat Imtiyaz*.

12. I think here of Stephen Sheehi's important work on photography, Anneka Lenssen's pathbreaking study of Syrian modernist painting, and Wendy Shaw's critical examination of late Ottoman painting. Sheehi, *Arab Imago*; Lenssen, *Beautiful Agitation*; Shaw, *Ottoman Painting*.

13. Fu'ad Sulaiman, *"Jawla fi Ma'rid al-Fannan Farrukh"* [A tour at Farrukh's exhibition], *al-Ahrar*, June 8, 1936, 1, 6, p. 1 (emphasis added).

14. Sulaiman's tactic can be traced to Yusef Ghoussoub's touring trope in his 1929 review of Farrouk's first exhibition (see chap. 2). The influential journalist Karam Milhim Karam perpetuated it with his essay *"Rishat al-'Imlaq fi Yadd al-Rassam al-Sa'luq"* [The brush of the giant in the hand of the Sa'luq-painter], *al-Ahwal*, December 1929, no page. Many Arabic-language exhibition reviews subsequently bore titles commencing, *"Jawla fi . . ."* [A tour of], while French-language reviews also employed the trope.

15. Sulaiman, see note 13, 1, 6 (emphasis added).

16. See the discussion of this event in chap. 2. Both newspaper coverage and photographs affirm the dominance of figurative art, whether portraiture or types.

17. Jawaba, *"al-Musawwirun al-Wataniyyun wa-l-Ajanib Ya'riduna Atharahum"* [Local and foreign artists display their works], *al-Ma'rid*, January 22, 1931, 8–9, p. 8. I do not have further information on the photographers mentioned.

18. Jawaba.

19. *"Ma'rid al-Sayyid Farrukh fi al-Jami'a al-Amrikiyya"* [Mr. Farrouk's exhibition in the American University], *Bayrut*, June 23, 1938.

20. *"Qaisar al-Jumayyil"* [Cesar Gemayel], *al-Makshuf*, May 5, 1937, 3.

21. Jawaba, *"al-Jinah al-Lubnani fi Ma'rid Nyu Yurk, 'Waha fi al-Sahra'"* [The Lebanese stand at the New York show, 'An Oasis in a Desert'], *al-Makshuf*, January 1, 1940, 3.

22. *"Le Liban à l'exposition,"* in *l'Almanach français* (Beirut: Imprimerie Catholique, 1940), 55.

23. See list for 1932 sales in the archive book for Omar Onsi compiled by Joseph Matar. JM.

24. For example, in 1939 Farrouk earned 34 Syrian pounds monthly from the American University of Beirut. With the Syrian pound pegged at a value of 20 French francs, Farrouk's monthly salary amounted to 680 francs.

25. See list for 1935 sales in Omar Onsi's archive book, JM. Farrouk's accounting book from the period testifies to the same trends, and his prices in 1939 appear to have been even higher, ranging between 800 and 1200 francs for an oil painting. HF.

26. *Al-Ahrar*, June 24, 1936, 1; "*Deux nouveaux timbres libanais*," *la Syrie*, June 24, 1936, 32; "*La peinture au service du tourisme libanais*," *la Revue du Liban*, July 1936, 17.

27. The French occupation's main stamp bore the *Niké of Samothrace*; Italy's, the *Cyrene Aphrodite*.

28. *Al-Ahrar*, June 24, 1936, 1.

29. These traits were specified by Decree 97 LR, issued May 4, 1935, according to the announcement in *la Syrie* (see note 26).

30. K. Clark, *Landscape*, 57, 54.

31. Farrukh, *Tariqi*, 132.

32. "Review of *The Modern Syrians*," *Living Age* 3, no. 26 (1844): 97–98.

33. Piaget, *Murs*; Weber, "Imagined Worlds."

34. Mustafa Farrukh, "*Tali`at al-Fannanin al-Lubnaniyyin*" [The vanguard of Lebanese artists] (lecture, Cénacle Libanais, Beirut, March 28, 1947). Cf. Naef, "*Peindre?*"

35. Shaw, *Ottoman Painting*, 33.

36. Tannous, "Village"; Fuller, *Buarij*.

37. On Mandate tourism promotion, see also Maasri, *Cosmopolitan Radicalism*, 27–29. A 1921 speech given by the high commissioner focuses on the "market," private banks, and international commerce. Haut-Commissariat, *La Syrie et le Liban*, xii. On French finances (or rather, debts) following WWI, see Thompson, *Colonial Citizens*, 60, 63.

38. Santer, "Imagining Lebanon."

39. Himadeh, *Economic Organization*, 45–46.

40. Tourism guidebooks from the period distinguished "Lebanon," meaning the mountain, and "Greater Lebanon," meaning the political entity separated from Syria and Palestine and mandated to French control. However, advertisements in the same guidebooks frequently located Beirut "in Syria," and maps did not uniformly provide boundaries between Lebanon and Syria. Santer, "Imagining Lebanon," 75.

41. Farrukh, *Tariqi*, 153.

42. At Farrouk's 1933 exhibition, twenty of the twenty-eight landscape paintings featured territory under French control.

43. Appadurai, *Modernity at Large*, 178, 179.

44. With *locality*, Appadurai critiqued anthropological concepts of cultural be-longing that naturalize a bounded ecological region's ability to define the subjec-tivity of its inhabitants. Appadurai, 182. Cf. Fabian, *Time and Other*.

45. Touma, *Un village de montagne*, 39 (my emphasis).

46. Cf. Peters, "Aspects of Rank"; Gulick, *Social Structure*; Fuller, *Buarij*.

47. Touma, *Un village de montagne*, 25.

48. This will strike some readers as ironic given the association of arabesque with Arab medieval culture. Later artists would tap the style to connect to au-tochthonous heritage and plumb its specific energies, but the connection was not self-evident. (On Syrian artists and the arabesque, see Lenssen, *Beautiful Agitation*, 132–39.) When Saliba Douaihy (Saliba al-Duwaihy, 1913–1993) lec-tured on "the arabesque" for the Arab Cultural Club in Beirut in 1948, he defined it as Romance-language term for a Far Eastern style distilled by Arabs and appreciated in European cultural production since the Renaissance. Saliba al-Duwaihy, "*al-Arabisk fi al-Sura*" [The arabesque in the image], *al-Adib* 7, no. 3 (March 1948): 6–11.

49. These sketchbooks date to the artists' late teens, ca. 1916–20. HF and MO.

50. A 1919 photograph among Onsi's private papers shows him with Farrouk in the same scout uniform depicted in Farrouk's watercolors. MO.

51. Muhi ud-Din Nusuli, "The Scouting Movement for Moslem Boys," *Al-Kulli-yah Review*, January 1921, 43–44, p. 44.

52. This was the itinerary followed for two days of a trip from Beirut to Damas-cus in 1927. See Baha' al-Din, "*Rihlat al-Kashshaf ila Dimashq 1*" [The scouts' trip to Damascus 1], *al-Kashshaf* 1, no. 5 (May 1927): 311–19, p. 311; Baha' al-Din, "*Rihlat al-Kashshaf ila Dimashq 2*" [The scouts' trip to Damascus 2], *al-Kashshaf* 1, no. 6 (June 1927): 372–78, p. 372.

53. Philip Khoury, *Politics of Arab Nationalism*; Provence, *Great Syrian Revolt*.

54. See also Baha' al-Din, "*Rihlat al-Kashshaf ila Dimashq 3*" [The scouts' trip to Damascus 3], *al-Kashshaf* 1, no. 7 (July 1927): 437–46, p. 438.

55. *Al-'Urwa al-Wuthqa*, August 24, 1927, 48. The writer alleges that they heard shouts of "Look, it's Amir Zayd," suggesting that the merchants impugned them as Druze mountaineers. The Ottomans introduced the tarbush in 1829 as "the sole ar-biter of identity" vis-à-vis the centralized state, but a century later many associated it with backwardness and preferred the kaffiyeh or beret as nationalistic symbols. Thompson, *Colonial Citizens*, 138.

56. Baha' al-Din, see note 52, 314.

57. Letter from Mahmud Ahmad 'Itani to Omar Onsi, April 11, 1923, MO.

58. Baha' al-Din, see note 52, 316.

59. The zincographer, Tabbara, stamped the photographs. Farrouk signed most of the drawings; all are clearly from his hand.

60. Likewise, in Farrouk's sketchbooks from the trips, close-ups of individual scouts almost entirely cover the scenery with the male body.

61. One scout prevailed on Onsi to translate "even . . . little by little" from Baden-Powell's volume for the newly licensed but not yet published magazine, whose format was to be "the same size as the English scouting magazine." `Itani, see note 57.

62. Baha' al-Din, see note 54, 445.

63. Nusuli, see note 51, 43 (emphasis in the original).

64. Dueck, "Muslim Jamboree," 493.

65. M. V. [Max Villard], "*Une heure à l'exposition d'Omar Onsi*," *l'Orient*, February 26, 1935, 1–2.

66. Georges-Albert Cyr (1880–1964) arrived in Beirut in 1934 through personal connections and opened an "académie de peinture" with Nelly Marez-Darley (1906–2001), an École des Beaux-Arts de Paris alumna. "*À l'académie de peinture Cyr et Marez-Darley*," *l'Orient* 11, no. 171 (January 31, 1935): 2. Cf. Fani, *Dictionnaire*, 85–86.

67. The same history pertains to *landscape*, from the Dutch. Adams, "Competing Communities."

68. An exact translation of *paysage* would be *manazir rifiyya* (countryside views) or *wataniyya* (national views). The closest term used during the period was *mashahid wataniyya* (national scenes), which referenced portraits of national figures. None makes the connection between "nature" and the viewing practice characteristic of manazir al-tabi`a.

69. Farrukh, see note 34, 264.

70. See also Mustafa Farrukh, "*al-Fann wa-l-Din*" [Art and religion], in *al-Fann wa-l-Hayat*, 59–62.

71. Niqula Baz, "*Jamal al-Tabi`a*" [Nature's beauty], *Minirva* 3, no. 3 (June 1925): 219–21.

72. Salah 'Abd al-Rahman al-Asir, "*Dhawq al-Jamal wa-l-Fann*" [Dhawq for beauty and art], *al-Ma'rid*, January 14, 1935, 9.

73. Khalil Taqi al-Din, "*Qaryati wa-Nafsi*" [My village and my soul], *al-Makshuf*, July 18, 1938, 3.

74. Jean Dobelle, "*Apprenons à dessiner*," *la Syrie*, December 8, 1932, 3.

75. Khalil al-Ghurayyib, "*al-Taswir fi Bayrut*" [Picturing in Beirut], *al-Ma'rid*, January 31, 1931, 14.

76. Juzif Hunayn, "*Mazahir al-Yaqaza*" [Signs of conscious-taking], *al-Fajr* 6, no. 7 (July 1939): 425–31, p. 429.

77. Mustafa Farrukh, "*Fann al-Taswir wa-l-Mujtama'*" [The art of picturing and society], *al-Adab* 1, no. 3 (March 1953): 33–34, p. 34.

78. Wendy Shaw also reports a widespread rejection of impressionism among the first generation of Ottoman teachers at the Istanbul Academy of Fine Arts (founded in 1882). However, the "distaste" she details for Halil Basha (1857–1939)

differs in ontological basis than what I present here. Shaw interprets "painting from nature" to be an unsettlingly "revolutionary" act for men proudly inhabiting Ottoman hierarchy. Shaw, *Ottoman Painting*, 103–5. Anneka Lenssen picks up on this interpretation for her study of Tawfik Tarek's landscape, *Dummar Track* (1908). Lenssen argues that Tarek's practice of working from photographs "effectively removed the notion of a subjective self from the picture plane and ensured that the world, in its *existing* orderliness, served as the initiating author of the image." Lenssen, *Beautiful Agitation*, 32. While I would surmise a subjectivity in the making from such a process, it is the *author* initiating that existing orderliness that I think artists like Farrouk and Onsi sought to acknowledge and submit to through their landscape paintings.

79. Ibn Manzur, *Lisan al-'Arab*, 9–10:101–3; Bustani, *Muhit al-Muhit*, 1265–66.

80. 'Umar al-Unsi, "*Ma Arahu*" [What I see] (unpublished manuscript, no date), MO. Cf. Dadi, *Modernism*, 119.

81. Hence it also translates as "recitation." Nelson, *Reciting the Qur'an*.

82. Wendy Shaw posits "a non-Cartesian subjectivity" among Ottoman landscape painters whose understanding of perspectival painting seems to have suggested a more active engagement of the world with their senses and being. She also surmises a Sufic source. See Shaw, *Ottoman Painting*, 94–95.

83. 'Umar al-Unsi, "*al-Khuluq al-Khalq*" [Character—creation] (unpublished manuscript, no date), MO. I have not presented the fragmented, interspersed, evolving thoughts in the exact order of their penciling. The text has an oral quality and uses colloquialisms.

84. 'Atika Salam, younger sister to Salim, was Omar's mother. Family members recalled Omar's tight friendship with his male cousins. Salibi, "Young Turks," 197.

85. Fouad Salaam, Onsi's cousin, photographed Onsi's corpus between 1969 and 1986, starting with his immediate family's collection and then expanding out. He printed reproductions of the artworks in large format (40 × 60 cm) for his own house decor and distributed postcard-sized copies at seasonal holidays. According to his widow, Hassana Jabr Salaam, he did not record the location, size, or provenance of the originals. I attribute an early date on the basis of stylistic resemblances to Onsi's scouting notebooks from the period.

86. The painting's current location is unknown. I date it to 1930 because Onsi's meticulous brushwork and variegated palette resemble those of works he displayed that year. Onsi frequently used Masonite during these lean years when canvas was scarce.

87. Al-Unsi, see note 80. Onsi appears to borrow from Surah 21:16, which reminds the pious that the world was not created in jest, and Surah 2:26, which insists that even the mosquito can instigate learning.

88. 'Itani, see note 57. 'Itani quotes Onsi's own words to him. Onsi documented his support for Faysal during his years as a student in the Business School at AUB

in the student journal, *al-Thamra* 1, no. 4 (June 1919), inside cover. From 1924 to 1927, Onsi accompanied his brother-in-law to the Jordan Valley to serve in the court of Faysal's father, King Hussein.

89. Salim Salam's fifteen-year battle with the London courts for recognition of the concession was widely known. Given Onsi's closeness to his cousins, it is likely he knew of the impending transfer in advance. Amir Faysal was a personal acquaintance of the Salams. Hallaq, *Mudhakkirat*, 43–45.

90. Sufian, *Healing the Land*, 151.

91. Sufian, 159–60.

92. Anton, "Blind Modernism," 83.

93. Anton, 85; Tyler, "Concession," 827.

94. Salam, *Qissat Imtiyaz*, 14. See also Tyler, "Lands Issue," 346.

95. Salam, *Qissat Imtiyaz*, 15.

96. Hallaq, *Mudhakkirat*, 13.

97. Salibi, "Young Turks," 198. For an analysis of Salim `Ali Salam's son Sa'ib's life as a za`im, see Johnson, "Political Bosses."

98. Hallaq, *Mudhakkirat*, 14–15.

99. Hallaq, 67.

100. Salibi, "Young Turks," 214.

101. Salam, *Qissat Imtiyaz*, 14–15.

102. Hallaq, *Mudhakkirat*, 68–69; cf. Salam, *Qissat Imtiyaz*, 19–20.

103. Hallaq, *Mudhakkirat*, 71.

104. Salibi, "Young Turks," 199.

105. Anton, "Blind Modernism."

106. Anton, 82; cf. Tyler, "Concession."

107. Sufian, *Healing the Land*, 152.

108. Anton, "Blind Modernism," 82.

109. Hallaq, *Mudhakkirat*, 71.

110. Zionists anticipated a large influx of German Jewish immigrants. Tyler, "Lands Issue," 362, 368.

111. Sufian, *Healing the Land*, 101, 178, 318.

112. Onsi details this method in his unpublished "Notes on Art" (MO). He also describes it in an interview from that period. Marcelle Proux, *"Onsi, le silencieux,"* *l'Orient*, November 17, 1937, 1–2.

113. Thurayya Malhas, *"al-Fannan wa-l-Tabi`a"* [The artist and nature], *al-Adib* 6, no. 10 (October 1947): 19–20. Malhas was a close friend of Choucair and an occasional student of Onsi (see chap. 5).

114. Malhas, 19.

115. Malhas.

116. Schimmel, *Signs of God*, 13.

117. Schimmel, 9.

118. Schimmel, 5.

119. Schimmel, 227.

120. On his palette techniques, see Proux, see note 112.

121. `Umar al-Unsi, "Kuo Hsi" [Guo Xi] (unpublished manuscript, no date), MO.

122. *Exposition du Peintre Farrouk, 15–24 December, 1933*, 30 (emphasis added; hereafter cited as Registry); HF. I gratefully acknowledge Kareem James Abu-Zeid's amendments to my translation. The liver is a particularly meaningful organ for Arabic speakers and Muslims. Parents call their children, "my liver," like the English, "apple of my eye." Muslim scholars speak of Hind bint `Utbah, a seventh-century woman who avenged the death of her father (or uncle) by prizing out his Muslim killer's liver and chomping it. Despite this desecration she later converted to Islam and aided the same army to victory over Byzantines.

123. Registry, 37. Again, I gratefully acknowledge Kareem James Abu-Zeid's amendments to my translation.

124. Gell, *Art and Agency*, 227, 3, 226.

125. Shows usually conformed to business hours and closed for the lunch siesta.

126. On the various religious-based arrangements proposed for an independent Lebanon in this period, see Thompson, *Colonial Citizens*; Firro, *Inventing Lebanon*; Kaufman, *Reviving Phoenicia*; El-Solh, *Arabism*.

127. Attendance surmised by reading the sales lists Onsi kept, including one for February 1935 mentioning "Mme Caland, M. Debbaneh, M. Pharaon" (all local merchant names) and M. Lévy (a French arts administrator in Istanbul), as well as De Martel and "l'Etat." JM.

128. The list mentioned in note 127 does not include "Salam." Perhaps Onsi gifted it after the exhibition or they purchased it later. Assem Salam confirmed that Onsi's cousins often commissioned works from the painter. The current owner, Tammam Salam, had no purchase records to share. During my visit in 2012, he displayed the work in his reception room with a second, set on the lake's edge, that featured the tents in which the Salam brothers lived during their engineering forays. Neither work appeared to have a date or a dedication.

129. Sufian, *Healing the Land*, 165nn256–57, 166n258.

130. Tyler, "Concession," 827. Salam recorded that he had negotiated handing over the twenty-two thousand drained dunams to the Arab cultivators. Hallaq, *Mudhakkirat*, 72.

131. Hallaq, *Mudhakkirat*, 74 (emphasis added). Al-Rihani recounted having rushed to his house to verify the news and hearing from Salam himself the saga of the concession retold "with lumps in his throat and pains in his heart." Others came to Salam's defense, some even claiming Salam channeled the transfer money to support Palestinian and Arab revolutionaries. Hallaq, 75–76.

132. "M. Pharaoun" appears twice on a list of customers correlated to the

February 1935 show; "Sursock" appears on three other undated lists. See Omar
Onsi's archive book, JM. Between 1906 and 1929, the Sursocks sold their lands in
the Galilee Valley to Zionist organizations. See Abboushi, *Unmaking*. They were
originally co-concessionaries, as were the Fara'uns, who partnered with Michel
Chiha in the leading regional bank, Banque Pharaon & Chiha.

133. Tyler, "Lands Issue," 365.

134. For Lebanon and environs, see Lenssen, *Beautiful Agitation*; Naef, "Paradise
on Earth?"; Rogers, *Modern Art*; Sheehi, *Arab Imago*; Shaw, *Ottoman Painting*.

135. On the implicit secularization of Islamic art, see Shalem, "Mean," 17; Dadi,
Modernism, 57. Ho shows a similar process interrupting studies of Chinese socialist
art in Ho, "People Eat."

136. Several scholars observe that artists set out not to create but to transfer or
transpose creative powers from a prior source, for example. See Winegar, *Creative
Reckonings*, 62–65; Jain, *Gods*, 272. Lenssen, whom I mention above for import-
ing and imposing secularizing binaries (see note 134), scrupulously documents an
artistic subjectivity devoted to unleashing rather than creating. Lenssen, *Beautiful
Agitation*, 11, 50, 77, 101, 109–11, 202.

137. Jain, *Gods*, 192, 202; Pinney, "Indian Work," 365.

5

ART LESSONS
Fantasmic Formations of the "Lady-Artist"

"LET'S PLAY A game." Our teacher, Cesar Nammour, produced a square wooden tray containing dark sand, three stones, and a miniature rake. Putting this on the table in front of my classmate Samar, he commanded, "Start." "Start what?" Like the rest of us, Samar had no idea how to respond. "Oh, it's a game, a Zen game, a surface garden with a contrasting frame," he coyly answered, "but I shouldn't talk about it." We were six students, all mothers, sitting in our children's elementary school to take a class on art appreciation offered as part of curriculum aimed at *tathqif al-ahl* (parents' cultivation). The class had been postponed six weeks in the uproar following the assassination of Prime Minister Rafic Hariri. Nammour, the same art historian whose lecture I had attended at the art soiree in 2000 (chap. 1), drew again on his personal collection of "Lebanese artworks" to teach us "how to look at paintings and sculpture, and eventually at things, through the study of the history of Lebanese art." He promised that by the end of the course our familiarity with Lebanese artists and their styles would be strong enough to purchase art on our own. First, "we have to learn the vocabulary and use it in seeing things." My classmates and I took notes on Nammour's injunctions: "You will learn to look *into*, not *at* art, to see things in a *creative* way." You must use "a different process" from "normal looking," which generates quick judgment. You must be "open-minded" to gain exposure in what is otherwise a foreign field. Our quest for "refinement and aesthetic taste" would require a long search for "relationships": point, line, form, color, texture, and shape. Then, after cursorily learning about "the three schools of analysis"—formalist, expressive, and content—we met the Zen garden.

Samar picked up the rake and drew a straight line in the "soil." More cautiously now, she added wavy lines above and deposited the stones in their

curves. Signaling her completion of the task, she pushed the tray forward and raised her hands in the air. "Wow!" exclaimed Dima before taking her turn with the game. We were already using our art vocabulary, I realized, to express appreciation. As the tray passed from student to student, Cesar complimented us, "I'm really surprised. I had a class of eight and they tried to be very creative, but this class is the most creative." I felt relief after having passed that test with my two waves and counterbalancing circle! Nammour then expanded our art vocabulary with words like *balance* and *harmony* to describe our compositions. Like me, the other students had notepads to record dutifully these terms. Still, no sooner had we begun to fill them than a plethora of absences started to crowd the pages and hover over our learning.

The abjections began with the personal introductions that followed the Zen game. Dima had earned her bachelor's degree in art fifteen years earlier from the Lebanese American University. However, since becoming an accountant and mother, she had no time for art. Now she wanted to get back into "art culture." Nammour nodded and welcomed her. Samar was a teacher of high school art appreciation at the private Ahliah School downtown. Her enrollment perplexed Nammour, who asked her why she had signed up for this course. She explained that despite teaching art appreciation, she knows "nothing" about Lebanese artists and thought it would be a good thing. Nammour exhaled with relief and then introduced me: "Kirsten is getting a PhD in Lebanese art history." He turned sharply to me. "So why are you taking this course?" It was the question I had been fretting over. I smiled and, politely avoiding a public correction of Nammour's disciplinary attribution, said, "Well, it's very important for me to be with people talking about art, to have a chance to talk with people, and that chance isn't very common in daily life." The student next to me, Rayya, snorted. "In this country?" I did not have a chance to explain that I meant everywhere.

Abjections accumulated rapidly. Rayya interjected that actually she had signed up for another course, but it had been canceled. She described herself as "far from art" and added that until a month ago, she had consulted for the minister of trade and economy, Bassil Fleihan. As we all knew, the minister now lay in a coma. He had been riding in the prime minister's car when it exploded. She added, "I've always been interested in art since I was small, but I never got any chance to. . . ."

Now Nammour intervened to recuperate the art we had each failed to actualize: "There's an artist in each one of us. If it gets encouraged, it develops. If it doesn't, it lies dormant. You ladies do the *poupée* [doll]. You dress us and know exactly what you're doing. There are so many art elements; you choose colors

and which accessories and which pieces go together. You coordinate with the current fashions."

I glanced at my fellow students. I was the only one not wearing makeup. Rayya had bobbed her dark, sleek hair and paired a crisply tailored black-and-red Massimo Dutti sports jacket and linen slacks with matching two-tone sneakers. Adorning her hands were a substantial silver Swiss watch and a neat French manicure. Samar topped her beaded, flared jeans with a taupe chamois jacket. Her flowing hair glimmered with a subtle henna wash. Dima, the sole student in glasses, had accentuated her bleached hair with a zebra-striped turtleneck and a black blazer. We all nodded as Nammour pronounced us "lady-artists" (*sayyidat fannanat*, sing. *sayyida fannana*), insisting that, as "ladies," we "know about art but aren't aware of it."[1] By cultivating our instinctual aestheticism, our teacher would help us awaken and develop our inner artists. Our tasks for each of the coming eight weeks would be to visit a gallery and report on our responses. Before sending us off, Nammour advised we visit Agial Gallery and Galerie Aida Cherfan in the coming week and cautioned against visiting outfits that had "nothing worth seeing" or showed "just walls of Lebanese artists, not really an exhibition."

The tension between gaining open-minded exposure and carefully curating the input into our art awareness struck me as I exited the classroom. The year 2005, which began with the prime minister's assassination and spawned unprecedented anti-Syrian occupation demonstrations, already equaled the late 1920s in the number of existential questions confronted by Lebanese civic subjects. Now a handful of us had gathered for Tuesday-evening classes in art appreciation on the same campus that had hosted Farrouk's first public exhibition and years of leading an art club. The assertion that "we must develop our acquaintance with the arts; they should not be a foreign field" resonated in my mind with Scoutmaster al-Nusuli's call to accept art and "walk with it" and Kamal al-Naffi's defense of the nude, lest foreigners keep charge. The same disaccord between al-fann al-jamil and local practices animated this classroom now. Even though we had been encouraged to reach inside for our approaches to the Zen garden, we had spent half an hour discussing the "best composition," in terms of formal elements such as balance and proportion, and taking notes on a holy trinity of analytical styles. Nammour's incitement to see with a "different process" and discover hidden inner elements of ourselves by doing so reminded me of Yusef Ghoussoub's provocation at that 1929 exhibition to see oneself seeing differently. His pronouncement on our innate aestheticism recalled Farrouk's imprisoned odalisque. To what degree were we lady-artists "to this very day" called on by the descendants of al-Naffi to carry out a

(self-)decolonizing (but gender-reinforcing) quest through the paradoxically universal practice of dutiful, reflective seeing? And what might studying this process of self-civilizing say to current quandaries of meriting self-governance?

Histories of art "in Lebanon" and other former colonies tend to take for granted the introduction of art lessons to the wider public and track the top-down power that art lessons allegedly imposed on the imaginations and identifications of colonized peoples.[2] They have variously seen mimicry and subjugation or autonomy and maturity result from the pedagogical encounters. Their findings, however, are mired in a model that treats power as a possession and art as a reflection. This approach reinforces an intentionalist account of art production, one that foregrounds either the individual makers who become heroic icons of national creativity or the perspicacious bureaucrats who become disciplining instruments of colonial statecraft or nationalist liberation. This focus dangerously ignores the fantasmatic materiality of art lessons, their synecdochical indexicality, their interactivity and nondeterminacy.

In the 1930s, Mandate Lebanese school curricula integrated art lessons and targeted pupils to cultivate not so much their potential natural talents as their potential for citizenship. Ilham Khuri Makdisi records that in the late nineteenth century, *drawing* could mean something dilettantish that "people of Paris" do, along with piano and embroidery and in opposition to ennobling themselves and others with reading and cooking.[3] Yet by the mid-1930s, not only were private lessons available at many artists' ateliers, including Omar Onsi's, but students sat for compulsory art lessons with Onsi at the Islamic Religious College (al-Kulliyya al-Shar`iyya) in Zaidaniyya.[4] Moustapha Farrouk taught art at the Maqasid School for Boys, Mar Ephrem School in Zahle, the Muslim Female Youth Association, and the American University of Beirut/Preparatory College.[5] Cesar Gemayel taught art history and practice at La Sagesse High School, the Jesuit Fathers' School, and the Military Academy.[6] Lessons by various other teachers were also available at Ahliah School for Girls, the American School for Girls, the Christian Youth Association, and Lycée Abdel-Kadir, to name only those I have been able to recover.[7] The diversity represented by these institutions is striking: teaching boys and girls, in religious and laical settings, with Arabic, French, or English as primary languages of instruction, run by "local" (watani) and "foreign" (ajnabi) administrations.

The infamous French civilizing mission aside, the populace, not the authorities, demanded and executed the broad implementation of public art lessons. Many nonstate actors intersected with and challenged governmental programs most radically in the area of education, producing intense competition between schools whose pupils frequently switched to express dissatisfaction with

curricula.[8] While already in the nineteenth century schooling had become a means for acquiring jobs one's relatives had not previously held, only in the Mandate period did social agreement consolidate schooling's role in mobility, and only then did drastic economic changes of fortune require it.[9] The popular demand for and expectation of art lessons in elementary and upper-school years makes the development of an aesthetic pedagogy an important lens on political movements and nascent affiliations during the Mandate era. The specific "difference making" built into Lebanese art education highlights the intersectional relations produced through aesthetic practices but erased by more conventional histories and maps. Contrasting the Lebanese case with those of colonial and postcolonial India and Syria, or the interwar United States, for example, also provides an angle from which to denaturalize the assumption of art as a marker of national or regional difference and to complicate the meaning of decolonization.

This chapter brings us back to Saloua Raouda Choucair, whose missing sculpture, *Poem*, has riddled Beirut's polis since the height of Lebanon's unresolved Civil War. Choucair was among the first generation taking lessons at Samar's employer, Ahliah, and she later paid for private painting lessons with both Onsi and Farrouk.[10] Tracking Choucair's career back to the lessons that launched her as an artist forces us to confront the uncomfortable topics of copying, mimicry, and mimesis in colonial and decolonizing situations. As techniques of self-production, they may have been more complex and generative than usually thought. Moreover, their contribution to the consolidation of stubborn gender stereotypes bears exploration, when many associations with gender roles trouble contemporary Lebanon.

Why would parents and pedagogues concern themselves with pupils' responses to art, let alone their ability to make it? How does this investment in personal difference—from whom one had been or might be—recast our understanding of often naturalized national difference? Ethnographically pursuing a local art history, I unravel the colonialist, nationalist, and feminist thinking about art that produced art pedagogy. Following their intertwined strands in Mandate Beirut can remind us of social connections often overlooked when attention confines itself to the application of imported models. I am especially concerned with the infilling that art lessons performed for people striving to become gendered and classed citizens. Informed by the lessons of the Zen garden and our poupée self-dressing in Nammour's class, I explore how the fantasmatic materiality of art lessons introduced interactive, nondeterministic techniques of self-production.

First, I examine this idea that everyone should learn art, by which advocates meant mostly drawing, though an array of additional skills might also

be included, from art history to art appreciation. Second, I consider why, over the course of the decade, *everyone* came to mean females *in particular*, and only some at that. My precise task in this chapter is to consider how, over the course of the decade, the professionalization of art became gendered. I argue that working out ideas about art amounted to working out ideas about gender and civic bonds. I refer to this process as "self-civilizing," for how it drew from but redirected colonial discourses of civilizational merit. While Beirut-based art educators and activists came to demand the establishment of a Lebanese national art academy, paramount to the Turkish one in Istanbul and the Egyptian one in Cairo, French authorities adamantly refused the request. Considering students' interactions with art lessons will help us understand the gap that came to emerge, after twenty years of "promoting art," between Mandate citizens and their colonial teachers.

A sidenote on the terminology is in order. Following historiographic conventions, I identify three strands of thinking about art that converged on the creation of a program to popularize art lessons: colonialist, nationalist, and feminist.[11] I use these terms to connect period art-thinking to other aspects of public and political work, and out to experiences elsewhere. By no means, however, are the labels predictive of an approach to art, not least because such political identities had not yet crystallized.[12] Nor was falling under one category mutually exclusive of contributing to others; indeed, most feminism was justified as "good for the nation" (though not all nationalism took women's concerns into account). While the terms can usefully indicate points of contention, they should not presume hierarchy between the identified entities, which were frequently "lateral," as Sbaiti puts it in her analysis of French authorities and Ahliah administrators.[13] The pedagogy that introduced Choucair to drawing exemplifies this lateralism: it resulted from newly introduced, government-decreed mass art lessons *and* from locally and regionally generated projects for harnessing the allegedly natural aesthetic power of females (that we met in chap. 3), toward earning civilizational merit to throw off colonial domination. Therefore, my contention is that thinking about art shaped nationalist, feminist, and colonial ideologies in ways adherents may not have predicted or totally recognized.

In chapter 1, I compared art acts to dreams for revealing their sociopolitical interventions only when studied as part of a transsubjective, shared subjunctive reality. Like dreams, art lessons locate art thinking and experience in a setting where pupils link to an array of emergent identities, statuses, and concerns. In the disciplinary setting of Mandate-era art lessons, a broader public than would ever professionally engage with art had to reconceptualize supposedly

FIG. 5.1 Saloua Raouda, *Boy Painting a Pot*, oil on canvas, 25 × 14 cm, undated. Anis and Wadad Rawda Collection, Beirut. Author's photograph.

essential entities like "nation," "modernity," and "gender" as the products of their diligence. Such entities were vague in daily life, but art lessons yoked them to manual, observational, and aesthetic practices.

Copied Postcards and Exalted Disciplines

One day in the summer of 1934 or 1935, a young Saloua Raouda signed her initials to a painting she had made for her high school art class (fig. 5.1). The scarlet-red, capitalized S and R still project boldly from the drab beige pigment of *Boy Painting a Pot*. Saloua may have been celebrating the culmination of her art lessons, with which she had ambivalent relations at best. Or perhaps her teacher had asked her to inscribe the canvas so the painting could hang in the exhibition accompanying her graduation ceremony. Journalists regularly reported on the graduation ceremonies held at *Madrasat al-Banat al-Ahliyya* (The National Girls' School, hereafter "Ahliah").[14] They noted the multiple languages Ahliah's valedictorians spoke, the dances they performed in costumes the pupils themselves had made, and the exhibitions of handicrafts and taswir. Such displays confirmed that Ahliah offered "educational innovations that had not occurred even to the minds of great foreign pedagogues," as one editorialist described the curricular inclusion of liberal art, languages, and "all fine arts."[15] Or perhaps the pupil did not sign her picture until she brought it home and her older brother, Anis, decided to put it in the living room. There is some evidence he may have wanted to mark the vindication of his family's controversial pursuit of that innovative curriculum at a time when social debate swirled around girls' education. Foremost, for decades to come the picture would hang in the brother's living room with several works that he preferred to the oeuvre for which the child was to become so famous with the expanded signature "Saloua Raouda Choucair."[16]

Anis Rawda's fraternal act of selection throws into relief the disciplining nature of art lessons.[17] When I asked Choucair about her brother, she told me a joke he once made (and frequently revisited): She had baked him a birthday cake—a proudly distinguishing feat of Ahliah graduates—and smacking his lips, he had quipped, "This is the only thing you have ever made that had any dhawq."[18] "Dhawq" for Anis was a bridge to a common ground, not a window to self-discovery. The cake was an "English" recipe, complete with frosting. *Boy Painting a Pot* should be ensconced not only amid the other paintings that hearken to this period but amid the whole Ahliah oeuvre: elaborately decorated cakes; an ornamented cooking apron and an illustrated recipe book; prettily painted glass jars and *saj* tins; as well as an armory of notions about dressing,

posture, household management, child-rearing, and public engagement. These constituted the trousseaux of the "best brides," as Choucair later characterized her class at Ahliah.[19]

It is perhaps not merely coincidental that Saloua's painterly hand was trained in submission on an image of submission, and North African submission, no less. *Boy Painting a Pot* responded to a prompt from a postcard, a common tool for art classes at the time. The postcard had traveled from one corner of the French empire to another. At a school renowned for its watani, Arabist stance, as we shall see, Saloua's ability to render the postcard as a credible painting indexed institutional modernity and national maturity, as well as personal talent. That Anis Rawda preserved in his domicile this corpus rather than any of his sister's mature, difficult invitations to artistic vision suggests he preferred and hoped to preserve Ahliah's production of his sister as a lady-artist. Thus, tiny though the painting may be, it embodies the vast social investment in art lessons developing during the Mandate struggle, an investment that made such pictures not only possible but commendable and their refusal a punishable offence. Let us consider more closely the material of the lesson.

Just larger than an outstretched palm, the signed *Boy Painting a Pot* portrays a young boy decorating a clay amphora. The style is naturalistic, with small brushstrokes conveying close attention to the light falling across the pot's round surface, the boy's concentrated mien, and the proliferating folds of his toga. The seated boy carefully inscribes red and white triangles on the neck of the amphora, the rotundness of which exceeds his lap and emphasizes the slenderness of the juvenile fingers gripping the paintbrush. Yet he faces his task with confidence and patience, in a posture that may well have motivated the young Saloua to face hers. The carefulness of his work in turn highlights the steady hand and trained eye Saloua mobilized for her own work, which here involved assiduously copying this scene from a hand-tinted postcard. Itinerant photographers Rudolf Lehnert and Ernst Landrock had produced the postcard under the title "Cairo, Native Artisan" a few years earlier.[20] Rudolph Lehnert probably photographed it among the Ouled Nayl people of Algeria or in Tunisia, between 1904–6.[21]

Copying postcards to make oil paintings was the apogee of the Mandate-era discipline of art in double-decolonizing Lebanon.[22] Partha Chatterjee observes that the creation of disciplines in colonial settings commences with an insistence on unity that diverts to comparability.[23] We may recall Farrouk's assertion at his New Year's Eve exhibition that art's "vast unity," instantiated in Mandate Lebanon in the professional form of al-fann al-jamil, created the means for both cross-cultural assessment and watani action. Chatterjee's point, however,

is that obstruction of their participation in the elevated field of "universal" knowledge leads colonial citizens to establish a comparable field, "literature in India," for example, and to assert a distinctiveness to it, as in "Indian literature." Studying colonial India's art scene, Tapati Guha-Thakurta documents how this translated into "fine/higher arts" for the Western artists practicing locally and "applied art" for the Indians, whose national future came to lie "in a revival of their traditional craft skills and in a new employment-oriented training."[24] Similarly, interwar Americans painting outside the big cities sought to spread a "regionalist" practice that would claim their status as "modern citizens, [in] a role defined by active participation in the democratic sphere rather than simply a conferred legal status."[25] In this view, art lessons in Mandate Lebanon likewise arose from an insistence on a unity, al-fann al-jamil, but settled themselves alongside paradigmatic metropolitan manifestations of art's production in a "Lebanese version."

Yet, we have already seen in the previous chapter how treating local landscape painting as simply another version of a universal genre misses the energy that animates its practice and creates its locality. Similarly, the ardent likeness of Saloua's painting to the photograph undermines Chatterjee's image of settling alongside. It nods toward Homi Bhabha's famous model of mimicry, which respatializes the idea of originality in its exploration of the production of discipline. For Bhabha, diligent copying reveals the inauthenticity of the colonial encounter, wherein neither colonizer nor colonized inhabits a position of "racial or cultural priority" or pureness. If an Indian can be like an Englishman, then Englishness is not exclusive and distinctive. Resemblance menaces. Yet being like is never being exactly, and making like involves "reform, regulation, and discipline, which 'appropriates' the Other as it visualizes power."[26] Copies encapsulate the colonized in the colonizer's world. In this view, Saloua's signature on *Boy Painting a Pot* denies inherent difference between her and the colonial makers of the postcard but also affirms the art form's authority over her and her inferiority, though subversive, in that relationship.

Scholars who take postcards' very design as an instrument of alienation and exoticization might take an artistic discipline based in copying them to affirm the "colonization of Lebanese eyes," as artist Najah Taher put it to me (see chap. 1), from the onset of national attempts at professionalization.[27] In common with Chatterjee and Bhabha's analysis of the artistic discipline, Taher's analysis assumes that those eyes always fixated on an *external* onlooker. The previous three chapters have shown how the structure of fantasmic art production inscribes an internality for the onlooker to fill. My exploration of copied postcards, accordingly, foregrounds mobility and reframes art lessons as

institutional *exaltation*. Institutionally, disciplines themselves "exalt" abstract unities that have no physical exactness. George Steinmetz uses "exaltation" to capture the aggressive, forward claim colonized pedagogues and pupils made for a hierarchy of value into which they strategically inserted themselves: an exaltation generates "a fantastic form of social mobility through interactions and identifications."[28]

Like the exhibition format and the genres of nudes and landscape paintings, the postcard and other art lessons that came to characterize Mandate Lebanon were "locally made imports." They scoff at established notions of context. As eminently mobile forms, postcards are immanently out of context. The travel and transformation of the photograph processed by Lehnert and Landrock into *Boy Painting a Pot* offers not a window onto the entities it moved between but a means for their interface. Always slipping through the vagaries of cosmopolitan capital, offtrack and into unforeseen homes, such fantasmic images ask not only what exactly was copied (per Bhabha) but what was incorporated (per the model of dhawq).

A Comparative Mythology of Art Lessons

I have imagined the multiple possible scenes surrounding the signature on *Boy Painting a Pot* to account for the presence, in 2002, of this same painting in Saloua's brother's reception salon when her own house contained no such "student works" and all those surviving deep in her atelier closet were unsigned. In fact, Choucair has not spoken publicly of such works except to repudiate their process of becoming. Take, for example, this excerpt from a 1979 journal profile on Choucair:

> It was in 1926, when Saloua the child was ten. . . . Her teacher in Ahliah . . . noticed her strong inclination toward picturing (taswir). She gave her encouragement. The more the girl advanced from grade to grade, the more this desire of hers grew, too. She still remembers how she drew her French teacher, Mlle Chapé, during the noon recess, and how she would draw her schoolteachers in chalk on the blackboard . . . which would elicit amazement and some laughter from her classmates. She continued drawing caricatures until she reached the year in which picturing lessons (*durus al-taswir*) were given, for which copying a classical picture was required. Saloua the student, however, pictured "according to her dhawq" and refused the *kazz* (tracing) method. So, the teacher would kick her out, and she would spend the hours for drawing (rasm) outside the classroom door.[29]

This tale, often repeated in local art history, leaves one wondering how *Boy Painting a Pot* came to be made, let alone signed.

Like all myths, those of first art lessons work metonymically to describe the founding of art and the establishment of its relationship to the community.[30] Yet these stories always hush other agencies involved in making art, among them locality and local pedagogical principles. Notice that this tale of Choucair pits copying, or "tracing," and "European classical art" against an indigenous resistance and quest for a type of art related to everyday sociality. When Choucair first reported this schooling experience to me, I, like the journalists before me, initially focused on Choucair's authenticity, both personal and cultural: "Saloua the student," essentially already "Choucair the sculptor," had an innate "taste" (for that was how I translated *dhawq*) to which she clung fiercely, unswayed by alien hierarchies of value (read: not colonized) and undeterred by having to suffer her teacher's marginalizing retaliation (read: not disciplined). Yet the postcard-copy confounds the terms on which I relied. Saloua may have rejected the ideas her teacher promoted, but she did make the required painting; and while the teacher may have procured the painting, she could not secure the student's commitment to her lessons. Second, Saloua's dhawq may have abhorred the lessons, but that followed on years of previous art training that focused on her body and capacity for self-vision as a lady-artist. In other words, as locally made imports, both the postcard lesson and dhawq beg us to meditate on the meaning of the signature, "S. R."

Consider that there is no counterpart to the signature on *Boy Painting a Pot* in the legend, which we heard echoed in chapter 2, of Moustapha Farrouk's quest to learn art as a child.[31] Farrouk's struggle for art lessons focuses on patronage and space, or the infrastructure of art making. This story occurs in Beirut circa 1910:

> While I experimented [with drawing], I was often stopped by a group of religious scholars, or rather pretenders who put on religious airs. They would say to me, "Boy, drawing is taboo. God will burn you in Hell on Judgment Day. . . ." I ultimately heeded these words, as their threat filled my soul and young mind. I stopped drawing. [Later] I entered an elementary school headed by a man educated by foreigners, Tahir al-Tannir. Under his tutelage my drawing attained prominence, because al-Tannir understood something of drawing. He encouraged me until [yet another] band of religious charlatans confronted me, again scaring me with the fires of Hell. I stopped entirely. One day it happened that I was asked to speak at a school ceremony. When I finished, Shaykh Mustafa al-Ghalayini took me aside asking, "How's your drawing these days?"
> With the naivety of a child I replied, "I quit."

He asked, "Why?"
I said, "They told me that on Judgment Day I was going to have to put souls
(*ada` arwahan*) for each of my drawings, or I would be thrown into Hell."
He laughed and said, "Good! You picture them, and I'll put the souls." Since
that day I picture, and Shaykh al-Ghalayini puts the souls.[32]

The story of young Moustapha's quest for a space to draw inverts Saloua's
story of expulsion from the space dedicated to drawing. In Moustapha's story
there is no signature; permission is the only issue. A renowned religious author-
ity had to clear space for the pupil Moustapha to practice his art, but a simple
functionary would soon command a space devoted to art practice and could
clear disobedient students like Saloua from it. Whereas twenty years earlier
drawing had signaled pomposity, even heresy in many circles (but most po-
tently, for purposes of the tale, at the pre-Mandate grade school), at Ahliah and
sister "nationalist" schools during the Mandate, disciplined drawing indicated
mental maturity and moral superiority.[33]

The arc from Moustapha, the little Muslim boy who *could* draw, to Saloua,
the secular but pious girl who *should* draw, reminds us that people invested in
art to control the population, and they contested, structured, and restructured
forms of authority through its medium. In each budding student's encounter,
art created a different set of problems. Both stories pivot on disagreement,
underscoring that overarching change had not been agreed on, much less
achieved, and both resound years later to persuade audiences of the righteous-
ness of the protagonist's perspective. That Farrouk's sketches received shelter
in shaykhly breath suggests that a young boy's attempts literally inspired auda-
cious rereadings of social hierarchies and the sacred conventions authorizing
them. Further, following the arc set in motion by their artwork, we eventually
find the religiously ordained Moustapha making "secular" nationalist artwork
and Saloua, the lady-artist from the secular national school that adapted a colo-
nialist curriculum, making deeply pious art. These amount not to a teleological
advance in art attitudes but the agential intervention of art acts in fashioning
society. Rather than reflect, art intervenes.

Art Lessons in History

Saloua Raouda's art lessons at Ahliah School and with two professional Beirut-
born artists culminated decades of shifting practices. In earlier centuries, tute-
lage flowed through kin connections: the eighteenth-century Musa Di'b (d.
1826) taught Kan`an Di'b (ca. 1830–1873), and the nineteenth-century Daoud

Corm taught his son Georges. Prior to the 1924 introduction of mass art in-struction, students in missionary schools might have had some training in drawing, and children of the nobility might have received lessons at home for a few months, but most pupils who learned art did so in painters' studios or photographers' shops.[34] A ledger figured by Francophone Beirut-born artist Philippe Mourani around September 1901 recalls that in the past six years he had earned 2,000 francs teaching *dessin*. A quarter of that income came from the St. Joseph University and the rest from individual students. The latter are listed with their honorifics, as in "Mlles. Assine, Hélène, and S. Faraon, Ms. Elias and Nagib Ferneini," suggesting that, despite their inferior age, Mourani's students outranked him socially.[35] Habib Serour, who taught at the Ottoman College from 1915 to 1918, privately tutored, among others, Georges Maqsud; the acclaimed calligrapher Tawfiq al-Baba; Farrouk; his fellow scout, Salah La-babidi; and ʿAli Qubaisi.[36] Lessons were held in his atelier on Alfred Sursuck's estate. Jean Debs, maker of the famine sculptures at the 1921 fair (chap. 2), taught Yusef Ghoussoub in his "factory."[37] Sometime after 1900, Khalil Saleeby, Onsi's mentor in nudes, had set up an atelier on Bliss Street, where he also taught Cesar Gemayel and others.[38] Jan Kober, the Polish-born nudist men-tioned in chapter 3, taught Marie Hadad, Gladys Shuqair, and a Miss Bart from his house in Ain el-Mreisseh.[39] Gertrude Lind, daughter of the photographer Jules Lind, gave lessons from her father's studio in Zaituny, to Farrouk among others.[40] From the foregoing, it appears that, until 1924, only Serour taught art in an official capacity from the auspices of a government institution to a group of students who had not chosen to study art per se but took it as part of an edu-cation. Those students were all male.

Serour's teaching stemmed from the incorporation of the greater Syrian region into Egyptian rule after 1832. First, Egyptian and, then, Ottoman au-thorities established military primary schools for young males, in what has been regarded as the beginning of a public educational system in the Ottoman Empire. Enrolled boys studied four years of languages, math, history, geogra-phy, calligraphy, and "*resim* (drawing)."[41] Raja Adal analyzes this last subject in his study of Egyptian pedagogy, concluding that "its primary objective was to provide the necessary skills for symmetry, precision, and calculation to support modern technical and scientific practices."[42] By the turn of the century, resim was taught, together with orthography and calligraphy, in the second- and third-year curricula of the *rusdiyye* (one type of secondary school), and as a separate topic in all five years of the *idadi* schools (another type of secondary school).[43] The last two years of curriculum serving the children of "tribal ar-istocracies" also required resim, as part of a Hamidian "civilizing" project to

incorporate ethnic, non-Sunni, and provincial groups into an Istanbul-based imperial outlook.[44] Drawing also served methodologically for a subject called "*ilm-i esya*," or "knowledge of objects," which Adal interprets as the antidote to idealism: "to capture each specimen in all its details and idiosyncrasies" meant to "teach children precision and truthfulness toward the objective world."[45] However, idealism and objectivism may not have been so sharply opposed.[46] Even in officials' understanding of the practice, motives mixed.

Listen to Egyptian minister of public education Sa`d Zaghlul's champion-ship of drawing presented in 1907 to the Egyptian Council of Ministers: "It is important to employ [the child] in reproducing the shape and movement which the eye perceives in living nature, so as to give birth and develop in him the spirit of observation, good dhawq, and *creative* faculties."[47] Zaghlul's words in-tertwine knowledge of objects, a plan for selective incorporation, and a concern for invention with a pedagogy of military preparedness, governmental control, and particularism. It is a world where attention to detail calls forth elaboration and development by the viewer.

During the same period of reform, social activists appealed to all Ottoman subjects to make ad hoc art lessons part of their daily lives. To understand their urgency, I examine a debate from 1912 between renowned belletrist May Ziadeh (May Ziyada) and Labiba Hashim, the anarchist and educator who the year be-fore had lectured on the importance of founding a "school of dhawq" (see chap. 3). Concerned about their peers' propensity to become "other to themselves" in a time of shifting boundaries, economies, and political systems, both activists promoted art exposure to prevail over alienation. Undergirding their prognosis of the era's woes was a model of imagination bequeathed by philosophers Ibn Sina and the Sufi Ibn al-`Arabi (see chap. 1). In an echo of Ibn Sina, Ziadeh lauded *al-mukhayyila*, the organ responsible for imagination (al-khayal), as "the strongest moral force." According to her, it alone could transform experience into possibility and thereby advance current social conditions to "the heights known by ancient Greeks." Unlike the predecessor philosophers, however, she doubted most modern humans still possessed this capacity. A close interlocutor of Kahlil Gibran, Ziadeh averred that the typical artist was a "hypersensitive, emotionally fragile, keen observer" who "bared his soul and conveyed the stuff of dreams from the world of fantasy to the real, tangible world."[48] Humanity should revere these special creatures.

Such elitism outraged Hashim. Displacing Ziadeh's civilizing discourse with a cultivating one, she ardently argued that not every observer-dreamer had to be a Gibran from birth; people could cultivate their mukhayyila. Just as she had advocated for a "school of dhawq" to evaluate the influx of novelties,

she now called for public learning to cultivate the capacity for conception (*quw-wat al-tasawwur*, the ability to generate taswir) among the populace at large.[49] Despite their differences over the state and capacity of mankind, Hashim and Ziadeh both advocated noninstitutionalized, self-organized encounters with the world in an aesthetic mode to exercise and harness their quwwat al-tasawwur and enhance their creative responsiveness.[50] Both promoted a fantasmic art that could map and flesh out a modern, civic internality; they differed only on how broadly art could work.

This belief in human malleability, environmental changeability, and a conse-quent self-civilizing responsibility (which we have already encountered in the formation of exhibitionary sociality and dhawq as a personal compass) infused thinking about pedagogy in the subsequent decades, when social reformers and activists took up the question of a national school system in the new political context of the French Mandate. For example, in 1922 prominent pedagogue Fu'ad Sarruf applied the model of aesthetic impressionability to early child-hood education. The child's brain, he explained, is a "canvas (*lawha*)" on which "mental images (*suwar dimaghiyya*)" impress themselves by the strength of their sensory affectivity and not by the degree of their moral or logical valid-ity. "Higher mental faculties" are still latent, but sensory perception, affective impressionability, and instincts for empirical investigation and imitation are vibrant. "So be careful what you do in front of the child," he warned, as "it is impossible to erase the sura impressed on the canvas of his sensitive brain."[51] Sarruf noted that these "mental images" may appear in other forms at unpre-dictable times, causing socially unwanted behavior, yet their manifestation is not attributable to the child's "internal nervous brain."[52]

Sarruf's mental images, in other words, are fantasms, created through fan-tasy. Opposing al-tasawwur and al-khayal not to truth but to logic (*al-'aql*), Sarruf credited the pair with the capacity to envision supreme philosophical verities and religious and moral principles as if they were actual things.[53] The child's brain is a treasure chest out of which al-tasawwur selects mental images and "corporealizes" them in his or her present. The magic of one's imaging (tas-wir) transforms the inert into living and dresses mere illusion in a robe of real-ity. This organ of recollection, representation, and reification was thus essential, Sarruf argued, to the development of the child from a sensual organism into a logical, moral being because it allowed children to extend experience beyond their limited worlds. Writ large, al-tasawwur developed society from a primi-tive stage in which passions and stimulations rule to an advanced one governed by compassion, philanthropy, and concern for the common good. Cultivating Mandate children's tasawwur, thus, would amount to a (self-)civilizational

mission. Sarruf's thinking—shared in widely read feminist and nationalist journals—suggests how educators interpreted and applied the coming educational reforms to introduce "watani" art lessons into school programs targeting the general populace.

Making Hadatha in al-Tasawwur and Taswir

Following the establishment of the Mandate, the high commissioner had total responsibility for school administration.[54] In the fall of 1924, five years before Saloua enrolled at Ahliah, the director of Public Instruction in Metropolitan France issued decrees on the teaching of "arts and handicrafts" in Lebanese schools.[55] Importing a curriculum from colonial Morocco, French authorities offered drawing lessons for cultivating "*le-compas dans l'oeil*" (ocular compass), or what historian Hamid Irbouh interprets as a sort of generalizable self-regulation.[56] Developed to pacify and indigenize artisans who would retain "their religious traditions" (i.e., iconoclasm) and stay out of politics (i.e., anti-colonialism), the ocular compass opposed both "self-expression" and "fine art."[57] One decree proclaimed that the goal of teaching handicrafts to nursery school children was to "establish constant and direct contact between the child and the objects surrounding him in view of developing his manual skills, his senses, and through these, to awaken his intellect."[58] Another decree specified that boys should learn drawing and girls, sewing.[59] A third clarified that the goal of teaching drawing in the elementary schools was to instill the "use of perspective, a sense of landscape, and respect for classical models."[60] Note that no decree dealt with training beyond grade six, for French allocated art training only to age twelve. Just as they deemed professionalism beyond indigenous capacity, the authorities issuing these decrees assumed colonial pupils lacked sufficient imagination or visual memory to draw freehand. Coloring books, grid transfers, and tracing with wax paper would support and limit their art lessons.[61] Where Sarruf envisioned nascent moralists and logicians, French authorities saw slumbering Mandate children to be awakened by exercises deliberately aligning their consciousness with an external, objective world.

I interviewed several of Onsi's and Farrouk's primary school students. They describe their lessons sparsely: They had pencils. The teacher would enter the classroom with an object in hand, perhaps an apple, a vase, or a chair (fig. 5.2). He would put the object on the teacher's desk at the front of the room and command, "Draw." For the rest of the lesson, the teacher was mostly silent. The students sitting in the last row of desks might hardly be able to see the object, but still they were supposed to take up their pencils and draw it as they saw it,

FIG. 5.2 Photographer unknown, Moustapha Farrouk in the Preparatory School art class, February 20, 1952. The chalkboard reads, "*Al-mawdu` kursi*" [The topic is a chair]. Hani Farroukh Collection, Beirut.

"from the place . . . from the place of sitting, I mean, how I personally was seeing the apple or chair"—the words of the former student still struggle to explain the counterintuitive command decades later. Because he was "terrible at drawing," Onsi would sometimes stop before his work and declare, "This is no good." He would cross out a line, improve the apple's skin, and finish with another, "No good." A student at the Lycée Abdel Kadir, a secular French school, in the 1930s recalls that rasm teachers would instruct students to "go out to the garden and find anything and bring it back to draw it." She remembers choosing an acorn. These lessons puzzled students because they focused on trivia, but their learners took pride in undergoing them. Many of the former students whom I interviewed, especially the females, assumed their school to be the first or only to provide such lessons, so strongly did these lessons symbolize institutional innovation. Even (or especially) as juveniles, they keenly experienced this pedagogy as part of *"asalib haditha li madaris haditha"* (modern methods for modern schools), to borrow from one of Onsi's pupils at the Islamic College.

Drawing's hadatha lay in the cut it sliced across the conventional thinking process. Ultimately, it was not a type of thing—apple, chair, acorn—that students learned to draw but a unique visual relationship, the fantasm, that indexed a "personal" position separate from all other viewers. This view of drawing-as-seeing made durus al-taswir the foundation for imagination (quwwat al-tasawwur).[62] Arts "vibrate the emotion and meaning that reside in the chest" and "provoke the viscera and rekindle the fire of existence in [listeners'] livers," wrote Marie Yanni, the editor of *Minirva*.[63] She particularly praised picturing for promoting awareness of and concern for virtue and perfection. Others held that art lessons alone could extend human awareness beyond the current material world in which things mattered only for their use value. Advocates multiplied. In 1932, eight years after the decrees, painter Khalil Ghoraieb pleaded for obligating all students to take durus al-taswir. He explained that "facing a general trend toward deviant tendencies due to chaos and unremittent confusion," picturing is a "mental exercise [that] moderates the feelings, inculcates a love of beauty, and increases one's sensitivity to and observation of one's surroundings."[64] In agreement, the following month an editorialist advocated adopting Ghoraieb's newly published "textbook on art" (history and aesthetics) in all schools so as to "expand [students'] culture (*thaqafa*)" and improve industry.[65] Intellectual ʿAli Saʿd argued that the new possibilities of capitalism had resulted in widespread selfishness among the populace and irresponsibility among officials. He suggested that drawing lessons offered a way of instilling self-control in the population without relying on the creation of an external force. Engaging eyes, hands, and whole bodies, art

lessons could be implemented to produce students who embodied concern for rationality, conformity, self-reliance, and decorum.[66] La Sagesse School made headlines when it took up the project of expanding thaqafa by hiring artist Cesar Gemayel to give durus al-taswir.[67]

The foregoing clues us into the efforts and urgencies to shape new social formations. Advocates felt Mandate authorities supported art pedagogy insufficiently. They argued that the new learning stimulated a visceral practice of experimental submission to random quotidian things in their transient appearances, which could not be known entirely through preconceptions. These debates ambivalently criticized Beirut's khawajat, the small and tentative "middle class" that al-Nusuli had hailed at Farrouk's first show, while also appealing to the lower-ranking officials and highly ambitious entrepreneurs among it. Although they confirm the ongoing emergence of that middle class, they beg for more consideration of how proclivities and concerns imbued by aesthetic experiences enfleshed the bodies of Beirut's citizens-to-be. To return to how particular people experienced and understood these projects: If young Moustapha was forbidden to draw because, as a believing Muslim, he could not hope to bring life to his mimetic creations, little Saloua was required to draw because, as a mature, urbane female, she had to bring cultured life to her eventual domestic creations (meaning child-rearing, husband refining, and home decor) and civic contributions (meaning creating the environment for raising citizens). Once permission arrived, Moustapha's pictures became coproductions, born from a partnership with a modern, post-Ottoman religious patron in a quasi-sacral space provided by cultivated public intellectuals. By contrast, in Saloua's story, the issue at stake is the signature, which should consolidate in one hand the commitment of the female colonial citizen and aesthete to mu'asara, dhawq, and exhibitionary sociality. The difference produced women as lady-artists. So let us follow S. R. back to the beginning of the art act.

The Body of Art

Ahliah School, where Saloua made *Boy Painting a Pot*, took its name from a "native/national (*ahliyya*)" program for social renewal, by which supporters initially meant a program that was neither religious nor imperialist. The rest was figured out in practice. At an early fundraising event, newspaper owner and politician Jubran Tuwayni, for example, distinguished Ahliah from the many vocational schools, which offered technical training without basic reading and math, and from the "foreign" schools, which taught neither "the language of the homeland nor the love of it."[68] The school's board of consultants

joined aristocracy, intellectuals, and entrepreneurs from across confessions with a commitment to achieving political liberation and social amelioration. The teachers were primarily Arabic speaking, missionary trained, and yet religiously unaffiliated. The student body was almost unique in its multiconfessional character.[69] These constituencies together crafted concepts of civic duty, national identity, and Arab belonging as indissolubly intertwined. Sbaiti observes that the notions of civic duty and citizenship emerging from Ahliah's classrooms were "not about the state but about one's relationship to the land, to the self, to an idea of a distinct past."[70]

Learning art at Ahliah contributed to a curriculum deliberately designed to counter the deleterious effects of French Mandate unconcern for their colonial subjects' tasawwur. Though regulated by the Mandate educational decrees, Ahliah's educational program added classes and extended their length to transform them into a "watani" curriculum, again a locally made import. Students learned history; math; life sciences; nursing; "home management"; literature in Arabic, French, and English; and, of course, "all the fine arts." To teach arts specifically, Ahliah used pedagogies common in Britain and France—both visited by its directors—which relied on drawing and other applied arts to channel girls' presumed imitative and aesthetically inclined nature into time-consuming, quiet, modest, and useful activity.[71]

The recourse to metropolitan curricula might seem counterintuitive at a "native," anti-colonialist school—that is, if we forget that these curricula were officially prohibited to non-French citizens.[72] They were excluded from the colonies (except through the reluctant work of missionaries, which was often at odds with their governments).[73] Themselves products of missionary pedagogy, Ahliah's directors revamped the supposedly simple expression of the feminine spirit into a patriotic plan to advance society by raising "modern women" who could contribute in equal measure to their homes and homeland.[74] Ahliah cultivated femininity through exposure to intellectual, sensual, and practical resources for "invigorating nationalism's body (jism al-wataniyya)."[75] They graduated lady-artists, key figures in the enactment of a "patriotic motherhood" that "glorified the traditional place in the woman's home and a mediated relationship to the public and political arenas."[76] Choucair recalls that she learned to sew aprons, follow recipes for English cakes and Arabic stews, decorate serving trays, and groom herself. While the production of the lady-artist accorded with French decrees, its centering of girls as transitive agents of aesthetic sensibility remapped the very limits of domestic space, to merge personal, familial, and national concerns. Ahliah's patriotic project returns the spotlight in a study of art's colonial institutionalization to dhawq.

Nicknamed "the Prophet of Dhawq (*rasulat al-dhawq*)," Zafar Mash`alani taught the lower elementary art classes at Ahliah. Remarkably, seven decades later, Choucair remembered not only her first art teacher's name but also her physique: "tall, a bit heavy, and strikingly elegant."[77] Choucair's strong memory of this teacher's physical presence underlines the understanding of art she imparted to her protégées. When I asked her why the teacher had this nickname, Choucair crossed and uncrossed her legs while repeating advice Mash`alani had given as they sat for drawing lessons: "Don't cross your legs because then your calves look wider, and that's ugly." Her body still activated by the prophet's words, the adult artist rhapsodized, "She brought beauty to our attention; she taught us everything about dhawq." Choucair explained that to approximate continental art lessons, Mash`alani brought "life models" to class: a carnation, a bottle, a piece of wood, a bell, a plaster female bust, and, also, watercolors to be copied (*li-naqalihi*). Developing their quwwat al-tasawwur, she encouraged her pupils to render these objects imaginatively and to envision them in different contexts. She would say, "Look at this carnation; draw a bouquet." Saloua's sister, Anissa, memorably drew hers as blossoms and stems scattered on a street. Significantly, Mash`alani accompanied her lessons with advice about recognizing and utilizing one's corporeal aesthetic qualities. Her lessons activated art as a fantasmic meeting point between world and subject.

By pairing her official classes in drawing with advice on how to use posture to maintain personal appearance, Ahliah's Prophet of Dhawq taught that learning taswir could inform a young girl's conscious self-development. If, with Ziadeh and Hashim, "art" was a project of discerning latent features and arranging them to best advantage, Mash`alani tied her pupils' art to daily life so that its display on their bodies would disseminate its principles. Theirs would be a transitive beauty, both in their artworks and their very being. Perhaps Mash`alani consciously applied Fu'ad Sarruf's advice that teachers carefully cultivate suwar dimaghiyya, by making students aware of their perceptual and conceptual abilities. If so, then she may have used the girls' physical connection to their own limbs deliberately to enable their formulation of aesthetic and, eventually, ethical principles. Or she may have simply imparted ideas that were in the air at Ahliah. Either way, female pupils became input for societal quwwat al-tasawwur, fantasms writ large.

Far off the grid of the colonial curriculum, the lessons of the Prophet of Dhawq vividly reveal that people were figuring out gender roles and art practices together. Throughout the period, educators, intellectuals, and activists debated the degree to which women differed from men—mentally and morally?—and the origin of this difference—essential or social?—and the rights

and responsibilities that ensued from it. They tended to agree that women had stronger sensory capacities than men and an essential appreciation for beauty.[78] By *beauty*, they meant a range of ideas, from basic arrangement of things "in their proper places" to the finest creations of the fine arts. An aesthetically "refined" woman could best care for her home, raise her children's hidden talents, and nourish their good manners, thus helping humanity distinguish itself from the world of beasts (and Ottomans). Sami Sham'a, in the feminist review *Minirva*, explained in a 1927 discussion of their "refinement" in youth, that girls could better engage and transmit art's lessons in beauty and harmony to the broader population.[79] Females became the natural fount of dhawq. The transitive role allotted to women in the arts not only demanded an educational program for girls that gave greater attention to aesthetic matters but rendered women innate artists.

However, females' transitive aesthetic role met ambivalence. Some worried that the feminine capacity for aesthetic self-enhancement, while natural, invited excessive behaviors that could affect society negatively. This is the very fear harnessed by Farrouk's *The Two Prisoners*. Even *al-Mar'a al-Jadida*, a consistent fan of Ahliah's program, reported a scathing critique of its curriculum, especially with regard to fine arts: "It is all very well for a girl to be an expert in the art of picturing (fann al-taswir), but that will not help her in her life as much as expertise in the art of cooking pudding or stuffed vegetables. It is all very well for the girl to have a connoisseur's eye that can distinguish between a picture made by the brush of a skillful painter and a copyist, but that will not benefit her as much as the *ability to distinguish between mutton and beef*."[80] Specifically invoking dhawq as a capacity to surmise internal qualities and incorporate them beneficially, the critique closed by casting scorn on the notion that a woman could achieve happiness by being "pretty and *mutafannina*." The neologism *mutafannina* signals diversification in skills and characterizes the "artistic," as discussed in chapter 3. Here, however, it indexes a contradiction in women's artistic role. Like professional, exhibiting artists, females could be recruited to propagate a type of awareness newly crucial to the nation's advance: the ability to distinguish beauty from ugliness, beneficence from malevolence. Unlike professionals, however, women activated their personal capacities rather than interpersonal, externalizing self-disciplines. They could be accused of selfishly, materialistically misusing their artistic capacities, and they could be derided for never rising above innate propensities. Only lady-artists who could afford innovational training and managed to apply their skills in public settings could advance the country.[81]

In a sense, this Mandate debate responded to the increasing insularity encumbering women's modernizing, which Akram Khater has documented, especially among returnee migrants.[82] If harems had not previously existed in the provincial Levant, many feared, they would materialize from the influx of wealth and goods relieving women of middling means from outdoors, group domestic labor and depriving them of social contacts. Channeling feminine aesthetics into watani prosperity was a matter of getting the odalisque of *The Two Prisoners* off her couch and out into the public sphere glimpsed through her window.

Contextualizing the Prophet of Dhawq's lessons in contemporary projects of womanhood fleshes out their implications, literally. Beginning in the 1930s, newspaper advertisements diagrammed lessons like Mash'alani's. Arrows in the Lebas Elegant Stockings ad indicate the areas on a curvaceous shin's silhouette that tend to visual "weaknesses," or excessive width, as the ad copy explains (fig. 5.3).[83] In the Luxite Stockings ad, the arrows are incarnated by a modishly dressed couple taking tea, seen from a telescopic distance (fig. 5.4).[84] In the foreground, three times the height of the couple, disembodied legs cross gently at the calf without pressing together, to form two perfect ovals, mirroring the tea table's leg. The elegant trio of limbs frames the couple in the background and reveals the woman, caught between the male partner and the second table, to be unable to converse. Ignoring her male admirer, she gazes fixedly (out of longing or fear?) at the stockinged pair of legs, which eerily frame her own self-presentation. While such advertisements command the purchasing of expensive commodities to enhance women's aesthetic self-presentation, the art lessons at Ahliah, befitting contemporary calls for cultivating a transformative mukhayyila, insisted that lady-artists needed no externally garnered goods to improve the external world.

I place these ads beside art lessons to highlight the unclear definition of womanhood lying at their intersection. Recall that for the child Farrouk, making pictures amounted to making bodies that needed souls to justify their presence in society. His fantasmic odalisque of *The Two Prisoners* was one response. Another was art lessons that materially and viscerally engaged Ahliah's female students in creating new bodies that, as Sarruf would say, otherwise have only philosophical existence. One such new body is the nation; another is the female citizen. Ahliah's integrative lessons in dhawq dismantled boundaries arising in other practices between home and public, self and populace, aesthetics and politics, even daily life and philosophy. While independence and self-reliance were encouraged, cosmopolitanism, *in place of* commodities, was an important resource for achieving them, as the next section discusses.

FIG. 5.3 Lebas Stockings ad, *al-Nahar*, February 7, 1934, 3. Courtesy of Digital Initiatives and Scholarship, American University of Beirut.

Copies, Postcards, and Intercultural Production

Developing the senses of nationalism and dhawq together, Mash'alani's embodied art lessons complicate our understanding of the student who some six years later stood at the threshold of the art classroom. Saloua may have been cast out, but she incorporated, literally, some of her classroom's premises: that art be modern, improve society, connect to the world, and allocate young girls a role in it. Saloua may have obeyed and copied sometimes, but she developed a fantasmic understanding of her undertaking. Let us look more closely at her

FIG. 5.4 Luxite Stockings ad, *al-Nahar*, February 4, 1934, 8. Courtesy of Digital Initiatives and Scholarship, American University of Beirut.

postcard-cum-paintings. Introduced in the eighth-grade art class by Helen
Saʿd, the exercise, called *kazz* (lit. gas, in reference to the greasy surface of the
paper used), required students to place wax paper over a printed picture (usu-
ally a postcard), trace the lines of the picture, and transfer them to another sheet
by laying the wax paper over it, retracing the lines to make new impressions, and
filling these in with color in accordance with the original. Choucair grimaced
when I asked about Saʿd: "She was awful, not artistic at all. She *just colored in*."[85]
Saʿd demanded that kazz be a nonintellectual activity, purely targeting hand-
eye coordination at the most basic level of muscular development while reliev-
ing the student of compositional and stylistic concerns. While Saʿd organized
her lessons according to Mandate regulations, she did not impart the logic
behind concepts such as perspective and shading. Choucair recalled only Saʿd's
reliance on coloring books and the technique of grid copying, "by squares," as
she disdainfully called it. "She would give us manazir al-tabiʿa [landscapes] to
do on cooking tins . . . *something for a girl's dowry*. Something to put *in her house*.
I would never do them." Recalling Saloua's appreciation of Mashʿalani's body-
with-art advice, it seems here she objected to Saʿd's emphasis of "sayyida" *over*
"fannana," as if the latter was an adjective for the former.

The Belying her rejection of kazz lessons, however, three school-era works hung
on the walls of Saloua's brother's home and several more lay in her atelier cup-
board, which we sometimes opened during our interviews. Almost uniformly,
these works, rendered in the academic art tradition, describe ethnic difference
that is tied to a nonindustrial livelihood (fishing, pottery, peddling).[86] The earli-
est, a postcard-sized watercolor, shows a seated man smoking a horn-stemmed
pipe (fig. 5.5). Saloua handles attentively the color, physiognomy, and costume
detail—the wrinkling of his brow, the bushiness of his whiskers—but she does
not give him physical weight. His slightly turned body creates a frame around the
pipe, which, like a saint's attribute, identifies the sitter. The focus suggests that
the emphasis in the act of copying was on learning not style or even anatomy so
much as the inscription of ethnic distinction through costume. Whereas smok-
ing features prominently in the Orientalists' repertoire, underscoring bourgeois
European concern for productivity and efficiency, this smoker belongs to the
Swiss Alps, thanks to his precisely described pipe, loden hat, and leather vest.

The focus in the watercolor contrasts with that of the later-copied *Cairo,
Native Artisan*. The colored postcard captures a moment when the boy's *burnus*
(outer garment) has "slipped" off his right shoulder (fig. 5.6). In a theatrical
mise-en-scène, a single sunray suffuses the pot's belly and the boy's hand, brow,
and nose in a brilliant glow, casting the rest of the image in deep shadow. The
fallen burnus summons to mind a Roman toga and invokes romantic European

FIG. 5.5 Saloua Rouda, *Alpine Shepherd with Pipe*, watercolor, 5 × 4.25 cm, ca. 1930. Courtesy of Saloua Raouda Choucair Foundation, Ras El Metn. Author's photograph.

beliefs that Berbers descended from a pre-Arab Roman civilization in North
Africa—a pretext given by some French for colonization. It is, nonetheless, also
a sign of oriental disarray—accentuating the sitter's fleshliness over his activity.
A visual rappel between the drapery folds, on the one hand, and the decoration
the boy produces, on the other, renders the boy's labor a mindless extension
of an existential state. Saloua's painting of the scene emphasizes the Roman
aspect: the burnus even loses its distinctive hood and gains a toga's elabo-
rate folds. However, the boy Saloua paints is squatter than Lehnert's model,
so much so that the amphora spills out of his lap and the picture frame (fig.
5.1). He has literally lost his classical proportions and, with them, his political
pedigree. What he has gained, however, is light on the full of his face, focusing
the scene on his concentration. This restaging enables the viewer of Saloua's
picture—unlike the viewer of the postcard—to empathize with the young
worker. Saloua casts him under a softer, humanizing light so that he is more a
little boy struggling against the double weight of his difficult task and heavy
clothing than a monument to essential, timeless difference. Though she still
produces an ethnic stereotype, Saloua locates the artisanal labor in the boy's
effort rather than his ethnicity.

How can we understand the postcard from the perspective of young Saloua
in Beirut, regarding, reproducing, and refining it on the way to becoming a
(sometimes disobedient) student and a (self-respecting) citizen? Studies of
postcards as techniques of representation have tended to start with the pho-
tographic medium that enables precipitate abstraction of sights from settings
and the unlimited multiplication of these sights into "icons of tradition."[87] Seen
this way, postcards encapsulate the senders' mobility, cosmopolitanism, and
learning associated with the modern, unbounded, universal citizen. Scholars
emphasize the transformative effect such "imperial spectacles" had in colonial
encounters.[88] Addressed by "authenticating messages" sent from the colony to
the metropole, colonial viewers stepped into the role of master subject defining
the viewed colonial objects.[89] Examining postcards from the Arab-European
encounter in particular, Malek Alloula argues that they operated as "phan-
tasms, democratically filling every poor man's dream of becoming tourist, sol-
dier, and colonist at once."[90]

Yet reception does not simply collapse into form. Alloula speaks of French
viewers, but such highly mobile forms were not confined to colonizers any more
than were educational disciplines. In Beirut, one could purchase postcards, of
local or foreign manufacture, at Daoud Corm's Maison d'Art near the post of-
fice, Edouard Angelil's shop in the same area, Sa`id Sinnu's shop at Bab Idriss,
or S. Shuqair's Photo Studio on Rue Capucin.[91] That a scene of a North African

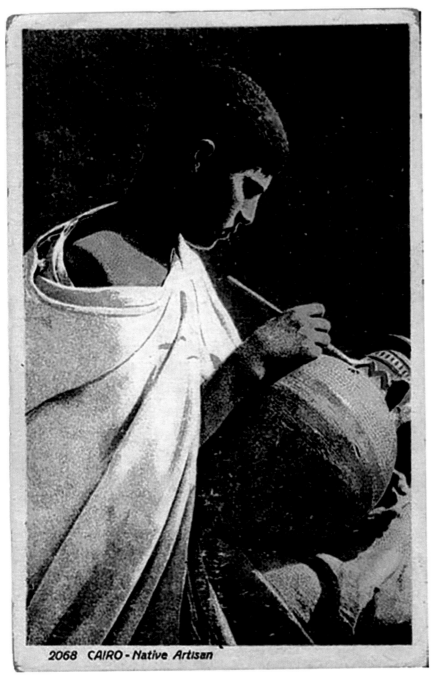

2068 CAIRO - Native Artisan

FIG. 5.6 Rudolph Lehnert and Ernst Landrock, "Cairo, Native Artisan," colored postcard produced after 1925, based on negative produced in Tunisia, 1904. Collection Michel Mégnin, France. Copyright Edouard Lambelet.

subject could be bought in Beirut or Istanbul as easily as in Tunis reminds us of what Anna Tsing, in her ethnography of a peripheral Indonesian community, calls "the possibility that alternatives [may] arise in connections."[92] Knowing the work of postcards as photographs is not the same as knowing their work for copies. We must not disregard what these traveling forms might have afforded the female pupils in Ahliah's nationalist crucible.[93]

To extricate reception from form and engage the postcard-copying lesson's materiality, I turn to a Maussian model of reciprocity. Any act of taking requires reciprocation lest the exchange become unproductive. For a photograph now inscribed with a blank to become a postcard, the reciprocation is a new context compensating for that lost. Materially made, the precipitate "picture" taken demands input. Ahliah pupils gave postcards new contexts, which included their daily lives, their family struggles, and their nationalist aspirations. Tracing and reproducing postcards through the medium of their own focus and labor exercised them in a certain way of seeing that they could meld into their own environment. Adopting the images across a given cultural boundary (academic, European) and into another system (ahliyya, nationalist, educational) constituted cultural and economic *likeness* instead of difference. Through the process of copying, the images fantasmically became authenticating messages from one center of art production (the metropole) *to* (not away from) self-addressed audiences in another center of art production (here, Beirut).

Paintings from postcards like *Boy Painting a Pot* are neither imitations of a colonial European worldview nor disguises for the perpetuation of patriarchal social structures and pedagogical models. Rather, they are diligent engagements in the construction of new power configurations and a new subjectivity through the appropriation of figurative schemes not originally designed for them. This process makes "Lebanon" something having to do with a state but also with the copyist's relation to the land, the self, the double-decolonizing past, and a shared future. Postcards whose line for inserting a message had been refashioned into a line for a painter's signature ultimately authenticated the signer's status as a modern image maker, one aware of global maps for conquest and commerce, of local projects for social advance, and of the duty to cultivate new skills. To wit, consider how students fit the "Cairo, Native Artisan," postcard into their lessons at Ahliah.

Choucair's sister Anissa, two years her senior, recounted a dramatic classroom confrontation during the citywide boycott of the French-controlled tramway. Having arrived late to French class because she had refused to take the tram, Anissa was asked by the French teacher, Mme Chabanne, to justify her decision to walk the mile-long route to school. Knowing full well that her

teacher's husband headed the tramway, Anissa repeated back to Chabanne an apothegm the teacher herself had taught in a lesson on the French counter-revolution in Algeria: "To combat a nomad, you must become one."[94] Installing the French in the role of "nomads," or savages from the urban perspective, both upheld a French aphorism and challenged its usage to suppress Lebanese nationalists, or North African ones, for that matter. Despite receiving a demerit for her defiance, Anissa became her school's valedictorian a few weeks later (delivering her speech in English).[95]

Clearly, some Mandate students took "French" lessons—whether drawing, civics, or history—and applied them in a new arena, one created out of the merging of these lessons with domestic, urban, and regional concerns.[96] *Boy Painting a Pot* instantiates alternatives that arise from their interconnections, which fed alternative notions and practices of nationalism, gender, and art. If drawing and copying installed an ocular compass per the imported colonial Moroccan curriculum for art, the North African association shifted its functioning for Ahliah's colonial citizens-in-the-making: Anissa's protest story suggests that, in the context of her family and school, Saloua thought about the Algerian resistance, and in contests over her city's public infrastructure, she could take it as a guide. It is entirely likely that Saloua's proudly signed representation of a young North African craftsman, if it showed at an Ahliah graduation ceremony, emblematized the zenith of this connection of Beiruti girlhood to an Arab region with a distinct past and culture. Like Anissa's re-purposed apothegm, Saloua's *Boy Painting a Pot* emerged from cosmopolitan, Arab nationalist, educated, and civically responsible female citizens at the same time that it marked the emergence of such a thing. It enabled thinking about and taking up this new, exchange-based nexus. The map of its existence included the metropole, whence photographs originated, but extended out as far as postcards circulated. At Ahliah, female pupils participated in creating and expanding an art world justified not only with regard to gender relationships but also, implicitly and explicitly, with regard to the concepts of citizenry, modernity, and nationalism in ways that both challenged French colonialism and drew on it.

Fantasmic Messages to the Civilized Self/Reconstructed Body

A final student work will demonstrate how a young woman who was trained in art copying to be a fountain of dhawq could grapple through fantasmic suwar with her gender, national, and civic identity. *Lady with a Parasol* portrays an anonymous woman in her twenties from the waist up, dressed smartly in

a skirt suit with a thin belt jauntily highlighting the shapeliness of her figure (fig. 5.7).[97] The satchel tucked under her arm indicates her involvement in learning, probably at college level, given her age. The parasol on her shoulder shades her on a rustic path. She passes cactus hedges, fruit trees, and flat-roofed stucco houses, but she stops briefly, only her head fully frontal, to offer a brilliant smile. The smile is visible because her yachmak has been pushed back, making her the obverse view of the women in Onsi's *At the Exhibition* (chap. 3). Like them, she wears clothing that signals multiple origins: the skirt suit, called *"tailleur"* by the Beiruti women I interviewed, points to Paris; the yachmak hearkens to Istanbul. The nonlocal apparel contrasts with the decidedly local setting: Saloua's own neighborhood of Ras Beirut, home to two Anglophone colleges. This localizing background implies that the figure is (at least) bilingual. While these multicultural references blend harmoniously, the yachmak flips more provocatively. Its placement subverts the cloth's purpose to protect females from the stranger's view. Contrarily, the satchel promises that this female is arming herself with other skills to deal with strangers. She addresses her unknown viewer with a welcoming beam.

This image confronts patriarchy with education. That confrontation interwove intimately with Saloua's personal life. By no coincidence, the school Saloua would attend was founded within months of her father's death. As discussed in chapter 2, famine and conscription ravaged Beiruti households during World War I. Resources lessened, and the male population halved. Many of the men who served in the Ottoman army never returned. One of those was Saloua's father, Salim Rawda, a rentier and ad hoc pharmacist who died of typhoid in 1917.[98] Beirut's inhabitants learned out of necessity that women could assume men's roles, and out of prudence, they undertook instilling in their daughters the skills—in accounting, polylingual literacy, and public service—to take on yet more responsibilities than had previously been allotted to adult women.[99] Saloua's family spearheaded this shift. Her mother, Zalfa, had been educated at the Brumanna High School in the 1890s. Enabled by property rents to maintain her family despite pressure from her in-laws, Zalfa contributed to several community-based women's organizations for social and cultural activism, such as the Ladies' League (Jam'iyyat al-Sayyidat) and the Women's Auxiliary Branch (of AUB).[100] She frequented literary salons where ideas like female enfranchisement were advocated. She put her daughters not only through secondary school but even through college.

By the time the Rawda girls graduated from college in the 1930s, the number of female pupils regionally had risen to 88,000, or 30 percent of school-aged girls.[101] As Thompson has shown, the new social formations developing

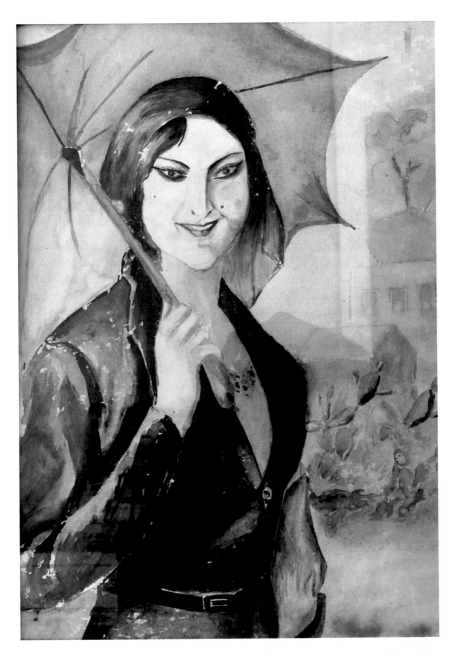

FIG. 5.7 Saloua Raouda, *Lady with a Parasol*, watercolor, 31 × 22 cm, ca. 1935. Anis and Wadad Rawda Collection, Beirut. Courtesy of Hala Schoukair.

in Lebanon, including female-led households and women's movements, posed an affront to the concept of patriarchy that had previously legitimated the civic order. In Saloua's case, the affront was met first with an attempt to wrest Zalfa of guardianship of her children and inheritance of her husband's property. Failing that, Zalfa's male inlaws demanded Anissa be veiled when she came of age.[102] Though herself veiled, Zalfa resisted. As her younger daughter explained: "At the time, they used to wear the *mandil* [a loose headscarf]—[Anissa] was a beautiful girl; in fact, hair that thick coming down here. [Choucair stretched her thumb and pinky to their farthest.] She would sit like this [with her hands, as if her hair, under her seat]. It was something! So, my uncles wanted my mother to put a veil [on her]. . . . My mother never wanted her to wear one, so she wore a hat. It was very original."

To this familial-national experience, Raouda brought her ongoing art training. She seems to have painted *Lady with a Parasol* under tutelage with Farrouk. She probably attended the "art club" Farrouk led at AUB.[103] Evidence from other exhibitions of Farrouk with his students indicates he encouraged his mentees to copy his own works.[104] Raouda clearly based *Lady with a Parasol* on an oil painting twice the size painted by Farrouk between 1929 and 1933, during the height of a furious debate about the merits of veiling (see chap. 3) (fig. 5.8).[105] Because some unveiled faces became targets for acid, some have argued that Farrouk's picture restitutes a specific Ras Beiruti woman's face that had been targeted.[106]

Using his painterly skills to make images pulsating with life, Farrouk's "reconstruction" contributes to restoring the casualty's pride and confidence. The (re)painted figure instantiates the moment of unveiling: she is not shown simply bareheaded but rather glistening beside the dark mesh of the yachmak, which has been pulled back and hangs aside her face, where the red glow of the parasol highlights its displacement. Farrouk's provocative mise-en-scène insists that the viewer deploy taswir to compare the previously veiled face and the sparkling smile now accessible. He not only connects this act of unveiling to a women's quest for higher education but, through his use of a flagrantly nonlocal medium, connects it to associations he could expect his viewers to make: the Italian Renaissance, the Enlightenment, and the bourgeois mercantile class were entities known to those with even minimal art knowledge. Enframing the female face's heightened visibility with these connotations, Farrouk's picture bestows a certain respectability on the feminine spectacle. Likewise, it points to local social models whom many in Beirut found worth emulating at a time when they aimed for their own nahda, or renaissance. Even more stridently than *The Two Prisoners*, this locally made

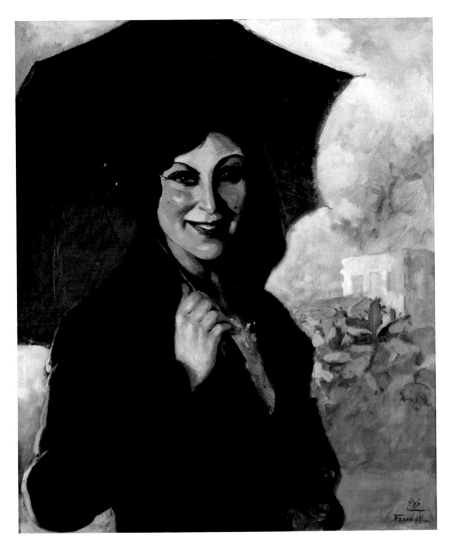

FIG. 5.8 Moustapha Farrouk, *Lady with the Red Parasol*, oil on canvas, 65 × 56 cm, ca. 1929–33. Courtesy of Saradar Collection, Beirut.

import fantasmically enjoins viewers to carry out the living model's promise in a life made with art.

Given the relevance of the veiling debate to her woman-headed family, I imagine that Saloua Raouda chose to copy Farrouk's picture to honor some-one whose activity encouraged her to explore the types of bodies art could contribute to the "national body." She may also have taken the moment of

copying as an opportunity to revise the fantasmic message art sent to herself as both artist and art subject. For by copying the picture, college-bound Saloua allocated to herself a role in advocating, for her audience of kin and neighbors, unescorted movement in public space and independence of thought for highly visible females.[107] Like the pupil who fantasmically combined the postcard's vision with other aspects of Ahliah's curriculum, Saloua may have found herself implicated: the object of Farrouk's painting, she reconstructed it anew. In place of Farrouk's heroine, Saloua's version seems to spotlight her sister Anissa: someone who critically escaped the gender-defining attacks launched by her own family. A caricature Farrouk made of Anissa as a student at the American Junior College to celebrate her socially active scholarship reveals a remarkable resemblance, especially in the pointier chin and longer face, to Saloua's subject.[108] However, Saloua's pictorial doubling of Farrouk's homage to the champions of unveiling amplifies the impact of her own family's struggle now in a medium produced not by a professional artist trained abroad but by a neighborhood girl trained at a nationalist school.

Whether or not the legend of thrown acid is true, neither Raouda's copy nor Farrouk's original reflects given reality: Farrouk's sitter no longer looked like the form on canvas; Raouda's combines that model with her familial biography. Both art acts work fantasmically. Farrouk heals an ostensibly active citizen through art to overcome socially inflicted wrongs. Generated for a female-citizen-in-the-making, now both artist and art-made, Raouda's copying-based-art differs. It sees in art the assertion of a way forward, a claim to exhibitionary sociality as the right to civic sway: the instantiation of the convergently modern, educated, transitive female. Just as primary school object exercises like *Boy Painting a Pot* participated in colonizing processes but exceeded colonial maps, mature copies of locally made imports like *Lady with a Red Parasol* make decolonizing claims on locality by tracing new horizons and forging novel perches for viewing the self and would-be compatriots. Raouda's version of the picture leaves the lady-artist by the wayside.

The foregoing provides an important prehistory to the struggle over the Lebanese Academy of Fine Arts that was to come to a head in 1943. It also establishes a new ontological angle for analyzing art at colonial junctures. While taswir became increasingly modern and (synecdochically) important for modernizing, it also became gendered, in a contrary way. The transitive role allotted to women in the arts designated them as lady-artists, aesthetically generative by virtue of their "natural" feminine qualities and devoted to a "natural" female duty, to raise productive citizens. This double-binding logic suggested that lady-artists were less intellectual, akin to artisans. Moreover, the emphasis on

the social benefit of women's art could label their creative production *not truly art*, in a Kantian sense of purposive purposelessness.[109] Indeed, this abjection encompassed all art made in the nationalist crucible for social good. Even male artists were feminized by it. Could one be watani and a fannan, native and professional, national and aesthetic? Colonial authorities and their colonial citizens gave diverging answers. Thinking about suwar as fantasms demands addressing this quandary without recourse to representational models of mimicry or authenticity, universality or locality, genetics, or visions.

No Art Academy for Semites, Artisans, and Lady-Artists

Among the urgent files sitting in June 1943 on the Beirut desk of the new ambassador, general, and plenipotentiary of France to the Levant, Jean Helleu, was a proposal for an academy of fine art (fig. 5.9). Nobody wanted to deal with it. Deferrals piled up and bulged from the file. This was not the first time the issue had been raised to the Ministry of Public Instruction since the founding of the French Mandate over Lebanon and Syria in 1920. All knew the matter was delicate. Although an "Académie Libanaise des Beaux-Arts" (Lebanese Academy of Fine Arts, hereafter ALBA) had been decreed in March 1931 and a director appointed, by spring 1943 there was still no establishment by that name (with building and administrative staff).[110] To the contrary, the appointed director had been arrested "for teaching without a license" in the halls of Ahliah and could only continue lessons secretly.[111] In the summer of 1943, the director of painting at Istanbul's Academy of Fine Arts, Léopold Lévy, pledged his support for a sister Lebanese institution, noting that the detailed curriculum plans showed that the proposed academy would follow closely the "traditional teaching [structure] of an Ecole des Beaux-Arts," as Lévy put it. Yet officials had already rejected a similar proposal by the expatriate painters Georges Claude Michelet and Pierre Lecoq de la Frémondière, on the grounds that the two painters' minimal talent would expose French interests to ridicule.[112] As we have already seen, many a minor scandal erupted when French officials who were called on to support professional painting in their Mandated territories demurred. (See chap. 3.) French renown in the arts was at stake, but so was France's civilizing mission, which in the case of Syria and Lebanon was the empire's only legitimation for continued control after twenty years of flagrantly exploitative colonization.[113]

The file on the plenipotentiary's desk accumulated the nervous notes secretaries sent between their employers' offices until autumn recalled from summer holidays the man with the longest local knowledge, Gabriel Bounoure.

ECOLE DES BEAUX ARTS

Direction et Administration

Sections : I. Peinture, dessin, sculpture

II. Architecture. Urbanisme

III. Arts appliqués : artisanat art décoratif
 mobilier . tapis. objets usuels.
 affiche. livre. gravure.

S E C T I O N I.

Peinture. Dessin. Sculpture.

Cours communs : dessin et modelage. anatomie artistique. Histoire de
l'art.

Cours de peinture : Composition. Croquis. Etudes à l'atelier. Perspective

Cours de sculpture : atelier.

S E C T I O N II.

Architecture : -Cours de dessin : Ronde bosse en partie communs avec
la Section peinture

-Lavis. Dessin d'architecture - Etudes et préparation
de projets - Présentation de projets (lavis, gouache..

- Architecture

S E C T I O N III.

Artisanat (en liaison avec le bureau spécial des oeuvres sociales)

- Etude des productions locales, d'après les modèles du Musée.
- Recherche de modèles nouveaux.
- Etude historique des productions de l'Art arabe (tapis, miniatu-
res, verreries, armes, objets usuels, bijoux, etc...
- Etude des moyens d'exécution et des matières à employer. Teintu-
res, etc...
Travaux pratiques; Etude des plantes et des êtres vivants au point
de vue stylisation.

.../..

FIG. 5.9 General Delegation of Free France in the Levant, curricular proposal for a Lebanese Academy of Fine Arts, 1943, les Œuvres Françaises, *Instruction Publique*, 2ème v, carton 182, file, "Questions diverses." Courtesy of FR-MAE Centre des archives diplomatiques de Nantes.

First posted to the Levant in 1923, Bounoure had served since 1937 the double role of inspector general for the Œuvres Françaises and adviser for public instruction to the High Commission. Arabophone literary scholars today celebrate his patronage of Algerian, Lebanese, and Egyptian writers and poets.[114] Yet Bounoure was ambivalent about visual arts among Arabs. In 1941, he had opened the annual *Friends of the Arts Salon* with a florid speech praising "the Orient of today, where [exists] a Pleiades of painters full of most brilliant gifts." The exhibition demonstrated how they had received "the lesson . . . of the universal history of art."[115] French cultural policy prioritized endearing the local populace to France through culture. Jennifer Dueck quotes Bounoure in 1936 averring that the French colonial future lay in the "duty . . . to win the Muslim population over to French teaching." He actively courted Muslim educational leaders, especially "as the French political position [in the Levant] became more tenuous."[116] Still, the "Beaux-Arts" files that survive from his office bespeak a mixed desire for art illustrating the beneficence of French presence, for budgetary parsimony, and for hegemony of control over "aesthetic standards." In this context, Bounoure's response to the academy's application is striking for its unequivocalness. The letter makes an astonishing read today (fig. 5.10):

> The envisaged foundation seems to me devoid of the least interest (except evidently for those aspiring to find employment there).
>
> Not only are the populations of these Semitic countries little gifted in the plastic arts, but moreover, these territories are too small and too poor for such an institution to be justified. Five million inhabitants, of which a large number are nomads and illiterates, can easily forego a school of fine arts.
>
> There are many Lebanese painters, and even Syrian ones. They live in hardship. They have repeatedly attempted to incite the public powers to establish a school where they would find a means of livelihood.
>
> The projects have failed each time, because the absence of all serious basis has condemned them fatally to failure. Anyway, it would not be possible to put the case under the direction of a foreigner. We would have an immediate mobilization of local painters and sculptors, at the head of which would be Mme Evelyne Bustros and several of the highest authorities of the land.
>
> The only useful creation, it strikes me, would be that of an office of local arts, proposing to reanimate, vivify, and transform moribund techniques and an artisanry in plain decadence.
>
> Signed, Bounoure[117]

The detailed curriculum plans for ALBA show that students were going to learn "*the* history of art and civilization" and study the same techniques as their French counterparts in Paris. This "lesson" of "the universal history of art" is

G.B./M.B.

OEUVRES FRANCAISES

Nº

INSTRUCTION PUBLIQUE
OEUVRES FRANÇAISES
8408 .9.43
Beaux Arts

N O T E

Pour Monsieur le Secrétaire Général

a.s. Création d'une Ecole des
Beaux Arts.-

 La fondation envisagée me paraît dépourvue du moindre intérêt (sauf évidemment pour ceux qui aspirent à y trouver un emploi).

 Non seulement les populations de ces pays semitiques sont très peu douées pour les arts plastiques , mais encore ces territoires sont trop petits et trop pauvres pour qu'une institution pareille s'y justifie. 5 millions d'habitants dont un grand nombre de nomades et d'illétrés se passent fort bien d'une école des Beaux Arts.

 Il y a beaucoup de peintre libanais et même syrien. Ils vivent difficilement. A plusieurs reprises, ils ont fait des tentatives pour déterminer les pouvoirs publics à créer une école où il auraient trouvé un gagne-pain. Les projets ont chaque fois échoué, parce que l'absence de toute base sérieuse les condamnait fatalement à l'échec. En tout cas, il ne serait pas possible de reprendre l'affaire sous la direction d'un étranger. Nous aurions immédiatement une mobilisation des peintres et sculpteurs locaux, à la tête desquels seraient Madame Evelyne Bustros et plusieurs des hautes autorités du pays.

 La seule création utile me paraît être celle d'un office des Arts locaux se proposant de ranimer, vivifier, transformer des techniques moribondes et un artisanat en pleine décadence ./.

Le Conseiller pour l'Instruction
publique, Inspecteur Général
des oeuvres françaises

Signé : BOUNOURE

2) A. Jour

FIG. 5.10 "Note regarding the creation of a school fine arts." Nantes, Ministry of Foreign Affairs, les Œuvres Françaises, *Instruction Publique*, 2ème v, carton 182, file, "Beaux-Arts," September 8, 1943. Courtesy of FR-MAE Centre des archives diplomatiques de Nantes.

what Bounoure had welcomed at the salon two years earlier. As we saw at the professional exhibitions introduced in chapter 3, proponents of al-fann al-jamil believed they were creating an "environment," a social condition, to rise from the sandy desert to the lofty skies of international art. Lebanese students' road to becoming professional "Lebanese artists" would commence, according to this vision, from their establishment as contemporary artists, inhabiting the shared end of a teleological history. Making fine art would move time forward.

Bounoure met this request for contemporaneity with a condemnation to locality. Everything about this locale was too small: the people, "little gifted" in the arts; their land, tiny; their population, limited. Mired in placedness, teleological time could not have a positive effect here. Repeated attempts to found a school had not accumulated and built a ladder history could climb. And whenever foreigners tried to help, they were confronted with "localist" sentiment. In such a place, there was no future for contemporaneity. The best that could be hoped for was to rescue "the local"—which for French colonizers were the signs of obvious difference in lifestyle techniques—from its decay and backwardness. Bounoure accused ALBA's advocates of marshaling universality in art merely by way of inventing jobs. In other words, he essentially treated them as lady-artists, innately aesthetic but tending to use art selfishly, and abandoning it (or so-called artisanry) when they failed to see its continued profit. This was, in the end, the practical outcome of denying Mandate Lebanese a professional academy that would peak in life-drawing classes for studying that key genre, the nude. Rather than seeing the project of a new arena arising fantasmically from localizing concerns and circulating strategies, Bounoure insisted on authenticity to trounce the unproductive mimicry he feared most. Ultimately, Bounoure reduced the aspiring artists to artisans and attached to them the racial identity of Semites, whose inability to be professional artists, well, *ça va sans dire*.[118]

Where art exists in a representational mode, what starts as an exoticizing description of a society of "nomads and illiterates" quickly becomes a prescription. The understanding of art embraced by French Mandate authorities responded negatively to the question of whether one could be watani and an artist. In their overview of the hidden history of indigenous modernisms, Elizabeth Harney and Ruth Phillips observe that aspiring indigenous artists were largely prohibited entrance to professional art schools.[119] Their barring was based on, enacted by, and solidified by what Harney and Phillips call "a deliberate misunderstanding of the inherent spatial and temporal politics of the modern world."[120] Through fantasmic art acts, double-decolonizing Lebanese artists undermined such misunderstandings, but art studies have not met their actions on their terms.

In closing, I want to indicate some of the ironies relating particularly to gender, nationalism, and ethnicity in this episode: ALBA was conceived in the model of metropolitan, colonial art pedagogy, but it was rejected by colonialists. While the colonial conception of art training limited it to six years, effectively feminizing the East, feminists and nationalists cultivated an understanding of universal art to launch an institution on par with the French-Turkish professional art institution in Istanbul.[121] Three days after Bounoure's response was drafted, Riad Al Solh declared the independent Lebanese state, and within a month a French countercoup had been rebuffed. This was the end of the French Mandate. Three months later, ALBA admitted its first students of painting. However, although Ahliah had hosted the nascent ALBA, its ontology of aesthetic integration did not prevail institutionally. While the idea of ALBA first received shelter at the feminist institution Ahliah, it ultimately gave priority to professionalizing male artists. The only female on the permanent staff for years was Miriam Khirru, the life model who previously had served as cleaning lady and personal model to the director of painting, Cesar Gemayel. Before the artworld's professionalization in Beirut, female practitioners had formed a significant and well-supported portion. That was to dwindle. Although Lebanon came to host a famously "high" proportion of female artists—around 30 percent according to Helen Khal's seminal 1970s study—the profession bifurcated into natural lady-artists in need of post-curricular training and feminized male artists.[122] Colonizers and decolonials had come to agree on the gender and temporality of art, producing a specific practice and kind of no-art. The stakes of a critical rereading of overlooked modernist histories loom large.

Coda

As promised, the International College art appreciation course in 2005 culminated in a field trip to an artist's "sculpture village," Rashana, where we were encouraged to apply our newly refined dhawq toward purchasing original artworks. Nammour still "corrected" comments we made about the works we saw. Two of my classmates, Samar and Dima, bought abstract metal sculptures by the Basbus brothers, though a third demurred because she wanted "something more established like a Farrouk or Onsi." At the following and final session of the course, the pair of purchasers presented photographs of their newly installed acquisitions, now gracing their conjugal abodes. Nammour told Samar the lighting was good for her sculpture but it needed a higher pedestal. Dima observed that only after her husband blessed it as "good, not too expensive" had she found the piece growing on her, but then she worried she had bargained the artist's price down too much! Nodding, Nammour commenced his final

slide lecture, which juxtaposed prehistoric depictions of women, such as the *Venus of Willendorf*, with contemporary works Nammour deemed "critical of the situation of women in modern times," such as Sarah Lucas's *Two Eggs and a Kebab* and Robert Rauschenberg's *Odalisk*. The choice of these Euro-American works for a class focused on "local" art initially struck me as strange, until I apprehended that they were descendants of the globally circulating postcards at whose intersection new arenas emerge.

Nammour asked if we had any comments on the pairs he projected onto the screen. "Very shocking," Samar said, referring to Lucas's installation and ignoring the *Venus*. "I mean, woman equals kitchen and sex? Yeah. . . ." She had already started to nod when Nammour contextualized its making in the wake of oral contraception and the feminist revolution. Samar cut him off: "No, I like it." Her evaluation abrogated discussion of particular problems in Lucas's society, or here, where women still did not (and do not) share with men full legal citizenship. Nammour's closing juxtapositions positioned us like the women in Onsi's *At the Exhibition* or the pupils sitting with legs uncrossed in young Saloua's grade school classes. The class discussion, however, removed the political teeth such configurations can have when taswir brings the local into the art act. Women looking at women looked at by art, we deployed the art vocabulary we had acquired from our two-month-long exercise in the "different process of seeing" to yoke Nammour's slides to delocalizing depictions of women. Sexual violence, "domestic" abuse, disinheritance, and the systematic denial of guardianship that Saloua's mother challenged in practice but without changing the law were all brushed aside by our demonstrating we had learned to "like" contemporary artwork. The aesthetic judgment we crystalized bypassed the specifics of women living in various modern societies. Much less, could we address the specifics of which sorts of women were incorporated into the model of citizenship—those able to "do the poupée," but not ones demanding a focus on local conditions. We'll forever make no-art. This double bind endures for lady-artists, a category that includes other marginalized and colonized populations that have invested in the universalizing promise of al-fann al-jamil. Looming hegemonically over the horizons we might have visualized, it circumscribes our subjectivity to strict domestic, provincial influence as a canvas for projections of "universal modernity."

Notes

1. The Arabic term counterposes two terms as equal and almost redundant, hence my transposition into English with a hyphen, which may jar readers bringing

English grammar to bear, but should also leave the door ajar to communicating a non-English idea. Likewise, I maintain the word "lady" rather than "women" or "female." While the latter terms have become acceptable, I hope my usage makes clear what was historically at stake in this parlance. Anticipating that readers will understand the term as a historical nomination with translation implications, I will hereafter remove the quotation marks.

2. See Lebanese nation-oriented studies by Kurani, "Lebanon"; Fakhoury, "Art Education." See broader research, e.g., Ali, *Modern Islamic Art*; Bahnasi, *al-Fann al-Hadith*. See cross-cultural studies, e.g., Irbouh, *Service of Colonialism*; Adal, *Beauty*.

3. Khuri-Makdisi, *Eastern Mediterranean*, 79.

4. In 1930, female students could take watercolor lessons for an extra 200 piasters yearly. Sbaiti, "Lessons in History," 277.

5. Establishments listed in Nicholas Sursock Museum, *Moustafa Farroukh*, 21; *Al-Kulliyah Review* 1, no. 1 (September 1934): 23; *Al-Kulliyah Review* 2, no. 5 (April 13, 1935): 132. In his memoirs, Farrouk credits Rev. Prof. Laurens Seelye, director of West Hall, with inviting him to give an "elective class" in taswir to students who would pay one Lebanese lira monthly for expenses. Farrukh, *Tariqi*, 154. Apparently Farrouk was not paid for the lessons but accepted out of obligation to reciprocate the university's services to him.

6. "Al-Taswir fi Madrasat al-Hikma" [Picturing at la Sagesse School], *al-Makshuf*, June 16, 1937, 4.

7. Abunnasr, "Ras Beirut," 163; Said Makdisi, *Teta*, 209, 277; "Tatwir al-Madaniya fi Bayrut" [The development of civilization in Beirut], *Lisan al-Hal*, January 13, 1931, 1. Najla Tannous ʿAkrawi, born 1914, attended the Rome Orthodox Elementary School in Tripoli and the American School for Girls in Beirut for her secondary years (i.e., after 1926). She recalled learning embroidery, sewing, and piano (which cost her father extra) but nothing related to drawing. Oumayma Ghandour Idriss, born in 1930 and attending the Collège Protestante, recalled that for embroidery lessons students first learned how to do letters and numbers, and then flowers and birds, but never freehand drawing.

8. For an overview of the schooling system emerging in French-occupied Mandate Lebanon, see Sbaiti, "Lessons in History."

9. See Betty Anderson, *Rulers, Rebels*, 112–24.

10. Edvick Juraidini Shaybub, "Maʿ al-Fannana Salwa Rawda" [With the artist Saloua Raouda], *Sawt al-Marʾa* 7, no. 12 (December 1951): 36–37, 49, p. 36.

11. Thompson develops and defends this vocabulary in *Colonial Citizens*, 2.

12. For example, a full list of actors involved in Mandate Lebanon's governance includes "French government, and Syrian, Lebanese and non-governmental French organizations, French entrepreneurs, French missionaries and secular philanthropic associations, Syrian and Lebanese in administrative roles, local

political leadership, [and] religious authorities." Dueck, *Claims*, 13. The list's messiness indicates that distinctions between the actors were not clear in advance or in the way we might assume today. Similarly, Sbaiti argues that although state actors identified Mandate Lebanon's schools as either "Islamic" or "French," "parochial" or "secular," the schools themselves tended to absorb influences from all domains. Sbaiti, "Lessons in History," 213.

13. Sbaiti, 112.

14. See, for example, *Lisan al-Hal*, May 21, 1921, 2; "al-Madrasat al-Ahliyya li-l-Banat" [The Ahliah School for Girls], *al-Mar'a al-Jadida* 4, no. 8 (August 1924): 367; "Fi Madrasat al-Banat al-Ahliyya" [At Ahliah Girls School], *al-Ma'rid*, July 5, 1931, 21; "Hafla 'Abaqa Jawuha bi-l-Shi'r wa-l-Fann wa-l-Adab" [A party whose atmosphere filled with poetry, art, and literature], *al-Makshuf*, July 11, 1938, 14–15. I follow the school's own transliteration. A few boys were admitted as students and boarders, too, but the school primarily targeted girls.

15. "Madrasat al-Ahliyya" [Ahliah School], *al-Haris* 7, no. 3 (December 1929): 222.

16. To underscore the indeterminacy behind the artist's social becoming through art, I refer to her by the names her contemporaries used respective to the different phases of her life.

17. Similarly, Najla Tannous 'Akrawi, a friend of Saloua's sister, recalled once praising another high school–era piece by Saloua that showed a mother and child "of the traditional, normal sort" and that was hung in the family house. In response, Saloua's mother exclaimed, "See, see, *this* is how Saloua used to make pictures. See today what's become of her!"

18. I heard this joke repeatedly and separately from Saloua's sister, sister-in-law, and daughter.

19. From the class that graduated with her in 1927, one alumna recalls that most "married prominent men from Beirut or surrounding Arab countries," though a few were jilted by their fiancés when their fathers went bankrupt. Makdisi Cortas, *World*, 41.

20. Michel Mégnin has collected multiple versions of this image. They edited the version shown here specifically for a Cairene audience after moving their studio there in 1924. Following Mégnin's advice, I take "Cairo, Native Artisan," which features green tinting and strong lighting, to be Choucair's specific reference.

21. Information on the origin varies. Lehnert and Landrock had a studio in Tunis where they produced two sepia versions in 1906 with the title "Artisan arabe." Michel Mégnin, communication by email, September 7, 2021. However, Mounira Khemir maintains that the subject comes from a 1904 trip to the Ouled Nayl. Mounira Khemir, "Photographer's Mirror," 191–92.

22. Fakhoury, "Art Education," 93–94.

23. Chatterjee, "Disciplines," 14–15; cf. Winegar, *Creative Reckonings*, 47.

24. Guha-Thakurta, *Monuments*, 143, 147.

25. Kroiz, *Cultivating Citizens*, 6.

26. Bhabha, "Mimicry and Man," 128, 126.

27. E.g., Alloula, *Colonial Harem*; Burns, "Six Postcards."

28. Steinmetz, "'Devil's Handwriting,'" 66. Steinmetz detects a blurring of pre-colonial and colonial in Bhabha's analysis.

29. Henri Zughaib, *"Salwa Rawda Shuqair Tahtarif Fann al-Nahhat bi-Fiʿl ʿIbara Sadamatha min Sharl Malik"* [Saloua Raouda Choucair professionalizes in sculptural art in reaction to a statement by Charles Malik that shocked her], *al-Hawadith*, no. 1167 (March 16, 1979): 70–71, p. 70.

30. Levi-Strauss, *Myth and Meaning*.

31. The inner covers of Farrouk's sketchbooks from 1916 are scrawled with trial signatures, but no paintings have survived from this era.

32. Farrukh, *Tariqi*, 33. This tale differs in emphasis from the one recounted in chap. 2 at the Muslim Scouts' celebration.

33. The location of Farrouk's tale is unclear. In al-Nusuli's version, told on the heels of "liberation" from the Ottoman Empire, it happens at the Ottoman College, which would have had strong symbolic status. In Farrouk's version, told decades later, it happens when he is a student at elementary school, before his transfer to the Ottoman College.

34. A sparse but steady stream of drawing lessons appear in missionary school reports and proselytizers' letters at the Female Seminary (1853), the constitutional statement of the Tripoli Girls School (1883), and the Sidon Seminary (1931). Ellen Fleischmann, personal communication, July 5, 2017. For evaluations of drawing and art lessons at "government" and "foreign" schools, see Khalil al-Ghurayyib, *"al-Taswir fi Bayrut"* [Picturing in Beirut], *al-Maʿrid*, January 31, 1932, 14; ʿAli Saʿd, *"al-Madiyya fi Thaqafatina"* [Materialism in our culture], *al-Makshuf*, July 18, 1938, 6–7, p. 7. In the 1890s, Huda Shaʿarawi, who became a prominent leader of the Egyptian women's movement, was tutored in the Qurʾan, the Ottoman language, Modern Turkish, French, grammar, calligraphy, piano, drawing, and painting; however, her peer in Beirut, ʿAnbara Salam, daughter of Salim Salam (see chap. 4), did not receive any art lessons. Said Makdisi, *Teta*, 210, 209.

35. Philippe Mourani, *"De ce que j'ai gagné depuis 1ère novembre 1895 jusqu'au 1ère septembre 1901"* (unpublished accounting book, 1901?), DG.

36. Sultan, *Ruwwad*, 130. The students, all born between 1884 and 1909, list Serour on their résumés.

37. Jawaba, *"Hayakil Tadmur Kama Kanat"* [Palmyra's temples as they were], *al-Maʿrid*, December 25, 1931, 17.

38. Samir Saleeby, personal communication, June 5, 2002.

39. Jawaba, *"al-Musawwirun al-Wataniyyun wa-l-Ajanib Yaʿriduna Atharahum"* [Local and foreign artists display their works], *al-Maʿrid* 10, no. 935 (January 22, 1931): 8–9, p. 9.

40. Muhyi al-Din al-Nusuli, "*Khutbat al-Ra'is*," [The president's speech], *al-Kashshaf* 1, no.1 (January 1927): 52–56, p. 53.

41. Somel, *Public Education*, 28–29. The vocabulary in this section comes from Ottoman Turkish.

42. Adal, "Nationalizing Aesthetics," 69.

43. Somel, *Public Education*, 303, 307.

44. Somel, 12, 313.

45. Adal, "Nationalizing Aesthetics," 12.

46. For example, a manual on technical perspective translated for the Ottoman Military Academy foregrounded pensive seeing, despite the practical thrust of the training program. Shaw, *Ottoman Painting*, 93–95.

47. Sa`d Zaghlul, "*Mudhakkira ila majlis al-nuzzar bi-sha'n ba`d al-ta`dilat al-murad idkhaluha `ala brogram al-rasm bi-l-madaris al-thanawiyya*" [Memorandum to the Council of Ministers regarding some changes to be made to the drawing curriculum in secondary schools], June 19, 1907, Naẓarat al-Ma`arif al-`Umumiyya 19/B 0075–045333, Egyptian National Archives, courtesy of Raja Adal (emphasis added). For more on Zaghlul's investment in natural aesthetics, see Adal, *Beauty*, 73.

48. May Ziyada, "*Shay' `an al-Fann*" [Something about art], *Fatat al-Sharq* 6, no. 5 (February 1912): 168–72, p. 170.

49. Labiba Hashim, "*Shay' `an al-Fann: Radd*" [Something about art: Reply], *Fatat al-Sharq* 6, no. 6 (March 1912): 172–75, p. 174.

50. Note that Ziadeh (see note 48) distinguished the imagination (al-mukhayyila) from logical thinking (*al-afkar*) and described the former as the capacity to take impressions from the external world and convey them to the conception (al-tasawwur), which could mine and recombine them for innovation (*al-ibtikar*).

51. Fu'ad Sarruf, "*Durus fi al-Tarbiya*" [Studies in pedagogy 1], *al-Mar'a al-Jadida* 2, no. 3 (March 1922): 94–95, p. 95.

52. Sarruf, "*Durus*," 95.

53. Fu'ad Sarruf, "*Durus fi al-Tarbiya*" [Studies in pedagogy 2], *al-Mar'a al-Jadida* 2, no. 4 (April 1922): 124–25, p. 124.

54. Sbaiti, "Lessons in History," 46; cf. Lattouf, "Higher Education," 151.

55. Fakhoury, "Art Education," 89. A job application Choucair filed with Point 4 on July 30, 1952, lists her dates at Ahliah as 1929–35. SRC.

56. Irbouh, *Service of Colonialism*, 159.

57. Irbouh, 159, 78.

58. Fakhoury, "Art Education," 91.

59. *Bulletin de l'enseignement* 1, no. 1 (1923): 3–10, Per 6, CDAN.

60. Fakhoury, "Art Education," 93.

61. The word *kazz* seems to be a corruption of *gas*, with which paper was treated to make it transparent. Cf. Aswad, "*Mu`adalat*." Anneka Lenssen documents a similar practice in Mandate Syria. Lenssen, *Beautiful Agitation*, 117.

62. See also Philippe Mourani, *"Le rôle des arts plastiques dans la vie des peoples,"* *la Revue du Liban* 4, no. 27 (March 1932): 3–4. Nasim Yazbak queried, "What sharpens the thinking and impresses the soul more than art?" in an essay about Farrouk. Nasim Yazbak, *"Fannan 'Arabi bayna Ruma wa-l-Andalus"* [An Arab artist between Rome and Andalusia], *al-Ma'rid,* October 26, 1930, 17.

63. *"Al-Funun al-Jamila"* [The fine arts], *Minirva* 5, no. 3 (June 1927): 152. Yanni works from poetry but does not limit her assertions to this medium. On liver's significance, see chap. 4, note 122.

64. Al-Ghurayyib, see note 34.

65. Karam Milhim Karam, *"Fann al-Taswir al-Yaddawi"* [The art of picturing by hand], *al-'Asifa,* February 20, 1932, 21.

66. Sa'd, see note 34.

67. *Al-Makshuf,* see note 6.

68. Julia Tu'ma Dimashqiyya, *"al-Anisa Mari Kassab"* [Miss Marie Kassab], *al-Mar'a al-Jadida* 4, nos. 1–2 (January–February 1924): 5–7, p. 5.

69. On Ahliah's foundation and first pupils, see Sbaiti, "Lessons in History," 61–2, 64, 72.

70. Sbaiti, 238.

71. Tamar Garb and Anne Bermingham explain these philosophies in nineteenth-century France and England, respectively. Garb, "'Men of Genius'"; Bermingham, *Learning to Draw.* Cf. Mariam Zakka, *"Hana Mur: al-Mar'a al-Muhadhdhaba"* [Hannah Moore: The polite woman], *al-Fajr* 3, no. 2 (February 1921): 102–8.

72. See chap. 3, note 71.

73. Transmitted through missionary education, this curriculum reserved drawing lessons for maiden teachers in training who needed a means for instruction. Said Makdisi documents local pressure shaping missionary pedagogy in the region. She also lists "object lessons" for the standard curriculum between 1893 and 1912, which sounds like the Ottoman "'ilm el-isya'." Adal, "Nationalizing Aesthetics," 12. A detailed lesson plan for 1908 included "simple Nature Forms, flowers and leaves (as usual)," and "Map—Palestine and North and South America." Said Makdisi, *Teta,* 179.

74. For example, founder Marie Kassab studied in the 1890s at the British Training Schools, run by English missionaries with her father, Salim Kassab. See Said Makdisi, *Teta,* 178–79; "Elisabeth Bowen Thompson," 93.

75. Term from Archdeacon Hanania Kassab, who in 1922 argued in *al-Mar'a al-Jadida* for expanding the role of feasts and grand rituals "to celebrate a nationalist future" and asserted that women were key to this future because of the country's "bankruptcy in men and money." Hanania Kassab, *"Ma Huwa Qawam al-Tarbiya al-Wataniyya?"* [What are the foundations of a nationalist education?] *al-Mar'a al-Jadida* 2, no. 1 (January 1922): 23–25.

76. Thompson, *Colonial Citizens*, 288. The term "sayyidat fannanat" proliferates casually in the period press, but its most thorough explanation comes at the end of the Mandate from Edvick Jureidini Shayboub, a preschool teacher, who drew on her classroom experience to argue that training pupils in art would rescue Arab society from death and advance it into the new era. Edvick Juraidini Shaybub, "Namadhij min Tufulat al-Fann" [Examples from the childhood of art), *Sawt al-Mar'a* 3, no. 7 (July 1947): 8–9 p. 9.

77. Anissa Rawda Najjar thought the last name might be 'Abd al-Nur.

78. See, by way of example, Jurji Niqula Baz, "al-Tahdhib" [Refinement], special issue, *al-Fajr* 1 (1919): 457–60; Muhammad Kamil Shu'aib al-'Amili, "al-Rajul wa-l-Mar'a wa-Ayyahuma Ahsan?" [Man or woman, which is better?], *al-Fajr* 3, no. 1 (January 1921): 11–14; Zakka, see note 71; Michel Shibli, "al-Mar'a fi al-Hai'a al-Ijtima'iyya" [Woman in the social body], *al-Mar'a al-Jadida* 1, no. 2 (May 1921): 47.

79. Sami al-Sham'a, "Tahdhib al-Fatayat" [Girls' refinement], *Minirva* 5, no. 3 (June 1927): 404–5.

80. *Al-Mar'a al-Jadida* 4, no. 5 (June 1924): 236 (emphasis added).

81. Jessica Gerschultz documents a similar phenomenon in the training of young women at the École des Beaux Arts and in the Office Nationale de l'Artisanat in 1960s Tunisia. Handicrafts were increasingly feminized, and only women with rank and assets could add "artist" to their ladyhood. Gerschultz, *Tunisian École*, 145.

82. Khater, *Inventing Home*, 126–32.

83. *Al-Nahar*, February 7, 1934, 3.

84. *Al-Nahar*, February 5, 1934, 8.

85. Emphasis added. Choucair remembers her name as Helen. An *al-Nahar* report refers to her as Aline. "Shajji'u al-Fann wa-'Amalu al-Khair" [Encourage art and do good], *al-Nahar*, November 30, 1933, 6. The discrepancy may be due to a difference of pronunciation between Anglophone and Francophone renditions of the name.

86. Choucair's tiny, framed oil portrait of Tolstoy is the only picture that does not adhere to the ethnic postcard format that I discuss here.

87. Apter, "Imperial Spectacle." The literature is immense. For a useful overview, see Poole, "Excess."

88. Rydell, "Souvenirs."

89. This is Rydell's main line of analysis as well as Alloula's. Rydell, "Souvenirs"; Alloula, *Colonial Harem*.

90. Alloula, *Colonial Harem*, 3–4.

91. See respectively ads for David Corm and Sons, Maison d'Art/The Art House, *Student Union Gazette* 9, no. 1 (November 1915): 224; Edouard Angelil, *Lisan al-Hal*, November 21, 1918, 2; Sa'id Sinnu, *Student Union Gazette*, Easter 1924, 189; S. Shuqair, *al-Kulliya*, July 1, 1928.

92. Tsing, *Diamond Queen*, 290.

93. Other students inscribed their voices on postcards, too. The *Student Union Gazette*, a single-copy, handwritten periodical limited to AUB, ran a contest in 1915 for the best story inspired by a selected postcard. Editors pasted the image on one page, and contestants penned their entries on the following pages. Between 1928 and 1932, *al-'Urwa al-Wuthqa* contained pasted-in postcard reproductions of English, American, and German paintings. *Al-'Urwa al-Wuthqa*'s 1932 issue contains Anissa Rawda's copy of *Cairo*, titled *al-Fannan*, AUB. These practices literally "spoke" the postcards by confiscating the images as sites for the viewers' voices. Nor were these the only "local" uses made of postcards. Awatif Sinno Idriss (born in 1923) recalled that her father would give watercolor copies of postcards ("of views or whatever") as wedding presents.

94. Sbaiti, "Lessons in History," 257. A guide to Mandate offices lists Monsieur Chabanne as the *"chef comptable,"* or chief accountant, for the Tramway and Lighting Concession, meaning he held direct responsibility for both the rise of ticket prices and, eventually, submission to strikers' demands. Papêterie Gédéon, *l'Indicateur Libano-Syrien* (Beirut, 1928), 177, CDAN. On the strikes, see Jackson, "Mandatory Development," 251–323; Eddé, *"Mobilisation."*

95. *"Fi Madrasat al-Banat al-Ahliyya"* [At Ahliah School for Girls], *al-Ma'rid*, July 5, 1932, 21.

96. Mandate authorities abhorred Ahliah for what they perceived as its "Anglo-Saxon, Protestant, and anti-French leanings." Sbaiti, "Lessons in History," 65. Ironically, schools that most effectively adapted the metropolitan curriculum were most feared by French administrators as economic and political rivals. The Maronite Catholic Archdiocese's la Sagesse feuded with the authorities over the allocation of resources, despite its shared religious and linguistic proclivities. See Dueck, *Claims*, 96.

97. This unpublished work does not have an official name. I follow family practice, as recorded during my visit to Wadad Rawda.

98. Unless otherwise noted, the following biographical information is based on my interviews with Choucair, her sister Anissa Rawda Najjar, and her daughter Hala Schoukair.

99. Thompson, *Colonial Citizens*, 31–37. On the founding of the American Women's Junior College, see Lattouf, "Higher Education," 148.

100. See *al-Mar'a al-Jadida*, April 1921, 7, 29; *al-Kulliya*, April 1935, 132; *Al-Kulliyah Review*, January 11, 1936, 3; *Al-Kulliyah Review*, March 28, 1936, 3.

101. Thompson, *Colonial Citizens*, 88.

102. Female head covering in public had become standard in Beirut by the turn of the century for both Muslim and Christian women, but it was far less common outside the city. Hallaq, *Bayrut al-Mahrusa*, 48.

103. This happened either at the end of her time at Ahliah or when she had just enrolled at the American Junior College. During one interview, Choucair asserted,

"I didn't study with him at all, but from the beginning I was very friendly with him." Another time she remembered that he taught a club at the Preparatory College of AUB while she was still a student at Ahliah, and she visited a few of his sessions. The discrepancy may resolve around Choucair's definition of *study* versus *visit*. Both sisters located their acquaintanceship in 'Abadiya, their mother's ancestral village, where the elder painter occasionally summered.

104. See "*Ma'rid al-Ustadh Farrukh fi al-Jami'a al-Amirikiyya*" [Mr. Farrouk's exhibition at the American University of Beirut], *Bayrut*, June 23, 1938.

105. Hani Farroukh calls the picture *Veil's Off!* and dates it to 1929. However, a work titled *La femme au parasol rouge* appears in the catalog for *Exposition du Peintre Farrouk* (Beirut: School of Arts and Crafts, 1933), HF. Since his 1929 show, Farrouk had already held another solo exhibition and spent nearly two years in Europe, so I surmise he displayed new work and painted this piece in 1933 to contribute to current debates.

106. 'Anbara Salam recalled that starting in 1928, and following the controversy of Nazira Zayn al-Din's book *Veiling and Unveiling*, "town criers bemoaned the destruction of morals in the streets of Beirut and, as in Damascus, men attacked women with acid, razor blades, and iron prongs for not veiling sufficiently." Thompson, *Colonial Citizens*, 136.

107. Male sartorial practices associated with schooling could also provoke violent responses. Schumann, "Generation."

108. The image appears in Nicholas Sursock Museum, *Moustafa Farroukh*, 24 (Arabic section). Anissa Rawda Najjar dated the caricature to when she was working on the *Art Gazette* in 1934. "*Art Gazette/al-Majalla al-Fanniyya*," 1.

109. As Gerschultz puts it for the Tunisian arts system, "in becoming a locus for the performative development programs of state feminism, the arts associated with the decorative and artisanal reassumed feminized qualities." Gerschultz, *Tunisian École*, 79.

110. Decree #2372, made March 15, 1943, refers to decree #7962, made May 1, 1931. Outre-Mer Archives, Nantes, *Instruction Publique*, 2ème versement, carton #182, file, "Questions diverses," CDAN. The official inauguration date recorded by the institution active today is 1937, when the appointed "director," Alexis Boutros, started giving public music lessons. Ammoun, *Alexis Boutros*. Despite the decree for a "fine arts academy" serving music, painting, and architecture, Butrus gave music classes only, in Ahliah's halls after hours, and was systematically denied both a location and a budget by the same French authorities who had issued the 1931 decree. Makdisi Cortas, *World*, 93.

111. On Ahliah's involvement and the director's arrest, see Makdisi Cortas, 93–96; Ammoun, *Alexis Boutros*, 51.

112. Gabriel Bounoure, "Académie Michelet (Michelet's Academy)," April 14, 1943, Ministry of Foreign Affairs, Œuvres Françaises, 2ème versement, carton #182, file, "Questions diverses," CDAN.

113. Dueck, *Claims*.

114. Gérard Khoury, "*Gabriel Bounoure*," 69. The Œuvres Françaises supervised the Mandate's francophone school system.

115. Gabriel Bounoure, introduction to *le Salon des Amis des Arts* (Beirut, 1941), exhibition catalog, 4, JM.

116. Dueck, *Claims*, 99.

117. Nantes, Ministry of Foreign Affairs, les Œuvres Françaises, *Instruction Publique*, 2ème versement, carton 182, file, "Beaux-Arts," September 8, 1943.

118. Nora Annesley Taylor documents the same list of objections to a Vietnamese academy of fine arts that was proposed to French colonizers there. Taylor, *Painters in Hanoi*, 27.

119. Harney and Phillips, "Introduction," 20.

120. Harney and Phillips, 4.

121. Egypt has hosted its School of Fine Arts since 1908 and gave life drawing classes as part of its earliest curriculum. Radwan, "Diana and Isis," 1.

122. Khal, *Woman Artist*, 15, 33.

6

PORTRAITS

Toward a Fantasmic Ontology of Art Acts

"GHALAT" (WRONG), IN the artist's hand, four times disrupts the margins of Thérèse al-Ghurayyib's March 4, 1962, review of Choucair's 1962 exhibition at the Ministry of Tourism, in Beirut (fig. 6.1). As with many of the clippings I found in her archive, Choucair objected to how the journalist discussed her art. Yet here she objected equally to how al-Ghurayyib discussed her person. Nor had the years softened her objection. When I interviewed her in 1999, Choucair paused on this page, commenting vehemently on the "misrepresentations" of her work and being:

> CHOUCAIR. I was off the beaten path. I mean, the pigeons are going that way, and I was off flying on my own, apart . . . apart. . . .
>
> SCHEID, *pointing to the margin*. And this part where you say, "I hate to have my art described as feminine [*nisa'i*] art . . . ?"
>
> CHOUCAIR. Yes, why *feminine*? I challenge all men. Why *feminine*? Just because I'm a woman?
>
> SCHEID. OK, but out of this sentence, they made a headline, and then they wrote, "And she has a sole daughter, Hala, who is five, and *despite* her domestic, family responsibilities, she is devoted to her Art." Also, "She hates to spend time on elegance, makeup, and fixing her hair." I mean, they almost don't want to allow you to be a woman anymore.
>
> CHOUCAIR. To this day, I'm not very interested; I don't go to the coiffure to fix my hair.
>
> SCHEID. But for the news, this was very interesting? To the degree that they had to write about it? This was news!

FIG. 6.1 Annotated clipping, from Thérèse al-Ghurayyib, "*Sajjad wa-Rusum wa-Siramik wa-Naht*" [Carpets, drawings, ceramics, and sculpture], *al-Nahar*, March 4, 1962, 4–5. Saloua Raouda Choucair Foundation, Ras El Metn.

We both laughed. "OK." Choucair reread the passage aloud and then, lifting her gaze, said in a deadpan voice, "So what?"

I had been hoping to get Choucair to talk about her work "as a woman," or from a woman's social position. After all, in 1999 *woman* was (and still is) a key term in the "matrix of hegemonic notions about art and freedom" that scholars bring to the Middle East.[1] I knew my dissertation advisers and future hiring committees would ask me about "the woman issue," so I sought an answer from my interlocutor. Her "So what?" could easily be dismissed by attributing it to a denial of her social condition and to a naive acceptance of art's unmarked masculinity. Lack of self-awareness, in other words. Yet we social scientists must not forget that Choucair was an artist, meaning she devoted her career to developing plastic and aesthetic forms for rethinking and unthinking the origins and formation of the self via social norms. Moreover, like many artists, she sought to intervene in those norms. Her "So what?" demands gravity.

What other ways of relating people to aesthetic practices and social configurations might we discover if we surrender the symbolizing and individualizing assumptions that ensue from a representational ontology?[2] How does art

expand the tool kit of vocabularies and ideas with which an artist may meet the world? For example, how does art convince an artist of her subjectivity? In what ways may art teach artists other possibilities for social interaction? Answering these questions becomes possible when we prioritize a local art history, meaning one grounded in practices undertaken in specific conditions rather than rigged toward meeting expected chronologies or idealized categories. Answering them feels more urgent when one recognizes that Choucair's career indicates a formal, material response to her "So what?" The mundane articles she had displayed at her 1962 exhibition exposed her to being registered as a *sayyida fannana* (see chap. 5), that is, a woman artist who makes *fann nisa'i* (feminine art) for feminine jurisdictions. Choucair stopped displaying them henceforth. This shift reinforces my interest in the dialogic relationship art acts establish with audiences.

For one thing, taking the category "women" as the starting point seems to undermine actual belief in art. As we saw in chapter 5, art forms socially produced colonial female citizens as women: makeup and clothing abetted; cultural models resulted; *fantasmic suwar* of femininity became orienting forms. We also saw how greatly Mandate Lebanese society relied on this constant flow of art acts but labeled their instigators "lady-artists."[3] Stepping aside from the double bind created for women in art, I want to expand the scope for a minute and consider the basic unfixity of life and the agency we allocate art to fix it for us. Given that neither society nor artists are finished entities, as Mandate Lebanon powerfully teaches, I eschew a representational mode for thinking about "women's art" and "art" in general. It cannot account for the emotional practices and materializing ways of thinking (taswir) documented throughout this study.

In this final chapter, I want to invert the premises of Choucair's trenchant "So what?" to ask not what gender or social identity does to art but what art does to the possibility of gender and social belonging. In other words, I want to consider how the first audience of an artwork is the artist "herself." Absent the assumption that social being is given, I see art acts affecting an artist's relation to the very possibility of subjectivity. How does art create the social positions whose joint constellation we know as society? Drawing again on the ambiguity of the Arabic concept hadatha, I explore the construction and infilling of modern citizens through processes of stylistic and emotional-practical disjunctions. Interacting with her art, producing a self for her own recognition, the artist *becomes* through her artwork. I set these issues in the context of the adult career of Saloua Raouda Choucair, which launched from a socially ascribed female position but explored that position and her society through the fantasmic project

of taswir. Attention to the dialogic nature of Choucair's corpus compels us to keep looking at the act of looking at looking—not for representation or expression but for presentation, implication, experience: becoming. This route returns our inquiry to the missing sculpture that opened the book with its tantalizingly present absence at Choucair's one-hundredth-birthday celebration in Sursock Museum. The yet-undetermined fate of this work speaks to the condition of an abject Lebanese modernism/modernity in art and the possibilities that lie ahead as Lebanese everywhere consider their potential social being through art.

Portraiture without Mirrors: Art Acts and Enfleshment

The preceding chapter concluded with the double bind facing Lebanese colonial citizens who enacted modernity in their aesthetic femininity. We saw that it was particularly problematic for women claiming "middle-class" status; freed from the most onerous manual labor and having received a cultivating education, they endured new isolation and confronted new material challenges to guide the family, and nation, away from its Ottoman past. Jean Said Makdisi has written eloquently of the experience of such women in "modern" homes. Having been trained extensively in marital and domestic skills, these women came to see marriage and housekeeping as ends in themselves. "Cleanliness, order, hygiene, mothercare, and perhaps above all good financial management, all this spoke to [Mother] of modernity, of something of which she was inordinately proud, of something that marked her out and made her shine, like her college education."[4] As noted in the previous chapter, "modern women" found that their spaces and discourses for applying their special feminine roles were circumscribed from the rest of society in a way that they had not previously been. The heirs to a feminist movement that had claimed a social status for women on the basis of their being the mothers of society's future citizens—the cutting materialization of hadatha—these women found themselves positioned to engineer families professionally but unable to shake that role's demands when it impeded their attaining other positions. Recall the prison sentence spelled out in the 1962 review, which Choucair vehemently rejected: "devoted to her art . . . *despite* her domestic, family responsibilities." This was a disintegrating modernism, for women generally, but especially for women operating at the juncture of two civilizational indices: femininity and fine art.[5]

 Lady-artists became both a feminine canvas onto which the spectacle of modernity was projected and, contrarily, a fannan in the sense of a "socially free agent."[6] Her presentation of art always pursued another goal, outside the realm of culture: social jockeying (she beautified herself to impress others with

her family's status); family comfort (she made "gifts to the house"); or national improvement (she brought culture to the forefront of public interaction). At the same time, the lady-artist did not contest the foundational distinction between art and these "externals," allowing them to seem to exist prior to and apart from art. The lady-artist started with her position as woman and acted as if she only added art to it. By contrast, the preceding chapters, which have focused on Choucair's first mentors and the Mandate context created with art, have documented forms of taswir that enjoin viewers to carry out subjectivities or story lines suggested in fantasmic images, such as *The Two Prisoners*, *At the Exhibition*, or *Houlé*. I argue here that Choucair drew on her mentors' training to expand the realm of the lady-artist and forge aesthetic encounters better termed *art acts* than *artworks*. Attending to art acts may help us answer Choucair's stubborn "So what?" without tying her back to a pre-given, fixed identity.

A tiny oil painting from early in her corpus (dated 1943–44) suggests that Saloua Raouda struggled with the lady-artist pretense.[7] Called *Sculptor Destroys Classicism*, it catches the moment a stocky sculptor swings a heavy mallet at an armless marble torso (fig. 6.2). The torso figures a woman in a manner reminiscent of ancient Greco-Roman statuary: like the *Venus of Milo*, its arms have long ago disappeared such that its healthy bosom and buttocks dominate its presentation. Compositionally, the picture divides along a diagonal between heavy impasto work building up the pigments in the lower left and smooth, strokeless expanses on the right. The division traces a separation of activity from passivity. At the center, the mallet's blows crack the breasts off the sculpted chest, creating a deep gash in the rock. Two more statues stand in the background as if awaiting their turn. They are not clearly feminine, hinting at the august forms of Michelangelo's *Sleeping Slaves*, with which the earlier artist is said to have explored the contradictions of the agential yet subjugated human condition. On the far left, three brightly colored vegetal forms receive or emit three beams of supernatural light. Although their role is unclear, their formal similarity to the crushing mallet, in color and vector, suggests some shared cause or energy. The curved forms of the sculptor's body indicate femininity, and indeed, with her grayed but shiny skin, she seems to be a bloated version of the statuary. This visual resemblance lends credence to the possibility that the picture shows a female artist in the act of destroying artistic renditions of womanhood, or even figuration (as the human condition?) writ large. Yet the work itself enlists figuration for its project.

Legend has it that Raouda formulated her rejection of the nude genre in response to the claim Charles Malek made in a philosophy class she was auditing

FIG. 6.2 Saloua Raouda, *Sculptor Destroys Classicism*, oil on Masonite, 17.5 × 23.5 cm, between 1945 and 1947. Saloua Raouda Choucair Foundation, Ras El Metn.

at AUB (1944 or 1945): that Arabs did not know the arts because they did not treat the nude.[8] I have been unable to document this statement in Malek's writings, but it does fit the prevailing Grecophilia among Mandate-era Arab intellectuals.[9] Malek's fame was growing; newly appointed Lebanon's UN ambassador, he had been selected to represent the Middle East and Africa in the drafting of the Universal Declaration of Human Rights. His theory of humans, however, ranked some above others, and, in line with much Mandate-era art criticism (see chap. 3), he seems to have taken art as an index of Arab inferiority, specifically Arab artists' alleged lack of the nude. In many of the interviews she was to give later, Choucair recalled hearing Malek's assertion in class and disagreeing. "I wasn't prepared to talk to him directly, and my English was not as good as his, so I remained silent. But I began to make an inquiry."[10]

Not allowing a domineering stature to determine her thinking, Raouda reworked her silence through plastic media, producing *Sculptor Destroys Classicism*. She also affiliated with the Arab Cultural Club (hereafter ACC), an Arab nationalist organization whose members dedicated themselves to cultivating universal and local cultural values that would guide the formation of a new

social order and reconfigure class, gender, and sectarian relations that had been violently transformed by the fall of Ottoman feudalism and the failure of French imperialism. Raouda contributed by organizing a monthly lecture and exhibition series that explicitly countered the "universality of art" her mentor, Farrouk, had consistently propounded. She assembled speakers from among her colleagues at AUB, the local art critical coterie, and foreign embassies based in Beirut to speak on the history and *diversity* of art practices across the globe. She remapped Farrouk's "vastness of art" onto a post–World War II map of allied nations. From December 1947 to April 1948, lecturers presented "the Ancients" (meaning Egyptians), "the [ancient] Greeks" (delivered by Raouda herself), Bibi Zughbi (a Lebanese-heritage artist active in Brazil), "the Arabesque," "the [Italian] Renaissance," "the Flemish [sixteenth-through-eighteenth-century] school," "the English [seventeenth-to-nineteenth-century] school," "French Impressionism," "modernism and the Parisian school," "modern American art," "modern Russian art," and "modern English art." Drawing lessons were planned for the following semester.[11]

The ACC lecture series afforded both exposure and enfleshment. Anthropologist Elizabeth Povinelli offers this latter term to explain the cosubstantial production of personal "insides" from which socially validated content emanates.[12] In her presentation of the ACC lecture series to the reading public of *al-Adib* journal, Raouda explained that, "counter to the dominant idea," there are no innate art lovers.[13] Her own intervention on "The Art of Picturing among the Greeks," for example, asserted that their famed "realistic" representation of mundane life, which is also the basis of the nude genre, amounted to the achievement of a "healthy, naive child."[14] If Greeks based their art on the human body, that was because "they stayed away from complicated principles out of fear of them."[15] Yet other societies, she held, had developed alternative principles that supported differing rationales for aesthetic priorities and worldviews. Invoking dhawq as an active response to repeated exposure, Raouda argued that the ability to judge art and benefit from it—to enflesh it in selves, sociality, and society—would remain incomplete if the only schools that bothered to train students to benefit from it were those run by "foreigners (*ajanib*)." In other words, Raouda demanded a restructured sensorium to embody and affect a modern, civic sense-realm. She cited "Arab critics from the forefathers to Ibn al-Athir" to back up her dissentient assertions and localize her strange project of dhawq making.[16] Declaring that the ACC sought to "fill in the gap" created by "the dereliction of the local authorities" to produce a modern sense-realm, Raouda reinforced the notion that there was a single path of development to be followed that had perhaps been blazed by the West but not owned by it. Thus,

she neither negated the abjection parlayed by her artistic mentors nor allowed its presence to act absolutely. Artist and audience alike could use dhawq to create insides that shared substance with foreigners while also setting a boundary for making and measuring local progress.

On March 16, 1948, art critic Victor Hakim gave the ACC lecture on "modern picturing since the Impressionists." Hakim, who reported worrying about translating the names of contemporary French art schools into Arabic, was delighted to find the walls of the ACC meeting room hung with works by Picasso, Dali, Tanguy, and Matisse, which Raouda had borrowed from the private collection of Henri Seyrig, a resident French archaeologist.[17] Hakim's audience seems not to have shared his enthusiasm. Immediately following the event, Raouda issued an attack on Arab society in the feminist review *Sawt al-Mar'a*, condemning the community of "cave people that have slept for five hundred years and now awoken to find all standards changed, especially in the arts." Today that community was encountering, through magazines and exhibitions, an art before which most Arabs would stand befuddled, asking, "What is this deformed picture? What are these shams? And how is this related to classical art, where life is depicted completely naturally and if a person is depicted, he is beautiful, and if a landscape is depicted, it looks completely familiar?"[18]

With her words, Raouda recreated the image of Farrouk's *Souvenir de l'exposition*, sketched a decade and a half earlier. Now, however, the picture before which the peasants scratch their heads is not a nude but an abstract painting. Recapping the ACC lecture series for an apparently unswayed public, Raouda explained the relation of modern art to classical art, following a long, steady process of development fueled by human restlessness and critique. Her image of an entire society sleeping for centuries illustrates aptly the notion that there is indeed one history all peoples share, one timeline they must all march, but that they are bound, by accidents of political and economic history, to travel it at different rates. Raouda seems thereby to have discarded the relativist notion she had previously toyed with in her own ACC lecture on Greek art, saying that different societies have different histories and different termini. Rather, all societies are hurtling toward the same end, al-hadatha, which simply cannot be avoided. Nor should it be postponed under the pretext of foreignness, contended Raouda, because "*ruh al-insan al-yawm*" (the spirit of the human today) is not defined by ethnic hegemony but by a humanist embrace of revolution and research and passionate immersion.[19] Affirming that life and art are indivisible, she closed her article by denouncing the call to revert to *al-klasikiyya* (classicism, by which she meant Onsi's and Farrouk's nudes and landscapes) as a call

to go backward in time and, consequently, to renounce all social, political, and scientific gains made in the previous decades:

> Those who today advocate returning to the classical method in art seek to deviate from the world's problems and trends. They distance themselves from reality to pretend they inhabit hermitages that will take them and their lives back to the dusty centuries that launched this art. Yet their work is not a revolution against modern art only, but rather a revolution against the entirety of modern life. *Art and life are inseparable.* The direction in visual art we also find in modern music, modern literature, poetry, philosophy, and life. We may either try to redirect the whole caravan, deviate from it, or *walk with it.*[20]

How do we grapple with the many paradoxes peppering Raouda's impassioned reprimand? Here the artist who had publicly claimed multiply mapped paths to modernity a month earlier eerily recalls Scoutmaster al-Nusuli's command to "embrace art" and "walk with it" or be left out in the premodern cold. Yet the art he advocated was exactly the stuff she now condemned as cave dwellers' art, or even no-art. Both the paradox of figuration in *Sculptor Destroys Classicism* and the paradox of unilinear development in Raouda's social project encourage a closer inspection of a series of portraits she produced before she had completely professionalized her production of art. Like the copied postcards of her training to be a lady-artist, these portraits were mostly not included in her professional, publicly displayed corpus. Nor were they discarded, also like the postcards. They were probably made after her lessons with Farrouk and Onsi but either before or during her enrollment in institutionalized art lessons in Paris. I take them as the elder Choucair's personal no-art: they remind us of a burden that fell on her shoulders as she applied art's fantasmic capacity to reject social givens and complicate presence. They help us to understand the now missing *Poem* and its apparently predestined present. In short, I posit that portraits intervened in the social setting of the lady-artist. At one and the same time, they incorporated audience participation into the materialization of Saloua Raouda's being, enfleshed them together, extended her corporeality to other climes, and undermined the limitations imposed on her present.

Not-a-Lady-Artist: A Counter-ontology of Portraiture

Saloua Raouda graduated from the American Junior College in 1938 with a degree in natural science. She then taught at a girls' school in Iraq for three years (until revolution there forced her to leave); visited family in Egypt, where she informally studied the local architecture (in 1943); and then took up employment

as a desk librarian at AUB (1944–47), during which time she audited courses on philosophy, history, and Arabic literature.[21] She could have been a lady-artist during this period, but she held off from pursuing the conventional roles of wife and motherhood.[22] Employment at AUB allowed Raouda to audit two courses annually and to borrow books. Her approach here, too, was resolutely nonconformist: She did *not* participate in library committee meetings.[23] She *did* draw during working hours, producing portraits of her fellow employees, and the head librarian offered to pose for her. Explaining that she could read *more* by not pursuing a degree, she took out literary works for diversion but derived the most pleasure from poring over books on the sciences, especially the philosophy of science. She may have read from the many Anglophone, mostly American-centric art journals to which the library subscribed then—such as *American Artist, Art Bulletin, Art in America,* and *Metropolitan Museum Studies*—but, as we saw from her lecture series at the ACC, she swiftly and consistently took her findings off campus to contribute to a nascent Arab nationalism that drew on "universal" and "local" cultural values alike. She started from a hypothesized Arab position but did not think that limited where and how one moves.

During one of my first interviews with the artist, Choucair read to me from an art historical lecture she had given years before: "The Sufi artist immediately understood that there is nothing visible that needs to be pictured mentally." Obediently, I disregarded her portraits and refrained from entertaining a figurative basis for any of her later work. Several reasons have since arisen for perhaps somewhat perversely regarding those works through the hazy lens of the portraiture genre: The first is to confront the overcategorization of Choucair's art (and its peers in the contemporary Arab regions and across the Global South), which leads to a reliance on dissatisfying and polarizing terms, such as *abstraction* versus *figuration,* or *public* versus *personal.* My "hazy lens" suggests an analysis irritably informed by a less-than-useful, not entirely clarifying model taken up because it had some yet-uncrystallized meaning for the people involved. Second, precisely because Choucair's oeuvre does not fit the conventional categories by which art history in a universalizing mold unfolds and enwraps cultures, it provides a sturdy foundation on which to pursue the questions about art acts and subjectivity I raise above. And third, I seek to resist the common temptation, when an artist declaims her truth, to stop taking her art into account. Her art becomes an illustration of her being, seen only for how it leads back to the declaimed personhood. This perspective would not take seriously Choucair's own request to know, "So *what?*"

So, take *Self-Portrait,* probably dating to 1947 (fig. 6.3).[24] It brings touches of a cubist-fauvist palette to Raouda's face, conflating her physical features with a

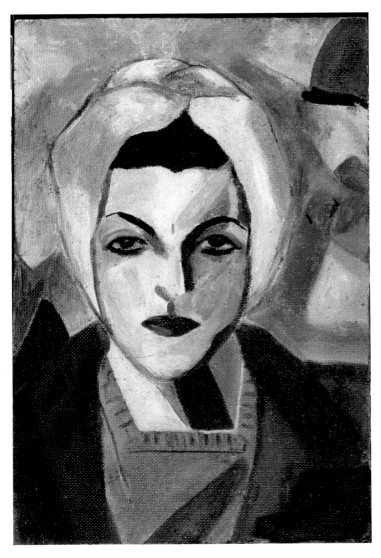

FIG. 6.3 Saloua Raouda, *Self-Portrait*, oil on Masonite, 45.5 × 42 cm, ca. 1947. Saloua Raouda Choucair Foundation, Ras El Metn.

locally innovative turban and a cosmopolitan mien. The heir to the copied post-
cards of her Ahliah oeuvre, *Self-Portrait* renders Raouda both local and nonlo-
cal. Her brushstrokes disrupt the common notion of a lady-artist, who would
draw on her allegedly natural, gender-engendered aestheticism to infuse her
home and community with harmony, proportion, and a longing for progress. In
a contemporaneous sketch by Ra'fat Buhairy, we meet the 1948 version of the
lady-artist: a woman in the thinker's chin-on-hand pose wears a simple short-
sleeved, tight-bodiced dress and pumps, which despite their common curves
align the woman's body precisely with the angles of the ultramodern armchair
in which she sits (fig. 6.4). Her young son, slightly more rumpled but squaring
his shoulders and holding his chin in as if buttoned by the top fastening of his
polo shirt, stands at her side awaiting her command. On the round table behind
them, a low vase of flowers shows the extent of the lady-artist's interventions.
The sketch accompanied a 1948 article by the prominent social critic Rushdi
Ma'luf (who had praised nudes for their refining capacities in chap. 3).[25] His
appeal to women to become educated domestic "specialists" was also a call
for women to make the management of their households and their conduct in
society measurable by visual standards. Interestingly, the maker of this instan-
tiation of the lady-artist started his career in graphic illustration at AUB some
twenty years earlier, ornamenting the pages of the Arab nationalist student
publication, *al-'Urwa al-Wuthqa*, with luscious art deco nude odalisques.[26]

If Buhairy's sketch and career prove that the odalisque, with proper social
support to cultivate her dhawq and improve her viewers' dhawq, could become
a lady-artist, Raouda's *Self-Portrait* reroutes the artist-audience relationship.
Here the slabs of color create jarring imbalances in her facial halves and merge
her body confusingly with the fluctuating background. The very idea of natural-
ness surrenders to the attack. Or, take an untitled work on Masonite from the
same period (fig. 6.5). On this board, the surfaces of Raouda's neck and head
share in the tan background tones while their maroon contours cavort with
calligraphic lines that whirl torrentially around her impassive mien. Arabic
script starts to issue the blessing of the *fatiha*, the verse opening the Qur'an.
Hallowed words disappear behind, or perhaps into, Raouda's head while her
first name merges with the exulted script. The image complicates knowledge
of where Raouda ends or begins.

Raouda's work prompts a counter-ontology of portraiture. Portraiture tends
to be studied through a model of internal to external effect, from a core self to an
onlooking world, but it could form other relations among art, self, and society.
The possibility that the audience of an artwork includes, perhaps even priori-
tizes, the artist herself foregrounds questions about her self-understanding and

FIG. 6.4 Ra'fat Buhairy, illustration for Rushdi Maʿluf's "*Dawr al-Marʾa fi Takwin al-Mujtama*ʿ" [The woman's role in the formation of society], *al-Shira*ʿ, November 1948, 16. Courtesy of Digital Initiatives and Scholarship, American University of Beirut.

social being. My approach focuses on method rather than content, to look for interactions more than intentions to flesh out becoming. Both of Saloua Raouda's painted self-portraits from her not-a-lady-artist's but not yet emphatically "not-a-woman's" (read professional) oeuvre actively draw on audience participation. The first, with its broad strokes and jarring colors, requires an injection of formal associations to imbue the strange brushwork with connotations of distance and cosmopolitanism. The second, with its clear calligraphic component, invites the viewer in more forcefully still. Thurayya Malhas, a modernist poet from Jordan studying at AUB who befriended Raouda during this period, recalls innumerable conversations with the artist about the nature of Arabic. She asserts that Raouda was fascinated by the unfinalized character of the written language, which generally includes only the consonantal portion of its articulation.[27] Eternally unfixed, it always flags its openness to elaboration, interpretation, and application. I suggest this unfixity keys us into the plastic, material reorganizing effect of the art acts Choucair would launch.

Structurally "purified of details," like the language itself, the untitled image requires Arabophone audiences to utter the missing words that wrest Saloua from the Masonite support and set her in a sacralizing context.[28] Here we confront an issue Kenneth George raises from his research into A. D. Pirous's art as a practicing Muslim: the predicaments of using Qur'anic verse as a pictorial sign.[29]

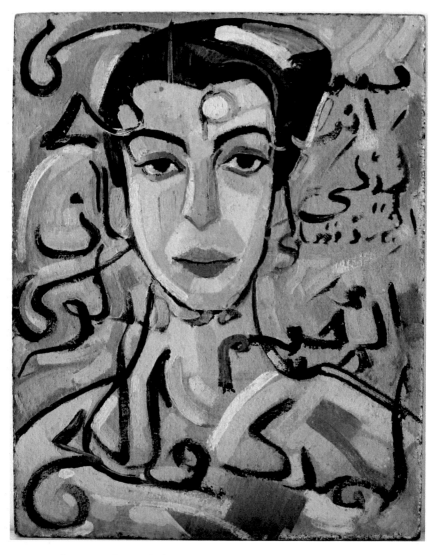

FIG. 6.5 Saloua Raouda, untitled, oil on Masonite, 50 × 40 cm, ca. 1947. Saloua Raouda Choucair Foundation, Ras El Metn.

Raouda's use seems to develop an ethics; not from deploying the verse as a sign but an instigation to practice. Her Masonite portrait engages its Arabic-speaking viewers in an articulatory art act that incorporates Saloua into the language and enunciates divine scripture from their mouths. Thus, Saloua's self-portraits neither represent her social identity nor express her desire but, vivifying dialogism, refashion her being, including her social relationships, and fantasmically launch her into something yet nonexistent. In other words, art acts have allowed Saloua Raouda to extend both her physical being from Lebanon to "contemporary culture" at large and to invite her audience into this new map of being to "walk with it," as she put it in her attack on those clinging to classicism. Her direction is not away from her local upbringing, language, or struggle but through them with new, modern resources.

A deliberate overlap created the map for Raouda's walking-with. A sense of entitlement and affiliation, fostered in a contest to localize the nature of the now-independent republic, forged its new, metaphysical boundaries. Trained on nudes and landscapes that imparted divine ayat and cultivated dhawq, the sensorium of Raouda and her cohorts at the ACC did not choose between "Arab" and "Western" identity; they used a sense of Arabness to create a culturally relative sphere that could be different from "Western." Audiences heard that in their art lectures that tied the art making of each society to its environment and mentality. Concomitantly, they used the "Western" as the embodiment of modernity, to demand that their consociates embrace specific social reform programs. Audiences confronted that in the exhibitions accompanying each lecture, including the "challenging" "contemporary art" show (for which, unlike all the others, no ethno-nationalist space was allotted). Again, these novel sensoria enact not an oppositional or unilateral modernity but convergence. In other words, in novel aesthetic encounters identities that may appear mutually exclusive were evoked conjointly through art acts to posit for the citizens of the newly independent republic ambiguous identities that were not limited to the previous molds of "Arab colonial subjects" or "Western anti-Arab colonizers." In such a sense-realm, Raouda's portraits acted like her mentors' nonrepresentational nudes. They opened up a space by creating an awareness of audience involvement in the materialization of locality at the juncture of emotional practices and responsible perception (taswir). They merged styles, topics, and identities such that the physically distant and disjunct conjoin and converge, if not in space, then in a time that is contemporaneous and cut from the prior "cave" era. If not on maps, then via sensoria.

We have learned from rich studies of the modern art of Egypt, India, Vietnam, and Pakistan, by Jessica Winegar, Tapati Guha-Thakurta, Nora Annesely

Taylor, and Iftikhar Dadi, respectively, about the invention of traditions and the relocation, re-presentation of a nostalgic past, like a periscope held high above a throng to espy the receding and place it in one's forethoughts. The double-decolonizing case of Lebanon, however, opens our awareness to another ontology, not set in a past but produced through a gap, a lack, a warp. There are glimpses of this structure in Kajri Jain's study of much-maligned calendar art, Christine Ho's plunge with socialist artists into the collaborative processes that figured it out on the go, and Philip Deloria's speculative recovery of his aunt Mary Sully's suitcase of drawings of her "becoming." Where conviction could be mobilized for the subjects of nostalgic practices about a specific past to be recuperated, only taswir—as an ongoing imaginative process that enfolds its audiences and actors into one—can account for gap-based ontology.[30]

Enfleshments of Being

Within months of painting *Self-Portrait*, Saloua Raouda moved to Paris and enrolled at the École nationale supérieure des Beaux-Arts. For a while she split her time between classes at that canon-setting institution in life drawing, mural painting, engraving, and sculpture and more loosely structured sessions at the Académie de la Grande Chaumière in the bohemian neighborhood of Montparnasse. The latter catered to amateurs, foreigners, and others who were unable to enroll at the École. The point of straddling these two oppositional zones of art making was "to gain experience," she later told an interviewer in Beirut, invoking again the concept of active dhawq production denied to the slumbering Arab cave dwellers.[31]

Around this time, Raouda made a self-portrait visually inserting herself into Farrouk's *Souvenir* and Onsi's *Imru' al-Qais*, as if to experiment with the experience of straddling "time zones," as it were (fig. 6.6). Titled *Subhan* [May he be glorified], it stylistically invokes the teacher whose atelier she joined for several months, the extremely well-known Fernand Léger. Despite an initial attraction to Léger's so-called realist abstraction, she seems to have become uncomfortable with the practical relations it afforded a master artist over his subjects.[32] *Subhan* bespeaks a period of separation, ca. 1949, when Raouda seems to be looking through art at whom she can become. The small gouache on paper introduces the viewer to a woman who takes the role of being visually desirable for her spectator by posing, one elbow raised, one leg folded under the other, one hand caressing the other outstretched thigh. When I saw *Subhan* on her studio wall, Choucair said that the female figure represented her in her Parisian apartment. Like *Souvenir* and *Imru' al-Qais*, the gouache presents a

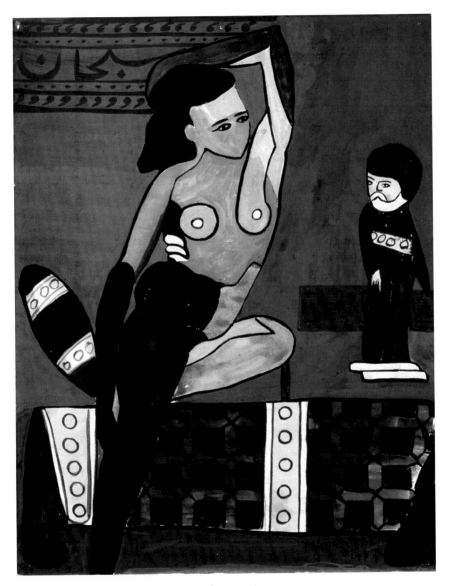

FIG. 6.6 Saloua Raouda, *Subhan* [May he be glorified], gouache on paper, 31. 5 × 24.5 cm, 1949. Saloua Raouda Choucair Foundation, Ras El Metn.

female consciously adopting a classic life model pose that opens her bare chest to full scrutiny while a male spectator peers at her from the side.

Yet unlike the naturalizing style of her Beirut teachers' works, in *Subhan* Raouda's thick black lines divide her body into anatomical segments: shin, thigh, abdomen, forearm, upper arm, breasts, ribs. Various unnatural hues fill the segments: turquoise, cerulean, ochre, and so on. Beside her, the bearded male figure, much smaller, clothed in a *jallabiyya* and turban, tops a thin pedestal. As he looks at the female, he points one index finger to the ground, in a gesture of acknowledgment of higher authority. Choucair identified him as a figurine of Ibn Rushd, which she had brought from Beirut. Inscribed in the background is the Arabic word *subhan*. As Choucair alerted me, the word can refer to the phrase *subhan al-khaliq* (may the Creator be glorified), which the pious utter to express awe. On Beirut's streets, marriage-aged men may murmur the full phrase when a woman they find attractive passes; sometimes they simply whistle the first word and let the second linger out of range of blasphemy. The creator, here, however, is clearly the painter who has bestowed such a strange look on the scene. And the created spectacle is hardly a naturalizing rendition of female delectation. The flattening, fragmenting style denaturalizes the relationship between the act of female modeling and the creation of art. It no longer appears to be an automatic process of representing that which presented itself visually to the artist. Perhaps the subjectivity of the lady-artist-cum-model has intervened in that easy transition.

As with Onsi's *Imru' al-Qais*, *Subhan*'s encompassing of both viewer and viewed calls into question the act of looking and what it reveals about the female subject seen. And as with Farrouk's *Souvenir*, the model seems fixed in her spot and unable to move, let alone confront her viewer. While both predecessor images rely on naturalistic presentation to locate the model outside in a plausible setting, to represent something else, Raouda's image foregrounds the model's subjectivity. That subjectivity with which she plays is her very own. A self-portrait of which she was the first and primary viewer, *Subhan* highlights the degree to which the human artist (she, herself) deformed the model as a woman (again, herself), on the one hand, but also the set of anatomical relationships that make up the female body as muscular fields, on the other. Indeed, the clothing on the male obscures these fields. At the same time, the repetition of brown circles on an ochre background joins the divan, the pillows, Ibn Rushd's belts, and Raouda-as-model's breasts, suggesting that other patterns connect apparently related and unlike entities: patterns only the Divine Artist oversees.

In a separate discussion of art making, Choucair told me that *subhan Allah* is what we are provoked to say when we realize that nature is entirely God's

creation, one unified expression of his being. The inclusion of *subhan* in the background—unfinalized by *Allah* or *al-khaliq*, let alone vowel diacritics—could point to a tension Choucair was learning to plumb. It is a tension that we can perhaps summarize by relating nudes as locally made imports to landscapes as divinely imprinting prints: First, women, especially for modern (i.e., aesthetically productive) viewers, can refract a spiritual, pious gaze that sees the (female) body, like a landscape or any "natural" entity, with mathematics and philosophy, to reveal deep connections, or the very patterns of creation that lead one to be aware of God's presence and glory. As well, the same body (or landscape) can refract a heteronormative, masculinist, titled gaze for which woman/land serves as medium for man's display of his mastery, whether as aspiring possessor on the street or ambitious painter in an art historical canon. Unlike the potentially flat surfaces of both nudes and landscapes as imported genres, however, Raouda's gouache embeds a scripted "subhan," which is not a mere linguistic symbol but an element involving the viewer's articulation. Vocal cords rumble and rustle to produce sound, while the spirit chooses the path onto which it will send the word and the woman it addresses. The painting *Subhan*, thus, both represents Raouda's given condition (in tension) *and* provides a forum for infilling, or alternative enfleshments, by engaging the fullness of one's being, both potentiality and responsibility, sensuality and unfixity. The piece seems not to have been displayed until a quarter century after its making. It may long have existed as the artist's emotional practice at feeling feminine *and* feeling professional. It may have been an exercise in becoming: an art act for the artist as audience.

The making of *Subhan* marks a breaking point for Raouda, who around the time of its painting left the type of figuration recognizable in Léger's atelier and helped to found l'Atelier de l'art abstrait (Atelier of Abstract Art), in association with Jean Dewasne, a fellow frequenter of the Grande Chaumière who was somewhat junior to Raouda but who quickly dominated the postwar Parisian scene, and Edgar Pillet, a somewhat senior painter who had recently launched a French-language arbiter on contemporary art, *Art d'aujourd'hui* [Art of today]. One art critic supportively described their project as the quest to paint a square—the epitome of a mental construction—that exists by dint of its plasticity and not by its reference to an ideal, Platonic form.[33] The quest mattered for its method as much as its topic. Art would be liberated from the demands of figuration and integrated completely into daily life, while hierarchies and barriers in life would be erased through art acts. Gone, the masters of studios, apprentices, and models. Promoting collaborative ventures to evolve, purify, and enrich anti-figuration and apply its principles of exploration limitlessly, the

Atelier housed an artisanal workshop, where there would be no "master" but rather the gathering together of useful experiences for the benefit of all.[34] It was a direct challenge to both the École des Beaux-Arts and, more provocatively, Léger, the Parisian art scene's proverbial "master." Raouda immediately volunteered to help administer the place and organize the twice-monthly debates while she also prepared her first solo show at Colette Allendy's prestigious gallery (March 1951).[35] After *Subhan*, Raouda seems not to have made (apart from sketches in family letters) any more portraits, let alone self-portraits.

The Matter of Portraiture

Or did she? The assertion may rely on a certain definition of portraiture, or even of the relation between humans and matter. One word usually applied to Choucair's corpus is *abstraction*, which would suggest a denial of material reality as the basis for artistic acts. *Abstraction* [*tajrid*, also "extraction"] is a term Choucair sometimes used.[36] Yet it is not a helpful word here, in part because it starts with figuration and whittles down from there and in part because it locates production firmly in a chronology of Western canonical art while ignoring other histories of practice, not least Islamic mathematics, philosophy, and pre-Islamic poetry, which Raouda, like Farrouk and Onsi, plumbed to understand Mandate citizens' civic capacities and duties. Let us pause from applying labels to consider practices undertaken in mundane, minute, intermeshed matters, from childhood education and daily life to encounters with audiences.[37]

Just as Raouda was finalizing her debut solo show, she was composing a stinging refutation to yet another "dominant idea" regarding Arab social progress and contemporaneity: that materialism had led Arabs astray. As we saw in chapters 3 and 4, this idea was dear to both her mentors in Beirut, Farrouk and Onsi. Their spiritually charged nudes and Lebanese landscapes sought to cultivate dhawq as an ethical capacity and stance for countering the deleterious effects of a rampant market, unsolicitous government, and fragile public budget. Raouda rook a different view.

A month after her show opened in Paris, Raouda published her attack on this understanding of dhawq in Beirut in the guise of a review of a colleague's study of Arabic fiction: *al-Adab al-Qasasi `inda al-`Arab* (Narrative fiction among the Arabs), by Musa Sulaiman. A comparison of Abbasid-era stories (such as *The Thousand and One Nights*) and classical Greek epics (such as *The Iliad*), *al-Adab al-Qasasi* condemned the former's "hyperbolic descriptions" and "fantastic plots," which seemed abjectly to lack character development, moralizing plotlines, and authorial personality. Developing the logic of early

twentieth-century belletrist May Ziadeh and pedagogue Fu'ad Sarruf (see chap. 5), Sulaiman attributed these literary traits to a faulty mukhayyila, or imaginative capacity, akin to that of juvenile children. Arabs live in an unreality, he asserted, seeking only material stimulation and satisfaction. He related this to a "materialist" outlook that appreciates things only for their use value. Arabs must develop an awareness of reality, especially its material constraints. If not, they will respond only to extreme conditions of material manipulation, such as cannons and rockets, he intoned, and they will continue to suffer spiritual unrest and to search for nourishment and entertainment in bigger, louder, and more wasteful material means. By way of remedy, Sulaiman called for a modern narration based on Greek models to provide realistic representations reflecting on social conditions, offer moral lessons, and enable philosophical inquiry.[38]

Raouda vigorously attacked the conceptualization of matter and materialism structuring Sulaiman's study. In a private letter to the scholar, who was also the fiancé of her cherished interlocutor Thurayya Malhas, she declared:

> The Arab did not disregard matter; he approached it through its essence. He will always choose *the essence or noblest material* to describe a thing. . . . From here we see that the Arab effected the realization of the essence in visions (*suwar*) more real than common reality. These visions were and would indeed have remained imaginary (*suwar khayaliyya*) were they not realized in this age: the flying carpet reappears today as the airplane that splits the billowing sky; those industrious workers, the daemons and genies, have come into existence today as robots; and the magic lamp is today's electric switch, a servant at your fingertips. . . . He who disdains matter is either benighted or prejudiced by the Greek standards that froze the world for centuries. He who fears matter is far from grasping the foundations of our era and the civilizations preceding it. . . . Despised in ancient Greece, the Middle Ages, and the Renaissance, matter has today become either a road to Heaven-on-Earth, as promised by the Qur'an, or living Hell, if misused.[39]

When she speaks of *suwar* that are "more real" than common reality, Raouda almost certainly draws on Alhazenian optics and chromatics. Abu 'Ali al-Hasan ibn al-Hasan ibn al-Haytham (hereafter Alhazen) provides the perfect rejoinder to Musa Sulaiman.[40] Alhazen was a contemporary of the medieval stories Sulaiman analyzed, and he introduced empirical experimentation into the study of optics, developing his work as a critique of the Greek scientists whose theory of knowledge and representation lies at the base of Renaissance art. He distinguished between "visibility," which relates an object to the eye through mere sensation, on the one hand, and "visuality," which relates eyes to

brains and societies, via inference or recognition, on the other.[41] Whereas the Aristotelian model of optics held that viewed objects emitted *eidola* (images), which entered the viewer's eye, Alhazen's empirical experiments compelled him to theorize a neutral medium that was produced by neither the object nor the eye but enabled by their connection: light. The ontological premise guiding his study of sight and light is that the latter is subject to "essential ordering structures" that can be experimentally manipulated, mathematically described, and multiply interpreted while still speaking of a singular essence.[42] That essence is what Saloua Raouda meant by the "more real," whereas the culturally learned interpretation is the "common reality."

Raouda's letter so powerfully enunciated alternative thinking about materialism and modernism, postwar political relations, and even the ethical duties of the socially integrated intellectual that it was circulated among colleagues and eventually published as a manifesto by the academic flagship journal of Sulaiman's employer (also Raouda's previously), AUB. Asserting that dominant ideas of "matter" in her day unthinkingly adopted ancient Greek assumptions, Raouda distinguished between the essence of matter and its surface, or better, its commonly perceived but misleading attributes. It was not matter per se that Arabs eschewed but the latter. The recent invention of atomic science and application of computer algorithms both actualized, for Raouda, the "promises of the Arab imaginaire (*al-khayal al-'arabi*)," meaning that the modern East and West are intimately entwined equals.[43] The question facing all peoples in 1951, regardless of origin, then, was how to use matter wisely, and for that she called on her peers to plunge deep into matter's essence, fathom its eternal truths, and envisage (tasawwur) inventions and practices that would make of society heavenly, spiritual imagination incarnate. A different ontology, in other words.

In an Aristotelian worldview, there is only one proper form (the one emitted by the object) that tells the object's truth, even substitutes for it. By contrast, in the Alhazenian model, the "true form" (*al-sura al-haqiqiyya*), or "the bundle of properties perceived and unperceived, in any single instance," is different from the "unified form" (*al-sura al-muttahida*) the optical nerve transmits from each eye to the brain.[44] The difference between these various types of form is accessibility, not substitutability. Suwar will always submit to sentient interpretation, which will in turn always be informed by a society's religion, history, politics, ecology, and so on. Hence, Alhazen relocated the meaning of images from themselves to their interpretive conditions. Ultimately, the importance of the sura lies in what we do with it. Following Alhazenian phenomenalism, we can think of vision as "a mode of de-distancing" and of "visual art" as the

manipulation of nearness, farness, access, and interpretative conditions.[45] The latter provides a key to concretizing the unconventional ontology.

By revealing that matter does not predetermine how we interpret it, Chou-cair rescued materiality for modernity. "Matter *has today become* a road to Heaven-on-Earth, as promised by the Qur'an, *or* a living Hell *if misused*."[46] Her sentence's strange tense leaves the future open but urgent. Matter *has become*, or it might *if misused*? She was speaking to an audience for whom materialism was overextension, deception, dependence, vulnerability, inferiority. Are Arabs trapped in matter? Trapped by not recognizing its implications (its reality) as Sulaiman asserts? Are they seduced by matter? The answer is in the way of looking, in the role the viewer assumes in the process of taswir:

> The Arab never took much interest in visible, tangible reality, or the truth that every human sees. Rather, he took his search for beauty to the essence of the subject, extracting it from all the blemishes that had accumulated in art since the time of the [ancient] Greeks (*zaman al-ighriq*) until the end of the nineteenth century. . . . Arabs are the most sophisticated of peoples in understanding art in terms of sensory perception, and that is why they broached the subject at its essence, abstractly. Visual art (fann al-taswir) has its own impact and value; from the Arab's perspective, its completeness requires no association with other art forms.[47]

Proffering an Arabic plastic language in visual experimentation, Raouda connects the history of Arab art to Malhas's theorization of the Arabic language as purified of details and requiring alertness to human deployment of it. After showing that the way matter is used in Arab art reveals a prioritization of essence, Raouda finds that people are not trapped; they can ride essence beyond given time/space limitations. Matter is no more antihuman than humans are immaterial. Meaning is always relational and solicitous. Building on Sufic Arab experimental philosophers, she suggests that art can and should provoke aware-ness of ourselves as sighted creatures. Art acts can open the space the mind collapses in perception, so that audiences become mindfully sighted, taking responsibility for their suwar.

Raouda shared the first results of her explorations into mindful sighted-ness at her debut solo show in 1951 featuring her *Modules* series. One of those pieces is *Plus et Moins*, a rectangular composition that seems to participate in the group quest to paint a square that exists through active seeing rather than referentiality (fig. 6.7).[48] Thinking about the difference between the visible and the visual, we can describe the actual, unmediated sight of a cube's side as an experience of slantedness and unevenness (the sura haqiqiyya) that we learn

to collapse into the square's mathematical status (the sura muttahida). We can "see" this iconic form (*sura kulliyya*) with our eyes closed; it has no visual status in fact. Starting with the rectangular canvas surface, Raouda mimics their straight edges and right angles but tilts their conjunction slightly, forming a mathematical square in the middle left. She then slices through this on a diagonal, roughly halving the square but also creating the exterior line of a larger square that forms to the right. The resulting shape, which Raouda called a "module," is then traced, like a pattern, into a field opposite the first (in the upper right corner of fig. 6.7). She then proceeds to parallel the original diagonal, tilting anew, shifting and following the lines beyond their limits within the smaller squares and into meetings with subtle curves that are not quite straight lines. These, too, are replicated, flipped, and expanded. Similarly, she creates a palette of rich maroon which she then "splits," chromatically as it were, into constituents of slate blue and red offset by white to provide the strongest contrast. Distributed across the canvas, the maroon seems to pull back toward itself while the pink that echoes it interposes itself dramatically, and the blue slips off into other, displaced squares.

Raouda's work thus separates the visible properties of an object from its visual structure. This compositional formula produces a visual ratio, in which segments of the picture echo the lines and tones from other parts of the surface in proportional harmonies. Viewers need not be fully aware of the ratio (and rational) structure underlying the equation, but they will sense a continual succession of resonances and convergences, a kind of fantasmic universe.[49] By submitting an iconic form to a range of interpretive conditions, the artist teases out its essence, the features that produce its iconicity. She creates an intervention before the mind's eye can grasp the square's aspects as those of a specific, unified thing. In doing so, she triggers the viewer's sense of perceptual capacity without allowing it to proceed mindlessly. The surrogate closeness afforded by visual art enables her to interrogate the possibilities of perception that tend to be foreclosed by our culturally learned habits. At the same time, this act of art holds iconicity hostage to the provoked intervention of a viewer.

For Raouda, the de-distancing of Alhazenian vision compels never-ending explorations of the infinitely possible understandings of the same object under different conditions of media and scale. It is a plastic means for enacting mathematically and linguistically grounded formulas of essentially limitless application and execution. These formulas are like seeds that grow when put into soil. Transitively, they can pass on their codes to other beings, too. Ultimately, this heightened awareness of the perception process ontologically calls into question how we relate to matter (*al-madda*): what material we make of it, and

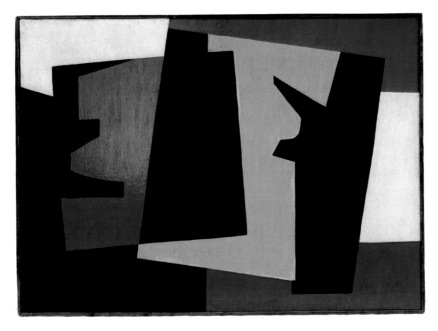

FIG. 6.7 Saloua Raouda, *Plus et moins* [more and less], oil on wood, 67 × 93 cm, 1951. Saloua Raouda Choucair Foundation, Ras El Metn.

what material we let it make us into. As part of this art act, this performance art of life, we now face that choice: "matter *has today become* a road to Heaven-on-Earth, as promised by the Qur'an, *or* a living Hell, *if misused*." Again, *has* or *might*? When we realize that our perception is infinite but not random, that it is the confluence of suwar and society, in our sighted brains, then we realize our ethical role. In terms of their methods and processes, then, Raouda's suwar are not figurative in as much as they respond to figures that exist visibly in the world, and they are far less portraits, in as much as they portray beings that inhabit the world. Still, they may figure viewers into ontologically new beings that can responsibly choose new relations to inhabit. The material of portraiture may simply resolve to the choice of perceptible matter or essential matter, of being or becoming.

Germinating Portraits

Within months of posting her letter to Beirut, Saloua Raouda herself returned. In March 1952, she showed the work she had brought with her from Paris at

the École supérieure des lettres, a sprawling but elegant campus on the road to Damascus. Perhaps the widespread assumption among the show's reviewers that she channeled French influences in part led her to seek a more "grounded" range of media for her subsequent work.[50] That appeared a decade later in a solo exhibition (UNESCO palace, Beirut, March 1962), garnering al-Ghurayyib's multiply ghalat review. The three-paged, unillustrated, bilingual catalog divided works by media and denominated them by numbers, colors, geometric shapes, or media terms. The format debarred the by-then-standard preface, artist's statement, and biography (which we first met at Farrouk's 1929 exhibition, chap. 2). The show stunned audiences with its diverse media—much of it domestic by association—and disavowal of figurative modes of representation. As Choucair explained to visitors, and as so many of her reviewers repeated, the Persian point carpet titled *Composition, Two Forms*, for example, was not *l'art pour l'art* but art for the user, to be touched, experienced, incorporated into daily life (fig. 6.8).[51] In this sense, her art spoke openly of an external motivation in a way that fit with the developed gendered notion of aesthetic activity discussed in the previous chapter: fine art for men, home decor for women; or fine art for the West, applied for the rest.

Consequently, what seemed strange to Choucair's Beirut-based audiences was not that she was a woman making pretty carpets and ashtrays but that she wanted professional recognition for doing so: That she did not think of it as no-art! Furthermore, her willful invocation of the sensual side of art making encouraged audiences to interact with it not as a matter of edification but one of feminine sensibility (that code word for dhawq), which was commonly understood to motivate skilled female art making. Yet Choucair insisted hers was fine art, universal, worthy of any museum or society. Fearing they circumscribed her work to a self-representation by tying it to her socially ascribed womanhood, she retorted emphatically, "So what?" What did tying it back to her womanhood add to understanding her art? In the wake of her previous exhibition—condemned locally for not being nationally representative (and praised for being "like the French")—Choucair's indignant query bundles the categorical terms—think also of *Lebanese, nationalist, local, Muslim*, which have surfaced in this study—by which we take art to represent or stem from a given reality rather than allow for its agency in creating reality fantasmically by incorporating audiences. Still, rather than relapse into a binary vocabulary of ungendered universal versus feminine applied art, of abstraction versus figuration, we might find another way of viewing Choucair's subsequent "I'm-not-a-woman corpus," in following the interactions and experiences funneled by her art acts.

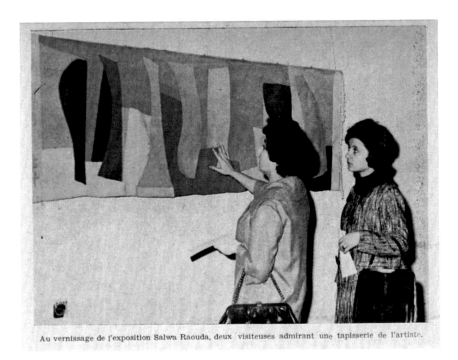

Au vernissage de l'exposition Salwa Raouda, deux visiteuses admirant une tapisserie de l'artiste.

FIG. 6.8 Uncredited photographer, visitors to Saloua Raouda Choucair exhibition, UNESCO Palace, March 1962. Reproduced from Victor Hakim, "*L'exposition Salwa Raouda*," *la Revue du Liban*, March 1962, 43. Courtesy of Digital Initiatives and Scholarship, American University of Beirut.

We can consider *Composition, Two Forms,* for example (fig. 6.9). Some reviewers in 1962 saw it simply as a demonstration of the artist's handicraft: "Look at all the media she has mastered," said al-Ghurayyib.[52] Rather, the piece implements the same mathematical method of formal decomposition that Choucair developed in her *Modules* series from the 1950s. She randomly slices geometrical shapes—here two rectangles, one larger and one smaller—then traces the outlines of their separated halves onto modules, flips these, severs them internally again, and repeats the tracing. The resulting series of outlines she then fills in with a palette of colors—here, contrasting shades of green and purple, themselves chromatically "sliced" from blue—but just as she incrementally divides the form, she gradually augments the shades. Rendering this formula on a rug (or pool floor or wall mural) allowed Choucair to integrate that thinking with the surfaces of daily life. As we saw in the previous chapter, she attended a school that countered art/life boundaries by insisting on aesthetic enfleshment and on deploying art

FIG. 6.9 Saloua Raouda Choucair, *Ta'lif `ala Shaklayn* [Composition in two forms], carpet, Persian point, 178 × 275 cm, 1961. Saloua Raouda Choucair Foundation, Ras El Metn.

everywhere. Replete with rugs, pool floors, fountains, gates, ashtrays, plates, and jewelry, her corpus does in fact closely fit contemporary articulations of a "feminine aesthetic" that was also a claim for female citizenship—a nationalist, political idea of womanhood. In fact, it somewhat ironically makes use of that much-despised tracing method. So, in rejecting the "feminine explanation" for her art, was Choucair not thinking of herself as a woman? Or, have we been coming at *woman* the wrong way? And at *Arab, Muslim,* and other labels, for that matter?

I see these formulas-cum-sculptures, -rugs, or -ashtrays not as metaphors for Choucair's conscious, formulated thought (as a woman, as an Arab, as a Muslim, and so on) but as instantiations of consciousness itself grappling with life through sculptural objects. My move does not seek to abstract or decontextualize consciousness but rather to admit that we do not know its bounds simply by reading a location, like a GPS signal, on a map formed for other means. Choucair's fantasmic objects demand from audiences a willingness to follow their growth and movement rather than a cleverness in tying them back to some source. Because they have no literal or figurative referents, they puzzle audiences. As you walk around the sculptures embodying Choucair's formulas, such as *Secret of a Cube*, also shown in 1962, you find components pointing outward, to the possibility of meaning and impact, not backward to a known thing (fig. 6.10). Yes, a cube, ideally is the three-dimensional projection of a square, perpetuating the exploration of mental constructions from the time Raouda participated at the Atelier de l'art abstrait and the quest to depict a square materially. But the "cube" of the title does not tell the sculptural form's secrets. You must keep moving with this "cube," physically and mentally. You must *walk with* its method of relating to the world. You must postpone the finalization of

FIG. 6.10 Saloua Raouda Choucair, *Sirr al-Muka'ab* [Secrets of a cube], wood, 84 × 60 × 60 cm, 1960–62. Saloua Raouda Choucair Foundation, Ras El Metn.

perception to plunge deep into your capacity for taswir. Where you start to perceive a flat surface, you suddenly spy an intrusion leading to a spiral. How did you think you saw a cube? Such artwork highlights our responsibility as viewers (and walkers) for the meaning we produce.

In subsequent years, Choucair would come to speak of sculpture as a living art: "Everything living grows," she reminded viewers applauding the installation of *Poem* in 1983. She sought scales of interaction that were at once public (monumental installations) and private (intimate maquettes drawing audiences into one-on-one interaction). The method of producing sets of formulas

that could be injected, as it were, into an infinite array of media and sizes refuses an inherent separation between categories like public and private.

Thus, while at first blush it might appear impossible that Choucair's art visually intervened in given social arrangements or remapped relations between her body and daily life, in the way of portraiture, exploration of Choucair's later oeuvre does give ample reason to reconsider our categories. Writing of a series of sculptures inspired by inquiries into DNA, Laura Metzler asserts: "Through these works we start to see Choucair's equations and lines from her earlier periods as the same elements that comprise the foundations of the study of genetics, intensifying and morphing through the understanding of their role in complex biological systems. They are no longer just creating form but *producing the human body and potentially Being.*"[53] In Choucair's *Duals* series from the 1970s–80s, Metzler finds unique patterns of bonding pairs (performing the DNA-RNA reading process). These three-dimensional pairs usually manifest in soft, warm material, such as burnished wood, or dense metals that snuggle heftily into one's palm (figs. 6.11 and 6.12). They create closed systems that temporarily open (as if to allow copying and growth) but, through their very surfaces, demonstrate a longing, or energy, to draw each other back together.[54] Rather than shape ideas or identities, they carve out existence itself.

Equations, poetic meters, patterns, genes, fundamental characteristics, essential materiality: this is the stuff of Arab art inspired by Arab science, language, and philosophy, meaning it is categorically not art for art, cut off or hermetically sealed into a sphere of its own. The sculptures do not represent. Their materiality does not fade upon recognition. Jack Assouad eloquently explains that "the tableau or sculpture for her, most likely stimulated by the art of architecture, was a system of points of view."[55] They implement the practice of generation in a new medium, allowing people sensually and consciously but *asexually* to engage with their capacity for generation. By *asexual* here I mean they do not demand sexual dimorphism distributing communally necessary traits—lactation glands, physical force, overwhelming size, and subtle camouflage—between opposed, fixed sexes that regularly conjoin to produce offspring belonging to one or the other sex, as humans have until recently understood their biology.[56] Rather, interaction is contextual and draws on given capacities in each (audience, sculpture) while also cultivating and submitting the parties to new conditions, which transform them and generate new possibilities: a square is a curve is a rug is a pool basin. Where are you in the midst of this flow? Not lost but alerted and braced by the beacon-like art that cautions, beckons, and invigilates your art act.

FIG. 6.11 and 6.12 Saloua Raouda Choucair, *Thana'iya* [Dual], wood, 21.3 × 21 × 12.5 cm, ca. 1970s. Alternate views, posed by the artist. Saloua Raouda Choucair Foundation, Ras El Metn.

And what of Choucair? No longer a spectacle to be seen, as in her early self-portraits, she has become a devoted force of creation. By 1957, her work took a decisive turn to three- and four-dimensional media, incorporating the motion of light, water, and viewers' physical responses. It followed essential units—whether modules, algebraic equations, poetic verses, light waves, or genes—into structures of composition that relate macro- and micro-level pro-cesses in systems of open-ended feedback and growth. The search for the es-sence became the exaltation of infinity, as Metzler has convincingly shown.[57] Limitlessness and liveliness replace the institutionalism and professionalism of her mentors. Choucair's "portraits" now come into being: both incorporat-ing audience participation into the materialization of her being and extend-ing her flesh through ever transmittable equations and seeds. Her "self" has relocated in the process; ever expanding through interactions in new settings, like DNA, the infilled self is now irreducible to either the lady-artist or the artist-hero, or any kind of fetishized individual. She has effected a transition from a woman-artist (a given social and academic ascription) to a creator, along the way loosening associations based on social oppositions and conventional art historical binaries. Taking on her mentors' project of social construction through art professionalization, her work builds "an environment out of art," as Metzler notes.[58]

Before Choucair put down the multiply ghalat article by al-Ghurayyib from 1962, she translated to me a quote attributed to her: "I don't believe that art, after today, should be restricted to the landscape and the portrait. It should roam the city, and all the people should benefit from it. I should do sculpture in various places, in the middle of downtown even. Art should serve people and not be left in the studio."[59]

After AUB installed a Choucair sculpture on its campus in 2018, a graduate student in anthropology, Rabea Hajaig, observed that "aside from a few quick glances, nobody seems to be interacting with it." Interviewing passersby, both students and professors, Hajaig received disparaging responses, such as "What does this design mean? What is the message?"; "I don't see the artistry in it"; and "If you are not an artist, you won't get it." Frustrated, he sought out Choucair's work at another installation, by the State Council Building, in downtown Beirut. Ensconced in a shady, cobbled square, the spirited and creative interactions with Choucair's Bench—Poem surprised him with their stark contrast. Young people in particular regularly use the square for public recreation—parcourse, skate-boarding, and off-trail biking—or for romantic intimacy away from parents' prying eyes. The intrepid graduate student interviewed visitors to the square about their thoughts on public art, art in Lebanon, and the artwork on which

they were sitting (or biking) (fig. 6.13). Many approved of the statue of Riad Al Solh in a neighboring square (the same nose-holding statue from chap. 3), adding that while "statues are important because they *attract tourists . . . people here don't value art.*" Hajaig's interlocutors seemed to chorus, "People here don't care for public sculptures," although they agreed that art is useful and beautiful for helping people express themselves. None had heard of Choucair, and none realized they were sitting on artwork during their interview. Most thought the stones were "just strange benches." One said he did think it was a sculpture but sat on it because he saw others doing so.[60] I witnessed the same tentative play occurring intermittently with another Choucair sculpture installed since 2003 in the Kahlil Gibran garden outside the ESCWA building: guards patrolling the grassy lawn's perfect edges scared children away from the multilevel form, but when the guards dozed and children clambered up its sides, it appeared to be truly living. And in the absence of guards and gardeners today (2022), it is perhaps the only thing thriving in downtown Beirut.

Choucair's few publicly installed works thus reinforce a paradox: when they have clear functions, they invite animated and inventive interactions. As Hajaig put it, "while social relationships—such as those of the skaters—were indeed *gelling* around the pieces, it seemed to be as a result of the bench-ness of the pieces; revealed by the irreverent leaning, sitting, climbing, and playing on them."[61] When the works peer down from a pedestal or across a distance as cold as the metal balustrade inked into Farrouk's *Souvenir*, they garner little interaction. The art acts only when it is unrecognized as art; recognizing it as art dampens people's sense of responsiveness and practice of moving with the pieces. On the other hand, recognizing the "art" of the sculptures leads people to condemn others or make specific demands of art—that it express, say— while letting *themselves* off the hook. Although this could be taken to mean that the works are subjugated to nonartistic needs of preformed subjects, I think an art act lens slows down the findings. To me, responses such as the demand for a message to decode, an expression to receive, or artistry "to get" within a work invoke an ontology that both Choucair and her mentors had tried to undermine. In this ontology, audiences find themselves firmly bounded in life, set off from art, looking at inert ("dead") art rather than looking with it at themselves and enacting themselves through it. The ontology fuels emotional practices of haughtiness or distance from "here." Even the emotional practice of dhawq is more transitive and intertwining than such a performance of abjection.

Hajaig's careful observations and patient interviews help us eschew a hagiography of Choucair. In reflecting on the various responses to present-day, public installations of Choucair's artwork, I have tried to avoid the trap of starting from

FIG. 6.13 Rabea Hajaig, photograph of boy seated on Saloua Raouda Choucair's *Bench—Poem*, downtown Beirut, January 2018. Courtesy of Rabea Hajaig.

the artist's intentions. That leads to declaring work successful or failed, but in either case dead. I have tried, instead, to consider seriously the fantasmic ontology of the art act, which insists that powerful suwar emerge from interactions of imagination, material input, and enfleshment. Notably, in concluding his findings, Hajaig quoted Farrouk's answer to a 1956 questionnaire conducted by the Beirut-based intellectual review *al-Adab* on the relationship between "our arts" and "the consciousness that is blossoming in the Arab nation in this period":

"We find that everything connected with culture in the Arab world is uncon-
nected to anything of our reality. We find that ... the Arab thinker 'lives in one
valley' while the rest of the Arab nation lives in another completely."[62] Yet Hajaig
did not cease typing when he completed the quote. Rather, as Copjec would
say, he stopped not writing and added his own lines, specifically "recommenda-
tions" to "decrease the chasm between artwork and the public."[63] Moreover,
for his subsequent research, Hajaig took up the topic of how Lebanese parents
and siblings resuture familial connections on discovering that heteronormative
conventions do not hold when a son or brother declares himself queer.

Local art history lets you see new configurations, definitions, and experi-
ences. It also requires you to acknowledge new responsibilities. Reflecting on
the abjection that has animated professional art production since the Mandate
era, Akram Zaatari wrote in 2006, "In the absence of dedicated art institutions,
an artist often finds him/herself focused on the development of structures
without being an arts administrator or a curator, interested in histories without
being a historian, collecting information without being a journalist. It is indeed
distracting to be an artist in such conditions, but it is also an unequivocal privi-
lege to be able to sustain so many positions simultaneously. Such a *blurring of
positions and roles* is neither superior nor inferior to an increasingly clear-cut
assignment of roles."[64]

Yet I notice a certain hypocrisy among would-be patrons who appreciate
Choucair's work as a historic incidence of modernism in the Arab world. In-
deed, I am as culpable as any, for I co-curated an exhibition called *Historical
Modernisms* for ArteEast and included Choucair's work. But in forcing Chou-
cair into history, I refused to believe that her art could prompt a world without
chronological time, a world of "endlessness," or immanent coevality, as Jo-
hannes Fabian would say.[65] I may know, say, how to relate Choucair's work back
to the Mandate era in which she was trained, when nationalist artists invested
their practices in the quest for sovereignty, or to Ahliah School, which educated
her in its innovative mix of natural sciences, literature, philosophy, crafts, home
economics, and polyglotism. Yet do I know how to relate it to the present? Or
more crucially, can I (and all who work in the realm of contemporary art today)
learn about life *in presentia* from it?

It is insufficient to appreciate Choucair's intentions to grasp her art. We
could "museumize" what we have come to know and like. Yet, this relationship
of admiration would ignore the creative formulas the artist has set into play.
They are not a matter of her intention or anything extant at all. In breaking
barriers between the individual, the artwork, and the audience, Choucair's
"portraiture" challenges people to reconsider their roles. To walk with this art,

live with it, and let it live requires offering it new interpretations and material settings into which to insert it. This is not only an alternative map but another ontology. I have suggested that the duals, gouaches, and maquettes the artist formed are nonrepresentational self-portraits of nonindividual entities in the process of becoming. If so, these art acts call for non-representation-seeking, non-individual-fetishizing sponsors willing to support their growth. They hail people willing to do more than look at artworks' surfaces, people willing to live the artworks' method fantasmically, by offering new enlargements and public installations. Here curators and museum directors need to ask whether their jobs require simple acquisition of finished objects or something more life-giving. How do they become objects of objects? How do they participate in a fantasmic life?

Generativity, let alone art acts, is perhaps a most frightening principle for art studies. No-art is much easier to accept as a description than a challenge. Working within an ontology of generative art acts means knowing you are being activated to take justifiable risks, to do things unforeseen by the (first-time) artist. This may pose a large burden on curators-cum-artists. They may have to say, "I am going to take a risk here in the spirit (gene/pattern) of this artist who sought to activate people. I am understanding her as if she were still alive, through me, coeval. She may pick up my body and scribble 'ghalat' all over, but at least the interaction she initiated would be living and growing." Otherwise, how can the curator or critic justify selecting a single moment from Choucair's life to freeze her work to its span? Perhaps, should we continue to insist on keeping Choucair's maquettes to their diminutive size, we should be prepared to shrink ourselves, too.[66]

Coda

In the fall of 2018, I participated in a class visit to a private collection containing a wooden *Dual*. The collection director, Fadia 'Antar, hushed as she came to the pedestal upholding the unassuming piece. She called on the students to draw close. Laying her palms on the gently curved wooden slabs, she solemnly pronounced the artist's full name: Saloua Raouda Choucair. A collective gasp sucked in the air. 'Antar gently pulled the pieces apart and again called the students to move closer to smell them. "I love the smell," she enthused, and she reminded the onlookers that the work demands to be touched as well as inhaled. Contra conventional museum behavior, 'Antar ran her hands over the exposed surfaces of the *Dual*. The polished exterior contrasted with a grooved interior worked by an adze. 'Antar's leaning into the shapes riveted me. She slid them

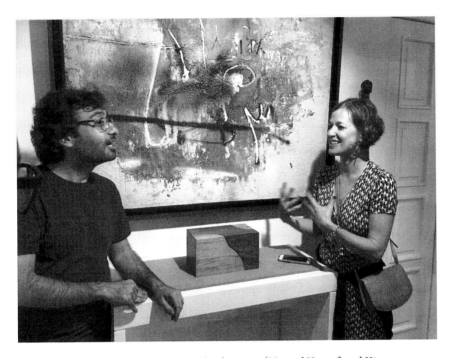

FIG. 6.14 Hannah Feldman, photograph of visitors (Hamed Yousefi and Kirsten Scheid) admiring a Choucair *thana'iya* at the Dalloul Art Foundation, Beirut, September 2018. Courtesy of Hannah Feldman.

over each other, over and over. The effect of the repeated pairing and unpairing extended from her resting fingers up her arms through her neck, as she seemed to breathe taller. Her entry into the art act performed a new set of relationships and invited sensual stimulation of possible subjectivities. Two students even held out their hands, breaking the ancient art historical barrier (fig. 6.14).

I have come to think of the art act as Choucair's means for spawning portraits that allow new subjectivities, portraits unmoored from gender, national, or ethnic identities and bodies that must account for their stance on energy, proximity, and wholeness. Whereas the view of a nude, such as the pupil Raouda learned, makes its unseen side imaginable, Choucair's works challenge the viewer's eye to wander across surfaces that take form by expanding a shape or field from an adjacent area but that are morphed by new contingencies. As a result, although patterns are perceptible in her sculptures, they never explain an entire piece. Viewers' curiosity about the outcome of construction principles activates their sense of their role in creating the encounter with the object, and

hence the object as a group portrait for an unfixed time. In other words, I think these surrogate bodies, nonfigurative and purely objective, do something to gender and social belonging that our current categories of representational, abstract, personal, and public do not yet have a vocabulary to explain.

I think they also culminate a long project extending from Farrouk's and Onsi's nudes and Lebanese landscapes to the *First Sanayeh Garden Art Meeting*, to discover selves through art acts. Whether a monument overseeing traffic at a roundabout, a rug welcoming dinner guests, or a ring gracing a hand extended in greeting, Choucair's art sets about stimulating audiences' self-awareness of their viewing experiences. Their answers are not contained within them. They suggest that motivating abjection can in fact open boundaries, but it is up to audiences to produce the suwar in the present that may map the future.

Notes

1. Winegar, "Humanity Game," 668; cf. Marks, "That *and*."
2. On the assumptions of a representational ontology, particularly associated with colonialism and extraction regimes, see Mitchell, "World as Exhibition"; Pinney, "Indian Work."
3. Hereafter I will not use the quotation marks but still ask readers to treat the term as a historical nomination. For more explanation, see chap. 5, note 1.
4. Said Makdisi, *Teta*, 321.
5. Cf. Hatem, "Women's Studies."
6. Salomon, "Sins of Omission," 223. With this term, Salomon summarizes canonical notions of the artist that invoke a pedigree established by Giorgio Vasari. She argues that such an agent is necessarily "gendered, classed, and raced, more specifically he is a white upper-class male. Only such an individual is empowered by his social position successfully to stake a claim to the personal freedom and creative calling that Vasari's construct requires." Salomon, 223. While I hesitate to assume that "socially free agent" encapsulates "fannan," the "artist-hero" features in art histories produced for Lebanon. E.g., al-Kamil, *al-Fann al-Lubnani*; Lahoud, *Contemporary Art*; Khal, *Woman Artist*. Cf. Winegar, *Creative Reckonings*, 32.
7. For my approach to denominating the artist, see chap. 5, note 16.
8. E.g., Henri Zughaib, "*Salwa Rawda Shuqair Tahtarif Fann al-Nahhat bi-Fi'l 'Ibara Sadamatha min Sharl Malik*" [Saloua Raouda Choucair professionalizes in sculptural art in reaction to a statement by Charles Malek that shocked her], *al-Hawadith*, no. 1167 (March 16, 1979): 70–71, p. 70.
9. The syllabus for Malek's philosophy course presented "the Greco-Roman-Christian humane synthesis." Creswell, *City of Beginnings*, 71. Malek's philosophical lectures delineate his preference for culture descended from "the 4000-year-old human

tradition"—in other words, the Greco-Roman lineage. Malik, *al-Muqaddima*, 362. See also Cesar Gemayel's art history series in *al-Makshuf* vol. 3, no. 121 (November 10, 1937) to vol. 4, no. 144 (April 18, 1938).

10. Cf. Zughaib, see note 8, p. 71; Khal, *Woman Artist*, 56.

11. Salwa Rawda, *"al-Nashat al-Fanni fi al-Nadi al-Thaqafi al-ʿArabi"* [The art activities of the Arab cultural club], *al-Adib* 7, no. 1 (January 1948): 59–61, p. 60.

12. Povinelli, *Economies of Abandonment*, 8, 32–33, 107.

13. Rawda, see note 11, 59.

14. Salwa Rawda, *"Fann al-Taswir ʿinda al-Yunan"* [The art of picturing among the Greeks], *al-Adib* 7, no. 2 (February 1948): 9–14, p. 14. Her argument echoes one Kahlil Gibran lodged against Greek art (and cubism) after visiting the 1913 International Exhibition of Modern Art. He found the art "lacking any perception of the world's great depths and heights." Lenssen, *Beautiful Agitation*, 71.

15. Rawda, *"Fann al-Taswir,"* 14.

16. I have not been able to locate the source for Choucair's knowledge of Ibn al-Athir and other early Arab philosophers. Many books she read were borrowed from nearby AUB's library, and the book collection she owned was much jostled and diminished by subsequent house moves. However, Lenssen documents 1940s high school curricula in Syria that contained such authors, particularly Ibn Sina and Ibn ʿArabi. Lenssen, *Beautiful Agitation*, 164.

17. Victor Hakim, *"L'exposition de Saloua Raouda,"* *la Revue du Liban*, 18, no. 3 (March 1962): 43. Cf. Nadi al-Thaqafi, *Nadi al-Thaqafi*, 13–14.

18. Salwa Rawda, *"al-Madrasa al-Haditha fi al-Taswir"* [The modern school of picturing], *Sawt al-Marʾa* 6, no. 4 (June 1948): 10–11, p. 10.

19. Rawda, 11.

20. Rawda, 10–11 (emphasis added).

21. This information comes from my interviews with Choucair and her family. Choucair listed the dates on a job application submitted on July 30, 1952, to the Point Four Program. SRC.

22. According to a sociological study led by Charles Churchill in 1954, 45 percent of Lebanese women married by the age of twenty, 85 percent started having children by age twenty-five, and few held extrafamilial jobs after marriage. Churchill, *Beirut*, 6.

23. See Minutes of the Jafet Library Committee, February 22, 1945, May 28, 1945, October 21, 1946, June 5, 1947, AUB.

24. My dating (which differs from Choucair's retrospective catalog and my own previous publications) relies on the following exchange: In 1951, Edvick Jureidini Shayboub, interviewing Raouda for her journal, asked, "I know that you made pictures in the realist school—I mean, like the Lebanese artists Onsi and Farrouk. So, when did your art develop to what it has become?" Raouda replied, "No. During the last year before I left for Paris [i.e., July 1948], I departed sharply from the

realist school." Edvick Shaybub, "*Ma` al-Fannana Salwa Rawda*" [With the artist Saloua Raouda], *Sawt al-Mar'a* 7, no. 12 (December 1951): 36–37, 49, p. 36.

25. Rushdi Ma`luf, "*Dawr al-Mar'a fi Takwin al-Mujtama`*" [The woman's role in the formation of society], *al-Shira`* 1, no. 11 (November 1948): 15–16.

26. The particular illustration is unsigned, but the stylistic consistency with pictures Buhairy signed in earlier issues suggests it is his.

27. Malhas, *al-Nahhata*, 47.

28. Malhas, 10–12.

29. George, "Ethics," 593.

30. Winegar, *Creative Reckonings*; Guha-Thakurta, *Monuments*; Taylor, *Painters*; Dadi, *Modernism*; Jain, *Gods*; Ho, *Drawing*; Deloria, *Becoming*.

31. Shaybub, see note 24.

32. Choucair's triptych, *les Peintres Célèbres*, removes the harem rationale for Léger's *Le Grand Déjeuner* (1921), for example, and reassembles them as models reading up on the "famous painters" who make their career, literally, off their backs. Scheid, "Distinctions," 45, 50–51.

33. Léon Degand, "*L'Épouvantail de l'académisme abstrait*," *Art d'aujourd'hui* 2, no. 4 (April 1951): 32–33, p. 32.

34. Announcement, *Art d'aujourd'hui* 2, no. 1 (January 1951): last page. Cf. Koenig, "*Abstraction chaude*," 8.

35. The official history of the Atelier remains to be written. The lectures were advertised in *Art d'aujourd'hui* with titles such as "Science and Beauty," "Mondrian and Neo-plasticism," "Constructivism," "Color," "Kandinsky's Theoretical Writings," and "What Is Abstract Painting?"

36. She posited it as an improvement on *handasi* (geometrical) and *neoplasticist* because it articulated an Islamic inspiration and countered the reliance on visual reality to know the world. Saloua Raouda Choucair, interview with the author and Jack Assouad, Beirut, May 15, 1999. See also Rawda, "*Fann al-Taswir*," 14.

37. I take the opportunity to acknowledge the inspiration of Jessica Gerschultz's "Notes on Tending."

38. Sulaiman, *al-Adab al-Qasasi*, 114–15, 11, 115.

39. Salwa Rawda, "*Kayfa Fahima al-`Arabi Fann al-Taswir*" [How the Arab understood visual art], *al-Abhath* 4, no. 2 (June 1951): 195–201, pp. 199–200 (emphasis added). See translation at Lenssen et al, *Primary*, 145–49. Cf. Scheid, "Material Modernism."

40. Given the limited availability of medieval Arabic scientific texts in this period, it would have been unusual for Choucair to access and interpret original texts by Alhazen. However, acknowledging her interest in the philosophy of science, I allow that she came across and elaborated from references to his work. Elsewhere in the letter, she cites unspecified "Sufic Arab experimental philosophers," of which Alhazen was certainly one, using the Arabic term *tajruba*, meaning both "experiment" and "experience," to describe their method. I surmise that she refers

to a "phenomenalist" scientist like Alhazen, with his systematic manipulation of light through dark chambers, water submersion, and varying apertures to induce the laws of nature manifested in light's behavior. Rawda, 198. Cf. Sabra, "Ibn Haytham's Revolutionary Project."

41. Nader El-Bizri, "Perspective," 192.

42. Bizri, 191. Cf. Behrens-Abouseif, *Beauty*, 39–43.

43. Rawda, see note 39, 199.

44. Nader El-Bizri, "Perspective," 192.

45. Bizri, 204.

46. Rawda, see note 39, 200 (emphasis added).

47. Rawda, 196.

48. On Choucair's relationship to abstract art practices in Paris, see Aswad, "*Mu`adalat.*"

49. Cf. Scheid, "Distinctions," 52.

50. For more on the media response, see Scheid, 53–54.

51. Simone Aubrey Beaulieu, "*Les quatres royaumes de Saloua Raouda,*" *l'Orient*, February 24, 1962; Najla Tannous `Akrawi, "Mrs. Salwa Rawda Shoucair AA '33, Awarded Prize," *Alumnae Bulletin*, 1969, 16–17. After marrying Yusuf Choucair in 1953, Saloua Raouda compounded her last name with his.

52. Thérèse al-Ghurayyib, "*Sajjad wa-Rusum wa-Siramik wa-Naht*" [Carpets, drawings, ceramics, and sculpture], *al-Nahar*, March 4, 1962, 4–5. Cf. Beaulieu, see note 51. Choucair contracted out the weaving.

53. Metzler, "(And so on . . .)," 33–34.

54. For more on this method, see Metzler, 39.

55. Aswad, "*Mu`adalat,*" 20.

56. There is a long literature, beginning in the 1980s, understanding biological sex as myth. See Hubbard, Henifin, and Fried, *Convenient Myth*; Haraway and Goodeve, *Modest_Witness*.

57. Metzler, "(And so on . . .)."

58. Metzler, 25.

59. Al-Ghurayyib, see note 52.

60. Rabea Hajaig, "Saloua Raouda Choucair and the City: An Inquiry into the Social Life of Sculpture in Beirut," class paper submitted for "Art, Aesthetics, and Social Change," graduate seminar at AUB, Fall 2018, cited with author's permission.

61. Hajaig (emphasis in the original). Hajaig herein references Alfred Gell's theory of abduction. Gell, *Art and Agency*.

62. For Farrouk's full response see, "Artists' Questionnaire: 'Art and Life,'" in Lenssen, Rogers, and Shabout, *Modern Art*, 167–75, p. 167. For the original Arabic, see "*al-Fann . . . wa-l-Hayat al-`Arabiyya*" [Art . . . and Arab Life], *al-Adab*, 3, no. 1 (January 1956): 3–10, p. 3.

63. Copjec, "Imaginal World."

64. Quoted in Feldman and Zaatari, "Mining War," 65–66 (emphasis added).

65. Metzler, "(And so on . . .)," 16; Fabian, *Time and Other*, 32–34.

66. I think here of Walid Raad's shrunken installation, "The Atlas Group," at his exhibition, "A History of Modern and Contemporary Arab Art: Part I_Chapter 1: Beirut (1992–2005)," Sfeir-Semler Gallery, Beirut, July 17, 2008–November 7, 2008. See https://www.sfeir-semler.com/beirut/exhibition/walid-raad, accessed April 15, 2022.

CONCLUSION

Between Art and Here

SEPTEMBER 17, 2021, I received a text message informing me that I owed $138.39 US or 209,591.66 LBP to the cellular company. Newly returned to Lebanon after a fellowship year abroad followed by a year of pandemic at my parents' house in Cleveland, I panicked and immediately called my bank. The bill was exorbitant or mild, depending on the currency. When I had activated my line years earlier, I received advice to "*uwattinhu*" in American dollars, not Lebanese pounds. The term, related by root to *watan*, the word for "nation" that we have met so frequently in Mandate art discussions, involves a choice of where to "settle" one's assets. The dollar had been my cell line's *tawtin*—or naturalization within a "watan" of choice; the same word is used for the highly controversial project of resettling Palestinian refugees. When opening the line, I had been asked to commit to a currency (dollars) that was pegged to another currency (pounds) which, in the meantime, had been decimated by political corruption. The bank manager laughed at my worried voice, noting that the cell company had calculated the pound-to-dollar rate as if *al-ʿumla al-wataniyya* (national currency) had not crashed. At the street rate, I only owed $14.77. Without skipping a beat, she advised me to "cancel my tawtin" and, after transferring pounds through an online service, declare a new watan instead.

Doing so meant rushing to the bank to unsign my cellular payment contract, calling the company for the form to redo my tawtin, and then scurrying to the nearby money transferer. One had opened right by my apartment owing to the mushrooming demand for transfer services these past two years. Inside, the line wound long, leaving me time to linger. Smartly adapted to the ongoing pandemic, the shop plays miniature general store: stocked with face masks and ethyl alcohol, charcoal, batteries, outlet adapters, CDs, and so on. I inventoried the marvelous

variety as an immaculately groomed man at the counter, exchanging dollars, rhapsodized about his summer travels to distant locales. Mid-transaction, he offered the shopkeeper black-market gas: "We know someone who can get you a twenty-liter container for three hundred thousand LPB." He nodded toward his companion, dressed as if she were still at a beach resort, with every article advertising its designer origin. The shopkeeper smiled as he shook his bald, visibly sweaty head. "No, I don't deal in such things." "The source would be clean," replied the customer. "You don't want dirty gas!" His warning conveyed, he asked the shopkeeper to recount the dollars he had exchanged before handing them to his female companion, who put them in her bag without looking. The couple exited in unison.

As I neared the counter, the shopkeeper saw that I needed to pay my cell bill and had his wife prepare the form while he finished helping the customer before me. Delighting at the pair's efficiency, I explained that I had been away for two years but that I actually live in Lebanon. I wanted to reestablish my watan, or at least explain the cut roots. When I hesitated to insist on a receipt, the shopkeeper warned me that I would need the proof. Raising his shoulders and outstretching his upturned palms, he declaimed, "Because you have to defend yourself with these companies. *Hayk Lubnan* [Lebanon is like this]." It occurred to me later that I fit into his sociality (of gestures, postures, values, assessment, and spatio-temporality) much more as a foreigner than as an indignant local. If he extended small favors and I eventually returned a bigger favor, I could deepen or expand his locality. In a cycle of favors, neither homogeneity nor conformity in your neighbors is a blessing. People matter to "here" for how they differ or for what they bring from places that would not otherwise be here. The groomed vacationing couple with their access to designer labels and black-market gas had announced as much. Everyone is a locally made import. This is just one way that art prepares us to live "here." Art has often been used to prove locality and compare between locales. In using art for these purposes, however, we miss how fantasmic objects expand localities, entwine them, and make the local by bringing what is not.

Why Art?

Sometimes I have wondered whether studying art really matters for anthropology based in Lebanon and the Middle East. I have even taken up other topics for periods of my life and fieldwork here: elite birthday parties, boycotts, antiwar activism, and more. Yet taswir always thrusts itself into the scene, convincing me that art acts key *any* ethnography. In his book *Life as Politics: How Ordinary*

People Change the Middle East, Asef Bayat notes, the Western academy has long
applied to the Middle East concepts and expectations developed from studying
European society which tend to skew its perspective.[1] I suspect Eurocentric
concepts and expectations of art have motivated a long-standing unwillingness
to take art as a lens on Middle Eastern vibrancy: social, political, or otherwise.[2]
Yet, in probing "nonmovements" and "distantiated communities" to explain a
"quiet encroachment" of "ordinary" readiness for social change, Bayat himself
often seems to entertain a binary between everyday life and conscientious fan-
tasy, making life, as he frequently phrases it *either*, "real or imagined."[3] I would
caution against downplaying the constant cosubstantiation of the fantasmic
and "everyday life." *The Two Prisoners* puts viewers on the spot and instigates
bodily connections between civility, piety, and a locally made import. An-
other locally made import, *Houlé* imprints and undergirds the bondedness of
economy, morality, piety, and the land. And Choucair's many self-portraits not
only do away with categorical boundaries, once more, but spawn new corpore-
alities able to restructure and resuture the world through taswir. Leela Gandhi
has remarked that one fatal flaw of conventional models of modernism is the
narrowing of the political—pitting reality against fantasy, art in opposition to
politics.[4] In focusing on taswir and art acts, I offer a method to avoid confining
them to the "unreal," lest, in our will to explain power's persistence we ignore
its perpetually unsettled hold.[5]

 This book's many examples of galvanizing, gap-making, and generative art
acts suggest the myriad ways that art maps and remaps our imaginal worlds
with impacts on our other worlds. Over and again, the experiences of still-
decolonizing Lebanese demand the denaturalization of categories, so that we
may consider art that involves social engagement as truly fantastic and poli-
tics that involve aesthetic imagination as deeply real. Gender stereotypes and
sexuality legislation plague the lives of Lebanon's population of effectively
disenfranchised female (half) citizens and disavowed queer communities.
Continued colonization, International Monetary Fund–structured neoliber-
alism, and the flames of climate catastrophe ravage Lebanon. Nearly 80 percent
of the populace finds itself unable to afford adequate food.[6] In mid-October
2019, an unprecedented heat wave ignited forests surrounding the capital city,
presenting to some a sura of Judgment Day.[7] The acrid smoke filled the lungs
of the protestors gathering to denounce the WhatsApp Tax, which many see
as the spark (taswir?) for the revolution launched on October 17, 2019. The
dual-currency market systematizes exploitation, and families in mountain en-
claves (this time) look down on the rapidly deteriorating capital with a mixture
of horror and opportunism that exceeds anything recorded from the 1915–18

famine. Plutocrats blatantly pursue personal profit and scoff when confronted with their improper management of public services. New taxes continue to be invented weekly. Indignation mounts, yet mobilization may be dwindling. Here, while the synecdochical clock continues to toll its "universal" demands, artists and audiences face new/old questions about their relations to social belonging, communal horizons, potential personhood, nature, and transglobal futures. Indeed, "at this particular juncture . . . imagining one's way beyond dichotomous distinctions . . . is not only an ethical and epistemological but also a political exercise."[8]

In this book, I have attempted to demonstrate the importance of leaving room in our analyses of the Middle East, modernity, and art for an ontology of which taswir informs us. This book brings together contemporary ethnography, local art history, and experimental Islamic ontologies to foreground taswir as a political, emotional, physical, and imaginal act. A fantasmic object activates taswir, making audiences the object of art. It enters them into the imaginal worlds that exist between concepts and content, between words and meanings, between boundaries and beings. Art acts enfold what artworks import with a sense of "not here" even while making the "distant" present and palpable. Fantasmic objects, through relationships of looking at looking, or exhibitionary sociality, produce civic subjects who are objects of objects. Unlike the public acts that aesthetically minded sociologists following Pierre Bourdieu have investigated, art acts do not rely on a habitus of given social roles but look cross-eyed at the holes created in sense-realms and emotional practices, to figure out—or, we could say, make sense of—the real and intelligible through the imaginal. I have discussed the gendered, pious, and ethical stances toward community, nation, and modernity that ensued when art audiences found, not mirroring reflections—as we may be wont to assume—but self-implications in taswir. In sum, this alternate ontology for art and society reminds us that our lives are full of fantasmic objects that do not represent but teach us to envision.

Not that this envisioning is imminently clarifying. The foregoing chapters on institutionalization, professionalization, and abjection enact a cross-eyed view that, while uncomfortable, may better suit our twenty-first century lives, in which reliance on ontological boundaries between human and beast, flora and fauna, mortal and divine have revealed their inadequacies in the devastated environment, racialized injustices including continued colonization, and rampant neoliberal capitalism. In response to the insistent descriptions of Lebanon as a no-art place, to absenting invocations of history, and to alienating ascriptions, I have cobbled together a contextual analysis of artworks-with-audiences. I have followed art acts across an array of actors whom I learned about through

the unfolding of art. I have listened to unfinalized folk understandings of terms that develop in tandem with art acts. I have explored the aporia in these terms rather than assume their self-evidence, and this has led to close looking, feeling, sensing. Like beacons, objects (particularly such nudes, landscapes, and portraits) have caught my attention without my knowing exactly where they begin and end, how they mean, or what they do. I have looked for what people made and make of ambiguity and learned to speak of an ontology of incompletion, of continual relation.

The rewards of this art-based alternate anthropology arise from describing a locality, or culture, called Lebanon without adjudicating on what is Lebanese or abnegating attention to efforts that produce "Lebanon" and displace it elsewhere at once. The nonrepresentational model of the fantasm proffered by my account complicates both strictly culturalist and discursivist models of social being. On the one hand, the social reality revealed by Farrouk's New Year's Day art neither relied on coherent cultural patterns nor on formal accomplishment. On the other hand, Scoutmaster al-Nusuli's pleading—like Choucair's ire at the "cave dwellers" attending the lecture series on "modern picturing"—reminds us that art needs people taking it up, walking with it, or it will simply cease to exist. When I argue that fantasmic art accomplishes a social shift or clinches a social form, I am speaking of the liminal middle ground where perception and interpretation, corporeal and incorporeal, public and personal meet but never fully meld. The unfinalized aesthetic imaginings that come into view are collective and meaningful as others take them up. It is that taking-up that fascinates and proliferates awareness of our agency in these localities. Just as the alternate angle widens our awareness of aporia in the citizenry and subjecthood of daily Lebanese, it embroils empires and postcolonial worlds in a myriad of localities. Defining that imbrication creates handles for taking responsibility for our imaginings. Fantasmic art puts the question of citizenship—its content, limits, and concerns—ever on display, and underlines the connection between art practices and political processes. In place of nationalist icons and boundaries, wataniyya can be understood and responded to as a set of emotional practices and aesthetic sense-making that enfolds the distant and fluidly generates displacement and movement.

The local art history I tell challenges the implications of art history's secular tilt on the study of modern art from the Middle East. It suggests that explorations in this field may remap both art history and spirituality's relationship to empirical argument and experience as cornerstones of modernity. For example, the testimonies of Farrouk, Onsi, and Choucair, may embolden us to speak of "Islamic landscapes," "Islamic modern art," and even "Islamic nudes." To

critique Islamic studies, Shahab Ahmed memorably starts *What Is Islam?* in
an art museum, from which he launches an undertaking that neither contracts
the "human and historical phenomenon" to an "Islam-proper" nor unhinges
Islamic practices and statements from specific focal actors. That is because
both approaches lead inevitably to a "principle of elimination": our own failure
to make sense of practices as Islamic, imputes the same illogic to practitioners
and labels them "bad Muslims."[9] The artists we have met in this book con-
trasted their appreciation of the nudes' and landscapes' hikma with (alleged)
Ottoman decadence. When they and their peers from Algeria to Syria were no
longer Ottoman subjects but not yet Arab citizens, many turned to taswir as
an important element in their self-fashioning and double-decolonizing. But
their perspective and pious practice has escaped our rigorous categorizations
of Islam and spirituality. As a result, we willfully know little about the intellec-
tual, cultural, aesthetic, and political activity of scores of artists who populated
metropolitan art schools as pious Muslims in the aftermath of the Ottoman Ca-
liph's abdication. We know woefully still less about the audiences and patrons
of these artists upon their return to found anti-colonial academies and politi-
cal movements such as independence activism, nudism, literary and musical
revivalism, anti-corruption campaigns, and new forms of Muslim piety. Thus,
this book spotlights the importance of art for probing *both* Islamic "aspiration
and challenges to coherence, particularly at a time where Islamic tradition and
its practitioners have been deeply reorganized by liberal modernity."[10]

Double-decolonizing art has lessons to complement those of interwar and
indigenous modernisms. In their recent volume of indigenous art modernisms,
Elizabeth Harney and Ruth B. Phillips suggest that revisiting the previous
century's modernist histories could unlock meanings obscured by "the failed
processes of decolonization and the rapid speed of neoliberalism [that] have
laid bare the mechanisms of globalization."[11] Indeed, anthropologist Gregory
Bateson's modernist-era reading of Balinese tourist art accounted for his in-
terlocutors' socio-political balancing acts and encouraged all humans in his
cybernetically connected world to learn such "grace."[12] I doubt histories of art
modernism read Bateson's essay. Anthropology and art history have not, thus
far, been seen to contribute to the same side of decolonial debates. (Each side
seems to suspect the other of patrician conservatism.) Yet, I think to avoid both
the recolonization and complete abdication that hail our world's death spin
requires both historical rereading and openness to the ontologies and imagina-
tions discredited by colonization and modernization, ontologies of imagination
that can flesh out and bring spirit to the future. Lest we bury ourselves in quib-
bling over periodization or attribution, let art studies follow art wheresoever it

arises and leads. Let us learn, from the beguiling of repetitious genres and the effronteries of formal reprises, about affiliation and convergence, modernity and contemporaneity in their human, material forms. Beyond putting to rest the "idealized as fixed, normative, centered" modernist subject, or simply adding in audiences' self-reflection, a blended ethnographic, historical, formalist method beckons.[13]

Fantasmic Objects has aimed to explain universals by attending to specifics of their engagement, such as the nude that is a "sura fanniyya" and the landscape that is a divinely imprinting print. This approach, in turn, explains—rather than naturalizing, glorifying, or condemning—the persistence of a genre like the nude, as well as its ghosting in local discussions of art and subjecthood. Equally, this study contributes a tool kit and vocabulary to globalizing perspectives on art. I situate art acts in emotional practices and sense-realms that inform ongoing political lives. I cultivate a heedful ear to attend cultural elements I might otherwise miss—such as the mundane but historically particular invocation of dhawq—or flatten through pre-emptively universalizing translations, like "taste." I do not train my eye on distinguishing national schools or "authenticity," for that denies art's own history of political engagement and guarantees mistaking its contemporary production. I develop muscles to handle fantasmic art but not to open doors to museums that ensconce it among offsetting spatiotemporal labels and suffocating formal comparisons.[14] Any project of decolonizing art studies, anthropological or art historical, requires recognizing on their own (nonrepresentational) terms the double-decolonizing art acts already undertaken by artists and audiences. Their "painterly modernism" and experimental, materially enacted Islamic piety provide the seeds of an ontology we can choose to consider and develop or ignore.

Reconstruction through an Exhibition

Perhaps a final historical anecdote will serve to convince readers of the connection between art acts, exhibitionary sociality, and decoloniality. Colonial authorities sponsored an exhibition in Beirut in December 1941. Just a few months earlier, De Gaulle's Free French forces, with massive British help, had ousted Vichy control of Mandate Lebanon, making Beirut the first liberated territory of "France." Still, with two-thirds of the French administration and most of the French army returning to France with the Vichy commissioner, the Free French forces could not revive an economy plagued by protests of bread prices and rationing. De Gaulle's supporters could not compete with international powers (especially the much stronger British) or suppress locally active

French officials who remained sympathetic to Vichy goals (such as the rector of Saint Joseph University who refused to stop leading his students in prayer for Marshal Pétain) or those indigenous inhabitants who had other plans in mind, including their own liberation.[15] Facing political, economic, social, and spatial precarity, General Georges Catroux chose to ply France's civilizational capital.

Following an announcement that the general would like to have an exhibition of fine arts for the holiday season (both Christmas and `Id al-Adha were on the horizon), volunteers with the Friends of the Arts Society set about gathering appropriate works.[16] The newspapers recorded a furious debate over what would be shown: Ottoman-era forefathers or only contemporary artists? Amateurs in addition to professionals? Locally active artists or those, regardless of origin or residence, present in local collections?[17] The choices pitted a sense of the spread and depth of al-fann al-jamil "in Lebanon" (if forefathers, amateurs, and active artists were joined) against a demonstration of the state of the arts in a Mandate-run city. Moreover, the haste to meet the holiday season meant only extant works could appear. As one concerned journalist wrote, the show impeded for "Lebanese artists a chance to show their latest achievements, their most current self-expressions."[18] An indignant discussion ensued of an alternative exhibition scheduled for a few months hence, which would include amateurs and forefathers and give living artists more time to prepare new works. Rather than respond to the worry, Mandate authorities censored it (fig. 7.1).[19]

At stake in the difference between summoning "current self-expressions" and displaying France's civilizational capital is, I argue, the ability of art to spawn life rather than tend symbols. Free Frances' authorities wanted signs of French-bestowed "freedom." Decolonizing citizens wanted art acts that generate a postcolonial sociality, temporality, and ontology. Eventually, the works of a few "forefathers" graced the exhibition halls alongside "French works" culled from local collections to emblematize French patriotism and anti-German aesthetics.[20] As the high commissioner's adviser for public instruction, Gabriel Bounoure opened the show with a speech using the display to prove that "not only is *French painting* the honor and glory of Europe, but it is fair to advance that one could not paint but in Paris or *à la France*."[21] This non-French collection of art, where "authenticity" was replaced by "universality," provided the ultimate proof.[22] Bounoure closed his fulmination with a representational model of art so strong that painting *à la France* could stand in for liberty:

> The more the current times seem given to the impersonal and collective spirit manifesting itself everywhere in industrial, social, and political creations . . . the more one realizes the need to seek and cherish the art most founded on personal

FIG. 7.1 Censored article, "Ma'rid al-Fannanin al-Lubnaniyyin" [Lebanese Artists' Exhibition], *al-Makshuf*, December 29, 1941, 1. Courtesy of Lebanese National Archives, Beirut.

sensation, most individual, most solitary: easel painting. That is why the freest nation—that in which the individual shows himself and always will with the maximum of independence, with invincible energy, and obstinacy—had, doubtlessly, the vocation to become, par excellence, the nation of painting.

France and liberty, these two words are so synonymous that one cannot unite them without committing a sort of pleonasm.[23]

Lebanon's colonial citizens had been promised independence from the mandate regime should the Free French wrest control from the Vichy authorities. Twice in four months, Catroux proclaimed Lebanese and Syrian independence as a ruse to secure internal cooperation. Martial law, deferred elections, and absolute control of all administration by the French remained in place. Mandate subjects were asked to look at easel paintings and see that they were already free: free of society, social oppression, and political life. Moreover, at their liberating exhibition, the same authorities who had consistently refused to

institutionalize a Lebanese academy of arts institutionalized and promoted an understanding of art that has come to predominate and eliminate attention to aesthetic encounters, exhibitionary sociality, taswir, locally made imports, and history across national boundaries. If for Farrouk, art-writer al-Naffi, and the Mandate-era art community, art acts provoked the would-be Lebanese to prove they were not slaves, it seems that for the colonially minded they substituted for not being colonized, too. The gap between these understandings aligns today with that between bringing art into postcolonial art institutions (wherever on the globe), and living through art acts.

Art, Civilization, and Anti-Coloniality

On August 4, 2020, nearly three thousand tons of highly volatile ammonium nitrate, precariously stored in Beirut's port, ignited and initiated a shock wave comparable to that of a nuclear bomb. Instantaneously, hundreds of civilians were killed or maimed, and hundreds of thousands more were dispossessed of their homes in the nearby, densely packed neighborhoods of blue-collar workers, migrant workers, and "creative communities"—meaning Beirut's art scene. Scores of galleries, studios, archives, and the Sursock Museum—where so much of the fieldwork for this study occurred—along with hospitals, schools, workplaces, stores, and cafés, were flattened, gutted, or severely damaged. *Poem*, Saloua Raouda Choucair's 1983 missing public monument to the end of the Civil War, is now joined in seeming oblivion by a host of destroyed artworks and foundations.

As of this writing, nearly two years later, no one has been found accountable for the explosion, but within hours of the cataclysm, theories of cultural culpability emerged on social media platforms: Some blamed the Lebanese elite for a "total inability to secure and manage the country," and others demanded, "We want to be civilized and *not represented by those barbaric creatures!*"[24] Petitions called for the reinstatement of the French Mandate. One received nearly sixty thousand signatures from Lebanese citizens torturously deploying their citizenship to prove its absence.[25] On the one-year anniversary of the port blast, Edwin Nasr, a young curatorial fellow in the Netherlands, disgusted at a failure of art to contribute to justice or reform, posted an equally painful query: "When will the Lebanese cultural sector (finally) die?"[26] Nasr noted that the "cultural sector"—the very term encapsulates the ongoing institutionalization, professionalization, and translocal displacement of art acts over the past century—has manipulated public attention, misdirected aid funds, demeaned "those who have succumbed to [the regime's] barbarity before us *and* ensured its own survival in time for the next funding cycle."[27]

Apart from the pronoun *us*, Nasr does not locate himself in relation to the described practices (despite having been assistant to the director of Ashkal Alwan during the period). The petitions previously circulating, by contrast, ambitiously speak in a *we* that is not royal but preemptive. Both petition and protest echo a long lineage of local, displacing artistic practices. Both reinvest in the image of the never fully waking cave people condemned by Choucair, the eternally relapsing peasants skewered by Farrouk, the greedily onlooking bard lambasted by Onsi, and the mummified shaykh cast out from the Muslim Scouts. I cannot close this book without confronting the ways artists and activists contribute to alienation, dispossession, and demotivation exactly when they undertake actions to improve society that operate by erasing it. In these appeals, one cannot ignore the immense pain, humiliation, and despair that the project of modern Lebanese citizenship brings, but I hope this book shows that we must not overlook its formulation in fantasmic objects and taswir practices.

Art acts involving audiences in the production of social imaginaries, bodily incorporation, and emotional cores have deeply shaped the notion of "here." My ethnographic experience since the 1990s has foregrounded those aporia, even when people smooth them over by simply announcing, "no art here," or no merit here, or hayk Lubnan. Moreover, the local art history I have presented shows that even generic art forms do not offer such fixity. Historically, the strategies of abjection, displacement, affiliation, peership, correspondence, and convergence propounded by the predecessors of Lebanon's nation-building period connect organically to the political imagination of reconstructed Lebanon. Shaykhs threatening hellfire, warriors spiriting away monuments, aristocrats buying cars instead of canvases, ladies smoking instead of culturing their households, brothers favoring cake over abstract paintings, audiences failing to appreciate nudes: all this no-art cleared space for, set the boundaries of, and cultivated the emotional practices and innermost cores of citizens-to-be. The fantasmic objects of uncaged odalisque, sun-saturated Lake Hula, and sculpture-smashing sculptor all put audiences on their mettle rather than letting them sit and simper about merit or, more simply, cast blame.

Today many Lebanese aspire to "be civilized," which I take to mean they seek ways to *become* subjects of a supportive civic, urban life. Like our Mandate counterparts, we conceptualize this quest as a representational project. While some abjectly accept their current representation—"Hayk Lubnan," some demand to be differently represented. Nihilistically, others, like Nasr, claim that all efforts, even recolonization, will fail in "this Lebanon." But does not the erection of a representational binary locate the present (here) as the failed reflection of there and reenact colonization? Not only does this binary project

summon *Souvenir*'s "uncivilized peasants," but it deafens ears to the challenge such fantasmic objects contribute to political and public imaginations. We neither mind nor mine the aporia founded between fantasmic objects and the taswir—citizens, "here," their sociality, gender, and being—they trigger.

Yet De Gaulle's exhibition warns that art without taswir structurally displaces modernity, as if plentiful in itself, to be discovered and imported from elsewhere. Treated as a description, art unfailingly disenfranchises. In the 2020 explosion's aftermath, mourning of art and ensuing pledges to support it—as a set of universal objects and value—threaten to re-inscribe art, in the guise of talent, possession, fetish, beyond some glittering balustrade. Seeing art across that social boundary blinds us to its existence at the core of society and self-imaginings as "civilized" or "backward" via-a-vis cultural others. Contrariwise, seeing no-art as a practice of taswir and tathqif reveals art and destruction's coupling as well as the vitality of audience responsivity to our becoming. When encountered as a claim in the public's name, the lack trope asserts needs not previously or unanimously identified. Ipso facto, as Lebanon reaches yet another crossroads, our political imaginary founders neither in artistic and cultural practices per se, nor in their history and institutionalization, but in the representational frameworks that obscure and decorporealize their fantasmic aspect. We can account for our exhibitionary sociality even as we enact it, and thus pollinate opportunities to take responsibility for it. Recognizing our practices of correspondence and peership, we can craft openings in our locality rather than (fore)closures. Embracing this inherent mobility and displacedness, we can take art neither as reflections nor tools of distinction. Let the cross-eyed stance of Farrouk's peasants, Onsi's onlookers, and Choucair's sculptures become our own ontological stance.

So, what of the missing *Poem*? This book fails if it has not proven *Poem* exists, awaiting to be returned to circulation and interrelation. Let us attune ourselves to Choucair's avowal: "Everything living grows." As a step toward that goal, I accept Walid Raad's gift, heir to Choucair's gift (see front cover). Raad promised if I ever finished this book, he would provide a cover for it. And now you behold it. Perhaps the ambiguous blinking of Choucair's beacon prompted Raad to respond (as it did me), to the taswir it engenders and extend it. He has taken liberties with the shapes of *Poem*'s first instantiation, nourishing their liveliness by boldly rearranging them, adding to their number and height, and inserting them into a new medium. This last element is worth a closer look. Peering closely, you may see an Arabic vocabulary I hope has grown somewhat familiar to you if it was not before: ma'rid, li-l-fann, fannanat, Lubnan, al-funun. Clipped words and inked page numbers fringe the jaggedly cut, yellowing surfaces

invoking newsprint's wood pulp and archivists' markings. The emptiness Raad structures from archives I long collected, guided by Beirut's librarians, artists' families, and fellow researchers, evokes taswir's ontology of lack—inviting incessant, introspective infilling and enfleshing, making fantasmic objects and their objects, cosubstantially, unendingly. With this cover we have received an original artwork. What will we do with this gift?

Notes

1. Asef Bayat, *Life as Politics*, 4–5.
2. This book does not claim firstness in learning from art about a Middle Eastern society or even Lebanon. See chap. 1, notes 67, 89, and 90.
3. Bayat, *Life as Politics*, 184, 205, 222, 229, 242.
4. Gandhi, *Affective Communities*, 146, 147.
5. This is in fact how Philip S. Gorski argues Bourdieu worked and hoped to be read. See Gorski, "Theorist of Change."
6. "Lebanon Children's Future on the Line," *Save the Children*, June 2021, https://www.savethechildren.org/us/charity-stories/lebanon-economic-hunger-crisis.
7. In the three days before, Beirut temperatures reached 10 degrees Celsius above their average for October. Timour Azhari, "'It Was Like Judgment Day': Lebanese Devastated by Wildfires," *Al Jazeera*, October 17, 2019, https://www.aljazeera.com/news/2019/10/17/it-was-like-judgment-day-lebanese-devastated-by-wildfires.
8. Mittermaier, *Dreams That Matter*, 239.
9. Ahmed, *What Is Islam?*, 115, 121; see also 180–83.
10. Nada Moumtaz, "Refiguring Islam," 141.
11. Harney and Phillips, "Introduction," 4.
12. Bateson, "Style."
13. Jones, "Presence," 15; e.g., Sadek, "Place."
14. For an example and a lengthier analysis, see Scheid, "MoMA Visa."
15. Thompson, *Colonial Citizens*, 232.
16. "*Ma'rid Jadid li-l-Musawwirin al-Lubnaniyyin*" [A new exhibition for Lebanese picturers], *al-Makshuf*, November 10, 1941, 4.
17. "*Tamaniyat 'ala Lajnat Ma'rid al-Fannanin*" [Wishes raised to the Artists' Exhibition Committee], *al-Makshuf*, November 17, 1941, 6; "*Jubran fi Ma'rid al-Fannanin*" [Gibran at the Artists' Exhibition], *al-Makshuf*, November 24, 1941, 5.
18. "*Ma'rid al-Fannanin al-Lubnaniyyin*" [The exhibition of Lebanese artists], *al-Makshuf*, December 29, 1941, 1.
19. *Al-Makshuf.*

20. Works by Daoud Corm and Habib Serour appeared, but Kahlil Gibran's work, which only a few years earlier had been repatriated from Boston and had never been displayed in Beirut, was trapped by a snowstorm blanketing his hometown of Bsharri. André Derain, André Lhote, and Kees van Dongen took prominent display and accompanied works by soldier and bureaucrat artists. "*Ma`rid al-Fannanin wa-l-Misyu Lasain*" [The Artists' Exhibition and Mr. Lassaigne], *al-Makshuf*, December 15, 1941, 5.

21. Gabriel Bounoure, introduction to *le Salon des "Amis des Arts"* (Beirut, Parliament Building Hall, 1941), exhibition catalog, JM (first emphasis added; second in the original).

22. According to Bounoure, non-French artists had learned the "universal history of art" to the point of "forgetting the genius of their race."

23. Bounoure (emphasis added).

24. Sarah Mahayri, "I Am Lebanese and I Want Lebanon to Be Placed under French Mandate," e-petition, *Change.org*, August 8, 2020, https://www.change .org/p/france-i-am-lebanese-and-i-want-lebanon-to-be-placed-under-the-french -mandate-again?source_location=topic_page. Emphasis added.

25. Angela Charlton and Sarah El-Deeb, "Is France Helping Lebanon, or Trying to Reconquer It?," *Washington Post*, August 8, 2020, https://www.washingtonpost .com/world/middle_east/is-france-helping-lebanon-or-trying-to-reconquer-it /2020/08/08/3b582afe-d94b-11ea-a788-2ce86ce81129_story.html. The number of signees of the version posted by "Cy. N." is said to have reached sixty thousand after French president Emmanuel Macron's visit. "Tens of Thousands Sign Petition to Place Lebanon under French Mandate," *Middle East Monitor*, August 7, 2020, https://www.middleeastmonitor.com/20200807-tens-of-thousands-sign-petition -to-place-lebanon-under-french-mandate/.

26. Edwin Nasr, Instagram story, August 4, 2021, quoted with permission.

27. Nasr (emphasis in the original).

BIBLIOGRAPHY

Abboud, Samer, Omar Dahi, Waleed Hazboun, Nicole Sunday Grove, Coralie Pison Hindawi, Jamil Mouawad, and Sami Hermez. "Towards a Beirut School of Critical Security Studies." *Critical Studies on Security* 6, no. 3 (2018): 273–95.

Abboushi, Wasif. *The Unmaking of Palestine.* Boulder: Lynne Rienner, 1985.

Abou-Hodeib, Toufoul. *A Taste for Home: The Modern Middle Class in Ottoman Beirut.* Stanford, CA: Stanford University Press, 2017.

Abu-Lughod, Lila. "Zones of Theory in the Anthropology of the Arab World." *Annual Review of Anthropology* 18, no. 1 (1989): 267–306.

Abunnasr, Maria. "The Making of Ras Beirut: A Landscape of Memory for Narratives of Exceptionalism, 1870–1975." PhD diss., University of Massachusetts–Amherst, 2013.

Adal, Raja. *Beauty in the Age of Empire: Japan, Egypt, and the Global History of Aesthetic Education.* New York: Columbia University Press, 2019.

———. "Nationalizing Aesthetics: Art Education in Egypt and Japan, 1872–1950." PhD diss., Harvard University, 2009. ProQuest (AAT 3385523).

Adams, Ann Jensen. "Competing Communities in the 'Great Bog of Europe': Identity and Seventeenth-Century Dutch Landscape Painting." In *Landscape and Power,* edited by W. J. T. Mitchell, 35–76. Chicago: University of Chicago Press, 1994.

Agamben, Giorgio. *Stanzas: Word and Phantasm in Western Culture.* Translated by Ronald Martinez. Minneapolis: University of Minnesota Press, 1993.

Ahmed, Shahab. *What Is Islam? The Importance of Being Islamic.* Princeton, NJ: Princeton University Press, 2017.

Ali, Wijdan. *Modern Islamic Art: Development and Continuity.* Gainesville: University Press of Florida, 1997.

Alloula, Malek. *The Colonial Harem*. Translated by Myra and Wlad Godzich. Minneapolis: University of Minnesota Press, 1986.

Alpers, Svetlana. "The Museum as a Way of Seeing." In Karp and Lavine, *Exhibiting Cultures*, 25–32.

Ammoun, Denise. *Alexis Boutros: Alba, le défi culturel*. Beirut: ALBA, 2002.

Anderson, Betty. *The American University of Beirut: Arab Nationalism and Liberal Education*. Austin: University of Texas, 2011.

———. *A History of the Modern Middle East: Rulers, Rebels, and Rogues*. Stanford, CA: Stanford University Press, 2016.

Anton, Glenna. "Blind Modernism and Zionist Waterscape: The Huleh Drainage Project." *Jerusalem Quarterly* 35 (2008): 76–92.

Antrim, Zayde. "*Watan* before *Wataniyya*: Loyalty to Land in Ayyubid and Mamluk Syria." *al-Masaq* 22, no. 2 (September 2010): 173–90.

Appadurai, Arjun. *Modernity at Large: Cultural Dimensions of Globalization*. Minneapolis: University of Minnesota Press, 1996.

Apter, Andrew. "On Imperial Spectacle: The Dialectics of Seeing in Colonial Nigeria." *Comparative Studies in Society and History* 44, no. 3 (July 2002): 564–96.

Aretxaga, Begoña. "A Fictional Reality: Paramilitary Death Squads and the Construction of State Terror in Spain." In *Death Squad: The Anthropology of State Terror*, edited by Jeffrey Sluka, 49–69. Philadelphia: University of Pennsylvania Press, 2000.

Ariss, Tarek, El-. *Trials of Arab Modernity: Literary Affects and the New Political*. New York: Fordham University Press, 2013.

Asad, Talal. "The Idea of an Anthropology of Islam." *Qui parle* 17, no. 2 (2009): 1–30.

Aswad, Jack al-. "*Mu`adalat Hissiyya*" [Sensory equations]. In *Saloua Raouda Choucair: Her Life and Art*, 17–34 (Arabic section). Beirut: Choucair Foundation, 2002.

Aydin, Cemil. *The Idea of the Muslim World: A Global Intellectual History*. Cambridge, MA: Harvard University Press, 2017.

Bagnani, Gilbert. "Hellenistic Sculpture from Cyrene." *Journal of Hellenic Studies* 41, part 2 (1921): 232–46.

Bahloly, Saleem Al-. "History Regained: A Modern Artist in Baghdad Encounters a Lost Tradition of Painting." *Muqarnas Online* 35, no. 1 (2018): 229–72.

Bahnasi, Afif. *Al-Fann al-Hadith fi al-Bilad al-`Arabiyya* [Modern art in the Arab countries]. Tunis: Dar al-Janub li-l-Nashar and UNESCO, 1980.

Balqaziz, `Abd al-Ilah. "'*Ata' al-Muthaqqaf al-`Arabi: Fi al-Tawjih al-Ijtima`i wa-l-Siyasi*" [The contribution of the Arab intellectual: Social and political guidance]. In *al-Muthaqqaf al-`Arabi: Humumuhu wa-`Ata'uhu*, edited by Anis Sayigh, 203–33. Beirut: Markaz Dirasat al-Wahda al-`Arabiyya, 1995.

Barak, On. "Egyptian Time: Temporality, Personhood, and the Technopolitical Making of Modern Egypt." PhD diss., New York University, 2009.

Barakat, Saleh. "The Place of the Image in the Levantine Interior: The Lebanese Case." In *La multiplication des images en pays d'Islam*, edited by Bernard Heyberger and Silvia Naef, 177–88. Istanbul: Orient-Institut, 2003.

Bardawil, Fadi A. *Revolution and Disenchantment: Arab Marxism and the Binds of Emancipation*. Durham, NC: Duke University Press, 2020.

Bashier, Salman. *Ibn al-'Arabi's* Barzakh: *The Concept of the Limit and the Relationship between God and the World*. Albany: State University of New York Press, 2004.

———. *The Story of Islamic Philosophy: Ibn Tufayl, Ibn al-'Arabi, and Others on the Limit between Naturalism and Traditionalism*. Albany: State University of New York Press, 2011.

Bateson, Gregory. "Style, Grace, and Information in Primitive Art." In *Steps to an Ecology of Mind: A Revolutionary Approach to Man's Understanding of Himself*, 128–52. New York: Ballantine Books, 1972.

Bauman, Richard. *Verbal Art as Performance*. Rowley, MA: Newbury House, 1977.

Baxandall, Michael. *Painting and Experience in Fifteenth-Century Italy: A Primer in the Social History of Pictorial Style*. 2nd ed. Oxford: Oxford University Press, 1988.

Bayat, Asef. *Life as Politics: How Ordinary People Change the Middle East*. 2nd ed. Stanford, CA: Stanford University Press, 2014.

Beal, Anne. "Real Jordanians Don't Decorate Like That! The Politics of Taste among Amman's Elites." *City & Society* 12, no. 2 (December 2000): 65–94.

Behrens-Abouseif, Doris. *Beauty in Arabic Culture*. Princeton, NJ: Marcus Wiener, 1999.

Bermingham, Anne. *Learning to Draw: Studies in the Cultural History of a Polite and Useful Art*. New Haven, CT: Yale University Press, 2000.

Best, Susan. *Visualizing Feeling: Affect and the Feminine Avant-Garde*. London: I. B. Tauris, 2011.

Bhabha, Homi. "Of Mimicry and Man: The Ambivalence of Colonial Discourse." *October* 28 (Spring 1984): 125–33.

Bizri, Hala. "The Nudism of Sheikh Fouad Hobeiche." Translated by Elisabeth Jaquette. In *Art, Awakening, and Modernity in the Middle East: The Arab Nude*, edited by Octavian Esanu, 86–96. London: Routledge, 2018.

Bizri, Nader El-. "A Philosophical Perspective on Alhazen's *Optics*." *Arabic Sciences and Philosophy* 15, no. 2 (August 2005): 189–218.

Blair, Sheila, and Jonathan Bloom. "The Mirage of Islamic Art: Reflections on the Study of an Unwieldy Field." *Art Bulletin* 85, no. 1 (March 2003): 152–84.

Bourdieu, Pierre. *Distinction: A Social Critique of the Judgement of Taste*. Cambridge, MA: Harvard University Press, 1984.

Bourdieu, Pierre, and Alain Darbel. *The Love of Art: European Art Museums and Their Public*. Translated by Caroline Beattie and Nick Merriman. Cambridge, UK: Polity, 1991.

Bredekamp, Horst. *Image Acts: A Systematic Approach to Visual Agency.* Translated by Elizabeth Clegg. Berlin: Walter De Gruyter, 2018.

———. "The Picture Act: Tradition, Horizon, Philosophy." In *Bildakt at the Warburg Institute*, edited by Sabine Marienberg and Jürgen Trabant, 3–32. Berlin: Walter De Gruyter, 2014.

Buck-Morss, Susan. *The Dialectics of Seeing: Walter Benjamin and the Arcades Project.* Cambridge, MA: MIT Press, 1989.

Buntinx, Gustavo. "Communities of Sense/Communities of Sentiment: Globalization and the Museum Void in an Extreme Periphery." In *Museum Frictions: Public Cultures/Global Transformations*, edited by Ivan Karp, Corrine Kratz, Lynn Szwaja, and Tomás Ybarra-Frausto, 219–46. Durham, NC: Duke University Press, 2006.

Burns, Peter. "Six Postcards from Arabia: A Visual Discourse of Colonial Travels in the Orient." *Tourist Studies* 4, no. 3 (2004): 255–75.

Bustani, Butrus al-. *Muhit al-Muhit* [Ocean of oceans]. Vol. 2. Beirut: Matba`a al-Ma`arif, 1869–70.

Carey, Moya, and Margaret Graves, eds. "Islamic Art Historiography." Special issue, *Journal of Art Historiography*, no. 6 (June 2012).

Chahine, Richard. *One Hundred Years of Lebanese Art.* 2 vols. Beirut: Imprimerie Catholique, 1982.

Chakrabarty, Dipesh. *Provincializing Europe: Postcolonial Thought and Historical Difference.* 2nd ed. Princeton, NJ: Princeton University Press, 2008.

Chatterjee, Partha. "The Disciplines in Colonial Bengal." In *Texts of Power: Emerging Disciplines in Colonial Bengal*, edited by Partha Chatterjee, 1–30. Minneapolis: University of Minnesota Press, 1995.

Churchill, Charles. *Beirut: A Socio-economic Survey.* Beirut: Dar al-Kitab, 1954.

Clark, Kenneth. *Landscape into Art.* New York: Charles Scribner Sons, 1950.

———. *The Nude: A Study in Ideal Form.* Princeton, NJ: Princeton University Press, 1956.

Clark, T. J. *The Painting of Modern Life: Paris in the Art of Manet and His Followers.* Princeton, NJ: Princeton University Press, 1984.

Cone, Michèle. *French Modernisms: Perspectives on Art before, during, and after Vichy.* Cambridge, UK: Cambridge University Press, 2001.

Copjec, Joan. "The Imaginal World and Modern Oblivion: Kiarostami's Zig-Zag." *Filozofski vestnik* 37, no. 2 (2016): 21–58.

Corbin, Henry. *Alone with the Alone: The Creative Imagination in the Sufism of Ibn al-`Arabi.* Translated by Richard Manheim. Princeton, NJ: Princeton University Press, 1969.

———. *Spiritual Body and Celestial Earth: From Mazdean Iran to Shi`a Iran.* Translated by Nancy Pearson. Princeton, NJ: Princeton University Press, 1989.

Council for Exterior Economic Relations (CREE). *Le jardinier des apparences.* Beirut: Le Conseil des Relations Economiques Exterieures, 1985.

Crary, Jonathan. *Techniques of the Observer: On Vision and Modernity in the Nineteenth Century.* Cambridge, MA: MIT Press, 1992.

Creswell, Robin. *City of Beginnings: Poetic Modernism in Beirut.* Princeton, NJ: Princeton University Press, 2019.

Dadi, Ifitkhar. *Modernism and the Art of Muslim South Asia.* Chapel Hill: University of North Carolina Press, 2010.

Dagher, Charbel. *Madhahib al-Husn: Qira'at Mu`ajamiyya-Tarikhiyya li-l-Funun al-`Arabiyya* [The paths of beauty: Lexicographical-historical readings for the Arab arts]. Beirut: Al-Markaz al-Thaqafi al-`Arabi li-l-Nashr, 1998.

Dakhli, Leyla. "The Autumn of the Nahda in the Light of the Arab Spring: Some Figures in the Carpet." In *Arabic Thought beyond the Liberal Age: Towards an Intellectual History of the Nahda,* edited by Jens Hanssen and Max Weiss, 351–71. Cambridge, UK: Cambridge University Press, 2016.

Davie, May. *Beyrouth et ses faubourgs,1840–1940: Une intégration inachevée.* Cahiers du CERMOC, 15. Beirut: Presses de l'Ifpo, 1996.

Davie, Michael, ed. *La maison beyrouthine aux trois arcs. Une architecture bourgeoise du Levant.* Beirut: ALBA, 2003.

Deeb, Lara. *The Enchanted Modern: Gender and Public Piety in Shi'i Lebanon.* Princeton, NJ: Princeton University Press, 2006.

Deeb, Lara, and Mona Harb. *Leisurely Islam: Negotiating Geography and Morality in Shi`ite South Beirut.* Princeton, NJ: Princeton University Press, 2013.

Deeb, Lara, and Jessica Winegar. "Anthropologies of Arab-Majority Societies." *Annual Review of Anthropology* 41 (2012): 537–58.

Deleuze, Gilles. *Difference and Repetition.* Translated by Paul Patton. New York: Columbia University Press, 1994.

Deloria, Philip J. *Becoming Mary Sully: Toward an American Indian Abstract.* Seattle: University of Washington Press, 2019.

Dodge, Toby. "Introduction: Between *Wataniyya* and *Ta'ifiyya;* Understanding the Relationship between State-Based Nationalism and Sectarian Identity in the Middle East." *Nations and Nationalism* 26, no. 1 (December 2019): 85–90.

Douglas, Mary. *Purity and Danger: An Analysis of Concept of Pollution and Taboo.* 1966. New York: Routledge, 2007.

Dueck, Jennifer. *The Claims of Culture at Empire's End: Syria and Lebanon under French Rule.* New York: Oxford University Press, 2010.

———. "A Muslim Jamboree: Scouting and Youth Culture in Lebanon under the French Mandate." *French Historical Studies* 30, no. 3 (2007): 485–516.

Duncan, Carol. *Civilizing Rituals: Inside Public Art Museums.* London: Routledge, 1995.

Eddé, Carla. *Beyrouth, naissance d'une capitale, 1918–1924.* Paris: Actes Sud, 2009.
———. *"La mobilisation 'populaire' à Beyrouth à l'époque du Mandat, le cas des boycotts des trams et de l'électricité."* In *France, Syrie et Liban, 1918–1946: Les ambiguïtés et les dynamiques de la relation mandataire,* edited by Nadine Méouchy, 349–75. Damascus: IFEAD, 2002.
El Guindi, Fadwa. *By Noon Prayer: The Rhythm of Islam.* Oxford: Berg, 2008.
Elias, Chad. *Posthumous Images: Contemporary Art and Memory Politics in Post–Civil War Lebanon.* Durham, NC: Duke University Press, 2018.
Elias, Jamal J. *Aisha's Cushion: Religious Art, Perception, and Practice in Islam.* Cambridge, MA: Harvard University Press, 2012.
Eliot, T. S. "The Love Song of J. Alfred Prufrock." In *T. S. Eliot: Collected Poems, 1909–1962,* 3–7. New York: Harcourt, Brace, and World, 1963.
Ettinghausen, Richard, and Oleg Grabar. *Islamic Art and Architecture, 650–1250.* New Haven, CT: Yale University Press, 1992.
Fabian, Johannes. *Remembering the Present: Painting and Popular History in Zaire.* Berkeley: University of California Press, 1996.
———. *Time and the Other: How Anthropology Makes Its Objects.* New York: Columbia University Press, 1983.
Fakhoury, Bushra. "Art Education in Lebanon." PhD diss., University of London, 1983.
Fakhuri, Riyad. *Hadiqat Duyuf: al-Fann al-Intiba`i al-Lubnani* [A garden of guests: Lebanese impressionist art]. Beirut: Gallery Bikhazi, 1993.
Fani, Michel. *Dictionnaire de la peinture au Liban.* Beirut: Editions de l'Escalier, 1988.
Farroukh, Hani, ed. *Farrouk Portfolios.* Beirut: self-published, 1980–96.
Farrukh, Mustafa. *al-Fann wa-l-Hayat: Maqalat Tabhath fi al-Fann wa-Itibatihi bi-l-Hayat* [Art and life: Articles on art and its relation to life] Beirut: Dar al-`Ilm li-l-Milayin, 1967.
———. *Tariqi ila al-Fann* [My road to art]. Beirut: Dar Naufal, 1986.
Farrukh, `Umar. "*Rajul wa-Fann*" [A man and art]. In Farrukh, *al-Fann wa-l-Hayat.*
Feldman, Hannah, and Akram Zaatari. "Mining War: Fragments from a Conversation Already Passed." *Art Journal* 66, no. 2 (Summer 2007): 48–67.
Firro, Kais. *Inventing Lebanon: Nationalism and the State under the Mandate.* London: Bloomsbury, 2002.
Flood, Finbarr Barry. "From the Prophet to Postmodernism: New World Orders and the Ends of Islamic Art." In *Making Art History: A Changing Discipline and Its Institutions,* edited by Elizabeth Mansfield, 31–53. New York: Routledge, 2007.
Flood, Finbarr Barry, and Gülru Necipoğlu. "Frameworks of Islamic Art and Architectural History: Concepts, Approaches, and Historiographies." In *A Companion to Islamic Art and Architecture: From the Prophet to the Mongols,* edited by Finbarr Barry Flood and Gülru Necipoğlu, 1:2–26. London: Wiley, 2017.

Foucault, Michel. *Discipline and Punish: The Birth of the Prison.* Translated by Alan Sheridan. 2nd ed. New York: Vintage Books, 1995.

Fuller, Anne. *Buarij: Portrait of a Lebanese Muslim Village.* 1961. Reprint, Cambridge, MA: Harvard University Press, 1970.

Gandhi, Leela. *Affective Communities: Anticolonial Thought and the Politics of Friendship.* Durham, NC: Duke University Press, 2006.

Gaonkar, Dilip Parameshwar. "On Alternative Modernities." *Public Culture* 11, no. 1 (1999): 1–18.

Garb, Tamar. "'Men of Genius, Women of Taste': The Gendering of Art Education in Late Nineteenth-Century Paris." In *Overcoming All Obstacles: The Women of the Académie Julian,* edited by Gabriel Weisberg and Jane Becker, 115–33. New York: Dahesh Museum and Rutgers University Press, 1999.

———. *Sisters of the Brush: Women's Artistic Culture in Late Nineteenth-Century Paris.* New Haven, CT: Yale University Press, 1994.

Gasparian, Natasha. "The First Sanayeh Plastic Arts Meeting, Ashkal Alwan Beirut 1995." In *Contemporary Art and Capitalist Modernization: A Transregional Perspective,* edited by Octavian Esanu, 169–83. New York: Routledge, 2021.

Geertz, Hildred. *Images of Power: Balinese Paintings Made for Gregory Bateson and Margaret Mead.* Honolulu: University of Hawaii Press, 1994.

Gell, Alfred. *Art and Agency: An Anthropological Theory.* Oxford: Oxford University Press, 1998.

George, Kenneth. "Ethics, Iconoclasm, and Qur'anic Art in Indonesia," *Cultural Anthropology* 24, no. 4 (2009): 589–621.

———. *Picturing Islam: Art and Ethics in a Muslim Lifeworld.* West Sussex, UK: Wiley-Blackwell, 2010.

Gerschultz, Jessica. *Decorative Arts of the Tunisian Ecole: Fabrications of Modernism, Gender, and Power.* University Park, PA: Pennsylvania State University Press, 2019.

———. "Notes on Tending Feminist Methodologies." In *Under the Skin: Feminist Art and Art Histories from the Middle East and North Africa Today,* edited by Ceren Özpinar and Mary Kelly, 131–43. Oxford: Oxford University Press, 2020.

Geurts, Kathryn. *Culture and the Senses: Bodily Ways of Knowing in an African Community.* Berkeley: University of California Press, 2003.

Ghorayeb, Marlène. *Beyrouth sous mandat français: Construction d'une ville modern.* Paris: Karthala, 2014.

Gilsenan, Michael. "Very like a Camel: The Appearance of an Anthropologist's Middle East." In *Localizing Strategies: Regional Traditions of Ethnographic Writing,* edited by Richard Fardon, 222–39. Edinburgh: Scottish Academic Press, 1990.

Gorski, Philip S. "Bourdieu as a Theorist of Change." In *Bourdieu and Historical Analysis,* edited by Philip S. Gorski, 1–15. Durham, NC: Duke University Press, 2013.

Grabar, Oleg. *The Mediation of Ornament*. Princeton, NJ: Princeton University Press, 1992.

Greenberg, Reese, Bruce Ferguson, and Sandy Nairne, eds. *Thinking about Exhibitions*. London: Routledge, 1996.

Grewal, Inderpal. *Home and Harem: Nation, Gender, Empire, and the Culture of Travel*. Durham, NC: Duke University Press, 1996.

Guha-Thakurta, Tapati. *Monuments, Objects, Histories: Institutions of Art in Colonial and Post-colonial India*. New York: Columbia University Press, 2004.

———. "The Museum in the Colony: Collecting, Conserving, Classifying." In *No Touching, No Spitting, No Praying: The Museum in South Asia*, edited by Saloni Mathur and Kavita Singh, 45–82. New Delhi: Routledge, 2015.

Gulick, John. *Social Structure and Culture Change in a Lebanese Village*. New York: Wenner-Gren Foundation for Anthropological Research, 1955.

Hage, Ghassan. *The Diasporic Condition: Ethnographic Explorations of the Lebanese in the World*. Chicago: University of Chicago Press, 2021.

———. "Hating Israel in the Field: On Ethnography and Political Emotions." *Anthropological Theory* 9, no. 1 (March 2009): 59–79.

Halabi, Zeina, and miriam cooke. "Nazira Zeineddine." In *The Arab Renaissance: A Bilingual Anthology of the Nahda*, edited by Tarik El-Ariss, 372–92. New York: MLA Texts and Translations, 2019.

Hallaq, Hassan. *Bayrut al-Mahrusa fi al-Ahd al-ʿUthmani* [Safeguarded Beirut in the Ottoman era]. Beirut: Dar Jamʿiya, 1987.

———. *Mudhakkirat Salim ʿAli Salam* [Salim ʿAli Salam's memoirs]. Beirut: Dar al-Nahda al-ʿarabiyya, 2013.

Hamzah, Dyala. "From ʿilm to *Sihafa* or the Politics of the Public Interest (*Maslaha*): Muhammad Rashid Rida and His Journal *al-Manar* (1898–1935)." In Hamzah, *Making of the Arab Intellectual*, 90–127.

———, ed. *The Making of the Arab Intellectual: Empire, Public Sphere, and the Colonial Coordinates of Selfhood*. New York: Routledge, 2013.

Hanssen, Jens. *Fin de Siècle Beirut: The Making of an Ottoman Provincial Capital*. Oxford: Oxford University Press, 2005.

Haraway, Donna, and Thyrza Goodeve. *Modest_Witness@ Second_Millennium. FemaleMan_Meets_OncoMouse: Feminism and Technoscience*. London: Routledge, 2018.

Harney, Elizabeth, and Ruth B. Phillips. "Introduction: Inside Modernity." In *Mapping Modernisms: Art, Indigeneity, Colonialism*, edited by Elizabeth Harney and Ruth B. Phillips, 1–29. Durham, NC: Duke University Press, 2018.

Hatem, Mervat. "Modernization, the State, and the Family in Middle East Women's Studies." In *A Social History of Women and Gender in the Modern Middle East*, edited by Margaret Meriwether and Judith Tucker, 63–87. Boulder: Westview, 1999.

Haut-Commissariat de la République Française en Syrie et au Liban. *La Syrie et le Liban en 1921*. Paris: Emile La Rose, 1922.

Hermez, Sami. *War Is Coming: Between Past and Future Violence in Lebanon.* Philadelphia: University of Pennsylvania Press, 2017.

Hibri, Hatim El-. *Visions of Beirut: The Urban Life of Media Infrastructure.* Durham, NC: Duke University Press, 2021.

Himadeh, Sa`id. *The Economic Organization of Syria.* Beirut: American University of Beirut Press, 1936.

Hirschkind, Charles. *The Ethical Soundscape: Cassette Sermons and Islamic Counterpublics.* New York: Columbia University Press, 2006.

Ho, Christine. *Drawing from Life: Sketching and Socialist Realism in the People's Republic of China.* Oakland, CA: University of California Press, 2020.

———. "The People Eat for Free and the Art of Collective Production in Maoist China." *Art Bulletin* 98, no. 3 (2016): 348–72.

Hubbard, Ruth, Mary Sue Henifin, and Barbara Fried. *Biological Woman—the Convenient Myth: A Collection of Feminist Essays and a Comprehensive Bibliography.* Cambridge, MA: Schenkman, 1982.

Ibn Manzur, Abu al-Fadl Muhammad bin Makram. *Lisan al-`Arab* [The Arabs' language]. Cairo: Bullag Misr al-Matba`a al-Kubra al-`Amiriyya, 1883.

Irbouh, Hamid. *Art in the Service of Colonialism: French Art Education in Morocco, 1912–56.* London: I. B. Tauris, 2005.

Ivy, Marilyn. *Discourses of the Vanishing: Modernity, Phantasm, Japan.* Chicago: University of Chicago Press, 1995.

Jackson, Shannon. *Professing Performance: Theater in the Academy from Philology to Performativity.* Cambridge, UK: Cambridge University Press, 2004.

Jackson, Simon. "Mandatory Development: The Political Economy of the French Mandate in Syria and Lebanon, 1915–1939." PhD diss., New York University, 2009.

Jain, Kajri. *Gods in the Bazaar: The Economies of Indian Calendar Art.* Durham, NC: Duke University Press, 2007.

Jay, Martin. *Downcast Eyes: The Denigration of Vision in Twentieth-Century Thought.* Berkeley: University of California Press, 1993.

Johnson, Michael. "Political Bosses and Their Gangs: *Zu'ama* and *Qabadayat* in the Sunni Muslim Quarters of Beirut." In *Patrons and Clients in Mediterranean Societies,* edited by Ernest Gellner and John Waterbury, 207–24. London: Gerald Duckworth, 1977.

Jones, Amelia. "'Presence in Absentia': Experiencing Performance as Documentation." *Art Journal* 56, no. 4 (2014): 11–18.

Kamil, Salih al-. *al-Fann al-Lubnani* [Lebanese art]. Beirut: Ministry of Education and Fine Art, 1956.

Kapchan, Deborah. *Gender on the Market: Moroccan Women and the Revoicing of Tradition.* Philadelphia: University of Pennsylvania Press, 1996.

Karnes, Michelle. *Imagination, Meditation, and Cognition in the Middle Ages.* Chicago: University of Chicago Press, 2011.

Karp, Ivan, and Steven D. Lavine, eds. *Exhibiting Cultures: The Poetics and Politics of Museum Display.* Washington, DC: Smithsonian Institution Press, 1994.

Kassir, Samir. *Histoire de Beyrouth.* Paris: Librarie Arthème Fayard, 2003.

Kaufman, Asher. *Reviving Phoenicia: The Search for Identity in Lebanon.* London: I. B. Tauris, 2004.

Kester, Grant. *Conversation Pieces: Community and Communication in Modern Art.* Berkeley: University of California Press, 2004.

Khal, Helen. "Embodying the Spirit." In *Saloua Raouda Choucair,* xvii–xxx.

———. *The Woman Artist in Lebanon.* Beirut: Institute for Women's Studies in the Arab World, 1987.

Khalaf, Samir. *Heart of Beirut: Reclaiming the Bourj.* London: Saqi Books, 2006.

Khater, Akram. *Inventing Home: Emigration, Gender, and the Middle Class in Mount Lebanon, 1870–1920.* Berkeley: University of California Press, 2001.

Khemir, Mounira. "The Orient in the Photographer's Mirror: From Constantinople to Mecca." In *Orientalism: From Delacroix to Klee,* edited by Roger Benjamin, 188–96. Sydney: Art Gallery of New South Wales, 1997.

Khoury, Gerard, ed. *Vergers d'exil: Gabriel Bounoure.* Paris: Geuthner, 2004.

Khoury, Philip. *Syria and the French Mandate: The Politics of Arab Nationalism, 1920–45.* Princeton, NJ: Princeton University Press, 1987.

Khuri-Makdisi, Ilham. *The Eastern Mediterranean and the Making of Global Radicalism, 1860–1914.* Berkeley: University of California Press, 2010.

Kitzinger, Beatrice. Review of *Theorie des Bildakts,* by Horst Bredekamp. *CAA Reviews* 103 (2014). Accessed May 12, 2021. https://dx.doi.org/10.3202/caa .reviews.2014.103.

Koenig, John-Franklin. "*Abstraction chaude* in Paris in the 1950s." In *Reconstructing Modernism: Art in New York, Paris, and Montreal, 1945–64,* edited by Serge Guilbaut, 1–16. Cambridge, MA: MIT Press, 1995.

Kristeva, Julia. *Powers of Horror: An Essay on Abjection.* Translated by Leon Roudiez. New York: Columbia University Press, 1982.

Kroiz, Lauren. *Cultivating Citizens: The Regional Work of Art in the New Deal Era.* Oakland, CA: University of California Press, 2018.

Kunzel, Regina. *Fallen Women, Problem Girls: Unmarried Mothers and the Professionalization of Social Work, 1890–1945.* New Haven, CT: Yale University Press, 1993.

Kurani, Habib. "Lebanon: Educational Reform." In *The Yearbook of Education,* 448–61. London: Evans Brothers, 1949.

Lacan, Jacques. "The Mirror Stage as Formative of the *I* Function, as Revealed in Psychoanalytic Experience." In *Écrits: A Selection,* translated by Bruce Fink, 3–9. New York: W. W. Norton, 2002.

Lahoud, Edouard. *Contemporary Art in Lebanon*. Translated by Philippe Michaux. Beirut: Librarie Orientale, 1974.

Lane, Edward William. *Arabic-English Lexicon*. Beirut: Librarie du Liban, 1968.

Lattouf, Mirna. "The History of Women's Higher Education in Modern Lebanon and Its Social Implications." PhD diss., University of Arizona, 1999.

Law, John. *After Method: Mess in Social Science Research*. London: Routledge, 2004.

Lebanese American University. *The Human Figure in Lebanese Painting*. Beirut: Lebanese American University, 1996. Exhibition catalog.

Lenssen, Anneka. *Beautiful Agitation: Modern Painting and Politics in Syria*. Oakland, CA: University of California Press, 2020.

Lenssen, Anneka, Sarah Rogers, and Nada Shabout, eds. *Modern Art in the Arab World: Primary Documents*. New York: Museum of Modern Art, 2018.

Levin, David Michael, ed. *Modernity and the Hegemony of Vision*. Berkeley: University of California Press, 1993.

Levi-Strauss, Claude. *Myth and Meaning*. London: Kegan Paul, 1978.

Maasri, Zeina. *Cosmopolitan Radicalism: The Visual Politics of Beirut's Global Sixties*. Cambridge, UK: Cambridge University Press, 2020.

Makdisi Cortas, Wadad. *A World I Loved: The Story of an Arab Woman*. New York: Nation Books, 2009.

Malhas, Thurayya ʿAbd al-Fattah. *Al-Nahhata al-Tajridiyya Salwa Rawda Shuqair fi Masaratiha al-Shakhsiyya wa-l-Fanniyya Namudhajan bi-Imtiyaz* [The abstract sculptor Saloua Raouda Choucair in her personal and artistic realm as an exemplar par excellence]. Amman: ʿImad al-Din for Distribution, 2011.

Malik, Sharl. *Al-Muqaddima: Sira Dhatiyya Falsafiyya* [The introduction: A philosophical biography]. 2nd ed. Beirut: Dar al-Nahar, 2001.

Mamdani, Mahmood. "Good Muslim, Bad Muslim: A Political Perspective on Culture and Terrorism." *American Anthropologist* 104, no. 3 (September 2002): 766–75.

Marcus, George, and Fred Myers. "The Traffic in Art and Culture: An Introduction." In *The Traffic in Culture: Refiguring Art and Anthropology*, edited by George Marcus and Fred Myers, 1–51. Berkeley: University of California Press, 1995.

Marks, Laura U. "What Is That *and* between Arab Women and Video? The Case of Beirut." *Camera Obscura* 18, no. 3 (2003): 40–69.

Marx, Karl. *The Eighteenth Brumaire of Louis Bonaparte*. New York: International Publishers, 1963.

Méouchy, Nadine, and Peter Sluglett. Introduction to *The British and French Mandates in Comparative Perspectives*, edited by Nadine Méouchy and Peter Sluglett, 1–19. Leiden: Brill, 2004.

Merabet, Sofian. *Queer Beirut*. Austin: University of Texas Press, 2014.

Mestyan, Adam. "Arabic Lexicography and European Aesthetics: The Origin of *Fann*." *Muqarnas* 28 (2011): 69–100.

Metzler, Laura. "(And so on . . .): Genetics, Quantum Mechanics, and Transcendence in the Late Work of Saloua Raouda Choucair." MA thesis, American University of Beirut, 2014.

Minissale, Gregory. *Images of Thought: Visuality in Islamic India, 1550–1750*. 2nd ed. Newcastle upon Tyne: Cambridge Scholars, 2009.

Mitchell, Timothy. "The World as Exhibition." *Comparative Studies in Society and History* 31, no. 2 (April 1989): 217–36.

Mittermaier, Amira. *Dreams That Matter: Egyptian Landscapes of the Imagination*. Berkeley: University of California Press, 2011.

Mollenhauer, Anne. "The Central Hall House: Regional Commonalities and Local Specificities." In *The Empire in the City: Arab Provincial Capitals in the Late Ottoman Empire*, edited by Jens Hanssen, Thomas Philipp, and Stefan Weber, 275–96. Beirut: Ergon Verlag Würzburg, 2002.

Monroe, Kristin V. *The Insecure City: Space, Power, and Mobility in Beirut*. New Brunswick, NJ: Rutgers University Press, 2016.

Moosa, Ebrahim. "Muslim Ethics?" In *The Blackwell Companion to Religious Ethics*, edited by William Schweiker, 237–43. Oxford: Blackwell, 2005.

Mouarbes, Tatiana. "Horizons of Possibilities: Artists and the City in Postwar Beirut." MA diss., Hunter College, 2017. Accessed May 31, 2018. https://academicworks.cuny.edu/hc_sas_etds/147.

Moumtaz, Nada. *God's Property: Islam, Charity, and the Modern State*. Oakland, CA: University of California Press, 2021.

———. "Refiguring Islam." In *A Companion to the Anthropology of the Middle East*, edited by Soraya Altorki, 125–50. Hoboken, NJ : Wiley-Blackwell, 2015.

Myers, Fred. *Painting Culture: The Making of an Aboriginal High Art*. Durham, NC: Duke University Press, 2002.

———. *Pintupi Country, Pintupi Self: Sentiment, Place, and Politics among Western Desert Aborigines*. Washington, DC: Smithsonian Institution Press, 1986.

Nadi al-Thaqafi al-ʿArabi, al-. *Al-Nadi al-Thaqafi al-ʿArabi khilala 35 ʿAman: 1944–1979* [The Arab Cultural Club through 35 years, 1944–1979]. Beirut: al-Nadi al-Thaqafi al-ʿArabi, 1980.

Naef, Silvia. 1996. *À la recherche d'une modernité arabe: L'évolution des arts plastiques en Égypte, au Liban, et en Irak*. Geneva: Slatkin, 1996

———. "*Peindre pour être moderne? Remarques sur l'adoption de l'art occidental dans l'Orient arabe*." In *La multiplication des images en pays d'Islam*, edited by Bernard Heyberger and Silvia Naef, 189–208. Istanbul: Orient-Institut, Ergon Verlag Würzburg, 2003.

———. "Reexploring Islamic Art: Modern and Contemporary Creation in the Arab World and Its Relations to the Artistic Past." *RES* 43 (Spring 2003): 165–74.

———. "Where Is Paradise on Earth? Visual Arts in the Arab World and the Construction of a Mythic Past." In *Roads to Paradise: Eschatology and Concepts of the Hereafter in Islam*, edited by Sebastian Günther and Todd Lawson, 2:1068–79. Leiden: Brill, 2017.

Naeff, Judith. *Precarious Imaginaries of Beirut: A City's Suspended Now*. Cham, Switzerland: Palgrave Macmillan, 2017.

Nammar, Nadia. *Hikayat Jasad* [Story of a body]. Beirut: Dar al-Nahar, 2001.

Nammour, Cesar. *Sculpture in Lebanon*. Beirut: Dar al-Funun al-Jamila, 1990.

Navaro, Yael. "Affective Spaces, Melancholic Objects: Ruination and the Production of Anthropological Knowledge." *Journal of the Royal Anthropological Institute* 15, no. 1 (2009): 1–18.

———. *Faces of the State: Secularism and Public Life in Turkey*. Princeton, NJ: Princeton University Press, 2002.

———. *The Make-Believe Space: Affective Geography in a Postwar Polity*. Durham, NC: Duke University Press, 2012.

Nead, Lynda. *The Female Nude: Art, Obscenity and Sexuality*. London: Routledge, 2002.

Necipoğlu, Gülru. "The Concept of Islamic Art: Inherited Discourses and New Approaches." In *Islamic Art and the Museum: Approaches to Art and Archaeology of the Muslim World in the Twenty-First Century*, edited by Benoît Junod, Georges Khalil, Stefan Weber, and Gerhard Wolf, 57–75. London: Saqi Books, 2012.

———. "The Scrutinizing Gaze in the Aesthetics of Islamic Visual Cultures: Sight, Insight, and Desire." *Muqarnas* 32, no. 1 (2015): 23–61. Accessed July 15, 2020. https://www.jstor.org/stable/44657311?seq=1.

Nelson, Kristina. *The Art of Reciting the Qur'an*. Cairo: American University in Cairo Press, 2001.

Nicholas Sursock Museum. *L'Orient Rêvé: Collection Adnan and Adel Kassar*. Beirut: Nicholas Sursock Museum, 2002. Exhibition catalog.

———. *Moustapha Farroukh 1901–1957*. Beirut: Sursock Museum, 2003. Exhibition catalog.

———. *Omar Onsi 1901–1969*. Beirut: Sursock Museum, 1997. Exhibition catalog.

Noorani, Yaseen. "Estrangement and Selfhood in the Classical Concept of Watan." *Journal of Arabic Literature* 47, no. 1–2 (2016): 16–42.

Nucho, Joanne Randa. *Everyday Sectarianism in Urban Lebanon: Infrastructures, Public Services, and Power*. Princeton, NJ: Princeton University Press, 2016.

Ogle, Vanessa. *The Global Transformation of Time, 1870–1950*. Cambridge, MA: Harvard University Press, 2015.

Pandolfo, Stefania. *Knot of the Soul: Madness, Psychoanalysis, Islam*. Chicago: University of Chicago Press, 2018.

Pascoe, Stephen. "Making the Middle East Modern: Shifting Historical Frameworks." *Arena Journal* 44 (2015): 14–30.

Peters, Emrys. "Aspects of Rank and Status among Muslims in a Lebanese Village." In *Mediterranean Countrymen*, edited by Julian Pitt-Rivers, 159–200. The Hague: Mouton, 1963.

Philipp, Thomas. "Participation and Critique: Arab Intellectuals Respond to the 'Ottoman' Revolution." In *Arabic Thought beyond the Liberal Age: Towards an Intellectual History of the Nahda*, edited by Jens Hanssen and Max Weiss, 243–65. Cambridge, UK: Cambridge University Press, 2016.

Piaget, Claire. *Murs et plafonds peints: Liban XIXème siècle*. Beirut: Terre du Liban, 1998.

Pieprzak, Katarzyna. *Imagined Museums: Art and Modernity in Postcolonial Morocco*. Minneapolis: University of Minnesota Press, 2010.

———. "Moroccan Art Museums and Memories of Modernity." In *A Companion to Modern African Art*, edited by Gitti Salami and Monica Blackmun Visonà, 426–44. Hoboken, NJ: Wiley, 2013.

Pinney, Christopher. "The Indian Work of Art in the Age of Mechanical Reproduction; Or, What Happens When Peasants 'Get Hold' of Images." In *Media Worlds: Anthropology on New Terrain*, edited by Faye Ginsburg, Lila Abu-Lughod, and Brian Larkin, 355–69. Berkeley: University of California Press, 2002.

Pollock, Griselda. *Avant-garde Gambits 1888–1893: Gender and the Colour of Art History*. London: Thames and Hudson, 1992.

Poole, Deborah. "An Excess of Description: Ethnography, Race, and Visual Technologies." *Annual Review of Anthropology* 34 (2005): 159–79.

Povinelli, Elizabeth. *Economies of Abandonment: Social Belonging and Endurance in Late Liberalism*. Durham, NC: Duke University Press, 2011.

———. *Empire of Love: Toward a Theory of Intimacy, Genealogy, and Carnality*. Durham, NC: Duke University Press, 2006.

Provence, Michael. *The Great Syrian Revolt and the Rise of Arab Nationalism*. Austin: University of Texas Press, 2005.

Rabbat, Nasser. "Continuity and Rupture in Islamic Architecture." *International Journal of Islamic Architecture* 10, no. 1 (January 2021): 47–55.

———. "What Is Islamic Architecture Anyway?" *Journal of Art Historiography* 6 (June 2012): 1–15. Accessed June 15, 2021. https://arthistoriography.wordpress.com/number-6-june-2012-2/.

Radwan, Nadia. "Between Diana and Isis: Egypt's 'Renaissance' and the Neo-Pharaonic Style (1920s–1930s)." In *Dialogues artistiques avec les passés de l'Égypte: Une perspective transnationale et transmédiale*. Paris: Publications de l'Institut national d'histoire de l'art, 2017.

Ramadan, Dina. "'One of the Best Tools for Learning': Rethinking the Role of 'Abduh's *Fatwa* in Egyptian Art History." In *A Companion to Modern African Art*, edited by Gitti Salami and Monica Blackmun Visonà, 137–53. London: Wiley, 2013.

Raouda Choucair, Saloua. *Saloua Raouda Choucair: Her Life and Art*. Beirut: self-published, 2002. Catalog.

Rogers, Sarah. *Modern Art in Cold War Beirut: Drawing Alliances*. New York: Routledge, 2021.

Rounthwaite, Adair. *Asking the Audience: Participatory Art in 1980s New York*. Minneapolis: University of Minnesota Press, 2017.

Roy, Srirupa. *Beyond Belief: India and the Politics of Postcolonial Nationalism*. Durham, NC: Duke University Press, 2007.

Rydell, Robert. "Souvenirs of Imperialism: World's Fair Postcards." In *Delivering Views: Distant Cultures in Early Postcards*, edited by Christaud Geary and Virginia-Lee Webs, 47–63. Washington, DC: Smithsonian Institution, 1998.

Sabour, M'hammed. *The Ontology and Status of Intellectuals in Arab Academia and Society*. Burlington, VT: Ashgate, 2001.

Sabra, Abdelhamid. "Ibn Haytham's Revolutionary Project in Optics: The Achievement and the Obstacle." In *The Enterprise of Science in Islam*, edited by Jan-Pieter Hogendijk and Abdelhamid Sabra, 85–118. Cambridge, MA: MIT Press, 2003.

Sadek, Walid. "Place at Last." *Art Journal* 66, no. 2 (Summer 2007): 34–47.

Said, Edward. *Orientalism*. New York: Vintage Books, 1978.

Said Makdisi, Jean. "Elisabeth Bowen Thompson and the Teacher Training College." *Archaeology and History in the Lebanon* 22 (Autumn 2005): 84–89.

———. *Teta, Mother, and Me: Three Generations of Arab Women*. London: Saqi Books, 2005.

Salam, Sa'ib. *Qissat Imtiyaz al-Hula, 1914–1934* [The story of the Hula Concession, 1914–1934]. Beirut: self-published, 1976.

Salamandra, Christa. *A New Old Damascus: Authenticity and Distinction in Urban Syria*. Bloomington: Indiana University Press, 2004.

Salibi, Kamal. "Beirut under the Young Turks: As Depicted in the Political Memoirs of Salim Ali Salam (1868–1938)." In *Les Arabes par leurs archives: XVIe–XXe siècles*, edited by Jacques Berque and Dominique Chevalier, 193–215. Paris: Centre National de la Recherche Scientifique, 1976.

Salomon, Nanette. "The Art Historical Canon: Sins of Omission." In *(En)Gendering Knowledge: Feminists in Academe*, edited by Joan Hartman and Ellen Messer-Davidow, 222–36. Knoxville: University of Tennessee Press, 1991.

———. "The Venus Pudica: Uncovering Art History's 'Hidden Agendas' and Pernicious Pedigrees." In *Generations and Geographies in the Visual Arts: Feminist Readings*, edited by Griselda Pollock, 69–87. London: Routledge, 1996.

Santer, Janina. "Imagining Lebanon: Tourism and the Production of Space under French Mandate (1920–1939)." MA thesis, American University of Beirut, 2019.

Sawalha, Aseel. *Reconstructing Beirut: Memory and Space in a Postwar Arab City*. Austin: University of Texas Press, 2010.

Sayigh, Samir. "*'Ariyat Muhajjabat wa-Sha'iriyya Masdarha al-'Aql*" [Veiled nudes and poeticism the source of which is the mind]. In Nicholas Sursock Museum, *Omar Onsi*, 23–26.

Sbaiti, Nadya. "Lessons in History: Education and the Formation of National Society in Beirut, Lebanon, 1920s–1960s." PhD diss., Georgetown University, 2008.

Scheer, Monique. "Are Emotions a Kind of Practice (and Is That What Makes Them Have a History)? A Bourdieusian Approach to Understanding Emotion." *History and Theory* 51, no. 2 (2012): 193–220.

Scheid, Kirsten. "Distinctions That Could Be Drawn: Choucair's Paris and Beirut." In *Saloua Raouda Choucair in Retrospective*, edited by Jessica Morgan, 41–55. London: Tate Modern, 2013. Exhibition catalog.

———. "Looking at/as Nudes: A Study of a Space of Imagination." In *Fashioning the Modern Middle East*, edited by Reina Lewis and Yasmine Nachabe, 113–34. London: Bloomsbury Visual Arts, 2021.

———. "The MoMA Visa: Modern Art after the Trump Ban," Review of Museum of Modern Art, New York, *Installation Following the Executive Order of January 27, 2017*. H-AMCA, H-Net Reviews. URL http://www.hnet.org/reviews/showrev.php?id=49264.

———. "Necessary Nudes: *Hadatha* and *Mu'asara* in the Lives of Modern Lebanese." *International Journal of Middle East Studies* 43, no. 1 (February 2010): 203–30.

———. "Painters, Picture-Makers, and Lebanon: Ambiguous Identities in an Unsettled State," PhD diss., Princeton University, 2005.

———. "Toward a Material Modernism: Introduction to S. R. Choucair's 'How the Arab Understood Visual Art.'" *ARTMargins* 4, no. 1 (February 2015): 108–18.

Schielke, Samuli. *Egypt in the Future Tense: Hope, Frustration, and Ambivalence before and after 2011*. Bloomington: Indiana University Press, 2015.

Schimmel, Anne-Marie. *Deciphering the Signs of God*. Albany: State University of New York, 1994.

Schumann, Christophe. "The Generation of Great Expectations: Nationalism, Education, and Autobiography in Syria and Lebanon, 1930–1958." *Die Welt des Islams* 41, no. 2 (July 2001): 185–87.

Sehnaoui, Nada. *L'Occidentalisation de la vie quotidienne à Beyrouth, 1860–1914*. Beirut: Dar An-Nahar, 2001.

Shalem, Avinoam. "Dangerous Claims: On the 'Othering' of Islamic Art History and How It Operates within Global Art History." 2012. Reprinted in *Art and Its Global Histories, A Reader*, edited by Diana Newell, 121–34. Manchester: Manchester University Press, 2017.

———. "What Do We Mean When We Say 'Islamic Art'? A Plea for a Critical Rewriting of the History of the Arts of Islam." *Journal of Art Historiography* 6

(June 2012): 1–18. Accessed June 15, 2021. https://arthistoriography.wordpress
.com/number-6-june-2012-2/.

Shami, Seteney, and Nefissa Naguib. "Occluding Difference: Ethnic Identity and the
Shifting Zones of Theory on the Middle East and North Africa." In *Anthropology
of the Middle East and North Africa: Into the New Millennium*, edited by Sherine
Hafez and Susan Slyomovics, 23–46. Bloomington: Indiana University Press, 2013.

Shannon, Jonathan. *Among the Jasmine Trees: Music and Modernity in Contempo-
rary Syria*. Middletown, CT: Wesleyan University Press, 2006.

———. "Emotion, Performance, and Temporality in Arab Music: Reflections on
Tarab." *Cultural Anthropology* 18, no. 1 (February 2003): 72–98.

Sharif, Malek. *Imperial Norms and Local Realities: The Ottoman Municipal Laws
and the Municipality of Beirut, 1860–1908*. Baden-Baden, Germany: Nomos Ver-
lagsgesellschaft, 2014.

Shaw, Wendy M. K. "The Islam in Islamic Art History: Secularism and Public
Discourse." *Journal of Art Historiography* 6 (June 2012): 1–34. Accessed June 21,
2021. https://arthistoriography.wordpress.com/number-6-june-2012-2/.

———. *Ottoman Painting: Reflections on Western Art from the Ottoman Empire to
the Turkish Republic*. London: I. B. Tauris, 2011.

———. *What Is "Islamic" Art? Between Religion and Perception*. Cambridge, UK:
Cambridge University Press, 2019.

Sheehi, Stephen. *The Arab Imago: A Social History of Portrait Photography, 1860–
1910*. Princeton, NJ: Princeton University Press, 2016.

Shuqair, Salwa Rawda. "*Kayfa Fahima al-ʿArabi Fann al-Taswir* (How the Arab
understood visual art)." Translated by Kirsten Scheid. *ARTMargins* 4, no. 1
(February 2015): 119–28.

Solh, Raghid El-. *Lebanon and Arabism: National Identity and State Formation*.
London: I. B. Tauris, 2004.

Somel, Selçuk Akşin. *The Modernization of Public Education in the Ottoman Em-
pire, 1839–1908: Islamization, Autocracy, and Discipline*. Leiden: Brill, 2001.

Steinberg, Leo. "Contemporary Art and the Plight of Its Publics." In *Other Cri-
teria: Confrontations with Twentieth-Century Art*, 3–16. New York: Oxford Uni-
versity Press, 1972.

Steinmetz, George. "'The Devil's Handwriting': Precolonial Discourse, Ethno-
graphic Acuity, and Cross-Identification in German Colonialism." *Compara-
tive Studies in Society and History* 45, no. 1 (2003): 41–95.

Stone, Christopher. *Popular Culture and Nationalism in Lebanon: The Fairouz and
Rahbani Nation*. New York: Routledge, 2008.

Sufian, Sandra. *Healing the Land and the Nation: Malaria and the Zionist Project in
Palestine, 1920–1947*. Chicago: University of Chicago Press, 2007.

Sulaiman, Musa. *Al-Adab al-Qasasi ʿind al-ʿArab* [Narrative fiction among the
Arabs]. Juniyah, Lebanon: Dar al-Kitab, 1950.

Sultan, Maha. *L'art au Liban: Du mandat français à l'indépendance*. Beirut: Kutub Publishing, 2019.

———. *Ruwwad min Nahdat al-Fann al-Tashkili fi Lubnan* [Pioneers from the renaissance of plastic art in Lebanon]. Kaslik: Université Saint-Esprit de Kaslik, 2006.

Tanielian, Melanie Schulze. *The Charity of War: Famine, Humanitarian Aid, and World War I in the Middle East*. Palo Alto, CA: Stanford University Press, 2017.

Tannous, Afif. "The Village in the National Life of Lebanon." *Middle East Journal* 3, no. 2 (1949): 151–63.

Tarrab, Joseph. "High above the Flock." In *Saloua Raouda Choucair: Her Life and Art*, xiii–xiv.

———. "Mirror of the Soul." *Landscapes. Cityscapes. 1*. Beirut: Saleh Barakat, 2009. Exhibition catalog.

Taylor, Nora Annesley. *Painters in Hanoi: An Ethnography of Vietnamese Art*. Honolulu: University of Hawaii and National University of Singapore Press, 2004.

Thompson, Elizabeth. *Colonial Citizens: Republican Rights, Paternal Privilege, and Gender in French Syria and Lebanon*. New York: Columbia University Press, 2000.

Tohme Hadjian, Christine. "Thugrat li-Asdiqa'" [Loopholes for Friends]. In Ashkal Alwan, *Liqa' al-Sana'i' al-Tashkili al-Awwal* [The First Sanayeh Plastic Arts Meeting]. Beirut: self-published, 1995. Exhibition catalog.

Toukan, Hanan. *The Politics of Art: Dissent and Cultural Diplomacy in Lebanon, Palestine, and Jordan*. Stanford, CA: Stanford University Press, 2021.

Touma, Toufic. *Un village de montagne au Liban—Hadeth el-Jobbé*. Paris: Mouton, 1958.

Traboulsi, Fawwaz. *A History of Modern Lebanon*. London: Pluto Books, 2007.

Troelenberg, Eva-Maria. "Arabesques, Unicorns, and Invisible Masters: The Art Historian's Gaze as Symptomatic Action?" *Muqarnas* 32 (2015): 213–32.

Tsing, Anna Lowenhaupt. *In the Realm of the Diamond Queen: Marginality in an Out-of-the-Way Place*. Princeton, NJ: Princeton University Press, 1993.

Turner, Victor. *The Anthropology of Performance*. New York: PAJ, 1987.

———. *The Forest of Symbols: Aspects of Ndembu Ritual*. Ithaca, NY: Cornell University Press, 1967.

———. *The Ritual Process: Structure and Anti-structure*. Ithaca, NY: Cornell University Press, 1969.

Tyler, Warwick. "The Huleh Concession and Jewish Settlement of the Huleh Valley, 1934–48." *Middle Eastern Studies* 30, no. 4 (October 1994): 826–59.

———. "The Huleh Lands Issue in Mandatory Palestine, 1920–1934." *Middle Eastern Studies* 27, no. 3 (July 1991): 343–73.

Ward, Frazer. *No Innocent Bystanders: Performance Art and Politics*. Hanover, NH: Dartmouth College Press, 2012.

Watenpaugh, Heghnar. "Resonance and Circulation: The Category 'Islamic Art and Architecture." In *A Companion to Islamic Art and Architecture: From the Prophet to the Mongols*, edited by Finbarr Barry Flood and Gülru Necipoğlu, 1:1223–44. London: Wiley, 2017.

Watenpaugh, Keith. *Being Modern in the Middle East: Revolution, Nationalism, Colonialism, and the Arab Middle Class*. Princeton, NJ: Princeton University Press, 2006.

Weber, Stefan. "Images of Imagined Worlds: Self-Image and Worldview in Late Ottoman Wall-Paintings in Damascus." In *The Empire in the City: Arab Provincial Capitals in the Late Ottoman Empire*, edited by Jens Hanssen, Thomas Philipp, and Stefan Weber, 145–71. Beirut: Orient-Institut, 2002.

Wehr, Hans. *A Dictionary of Modern Written Arabic*. Edited by J. Milton Cowan. 3rd ed. Ithaca, NY: Spoken Language Services, 1976.

Westmoreland, Mark R. "Making Sense: Affective Research in Postwar Lebanese Art." *Critical Arts* 27, no. 6 (2013): 717–36.

Williams, Raymond. *Keywords: A Vocabulary of Culture and Society*. Oxford: Oxford University Press, 1983.

Wilson-Goldie, Kaelen. "Digging for Fire: Contemporary Art Practices in Postwar Lebanon." MA thesis, American University of Beirut, 2005.

Winegar, Jessica. *Creative Reckonings: The Politics of Art and Contemporary Culture in Egypt*. Stanford, CA: Stanford University Press, 2006.

———. "The Humanity Game: Art, Islam, and the War on Terror." *Anthropological Quarterly* 81, no. 3 (Summer 2008): 651–81.

Wishnitzer, Avner. "'Our Time': On the Durability of the *Alaturka* Hour System in the Late Ottoman Empire." *International Journal of Turkish Studies* 16, no. 1–2 (2010): 47–69.

Yammut, Ghazi. "*Bashir Yammut: Hayatahu wa-Adabahu*" [Bashir Yammut: His life and literature]. PhD diss., Saint Joseph University, 1978.

Zabadi, Muhammad Murtada al-Hussaini al-. *Taj al-'Arus* [The bride's crown]. Kuwait City: Kuwait Government, 1989.

Zitzewitz, Karin. "Infrastructure as Form: Cross-Border Networks and the Materialities of 'South Asia' in Contemporary Art." *Third Text* 31, no. 2–3 (October 2017): 341–58.

INDEX

The index below additionally functions as a glossary of Arabic terms that appear more than once in the text (and thus unaccompanied by translation). It serves as an image list, too. All images reproduced in the book are listed in transliterated Arabic and English (for titles used in translation). Seeing the medium, size (if available), and date alerts you to an image on the italicized page number.

`Abdu, Muhammad, 69
Abdülhamid II, 47
Abillama, Ziad, 88n151
abjection, 1–2, 18, 78–79, 98, 103–4, 110–11, 113, 146, 193; absence of art, 30, 54–55, 74, 93, 129–30, 233, 248; Arab inferiority, 231, 249–50; vs. artistic achievement, 61, 78–79, 104, 110; audience inadequacy, 3, 5–6, 55–56, 78–79, 90–93, 176–79, 193, 251–52; calls for reeducation, 77–78, 177, 193–94; French evocation of, 229, 231–33; government neglect, 2, 76, 92, 121–23, 193, 248, 251; life models and, 89–90, 102–4, 125–30; Ottoman legacy, 144, 161; provoking infilling, 93, 161, 248–49, 259–60, 299; religious oppression and, 92, 231; time and, 145–46, 259–60. See also *hadatha*; no-art; universality

Abou–Hodeib, Toufoul, 11, 71, 94
abstraction: abjection and, 5–6, 18, 252, 297; Choucair and, 15, 25, 254, 260, 263–64, 267, 270, 285n48. *See also* Atelier de l'art abstrait
Abu–Lughod, Lila, 37n43
ACC. *See* Arab Cultural Club
Achkar, Yvette, 19
al-Adab (review), 278–79
adab al-dars (internalisation of pedagogical norms), 49. *See also* ethics; Islam
adab al-nafs (discipline of the self), 49, 167. *See also* ethics; Islam
al-Adab al-Qasasi `inda al-`Arab (Sulaiman), 264–67
Adal, Raja, 205–6
al-Adib (journal), 251
Advocates of unveiling, partisans of the veil (Farrouk, ink on paper, 1929), 127–28, *129*

Kirsten L. Scheid is Associate Professor of Anthropology in the Department of Sociology, Anthropology, and Media Studies at the American University of Beirut and Affiliated Faculty in the Department of Fine Art and Art History. She is Cofounder of the Anthropology Society in Lebanon (ASIL) in Beirut (since 2006) and Cofounder and Producer of the *Hikayat Walad min Bayrut* [Stories of a child from Beirut] (2004). She co-curated *The Arab Nude: The Artist as Awakener* (2016) and *Jerusalem: Actual and Possible,* 9th edition of the Jerusalem Show (2018).